KURT

ASPHALT RENAISSANCE

THE PAVEMENT ART AND 3-D ILLUSIONS OF KURT WENNER

WENNER

by Kurt Wenner with B. Hansen and M. Hospodar

ASPE
RENAISSANCE

TO ELIZABETH AND ANDERS

HALT

THE PAVEMENT ART AND 3-D ILLUSIONS OF
KURT WENNER

Sterling Signature
NEW YORK

CONT

STERLING SIGNATURE and the distinctive Sterling Signature logo are registered trademarks of
Sterling Publishing Co., Inc.

Library of Congress Cataloging-in-Publication Data

Wenner, Kurt.
 Asphalt renaissance : the pavement art and illusion of Kurt Wenner / Kurt Wenner.
 p. cm.
 Includes index.
 ISBN 978-1-4027-7126-2
 1. Wenner, Kurt--Themes, motives. I. Title. II. Title: Pavement art and illusion of Kurt Wenner.
 NC139.W434A35 2011
 741.092--dc22
 2010049807

10 9 8 7 6 5 4 3 2 1

Published by Sterling Publishing Co., Inc.
387 Park Avenue South, New York, NY 10016
© 2011 by Kurt Wenner
Text by Kurt Wenner, B. Hansen, and M. Hospodar

Distributed in Canada by Sterling Publishing
c/o Canadian Manda Group, 165 Dufferin Street
Toronto, Ontario, Canada M6K 3H6
Distributed in the United Kingdom by GMC Distribution Services
Castle Place, 166 High Street, Lewes, East Sussex, England BN7 1XU
Distributed in Australia by Capricorn Link (Australia) Pty. Ltd.
P.O. Box 704, Windsor, NSW 2756, Australia

Sterling ISBN 978-1-4027-7126-2

For information about custom editions, special sales, premium
and corporate purchases, please contact Sterling Special Sales
Department at 800-805-5489 or specialsales@sterlingpublishing.com.

ENTS

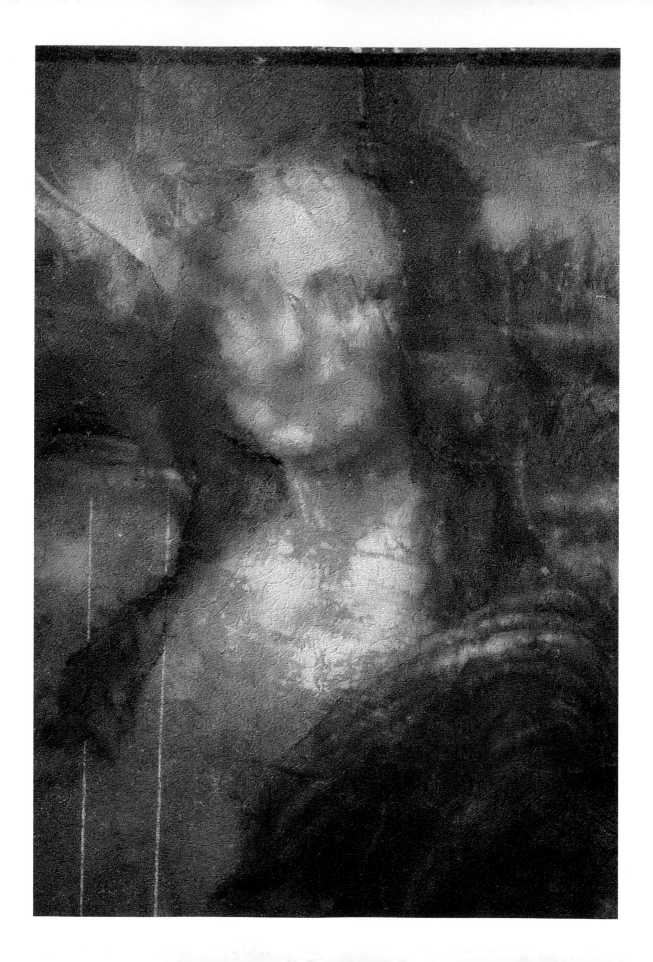

PROLOGUE

In the twenty-five years I have spent with the art form, I have seen street painting inspire thousands of artists and be appreciated by millions of spectators. Although a historical and cultural context is provided, this book is mainly a narrative about my personal experiences and vision of the art form. I have attempted to use these experiences to illustrate the story of street painting and show its evolution. Despite its historical and current popularity, there is little documentation that can be referenced by those wishing to better understand the art form. This book contains the most comprehensive account of its historical origins to date. During the past several decades, many other artists have contributed to the growth and proliferation of street painting, and I hope this account will inspire others to tell their stories.

—Kurt Wenner

▶ Kurt Wenner.

◀ **Faded *Mona Lisa*.** After a rainstorm, a washed-out, fresco-like image remains.

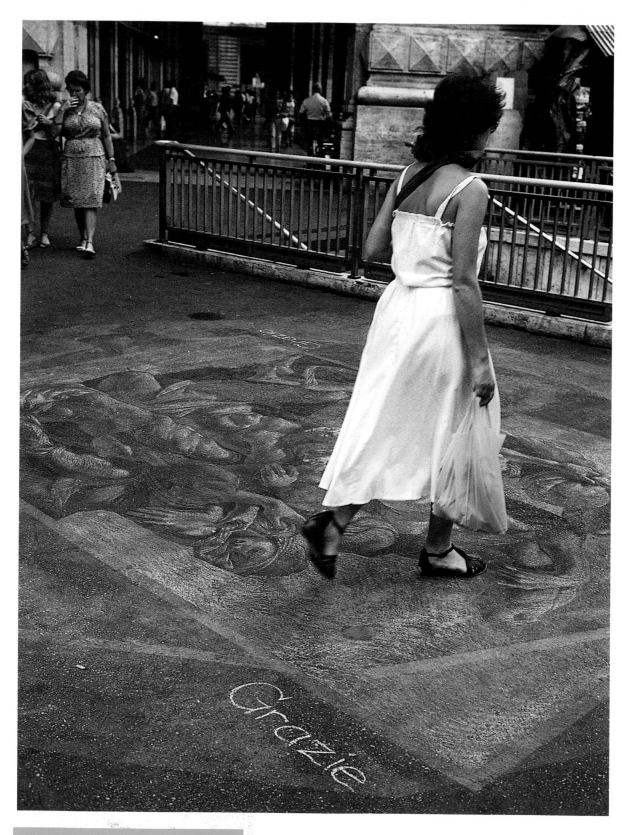

▲ **Passing over a memory.** When a work has faded, pedestrians pass freely over the site.

INTRO

THE IMPERMANENT AND THE ETERNAL

THE MOST FREQUENTLY ASKED QUESTION OF A STREET PAINTER IS "WHAT HAPPENS WHEN IT RAINS?" THE SECOND IS "AREN'T YOU SAD WHEN IT WASHES AWAY?" KURT WENNER HAS BEEN ASKED THESE QUESTIONS THOUSANDS OF TIMES WHILE CREATING HIS ART. AS WITH ALL QUESTIONS THAT ARE ASKED REPEATEDLY, THE TEMPTATION IS TO GIVE A BRIEF ANSWER; HOWEVER, SOME QUESTIONS THAT ARE ASKED IN JUST A FEW WORDS DESERVE A PROPER RESPONSE.

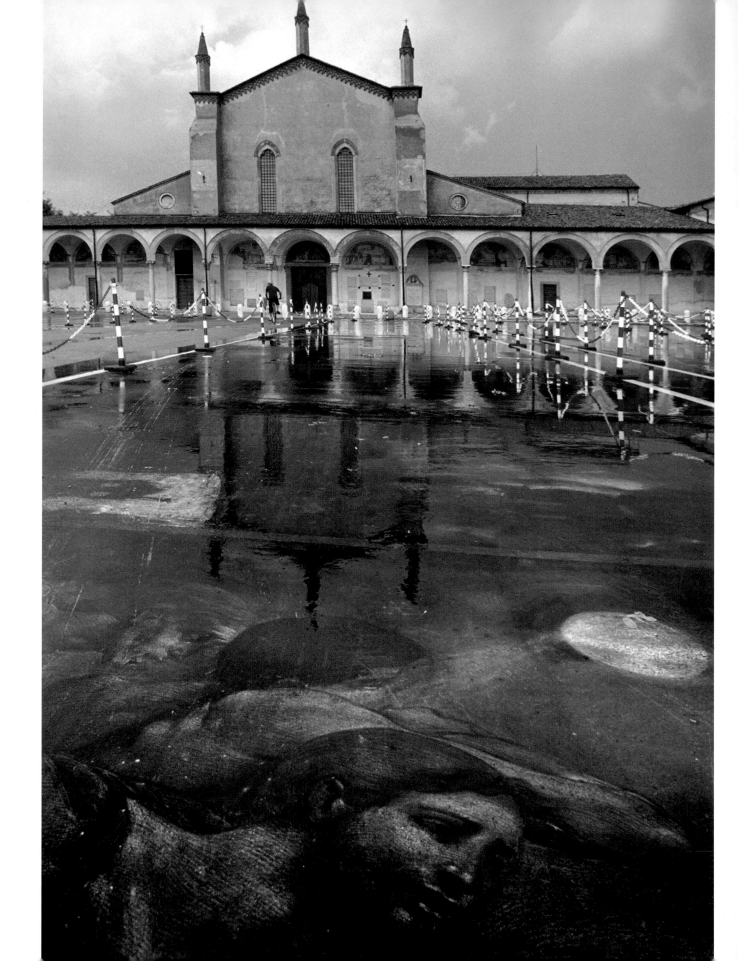

No MATTER HOW MANY TIMES THESE QUESTIONS ARE ASKED, THEY ALWAYS FORCE ME TO PAUSE FOR A MOMENT. NORMALLY, I AM NOT IN A POSITION TO GIVE A FULL EXPLANATION, BECAUSE I AM WORKING IN A PUBLIC VENUE AND IT WOULD TAKE TOO MUCH TIME. THE PROBLEM WITH THESE QUESTIONS IS THAT THEY CONTAIN A COMMON MISPERCEPTION BY SOCIETY THAT ART IS SOLELY A PRODUCT, BUT STREET PAINTING PUTS THE FOCUS SQUARELY ON THE ACT OF CREATION, AS THE FINAL PRODUCT WILL NOT LAST FOREVER. THERE IS NO WAY TO RETURN TO THE ARTWORK AFTER WEEKS, MONTHS, OR YEARS AND REWORK IT. IN THE END, THE IMAGE RESULTS FROM THE ACT OF DRAWING. AND IT SHOWS ALL THE STRENGTHS AND WEAKNESSES OF THE ARTIST. A STREET PAINTING IS A WORK IN PROGRESS FOR MOST OF THE TIME IT'S ON DISPLAY, AND AUDIENCES ARE PARTICULARLY ENGAGED BY THE OPPORTUNITY TO OBSERVE THE CREATIVE PROCESS.

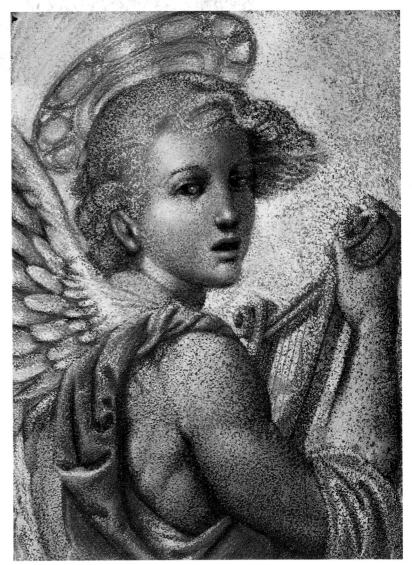

Street painting is not typical of our time or culture. Its roots reach back through history to a time when people had a different relationship with the world. All the great monuments of the past were created to immortalize customs, beliefs, or ideas. The creators of these monuments wanted to record in stone ideas that seemed extremely important but also fragile and impermanent to them. Temples, tombs, and triumphal arches are permanent records of events and practices that have long since disappeared or been transformed beyond the point of recognition. The original motivations for creating permanent works of art were of course social and cultural.

▶ Wenner. *Angel with Harp*. Mantua, Italy.

◀ After the rain. Handmade pastels hold up better than the commercial brands, but once the picture is wet the entire surface must be repainted.

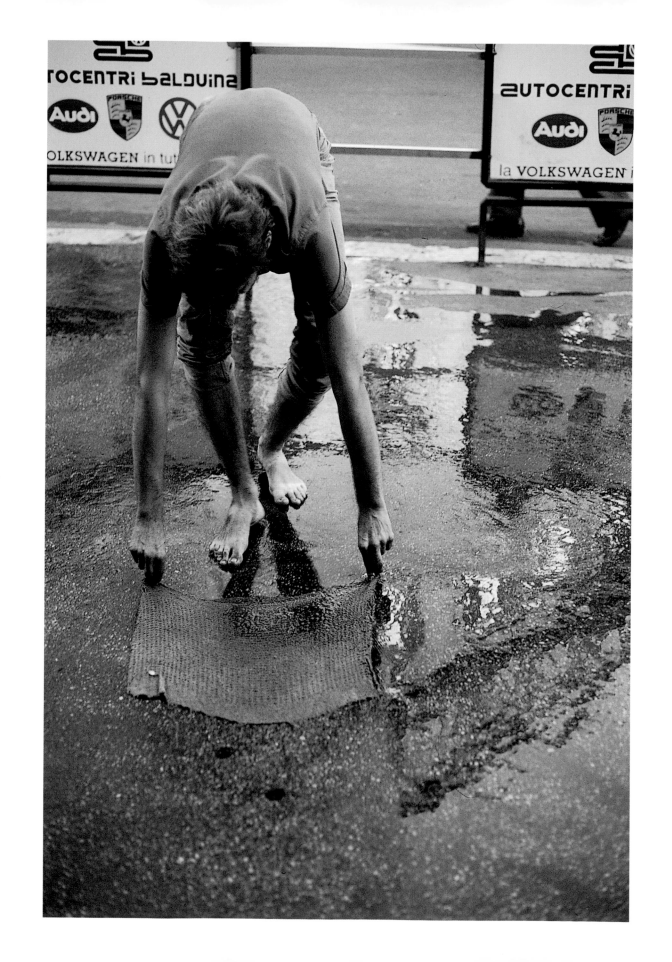

European nobility made art into a commodity by buying, trading, and stealing it from one another. Only during the last centuries has fine art been perceived almost exclusively as a marketable commercial product with a fixed value. This has led to the current and often confused perception that the cultural and artistic worth of a work of art is determined by its profit-making value. Because street painting cannot help but be tied to impermanence, it reminds the artist and the observer of the ancient origins of the artistic process.

Ephemeral art (art that is fleeting and impermanent) is rooted deeply in Italian culture, and stems from the pagan era when all of life was seen as transient. Religious rites and processions played an important role in marking events during pagan times, and such traditions continued throughout the early Roman era, directly inspiring secular celebrations. Rome's military successes were celebrated with parades, which, like pagan processions, were based on the idea of marking the passage of time. To honor god-like beings such as triumphant military generals, the Romans created lavish public spectacles filled with temporary decorations.

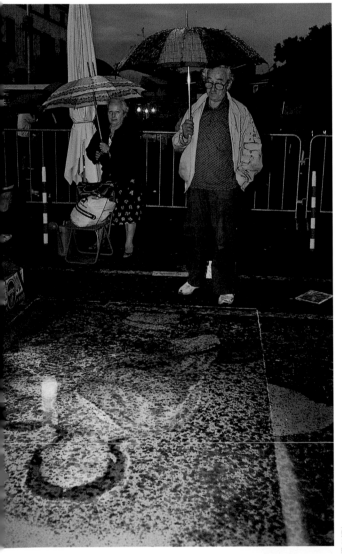

◀ **Prisciandaro in the rain.** Although younger generations of street painters work hard to maintain their compositions for several days, older artists limit the scope of their work to images that can be executed in a shorter time period. They watch the work wash away with a sense of detachment born of years of experience.

◀ **Preparing the pavement.** When the rain does not wash an image away, street painters must wash away remnants of old works before beginning afresh.

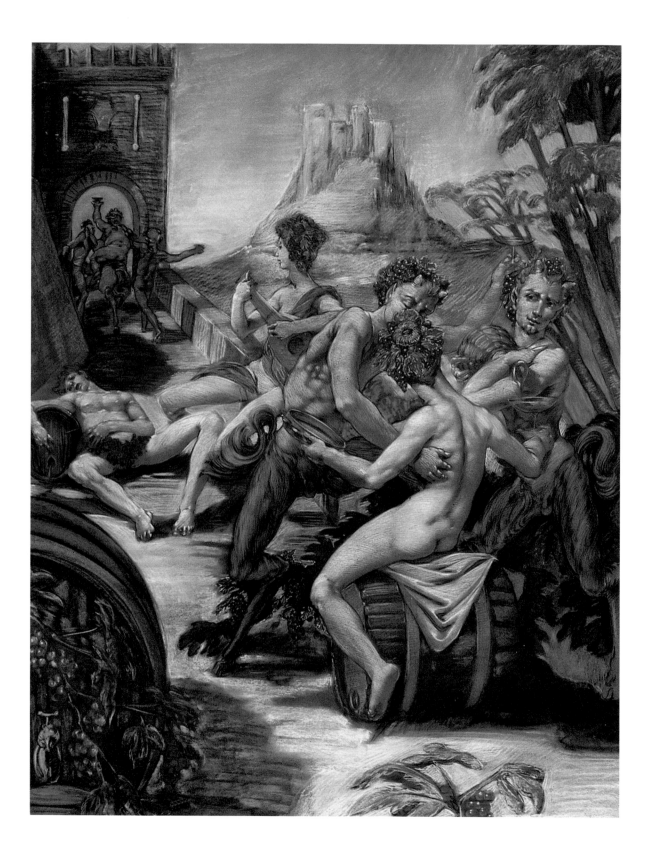

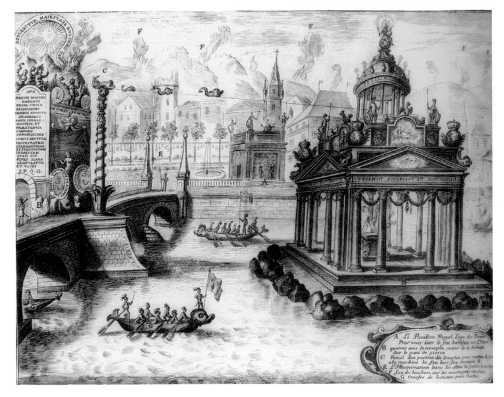

Among the most famous of the military parades was the Triumph, which was awarded by the Roman Senate to a returning victorious general. The general would arrive at the place of festivities in a chariot drawn by a team of horses and would lead his army through a temporary triumphal arch erected in his honor. As the general and his soldiers made their way through the parade route, they passed fountains flowing with wine, observed theatrical acts on barges set on false lakes or moored along a riverbank, and passed alongside obelisks, provisional arches, and structures all made from papier-mâché. What remains of these elaborate celebrations are the enormous stone triumphal arches of Rome today. Although commissioned immediately on a general's triumphant return, a permanent stone arch took years to create and therefore did not exist at the time of the actual festivities. The permanent arches were created as lasting symbols in what was otherwise perceived to be a very short-lived world. An enormous part of the ancient world's artistic production was comprised of impermanent works of art that would only survive a single celebration. Street painting is rooted in the ancient idea of impermanence, of creating images and decorations that survive but a single event.

▲ *Fireworks Pavilion.* European nobility once spent vast sums on impermanent displays such as this fireworks pavilion, which would end up in flames as part of the spectacle. Etchings preserved the memory of the event.

◀ *Barolo Bacchus.* Wenner composed this bacchanal in competition in Barolo, Italy. The triumph of Bacchus was a popular classical theme recalling Roman triumphal processions.

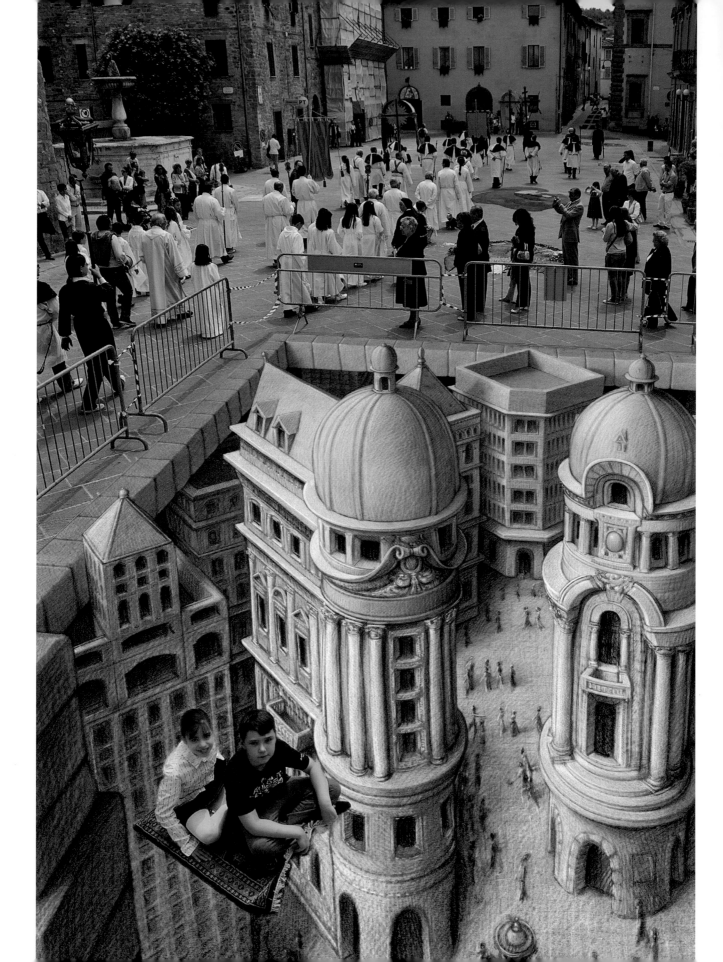

WHILE PAINTING A MADONNA IN FRONT OF A CHURCH, I COULD FEEL HOW WEAKLY THE PASTELS GRIPPED THE EARTH AND HOW TRULY TEMPORARY MY PAINTING REALLY WAS. TO HELP IT LAST A LITTLE LONGER, I'D COVER THE PICTURE AT NIGHT WITH CLEAR PLASTIC TO PROTECT IT FROM THE FEET OF PASSERSBY. THE IMPERMANENCE OF THE ARTWORK MADE ME REALIZE THAT ITS CREATION WAS PART OF A LARGER CYCLE OF TRIBUTE AND RITUAL. EVENTUALLY, THE PAINTING WAS WASHED OFF OR FADED AWAY, AND THE OFFERING WAS COMPLETE.

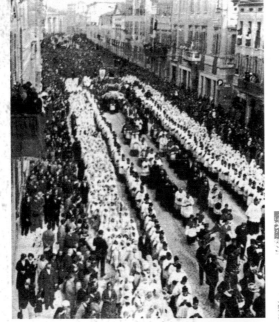

◀ **Mantuan procession.** Until recently, the miraculous image of Santa Maria delle Grazie was carried in procession through the streets of Mantua, Italy. Now pilgrims arrive at the festival on the fifteenth of August to pay homage to the holy image.

With the emergence of the Catholic Church, a liturgical calendar was established to continue the tradition of processions and religious ceremonies. The most famous procession is the *Via Crucis*, literally the "Way of the Cross." It marks the passage of time by the movement of the procession through the Stations of the Cross. An annual reenactment of a procession also indicates the passage of time moving through eternity.

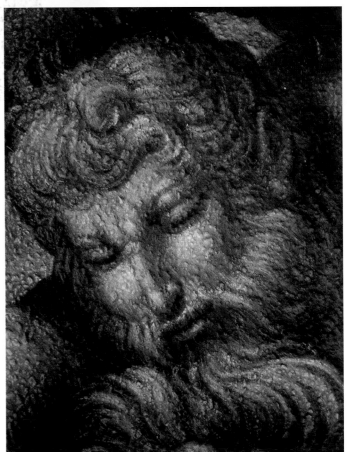

▶ Wenner. *Hercules detail*. **Mantua, Italy.** The texture of the pavement can be a beautiful part of the image, but extreme roughness becomes a limitation.

◀ Wenner. *The Ideal City.* Processions still occur in many Italian towns during important holidays. This procession was for Corpus Domini, the same day as the Genzano Infiorata.

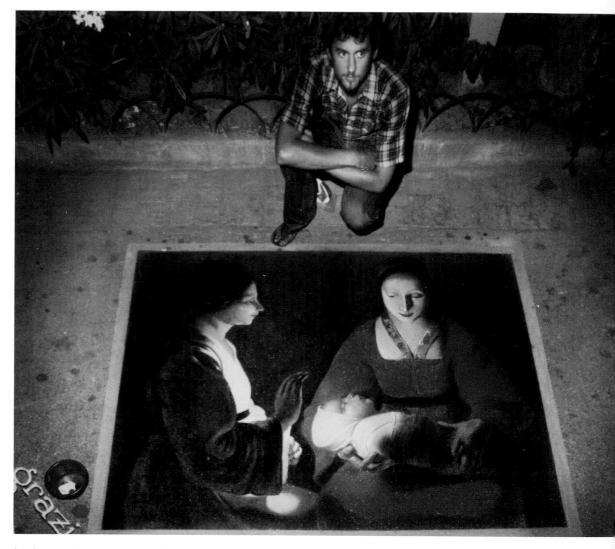

In the early centuries of Christianity, processions with a miracle-working icon or reliquary were often held to ask for divine intervention to end plagues and other natural disasters. If a procession moved God or a saint to intervene on behalf of the beleaguered people, it was often made into an annual event to commemorate the miracle. Processions, along with pilgrimages and festivals, offered a brief respite from the misery of daily life, which was often fraught with disease, violence, hunger, and endless toil. Temporary spectacles were accepted without question in a culture that was more concerned with the spiritual

▲ Wenner after La Tour. *The Newborn Child.* Rimini, Italy. This small picture also lent itself to illumination at night.

▶ Wenner. *Angel with Violin.* Mantua, Italy. The first original images Wenner created were hard to distinguish from the copied masterpieces. The public began guessing the identity of the "original" artists.

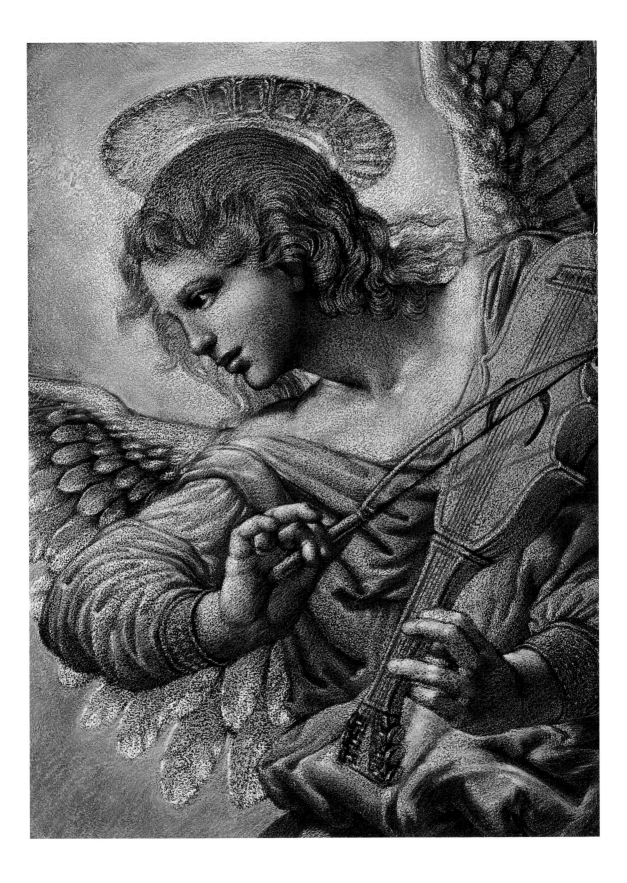

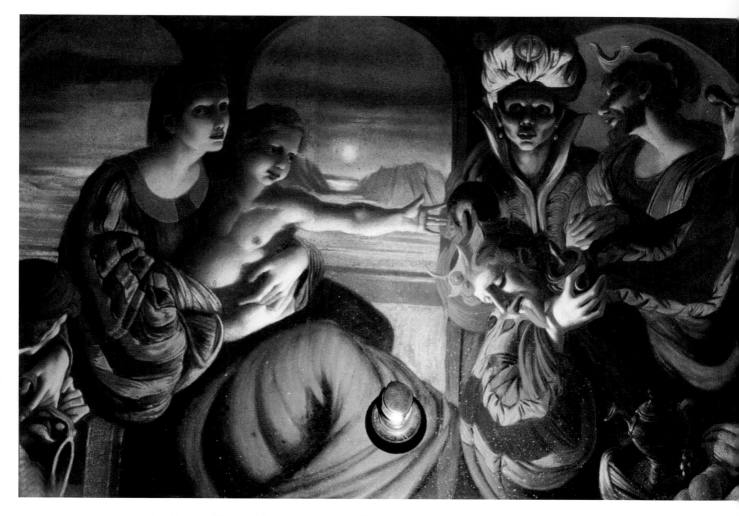

realm than with earthly permanence. Early street painters were often regarded as pilgrims, in part because of their itinerant lifestyle, and also because of the icons and biblical scenes they created. With the simplest tools and a minimum of physical comfort, they were able to create inspirational images.

STREET PAINTING IS MOSTLY AN ENJOYABLE PROCESS, ALTHOUGH A PAINTING IS RARELY BROUGHT TO COMPLETION WITHOUT SOME PHYSICAL DISCOMFORT. WHEN AN ARTIST IS WORKING OUTDOORS, EXTREMES OF HEAT AND COLD, WIND AND RAIN, CAN CAUSE A GREAT DEAL OF DISCOMFORT. IT IS ALSO HARD ON THE BODY TO BE BENT OVER AND CONCENTRATED FOR HOURS ON END. WHILE WORKING ON A STREET PAINTING, I AM ALWAYS AWARE OF THE METRONOME-LIKE MOVEMENT OF THE DRAWING PROCESS IN CONTRAST WITH THE FRENETIC AND CHAOTIC MOVEMENT OF TRAFFIC AND PEDESTRIANS. IT TAKES A LOT OF PATIENCE AND FAITH TO WORK ON AN IMAGE OUTDOORS; IT'S TOUGH TO BE AT THE MERCY OF FORCES MUCH LARGER AND STRONGER THAN YOU.

▲ Wenner. *Rimini Adoration.* Rimini, Italy. Much of the pedestrian traffic in Rimini was at night. Wenner composed this piece with the light coming from the center. At night, a gas lantern placed at the source lighted the picture.

▶ Jaques Callot. *The War of Love.* Great secular displays of pageantry were also a part of civic life in the Middle Ages. Ephemeral displays on mythological and allegorical themes were created for these events by some of the most famous artists of the day.

Italy has few permanent reminders of the many ornate and sophisticated celebrations that temporarily graced its piazzas and transformed its public spaces beyond recognition. In preparation for sixteenth-century pope Leo X's entrance into the city of Florence, for example, every available artist and artisan spent months preparing decorative carriages, plaster triumphal arches, wine fountains, obelisks, and pyramids, along with decorative columns and statues, all to give the appearance of an idealized city. Buildings and walls were covered with trompe l'oeil (illusionistic) paintings and murals. Great, luxurious swags of extravagant fabric and garlands graced the area. Masks, floats, banners, costumes, and exotic animals were used in enormous processions. Grand temporary arches were placed in prominent spots along the procession route for floats, horses, and carriages to pass under. Similar grandiose spectacles were constructed for royal marriages, visits by important dignitaries, and other secular celebrations. Historically, street painters have always followed a circuit of these events as they provided a venue for the art and a collective consciousness that was receptive to it.

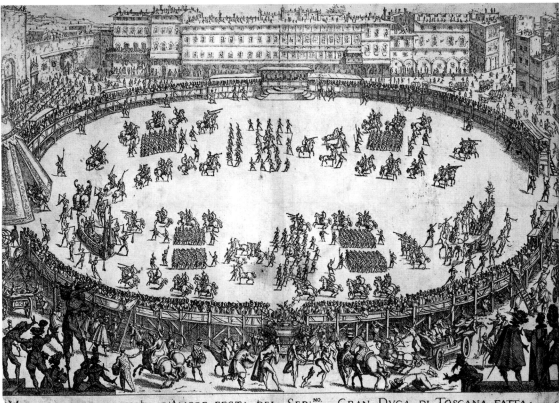

MOSTRA DELLA GVERRA D'AMORE FESTA DEL SER:^MO GRAN DVCA DI TOSCANA FATTA L'ANNO. 1616

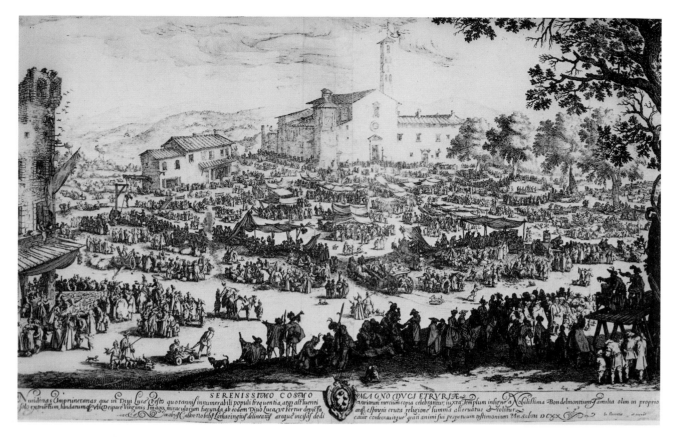

In contemporary Italy, the lavish celebrations of the nobility and church have disappeared. However, one last vestige of this tradition can still be seen in the numerous *sagre* and *feste* (festivals and holidays) held once a year in most villages, towns, and cities throughout Italy. While all of these events seem to share a common dedication to delicious food specialties like pasta, risotto, melons, wine, or truffles, they almost always have a component that honors or celebrates a saint, a pagan god such as Bacchus, or an ongoing annual fair from a time when kings and dukes ruled the area. Street painters still follow a circuit of these events.

Two other forms of ephemeral art still exist widely throughout Italy. The *infiorata* and the *pula toscana* are processional art traditions, akin to street painting. The more famous of the two is the *infiorata,* which is painting with flower petals, with the most renowned festival being held every year since 1778 in Genzano on the day of Corpus Domini. The *infiorate* occur sixty days after Easter and can be found throughout central and

▲ **Jacques Callot.** *Fair at Impruneta.* This etching shows in extreme detail an important country fair in 1622.

▶ **Destroying the** *Infiorata.* Artists work through the night creating the enormous carpet of colored flower petals; after the procession, children take great pleasure in scattering the decorations.

southern Italy. An *infiorata* takes days of preparation, as the flowers must be sorted by color and the petals carefully removed and stored in cool water until the moment of the event. On the night before Corpus Domini, the artists trace an outline of their design on the pavement. They then work for hours laying the colorful petals in place until they have created a wonderful show of color that resembles a carpet. This vibrant display of flower petals depicting images of the Madonna, saints, and religious scenes is then walked on as part of the annual procession. The dispersion and scattering of the petals and images sacrifice to God the devotional efforts of all those who participated.

The *pula toscana* came to Italy with the Bourbon kings of Parma, and is very similar in nature to the *infiorata*. Each year, colored sawdust is carefully placed on the street to create elaborate pictures and murals. The murals are admired for a brief time, and then a religious procession passes over them, scattering the sawdust and sacrificing the images. Some events allow artists to combine media and use materials such as colored glass, birdseed, and sand. While street paintings do not usually disappear in a programmed fashion, and there is no tradition of processions passing over them, they do share many common elements with these other forms of ephemeral art.

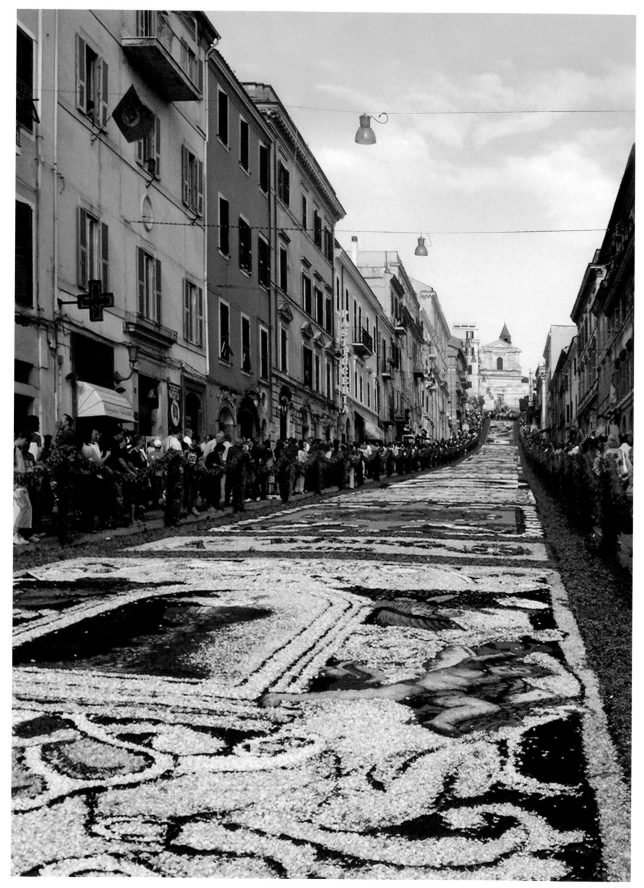

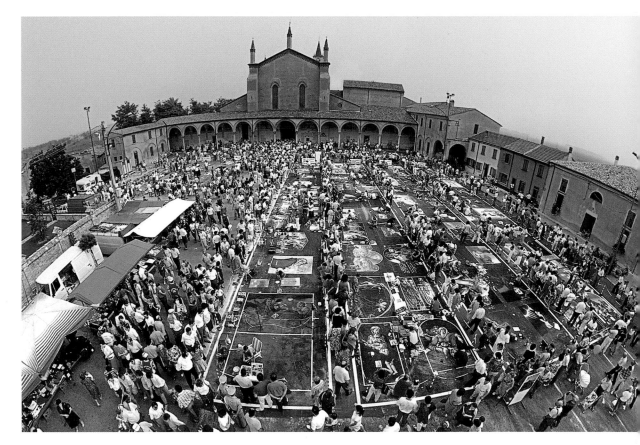

During the past two decades, street painting festivals have succeeded in transforming large public spaces with bright colors and spectacular imagery. The most famous of these festivals in Italy is the Incontro Nazionale dei Madonnari, held on Assumption Day in Grazie di Curtatone outside Mantua. Each year on August 15, the piazza is turned into a colorful tapestry of religious images. Traditional subjects such as the Madonna adorn the pavement momentarily before returning to the elements. In this way, street painting shares in the sacrificial and spiritual impulse that underscores the paintings made from petals or sawdust.

▲ **Festival at Grazie—detail of piazza.** As more sophisticated copies of masterworks appeared at the festival, the classic street painters were marginalized from the competition. A large stipend and special prizes kept them returning, providing a sense of continuity to the art form.

◀ **The *Infiorata* of Genzano.** The Genzano Infiorata is the most spectacular of the processional pieces created for the holiday of Corpus Domini, although many other cities hold similar celebrations.

Street painting enables anyone to create his or her personal version of this ritual and weave it into the everyday fabric of society.

Several other cultures celebrate the ephemeral with elaborate paintings made from impermanent materials. In almost all cases, they are works of a

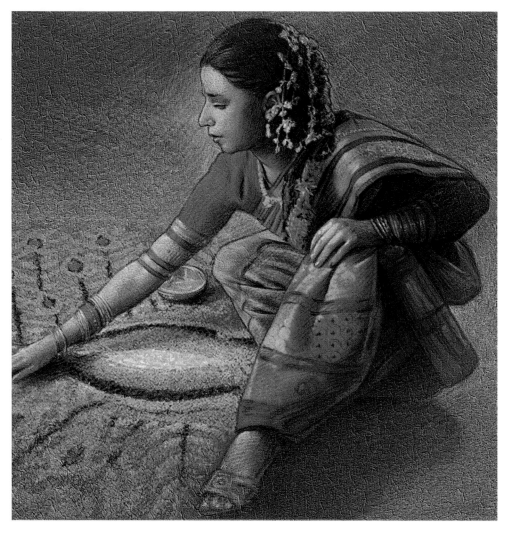

spiritual nature, and their destruction is just as important to their sacred purpose as their creation. Kolam paintings are made from finely ground rice and placed outside Hindu homes. Each day, women rise before dawn to prepare their doorsteps for the artwork by sweeping and cleaning the area thoroughly. They then carefully sprinkle white rice flour onto the ritually purified surface and make auspicious designs of their own choosing. A kolam is like a painted prayer, which also serves as a sign of invitation to welcome all into the home, including Lakshmi, the goddess of prosperity, beauty, and good fortune. Over the course of the day, as people come

▲ Wenner. *Hindu Kolam.* Dedicated to the goddess Lakshmi, the kolam separates the protected world of the home from the unprotected world of the outside.

▶ Kolam festival. At the Mylapore festival, no color is allowed for the kolams. They must also be based on the pulli, or dot, technique—the traditional way of drawing them.

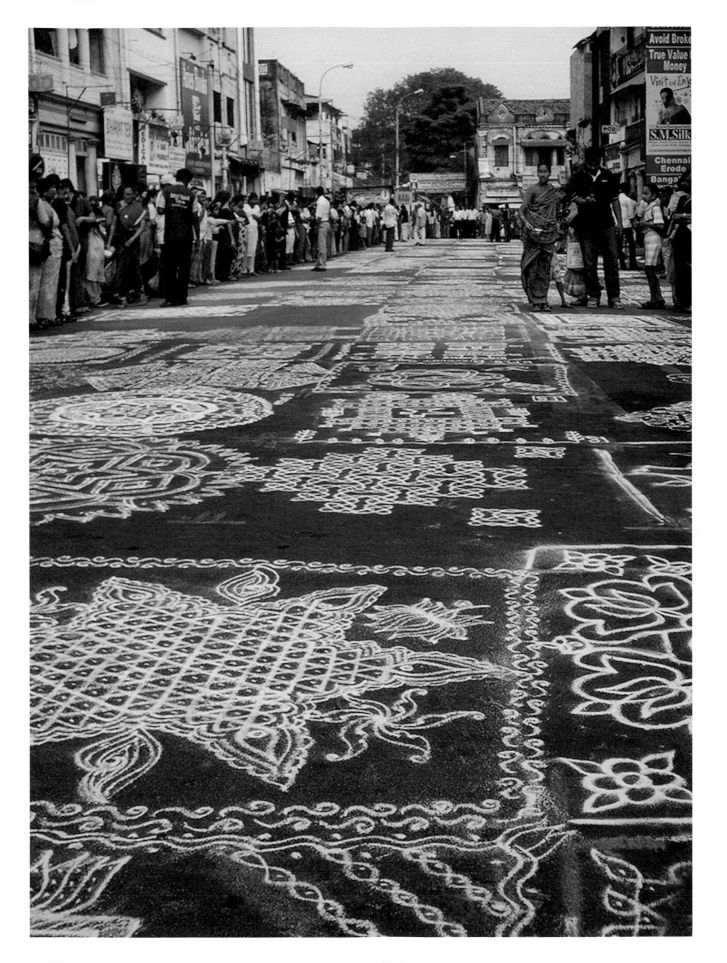

and go from the home, the kolam will be destroyed. The next morning before anyone else has risen, the women will begin all over again and create new sacred paintings to draw blessings to their homes and families.

As a street painter, I usually set out for a new site very early in the morning, because it was important to me that the public, and especially the nearby shop owners, see the quality of my work when they arrived. As I was setting out my supplies, the pavement and surroundings often felt cold and gray, even forbidding. I'd concentrate on my work, and by the time I looked up, the morning sun would be wending its way through the buildings, giving color to the world in the same way that I was giving color to the pavement.

▶ **Wenner after Honthorst.** *Nativity.* **Rome, Italy.** Street painters often usher in the daylight with images created at the crack of dawn. In their own way, such designs are auspicious for the well-being of passersby.

▼ **Navajo sand painting.** A sand painting in the Navajo tradition is literally a doorway for the gods. The images have healing powers, and their ritual dispersion eliminates sickness.

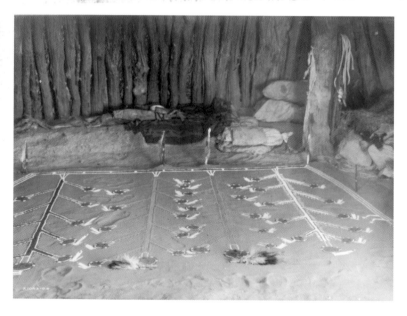

Tribes throughout the American Southwest and in northern Mexico practice sand painting. The Navajo tribe uses the art form in curing ceremonies. Painted prayers call on powerful spirits to help people suffering from disease. The Navajo word for sand painting, *ikaah*, literally means "the place where the gods come and go." These paintings depict specific Yei, which are divine beings who can help a patient. An aspiring Navajo medicine man may work for years perfecting just one design. Images like the ikaah, kolam, and Tibetan Buddhist mandala are often highly symmetrical and geometric in nature. The use of a formalized geometry invokes the passage from the physical (or manifest) world into the world of pure spirit.

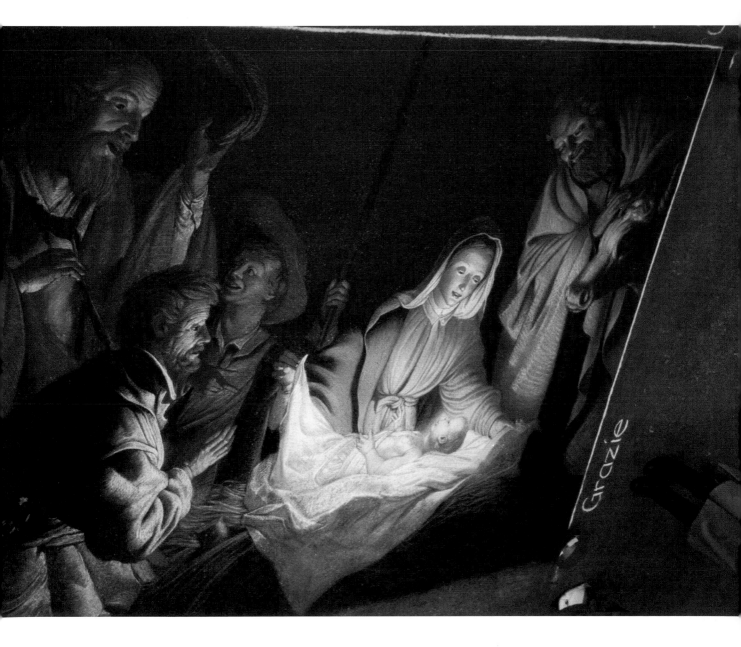

▲ Wenner. *Sky Woman*. Green Bay, Wisconsin.
Wenner enjoys the imagery of magic circles and
incorporates the theme into his own compositions.

The Navajo medicine man makes a painting by
carefully sprinkling finely powdered sandstone
onto the floor with the tips of his fingers.
This fine sand contains such agents as vegetable-based pigments, pollen, and
pulverized flower blossoms that dye the sand in the five sacred colors (white, black,
blue, yellow, and red). Each ritual artist has his own private formula for the colored
sands. After the painting is finished, the medicine man performs ceremonies to
offer the spirits respect and make them welcome. The Yei will only enter into a
complete and perfectly executed painting. At the right moment in the ceremony,

the medicine man touches the painting and then the patient, thus transferring the power of the Yei to him or her. The gods will later depart from the painting. The medicine man then destroys the image by brushing the sand away in the direction opposite to the one he started from. He collects the sand and takes it outdoors. It contains the last vestiges of the disease, and in destroying the painting and scattering the sand, the disease itself is removed from the patient.

For centuries, on the opposite side of the world, groups of Tibetan Buddhist monks have created intricate sand paintings designed to purify and heal the suffering of inhabitants in a troubled world. The idea of impermanence is central to Buddhist doctrine. All material phenomena are considered to be illusions that mask the state of nirvana, or enlightenment, which lies beyond the field of change. Tibetan sand paintings usually depict mandalas, cosmic diagrams of the Buddhist universe, which includes celestial, terrestrial, and demonic realms, with the Buddha's heavenly region in the center. On a subtler level, mandalas are diagrams of the inner world of the psyche, with ignorance, conflict, and desires depicted around the periphery, and nirvana in the still center. Mandalas are used as meditation maps to guide seekers to enlightenment. The process of making a sand mandala is itself a form of meditation.

▲ Villaroya. *Seven Sins and Seven Virtues*. Grazie di Curtatone, Italy. The artist Villaroya incorporated many traditional techniques into this modern work. The seven sins were depicted as Picasso-style chalk images, and the virtues were expressed as still lifes using many *infiorata* and *pula* references.

▼ Villaroya with his work. Grazie di Curtatone, Italy. Here the artist is shown with his work. The piece confused the Mantuan jury, which expected more straightforward religious compositions.

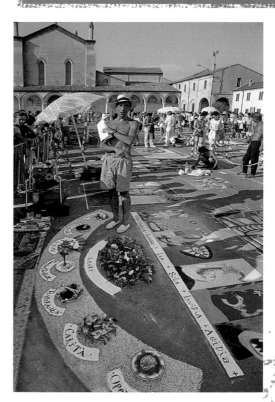

Like a large and complicated street painting, a Tibetan sand painting can take days or even weeks to complete. Starting from the center and working outward, the monks carefully apply fine sand colored with vegetable and mineral pigments, flower petals, and ground semiprecious stones. They add fine lines and tiny details by using a long metal funnel, which is ridged around the narrow end like a washboard. An artist pours a small amount of sand into the funnel, and then runs a stick quickly back and forth over the ridges. The vibrations cause the sand to flow out in a narrow, even stream. The monks ritually destroy the mandala, usually no more than a few days after completion. The Tibetans ceremonially sweep the sand from the outer edges toward the center, the opposite direction from the way in which the mandala was created. The destruction of the painting symbolizes the Tibetan Buddhist concept of the mechanics of death, in which the senses are drawn inward to the heart center. The ritual also denotes the impermanence of life and the fundamental unreality of all physical phenomena.

▶ Wenner. *Tibetan Buddhist Mandala.* The mandala is created slowly, as a meditation. Its destruction will be a controlled ritual.

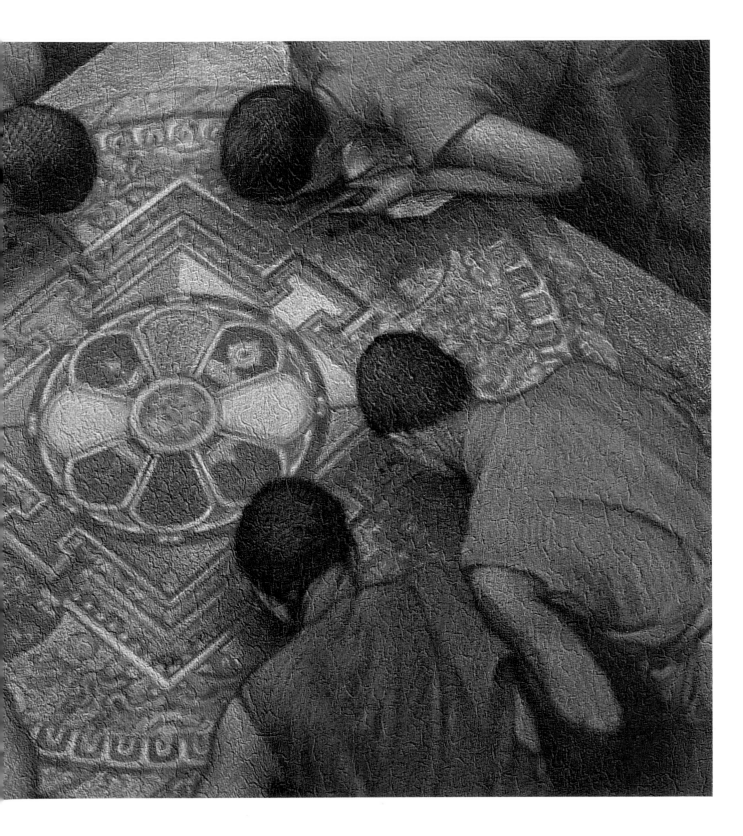

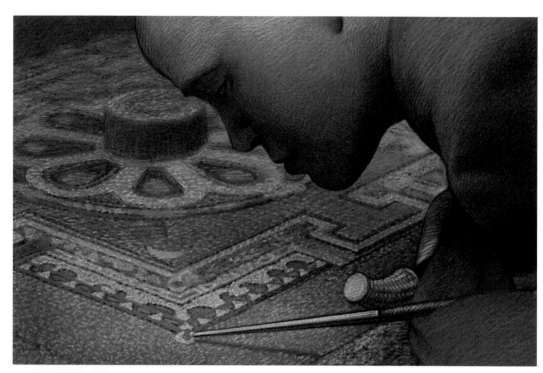

The monks give half of the sand to the witnesses of the ceremony as a blessing. The remainder is thrown into a body of water, which will eventually transport the mandala's healing effects to the entire world. In contrast with the mandala, a street painting is rarely destroyed in a controlled or ritualistic fashion.

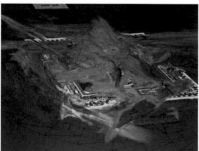

▲▲ **Working on the mandala.** Sand is coaxed down a fine tube to create the work over a period of days or weeks.

▲ **Premature destruction.** Here a mandala came to a premature end at the hands of a three-year-old. Normally the destruction is controlled and ritualistic.

IN THE UNITED STATES, IMPERMANENCE HAS BEEN A DIFFICULT CONCEPT FOR AUDIENCES TO EMBRACE. MATERIALISTIC CULTURES MAKE IT DIFFICULT TO ACCEPT THAT AN ARTIST'S WORK WILL WASH AWAY. MANY PEOPLE NO LONGER UNDERSTAND THE EPHEMERAL, AND WHEN A PAINTING IS PURPOSELY POWER-WASHED OFF A PUBLIC SPACE, LOCAL NEWSPAPERS OFTEN RECEIVE IRATE LETTERS TO THE EDITOR SAYING, "HOW DARE YOU WASH THE ART AWAY!"

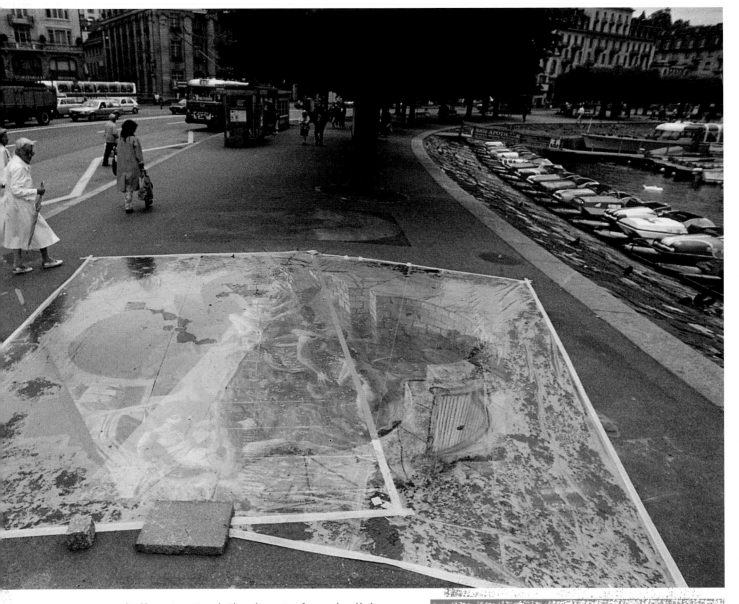

Italian street painting is not a formal religious practice, and street painters today are hardly regarded as performing religious rituals. The effects of their artwork on the environment are subtle and more personal. Most street painters, including Wenner, can attest to the

▲ **Covered for the rain.** Lots of plastic and tape was used to bring large street paintings through days of stormy weather. Rain inevitably soaks under the plastic, usually within fifteen minutes. The plastic does not prevent damage to the piece but prevents the wet color from being tracked far and wide by pedestrians.

protective powers radiated by the saints and images they portray. Passersby often feel moved and spiritually uplifted by street paintings, whether or not the subject matter is overtly religious.

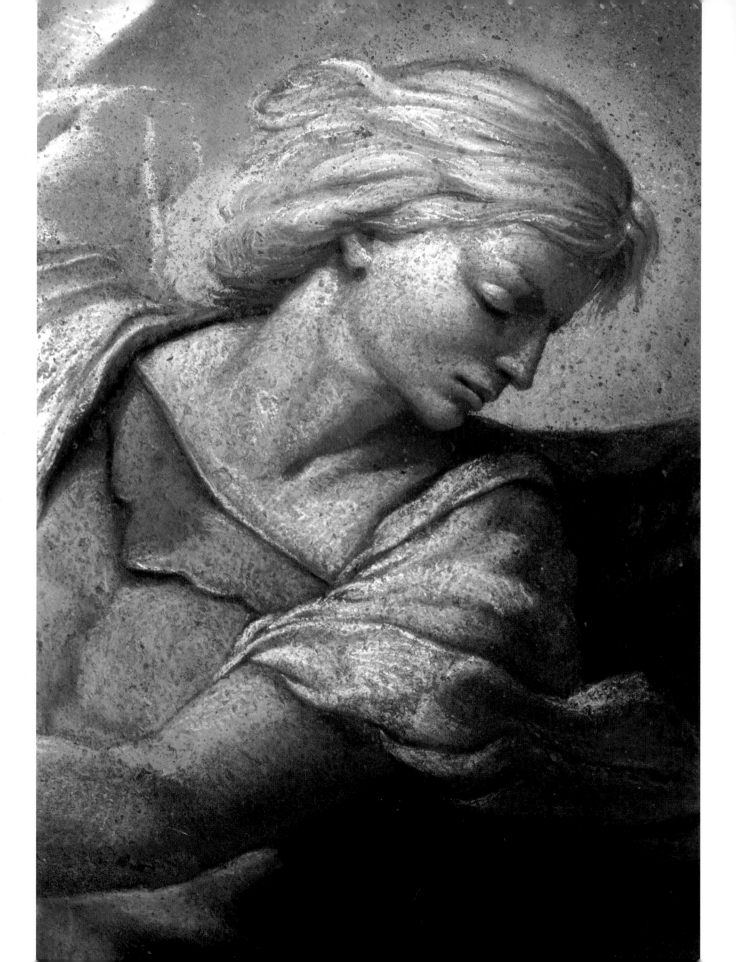

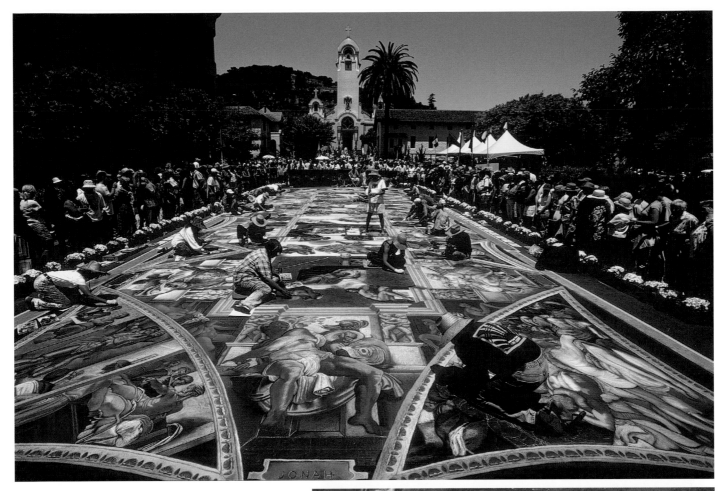

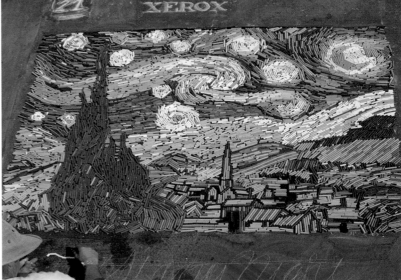

▲ **Street painting festival in San Raphael, California.** Today street painting festivals create enormous spectacles, such as this rendition of Michelangelo's Sistine Chapel ceiling in chalk. The events underline the importance of the ephemeral in societies that are known for their materialism.

▶ **Chalk It Up artist.** *Starry Night Mosaic.* **West Hollywood, California.** The artist makes a brilliantly innovative use of his materials in this composition. The spirit of the work is as close to an *infiorata* as it is to a street painting.

◀ **Wenner.** *Head of St. Michael.* **Rome, Italy.** Whether or not a street painting has a religious theme, the image is often uplifting because of the spirit in which it is created.

1

GROUNDED IN TRADITION

▶ **On the dry earth.** *Terra battuta* is a hardened mixture of clay earth, lime, and straw whose use predated asphalt in many public areas. The hard surface often had a rough, cracked texture that was perfect for chalk.

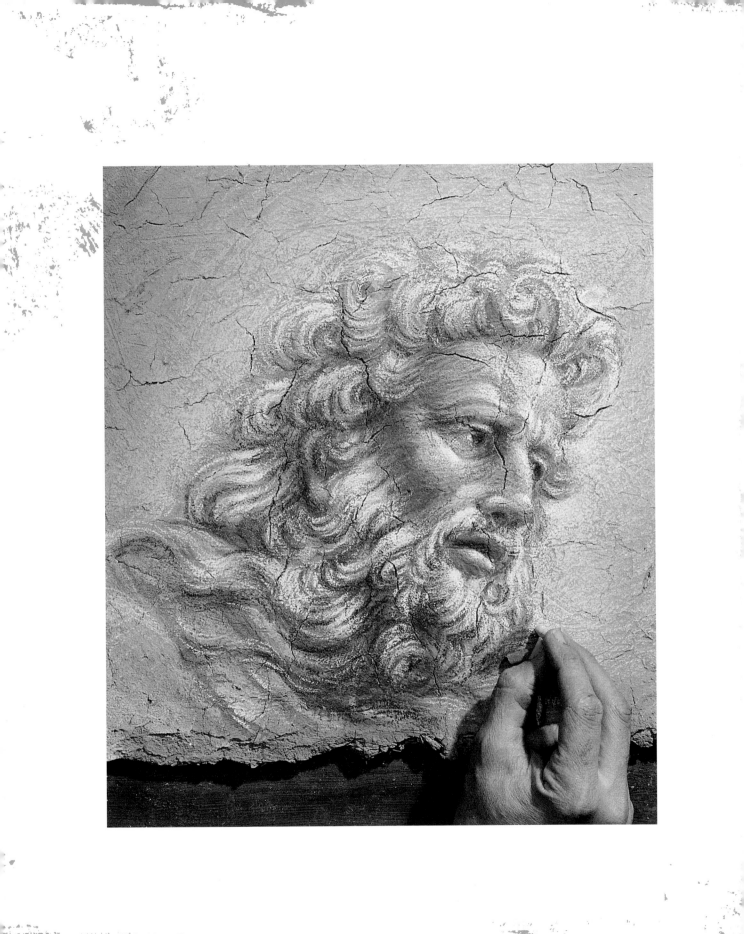

"Bert, what a lot of nonsense! Why do you always complicate things that are really quite simple?" Mary Poppins and Bert the street painter take the hands of two children and jump into a chalk painting. Colorful clouds of dust arise, and the four characters are transported into a magical world. The adventure lasts until the first rainstorm, when their fantasy world melts away and they are returned to the London streets to watch the colors of the street painting dissolve. This famous scene from the film *Mary Poppins,* with Julie Andrews as the nanny and Dick Van Dyke as the pavement artist, immortalized street painting and introduced the art form to millions of people. Disney studios created the choreography of the scene, but the story itself was the work of popular children's book author Pamela Lyndon Travers. In her book, the character of Bert is a Cockney jack-of-all-trades who mixes pavement art and street music with chimney sweeping to make his living. The book was first published in 1934, and was an instant success. At that time, most people in the United States had never seen a street painting, and the book was a rare source of allusion to the art form.

▲ **Wenner.** *In a Puff of Dust.* Mary Poppins and friends are transported into a fantasy realm. Bert the screever idealized the figure of the pavement artist.

▶ *An Artist of the Pavement.* This 1872 image shows great sympathy for the artist. Even the title of artist is a promotion from the earlier appellation of screever. The term *screever* initially referred to the writing on the pavement that requested alms, rather than to the picture. The term returned in the 1940s, having lost most of its derogatory associations.

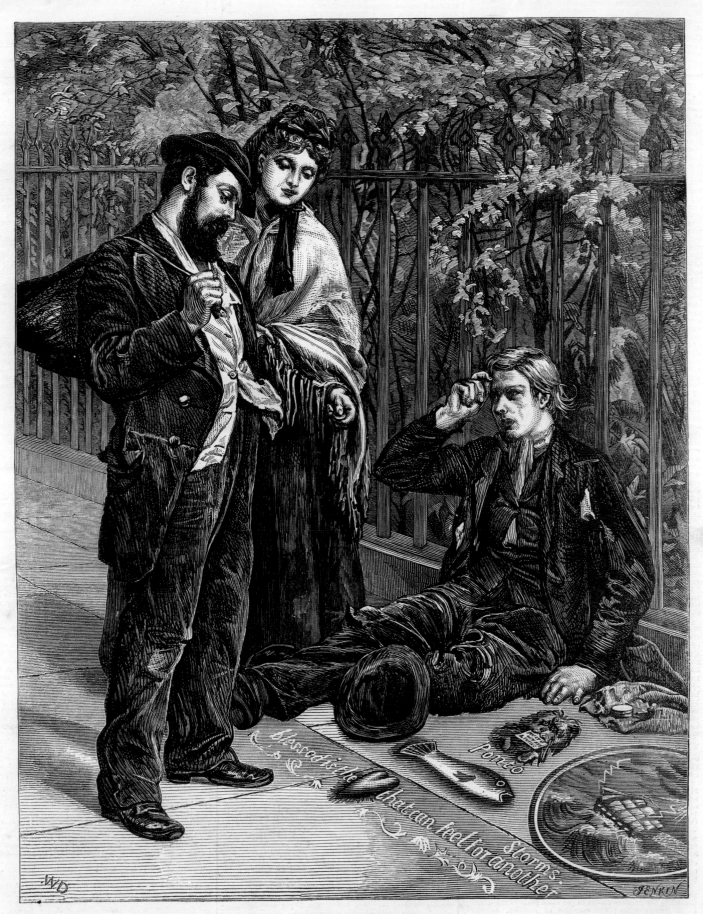

AN ARTIST OF THE PAVEMENT.

A year earlier, George Orwell, one of the most influential and admired writers of the twentieth century, was among the first to write about pavement artists in his book *Down and Out in Paris and London,* published in 1933. Although educated at Eton, Orwell could not afford to attend university and could not get a scholarship. At the age of twenty-five, he moved to Paris to become a freelance writer. Orwell's outrage at the conditions of the underclass prompted him to live the life of a tramp and write about his experiences. Among those described in *Down and Out in Paris and London* are pavement artists, whom Orwell treats with a compassion born of shared poverty.

In the 1930s, according to Orwell's account, there was a pavement artist every twenty-five yards along the London Embankment. Pavement artists appear in literature by the end of the nineteenth century, but except for Orwell's and Travers's

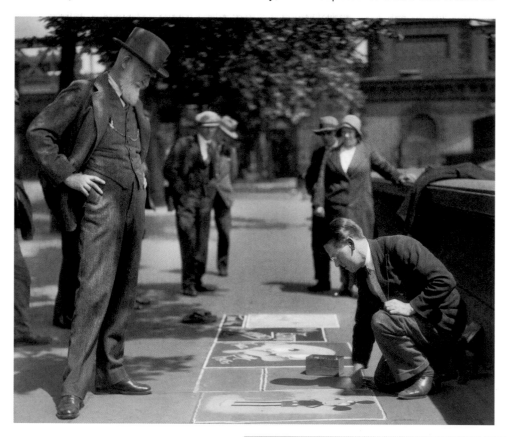

▲ **George Bernard Shaw admires a pavement artist.** The famous author poses with a young pavement artist working on the Bentley pavement in London.

stories, few written records of them or their works have survived. The street paint-
ers Orwell met described universal experiences that could have occurred at any
time. One artist who had studied in Paris and made remarkable copies of Old Mas-
ter paintings on the stone pavement recounts his experience:

> My wife and kids were starving. I was walking home late at
> night, with lots of drawings I'd been taking round to the deal-
> ers, and wondering how the devil to raise a bob or two. Then, in
> the Strand, I saw a fellow kneeling on the pavement drawing,
> and people giving him pennies. As I came past he got up and
> went into a pub. 'Damn it,' I thought, 'if he can make money at
> that, so can I.' So on an impulse I knelt down and began draw-
> ing with his chalks. Heaven knows how I came to do it; I must
> have been lightheaded with hunger.

Unlike other people Orwell met on the street, the pavement artists were not
demoralized by their poverty. He writes of an artist who called himself Bozo:

> He had managed to keep his brain intact
> and alert, and so nothing could make him
> succumb to poverty. He might be ragged
> and cold, or even starving, but as long as
> he could read, think, and watch for meteors,
> he was, as he said, free in his own mind.

Travers would have also seen the many pavement artists on the Strand, and it's
possible that Orwell's account inspired her to include pavement art as one of Bert's
many talents. At the time of Orwell, a street painter in England was called a screever.
The word appears to refer to the written text that often accompanies the image and
asks passersby for a donation, or appeals to their generosity by quoting biblical
passages. Early colloquial dictionaries assign the term Scottish or Dutch origins
but are uncertain. The word could possibly come from the Italian word *scrivere*

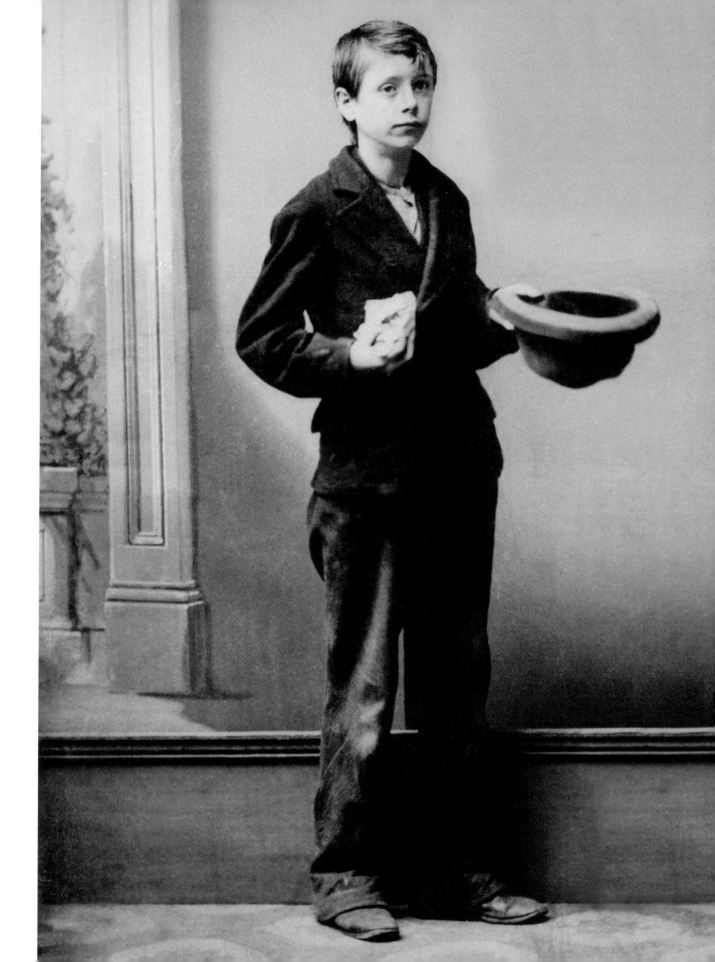

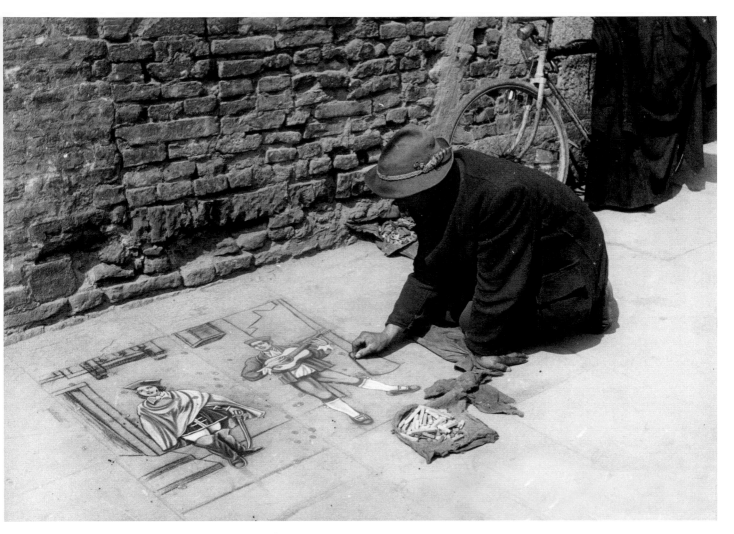

(pronounced scree-ver-eh), which means "to write." The first screevers in England may have actually been Italians who brought the tradition with them. As can be seen in the film *Mary Poppins,* a pavement artist often wrote a caption under the image, and added a word or two of gratitude for any offerings. Even today, it is not unusual to see a written description and a word of appreciation for a donation.

▲ **Franz Klammer.** The earliest known photograph of an Italian street painter is dated March 1921. The artist is from Val Sarentino, Bolzano, which explains his Teutonic name.

◄ **James Carling portrait.** This is the earliest photo of a street painter, dating from about 1870 and showing the boy at about thirteen years of age. He suffered hunger, poverty, and beatings from the police before being arrested on Christmas Eve shortly after his eighth birthday. Today he is remembered with a street painting festival in his honor.

Orwell does not speculate on the origins of pavement art any more than he speculates on the origins of street musicians, or any of the other ways that people tried to feed themselves and their families in times of need. It's likely that the

large number of street artists and musicians was a result of the law, as busking was tolerated in London and panhandling was not. Simply asking for money would bring an arrest for vagrancy, so some act had to be performed in order for there to be an exchange. Impoverished people without much skill were forced to join the ranks of tramps and move from town to town to avoid arrest. They survived on rations of tea and bread with margarine. These were doled out in bleak shelters where people could stay for a night or two before moving on to the next town.

Unfortunately, Italian pavement artists never had a George Orwell to join their ranks and describe their experiences. The last of the traditional Italian street painters would, however, receive recognition and acclaim in their later years, and eventually see the art form officially recognized, transformed, and diffused throughout the world.

ICONS

The Italian art of street painting is a visual link between the past and the present. An ephemeral art form, it is rooted in the history of icons, celebrations, homage, and pilgrimage. Nobody knows when the first itinerant artist drew the image of an icon with charcoal and limestone on the hardened clay earth, but testimonials to this tradition reach back for centuries. In Italy, street painters are called *madonnari,* meaning "painters of the Madonna." This term applies not only to street painters, but also to any artist who produces simple images of the saints, especially the Virgin Mary (*Madonna* in Italian). The earliest madonnari were icon painters from Venice and Crete.

An icon is very different in both form and content from other kinds of religious images. Most are treated as sacred objects of veneration, the intention being to honor the person depicted and not the material substance of the icon. The images of the traditional Italian street painters followed this approach and usually consisted of large bust-length or full-length portraits. The eyes of the saint or Virgin

▶ Wenner. *Icon of Christ.* **Bettona, Italy.** Early representations of Christ were very formalized, and created to be objects of veneration. This type of representation was typical of the Italian *madonnari* as well.

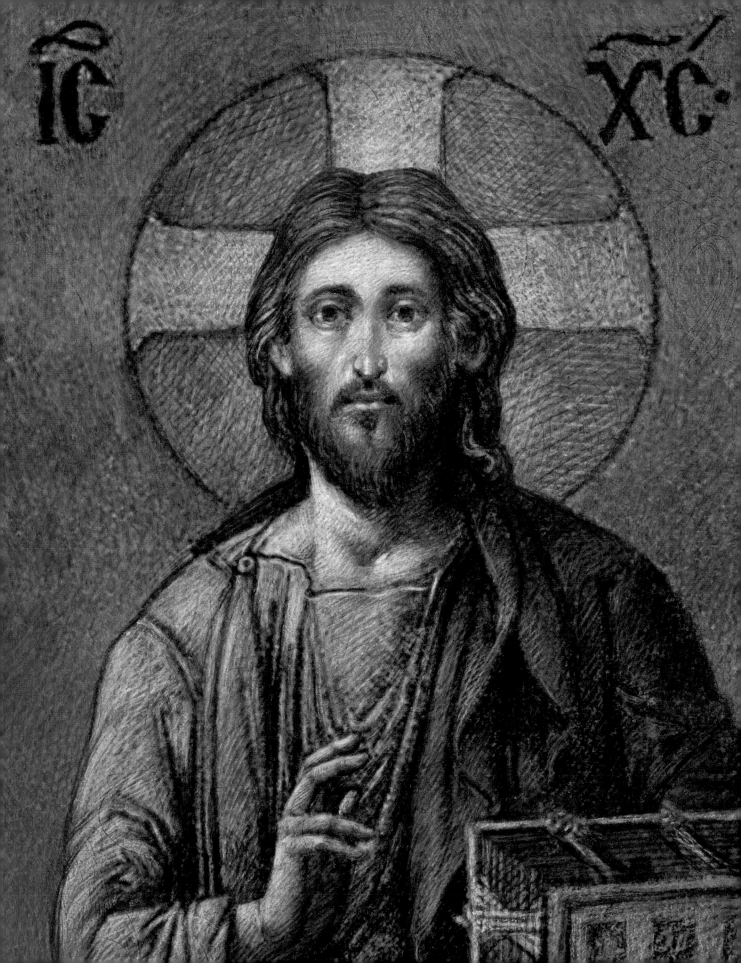

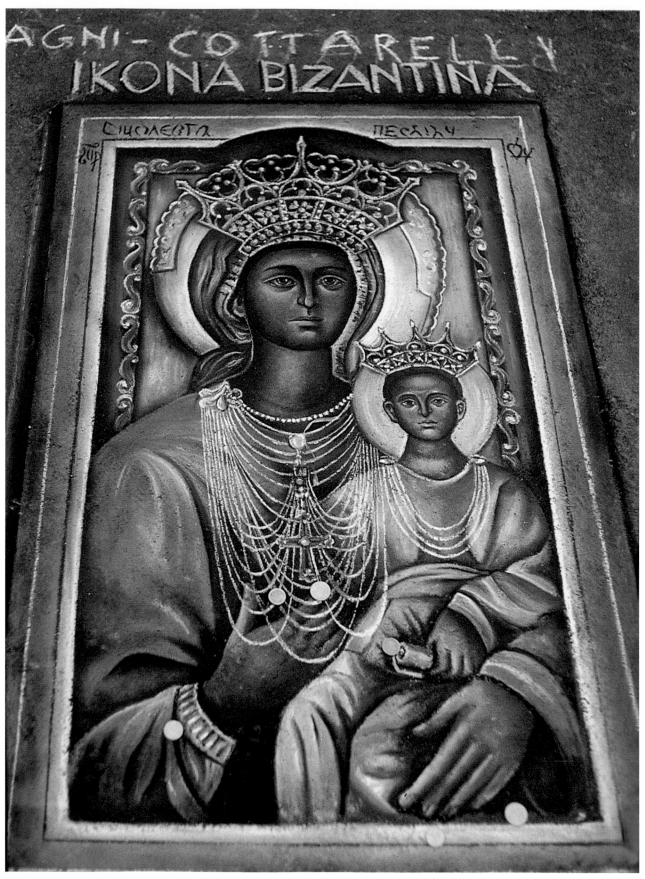

were sometimes shut in meditation, and sometimes stared straight out from the pavement, giving the illusion that they followed the spectator. Several of the street painters worked from memory, and their images were transformed through repetition, becoming highly individual. These men did not consider themselves naive or folk painters, but madonnari, painters of ephemeral objects of veneration.

Icons are ancient expressions of a culture's belief in miraculous powers. The word *icon* comes from the Greek word for "image" (*eikon*). Before the Christian era, the world was full of pagan gods and demigods who were worshipped in the form of statues and paintings. Christianity inherited Hebrew monotheism, and early Christians were expected to worship their God without an image before them. Throughout its history, Christianity has been ambivalent toward the ritual worship of holy images. The early church agonized over the use of icons, fearing that they would take the place of pagan idols and become objects of worship. However, Christianity was also deeply rooted in Greek Hellenistic culture and philosophy. Although iconoclasm (the objection to the use of images) persisted in the Hebrew and Islamic traditions, and was a subject of controversy within the Catholic Church, the classical heritage in Christian culture eventually triumphed.

► **Luigi del Medico.** *Ave Maria.* **Grazie di Curtatone, Italy.** Luigi del Medico was the youngest artist to work in the style of the traditional madonnari.

◄ **Christina Cottarelli.** *Byzantine Icon.* **Grazie di Curtatone, Italy.** Cottarelli reproduces a famous icon for the Grazie street painting competition. She would later become one of the first women to be recognized as a Master Madonnara (female *madonnaro*).

I CAN'T IMAGINE THE CATHOLIC CHURCH DEVOID OF THE COUNTLESS MASTERPIECES CREATED OVER THE CENTURIES. THE FIRST CHRISTIAN IMAGES WERE CREATED IN A SPIRITUAL ATMOSPHERE, AS A SORT OF PRAYER. IN A VERY REAL SENSE, STREET PAINTING INCORPORATES THIS IDEA. THE ARTIST IS BENT OVER IN THE FORM OF A SUPPLICANT; HIS CONCENTRATION IS ON THE PROCESS OF CREATING THE WORK. THE STREET PAINTING IS CREATED WITHIN THE SPAN OF SEVERAL HOURS AND THE IMAGE COMES FROM WITHIN THE PAINTER.

During the ninth century, icons were fully embraced by Eastern Orthodox dogma, and their use and diffusion has continued to the present day. An icon painting is required to show the characteristics of a holy person, yet remain discernibly separate from the living figure. Early icons emphasized the disparity between a saint and the saint's image by rendering the image with unnatural flat, artificial, and stylized proportions and colors. An icon only becomes a living force through devout prayer, which brings forth the Divine Spirit from within.

When Wenner arrived in Italy, the sanctuaries were full of the devout, and individuals frequently undertook pilgrimages to a healing icon in order to pray for a cure. A childless couple might approach an icon of the Madonna and Child believed to grant

miracles. The attributes of such works arose out of common popular consensus, rather than official church doctrine. The debate over the use of icons still continues in some branches of Christianity, but for the Catholic Church the phenomenon of miracle-working images is well established. The acceptance of religious imagery has enabled street painters to survive in Italy. Money given on the street (*la mancha*) is not necessarily in appreciation of the skill of the painter. Donations can also be charitable (*l'elemosina*), or in recognition of the image itself (*l'obolo*). The sacred portraits of the madonnari are reminiscent of the ancient tradition of the *voto* (Latin for "by reason of a vow"), an object offered up to the gods to lend extra strength to a prayer. The creation of a sacred image on the pavement was not only a way to earn a bit of bread and oil, plus a coin or two; it was also a spiritual exercise in itself. A donation was a means by which the public could share in the offering.

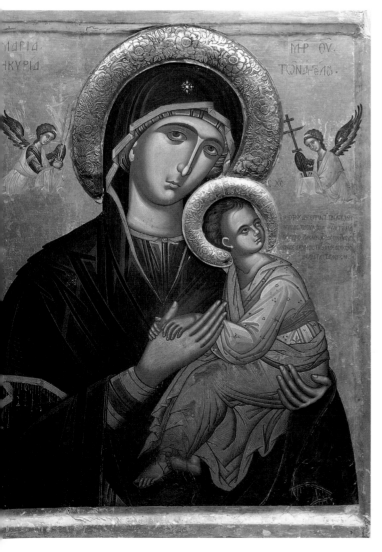

▲ **Patron saint in southern Italy.** This photo shows a typical madonnaro at work, probably during a religious festival.

◀ *Virgin of the Passion.* **Florence, Italy.** Although seemingly much older in style, these icons are painted at the same time as works by Mantegna and Botticelli.

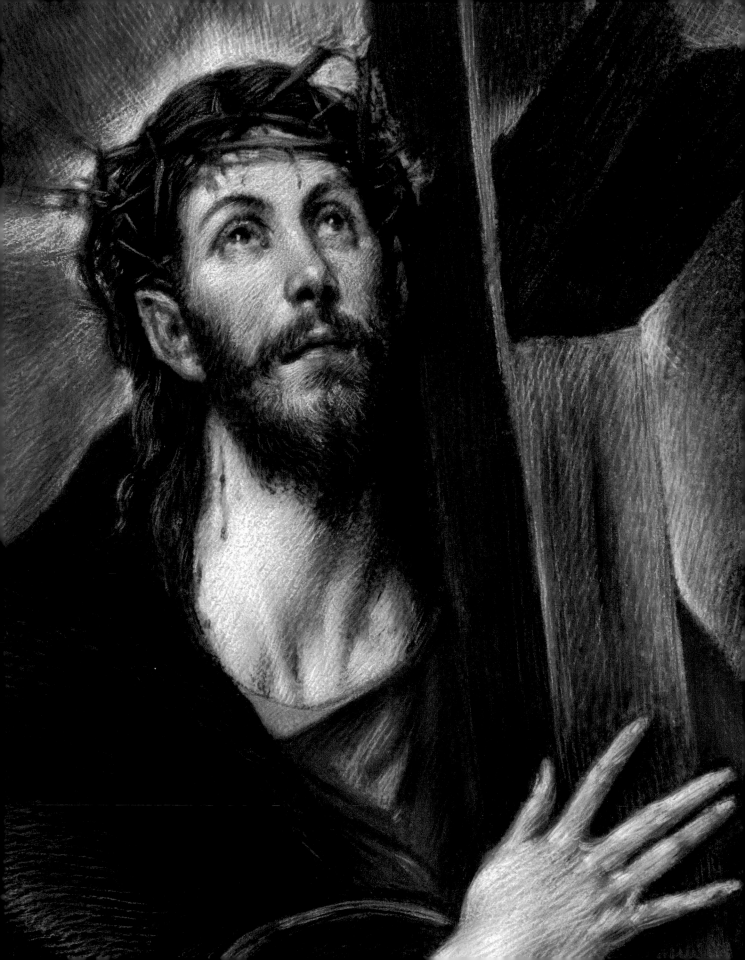

Italian street painting is believed to have evolved from the icon painters who traveled from Venice and Crete between the twelfth and the fifteenth centuries. These artists painted permanent images of saints in niches over front doors, along pilgrimage routes, in shrines throughout the countryside, and at city entrances. These small devotional images were used as sources of divine protection. Street tabernacles can still be found today throughout Italy. Domenikos Theotokopoulos, the most famous artist who began in this tradition, became known as the painter El Greco (literally "the Greek"). He was born in Crete and was trained as an icon painter. Traveling between Venice and Rome, he trained himself in the mannerist style, eventually becoming one of its greatest protagonists.

El Greco, like many other artists at the time, moved to the Serene Republic of Venice. Not all of these artists had the ability or the desire to change their styles, and icon painting flourished alongside the new, classicizing styles of the Renaissance. Some artists partially absorbed the new techniques and forms of the Renaissance and fused the styles. In the elongated and ethereal figures of El Greco, the influence of icon painting is very evident. The Renaissance fleshed out, draped, and embellished these earlier forms, but never really abandoned them

These painters made small icons for private prayer and devotion in the home, which they peddled in the public squares. They also made altar paintings in humbler churches and private chapels. These painters were dubbed *madonneri* in the Venetian language (which evolved into the word *madonnari*), because they frequently depicted the Madonna. Many of the icon painters created images for street tabernacles and were nicknamed *pittori di santi* (painters of saints), a term that still occasionally follows them. By the sixteenth century, nearly every church and Venetian household owned a painting of the Virgin and Child.

Even at the end of the twentieth century, traditional madonnari accepted commissions for small devotional pieces. Sometimes they painted images of the Madonna or St. Andrew on fishing boats, or repainted the small tabernacles that had eroded with time. Each artist had a unique temperament: Some tended to copy popular works, while others created highly original images.

◀ **Wenner after Domenikos Theotokopoulos.** *Christ Carrying the Cross.* El Greco was a trained icon painter before he traveled to Italy and became a famous late-Renaissance (mannerist) artist. While his work is masterful in every way, the tone of the images is often similar to the madonnari.

Although the art of the madonnari may be fleeting, its roots are based in perma-
nent icon paintings and *ex-votos*. In ancient times, a *voto* was a promise or pledge in
anticipation of a celestial favor, while ex-votos were gifts of gratitude presented to
the gods for a grace already received. Thousands of ex-votos have been unearthed
from wells beneath Greek and Roman temples. These small terra-cotta sculptures
depict an array of anatomical parts such as arms and eyes, and are believed to have
represented the part of the worshipper's body that had been healed. The Catholic
Church adopted this practice in several different forms; the best known and most
widespread is the use of votive candles, which are used as an offering when re-
questing a particular grace to be granted. Paintings were also popular ex-votos,
and icon artists were commissioned to create small pictures of the Madonna, who
had bestowed a miracle on the
worshippers.

Many of the paintings included
a complete illustrated scene of
the specific miraculous event,

▲ Italian *Edicola*, Tabernacle. Today the term *edicola* most often
refers to newsstands, but the Italian landscape is still dotted with
these exterior altars. Paintings in these altars had a limited life
span, and re-creating them was often a job for madonnari.

▶ Luigi del Medico. *Tavoletta*. The madonnaro Luigi
del Medico reproduced an ex-voto *tavoletta* during
the competition at Grazie.

with the Madonna looking down on it. By the seventeenth century, ready-made prints and paintings of Madonnas and saints could be bought at fairs for devotional use, but an ex-voto had to be individually commissioned. While the wealthy could engage a trained artist, a common person could only afford some wine, bread, and olive oil, or a very small sum, to pay an untrained folk artist. These artists would often wait outside sanctuaries and churches in order to make small paintings for those in need of ex-votos. While waiting for a commission to come along, they would paint a portrait of a miracle-working Madonna or saint on the sacred ground so that a passerby could make an offering.

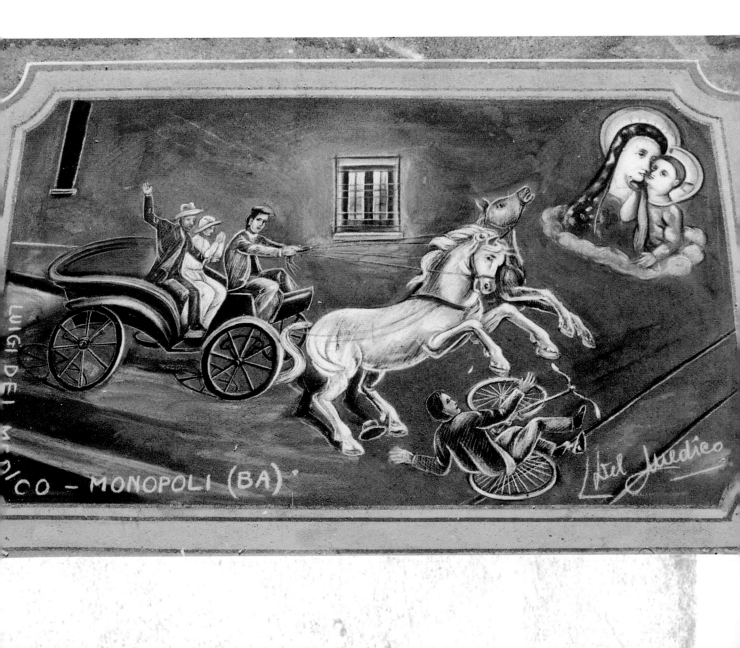

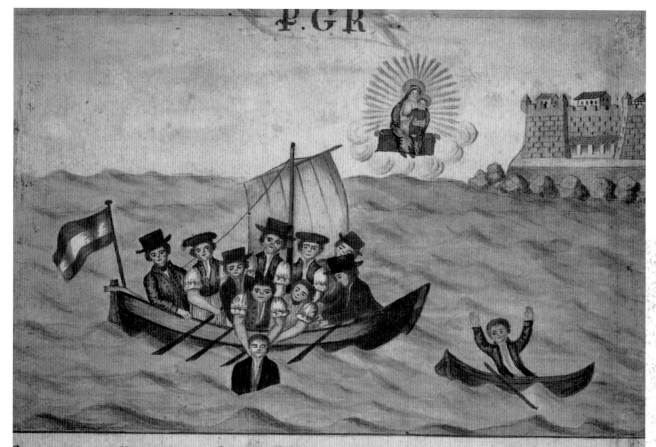

Giuseppe Bartorelli nel ritorno da pescare levatosi un fortunale e trovandosi sulla piana, un colpo di Mare lo levò da bordo e lo portò seco. Invocata la VERGINE SS. di Montenero per sua misericordia e grazia vi s'imbatté il Gozzo dell'I.R. Sanità, dall'Equipaggio del quale fu salvato Il di 10. Giugno 1829

EVEN IN THE TWENTIETH CENTURY, MANY OF THE TRADITIONAL STREET PAINTERS HAD FAVORITE SANCTUARIES WHERE THEY ENJOYED WORKING. I REMEMBER SEEING THE NEAPOLITAN STREET PAINTER GAMBARDELLA OUTSIDE THE SANCTUARY OF THE MADONNA DI POMPEI. HE WAS PAINTING A COPY OF THE SANCTUARY'S MIRACULOUS ICON ON A SMALL BIT OF PAVEMENT BETWEEN THE MANY SOUVENIR STANDS. OTHER SANCTUARIES, SUCH AS LORETO'S HOLY HOUSE WITH ITS FAMOUS BASILICA, HOST STREET PAINTING EVENTS. SOME SANCTUARIES ARE BUSY ALL YEAR LONG, BUT MOST ARE GOOD STREET PAINTING VENUES ONLY ON SPECIFIC HOLIDAYS WHEN THEIR PARTICULAR ICON OR RELIC IS HONORED WITH A FESTIVAL.

TRAVEL

A madonnaro's itinerant lifestyle is born of necessity, as he must move on in order to find the next crowd or mass gathering. In the Middle Ages, hundreds of thousands of pilgrims laboriously journeyed to sanctuaries and shrines to celebrate the icons or relics they venerated. Individuals and groups of worshippers made pilgrimages to leave votive offerings at holy sites. The annual trek of hordes of pilgrims to a site often overwhelmed the food and supplies of small towns.

◀▲ *Per Grazie Ricevuta.* The initials *PGR* refer to a specific miraculous event in the donor's life. This *tavoletta* (small panel) shows a rescue at sea. The painting was commissioned to hang in the church as testimony to divine intervention.

◀ **Metal ex-voto.** Some ex-votos were simple store-bought items, like this metal plaque. An ex-voto could also be a large offering such as a chapel or even an entire church.

▲ Antonio Grillo. *Volto della Madonna.* Grillo was one of the last classic madonnari, and one of the first participants at Grazie. Here he is shown with many attributes typical of the early madonnari: a crutch, shoe boxes for coins, and a message in French and Italian inviting the public to make a donation.

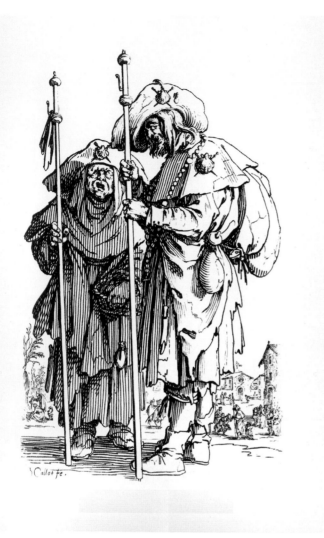

▲ Jacques Callot. *Two Pilgrims.* Callot pokes fun at disreputable beggars thinly disguised as religious pilgrims.

▶ Two generations of madonnari. Kurt Wenner with Francesco Morgese.

Country fairs soon sprang up to sell food and other goods to pilgrims on their way to and at the sanctuary sites. After completing their religious devotions, pilgrims enjoyed leisure activities such as Passion plays, music, and equestrian displays. Fairs soon became attractions in their own right, attracting residents from the countryside in addition to pilgrims. Locals came to socialize and enjoy the entertainment, but mostly they came to buy goods from traveling vendors that were otherwise unavailable to them throughout the year. They also came to seek out the itinerant craftsmen who followed the fair circuit—artisans sharpened knives, repaired shoes, fixed umbrellas, and caned chairs. Even executioners traveled from town to town, dispatching hapless prisoners who had been languishing in jail until they turned up.

Very early madonnari traveled between city-states going to pilgrimage sites, country fairs, civic pageants, and sanctuaries on religious holidays and saints' feast days. Each city-state had different languages and customs. Even today, dialects differ dramatically from region to region in Italy, and linguistic differences remain even between neighboring villages. Fortunately, a street painting is a visual language that is universally understood.

Using simple materials such as white chalk, a piece of charcoal, and the broken end of a red brick, a street painter was able to make a copy of a cherished icon on the pavement. There were, however, many technical difficulties to be overcome by these early street painters. The Italian word for "pavement," *pavimento,* does not distinguish between the flooring material used in a building's interior and that

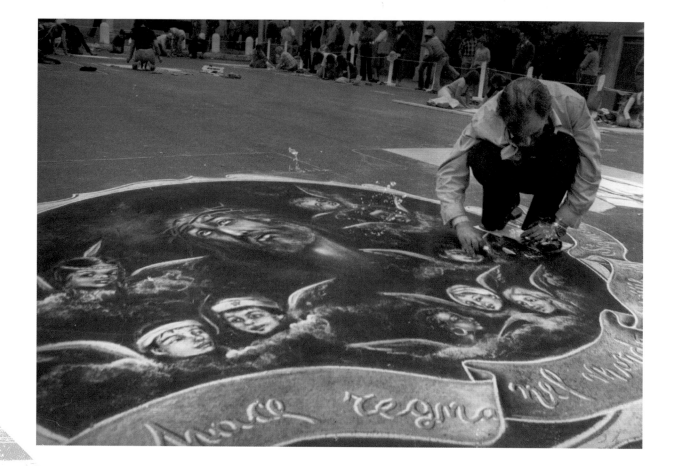

During my street painting travels, I occasionally ran into Antonio Grillo, a traditional madonnaro, in Rome, Milan, and Verona. He would write a message in chalk below his large icon-like images that said, "Painter traveling without means. If my work merits it, I will use the donation to continue my travels." He walked with a crutch, but was hardly a cripple. He was a tough old bird, and did not tolerate finding younger street painters in "his" spot. If need be, he would make sure that the artist moved on to another space. One evening I had dinner with him, after promising to vacate his painting spot the next day. He had a strong sense of his place in the world, and was extremely proud of his work. He made good money on the street, and spent his winters painting commissioned works.

▲ Antonio Gambardella. *Volto Santo with Seraphim.* Gambardella was a Neapolitan madonnaro who could be found working outside the sanctuary of the Madonna di Pompei.

▶ Nicolino Picci. *Four Portraits.* This winning entry in the first competition at Grazie shows a typical work of a classic madonnaro.

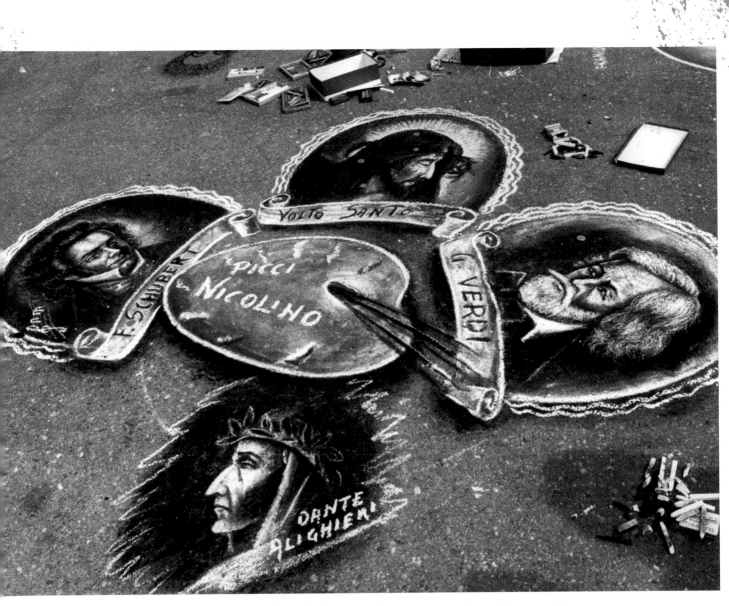

used to pave the streets. Beautiful marble flooring can be found flowing right out of a church in order to provide a continuous smooth walkway to the sidewalk or piazza. Ancient mosaics inspired other surfaces, where paving is composed of rocks or cut stones. In order to work on a rough surface, a street painter would push fine grout made from sand and chalk into the cracks and gaps between the stones. Even though this gave a smooth surface on which to work, fine details could not be painted, as the chalk was blended into the grout with the palms of the painter's hands. Therefore, traditional street painters had a repertoire of *faccioni*, or "big faces," that did not require much detail. These oversized portraits of Madonnas and saints generally measured four feet by eight feet.

A much easier surface to work on was *terra battuta,* literally "beaten earth," which was formed by combining clay-rich earth with hay and lime. The mixture was spread out and then beaten with poles until it dried. Terra battuta was typically used in public areas that were not paved with stone, and on the ground floor of many homes. The eventual widespread use of asphalt in public areas provided a smooth, uniform surface, which contributed to the shift in the types of images that could be created. As the surfaces that painters could work on improved, so did the level of detail in their paintings.

REBIRTH

The hardships of World War II, industrialization, and the mass migration of the Italian population to the northern cities all took a toll on the madonnari. In the second half of the twentieth century, it seemed as if the tradition would soon be lost. In the early 1970s, a young journalist named Maria Grazia Fringuellini read that a man had been tossed into jail and heavily fined for making street paintings. Madonnari had been a common sight during Fringuellini's childhood, and were considered part of the daily life in her community. She suddenly realized that she no longer saw them at festivals and markets painting saints, Madonnas, or characters from popular operas on the pavement. What had happened to all the street painters? When had they disappeared? And why was this lone artist being punished by the police for doing what seemingly had always been done on the streets of Italy?

Intrigued, Fringuellini went looking for street painters. After much searching, she was able to locate a small number of elderly men scattered around Italy who were still making paintings on the streets in exchange for donations. Their arduous lives were more challenging than ever, as they were being harassed by the police and treated as vagrants, while their artistry went largely unnoticed and unrewarded. What was once an integral part of Italian culture was rapidly coming to an end.

Wanting to honor the last few street painters and call attention to their dying art form, Fringuellini and her friend Gilberto Boschesi, a member of the noble Gonzaga family of Mantua, conceived the idea of a street painting manifestation and selected the piazza in front of the sanctuary in the town of Grazie di Curtatone as its venue. The sanctuary was a centuries-old pilgrimage site, and its asphalt piazza was suitable for painting. The village's historic annual fair was also in need of a boost to attract more than just the local population.

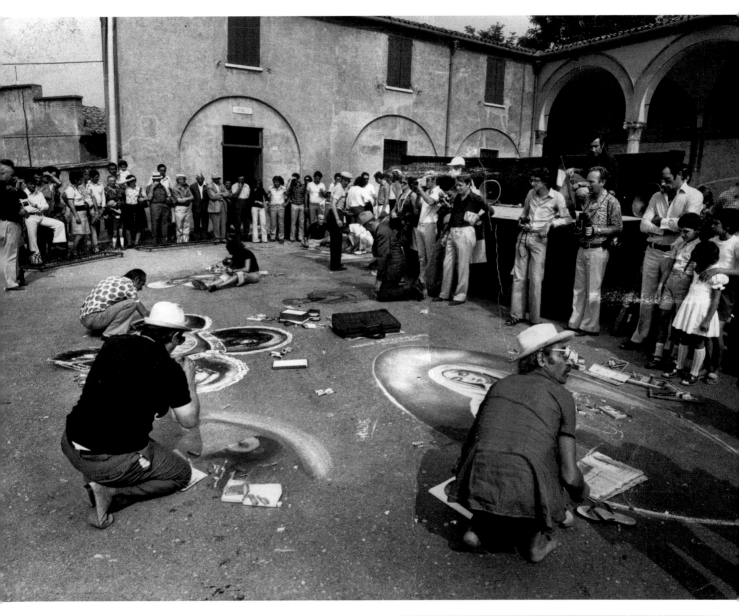

▲ Grazie, 1972. The small group of classic madonnari brought together by Maria Grazia Fringuellini for the first street painting manifestation seemed to be the end of a tradition rather than the beginning of a new and vibrant art form.

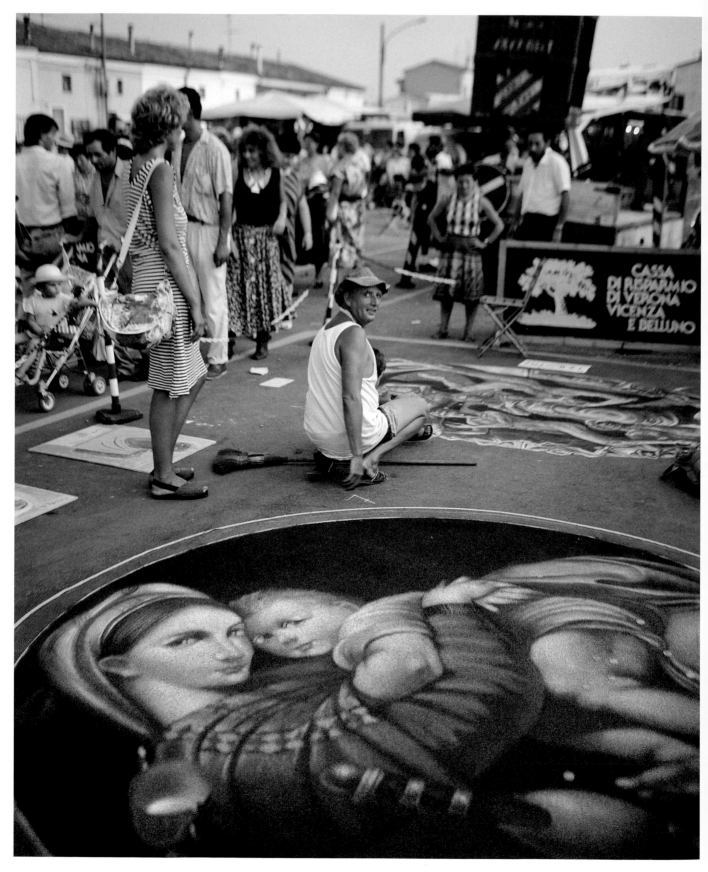

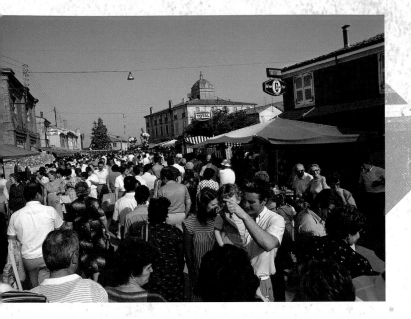

MARIA GRAZIE FRINGUELLINI WAS AN ENERGETIC, ENTHUSIASTIC PERSON, GENEROUS TO A FAULT WITH STREET PAINTERS. THE STIPEND SHE GAVE TO THE OLD ARTISTS TO PARTICIPATE IN THE MANIFESTATION AT GRAZIE WAS SO CONSIDERABLE THAT THE SUM REMAINED UNCHANGED FOR NEARLY THREE DECADES. THIS ENSURED THE RETURN OF MANY OF THE TRADITIONAL STREET PAINTERS FOR A NUMBER OF YEARS, GIVING CONTINUITY TO AN ART FORM THAT MIGHT OTHERWISE HAVE BEEN LOST.

La Fiera delle Grazie had been inaugurated on August 15, 1425, to provide food for the numerous pilgrims who had journeyed to Grazie's sanctuary to celebrate the festival of the Assumption of the Madonna. To promote the fair and encourage vendors to sell their wares, the duke of Mantua had lifted the taxation on bread, meat, wine, and other comestibles. Taxes were eventually removed from gold, silk, linen, dry goods, animals, and grain as well, helping the fair to grow and become one of the largest in northern Italy. In order to earn income, the sanctuary rented out the merchant booths that lined the piazza. Displays of livestock were an especially impressive feature of the fair; even in 1945, at the close of a devastating war, vendors still brought fifteen hundred horses to exhibit there.

Life was changing, though, and soon livestock was replaced by farm machinery and winemaking equipment as the fair's primary wares. Then in 1972, an economic boom led to a better general distribution of goods and services, and it appeared that after more than nearly 550 years the fair had reached the end of its usefulness for the people of Grazie. When Fringuellini and Boschesi presented their proposal, the community leaders readily agreed to host the street painters. August 15, Assumption Day, was a fitting holiday to honor those who had traditionally painted images of the Madonna. To strengthen that connection and bestow a mantle of respectability on the artists, Fringuellini and Boschesi officially referred to the street painters by their traditional name, madonnari.

▲ **The festival market.** Today the festival of Grazie is large and lively, with hundreds of thousands of spectators.

◀ **Flavio Sirio.** *Madonna della Seggiola.* **Grazie, Italy.** By 1980, the imagery of the traditional madonnari had been replaced by more refined copies of known masterworks. Flavio Sirio won many competitions with his large and colorful interpretations.

The first manifestation, held in 1972, drew eight madonnari from as far away as Puglia and Naples. One street painter, who was in his nineties and lived in a rest home, snuck out his window and bicycled eight kilometers to Grazie. Unlike the grueling all-night competition it would later become, the first event was easygoing. The artists began working on the morning of August 15 and painted at a leisurely pace until they were finished. These men were accustomed to spending about five hours on a painting, and the festival conformed to their pace.

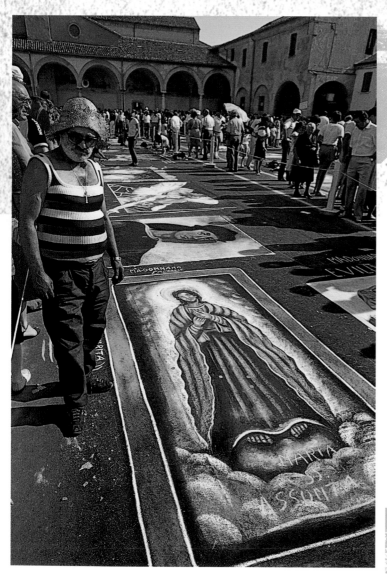

WHEN I BEGAN PAINTING ON THE STREET, I REALIZED THE ART FORM WAS DISTRESSING TO SOME PEOPLE, ESPECIALLY THOSE THE AGE OF MY GRANDPARENTS. THEY WERE CONCERNED ABOUT MY WELFARE, AS THEY ASSOCIATED MY WORK WITH THE EXTREME HARDSHIP AND SUFFERING THEY HAD WITNESSED IN THEIR YOUTH. FOR THEM, IT WAS DIFFICULT TO IMAGINE THAT ANYONE WOULD STREET PAINT EXCEPT OUT OF SEVERE NEED.

Street painting's popularity surged with the advent of the festival and the resulting press coverage. The competition also brought a new level of credibility and recognition to street painters as artists and to their art form. For the first time, street painters were recognized as professionals and received awards along with letters of recommendation from the festival judges and organizers. It wasn't long before the Italian Ministry of Culture

◄ **Francesco Morgese.** *Maria Assunta.* **Grazie di Curtatone, Italy.** Morgese had a sunny and cheerful character that was typical of street painters working in the south.

► **Morgese at work.** Many first-time street painters did not realize that the competition at Grazie started at midnight. More than half the working time was spent in the near darkness to avoid the melting daytime heat.

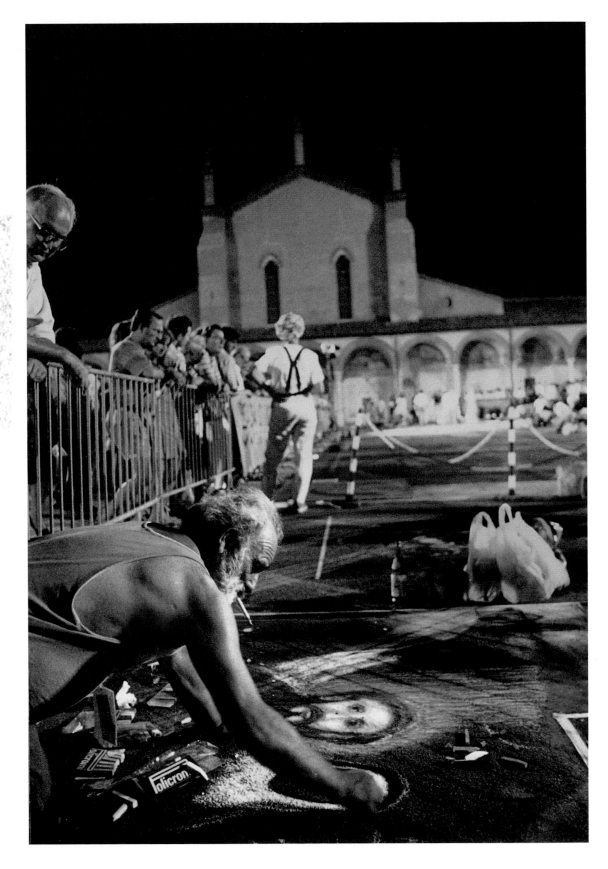

issued a decree legalizing street paint-ing on the national level. If anyone attempted to stop a madonnaro from working on the street, he could present these documents to the police officers who confronted them.

Once the street painting manifesta-tion was established, the community took the event over from Fringuellini. Soon the last exponents of this art form were asked to choose between attend-ing new events started by Fringuellini and continuing to participate at Grazie. This created the first of many schisms. In order for Grazie to make up for the number of lost artists, they opened the event to all artists and the local commu-nity. That changed the art form forever. The newfound respect and popularity accorded to street painting encouraged a new generation of artists to take it up. These artists eschewed the clas-sic icon-like images that the traditional street painters had created for genera-tions. Instead of creating original works from memory, they opted for copying famous masterpieces. In the late 1970s, many young Europeans were travel-

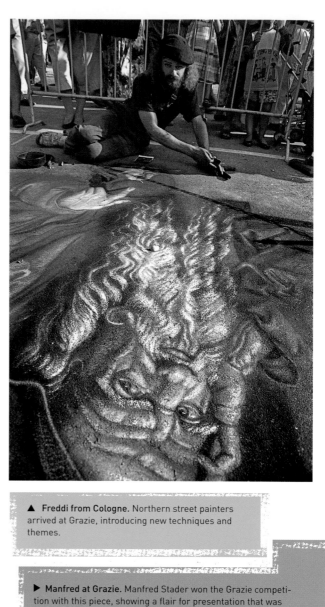

▲ **Freddi from Cologne.** Northern street painters arrived at Grazie, introducing new techniques and themes.

▶ **Manfred at Grazie.** Manfred Stader won the Grazie competi-tion with this piece, showing a flair for presentation that was new to street painting.

ing throughout the Continent, and street painting traditions from the northern countries, especially Holland, Germany, and England, began to arrive in Italy. A few of these artists had studied art formally, but most had little art education or training and therefore chose relatively simple images to copy, such as Raphael's *Madonna della Seggiola,* or small works by Caravaggio. By introducing new imagery, they were also responding to the changing tastes of the public. Street paintings of well-known works of art earned more donations than the static, staring portraits of saints and Madonnas.

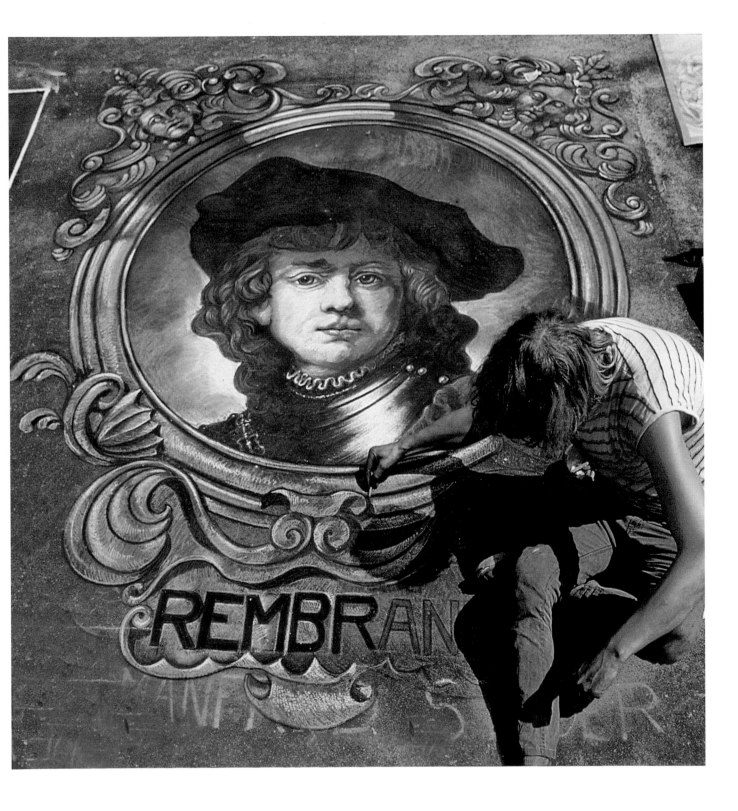

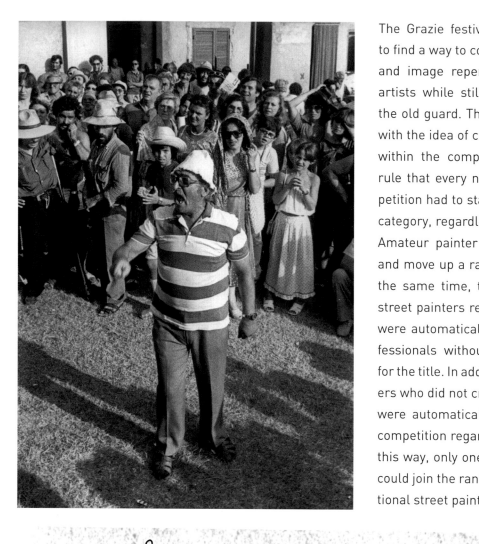

The Grazie festival organizers needed to find a way to cope with the new skills and image repertoire of the younger artists while still continuing to honor the old guard. The organizers came up with the idea of creating two categories within the competition. They made a rule that every newcomer to the competition had to start out in the Amateur category, regardless of ability. Only one Amateur painter could win each year and move up a rank to Professional. At the same time, the elderly traditional street painters returning to the festival were automatically designated as Professionals without having to compete for the title. In addition, any street painters who did not create religious images were automatically excluded from the competition regardless of their level. In this way, only one new artist each year could join the ranks of the elderly traditional street painters.

BY THE TIME I ARRIVED AT THE GRAZIE COMPETITION, I WAS COMPETING NOT WITH THE AGED GROUP OF TRADITIONAL STREET PAINTERS, BUT WITH A NEW GENERATION; THE TRADITIONAL PAINTERS HAD ALREADY BEEN RELEGATED TO RECEIVING SPECIAL PRIZES AND THEIR STIPEND. UNFORTUNATELY, THE TWO GROUPS OF PAINTERS WERE AT ODDS WITH EACH OTHER. THE OLDER TRADITIONAL PAINTERS ACCUSED THE NEWER, YOUNGER ONES OF BEING COPYISTS AND NOT HOLDING TRUE TO THE SPIRITUAL ELEMENT OF THE ART FORM. THE YOUNGER PAINTERS WERE UNHAPPY, AS THEY WANTED TO EXPLORE NEW IMAGERY, EVEN IF IT MEANT COPYING. OCCASIONALLY, A SHOUTING MATCH BETWEEN THE TWO WOULD END IN THE DESTRUCTION OF THE WORKS WITH BUCKETS OF WATER.

There was much debate about how to evaluate the merits of the works when it came time to award the prizes. Street paintings had never been judged before. Did you reward virtuosity? If street painting was considered a type of folk art, was the naive quality of a painting more important? Naive painting had become popular among several younger street painters who asserted that the entire tradition was a form of naive art. The festival organizers finally left it up to the men who actually did the work to decide on the criteria for winning the competition. It became clear that the traditional madonnari considered themselves skilled artists. They felt strongly that skill and talent should be rewarded rather than some romantic notion of a rustic folk artist doing charmingly crude works.

In reality, street painting had no choice but to change with the tastes of the public. Although the festivals are a great venue for giving the art form recognition, its survival ultimately depended on an artist's ability to earn money with it. The public supported the artists, one coin or bill at a time, and therefore had the greatest say in how the art form would evolve. Street painting is a living form of popular art, so no matter what critics or judges might say, it will continue to evolve according to the response and encouragement of the public.

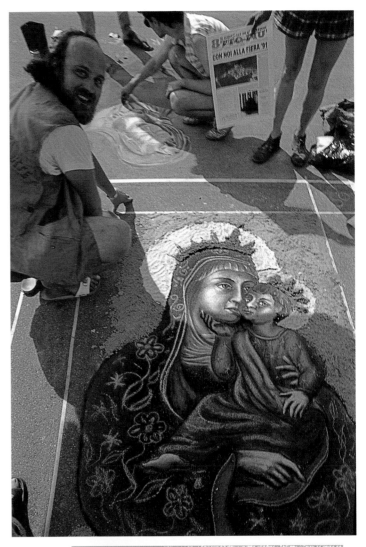

▲ Claudio Sgobino. *Madonna della Grazie.* The madonnaro surrounded his Madonna with sand and sawdust, recalling other early ephemeral traditions.

◀ Prisciandaro disputes the results. The grueling nature of the festival combined with fairly unpredictable jury results often resulted in tempers flaring. The townspeople loved the drama and would sometimes incite the artists.

I PREMIO MAESTRI

ARCHEOLOGIA MADONNARA

DISEGNO ESEGUITO CON SASSI DEL LAGO DI GARDA

◄ *Archeologia Madonnara.* Master street painter Andrea Bottoli demonstrates how a street painting may be done with stones and charcoal. For his picture, he collected stones from Lake Garda. Some of the red stones may be terra-cotta roof tiles from ancient Roman villas.

▼ I Madonnari artist. *Garden Scene.* I Madonnari Festival, Santa Barbara, California. California artists could express themselves more freely than traditional street painters as they did not rely on tips or hope for recognition.

► Daryl Todd. *Manhole Cover.* I Madonnari Festival, Santa Barbara, California. Imagery changed very slowly in Europe, partly due to the tastes of the public. Radically new types of images were seen the moment street painting was successfully introduced to the United States.

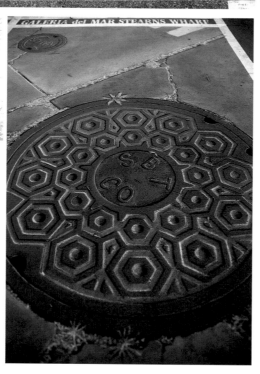

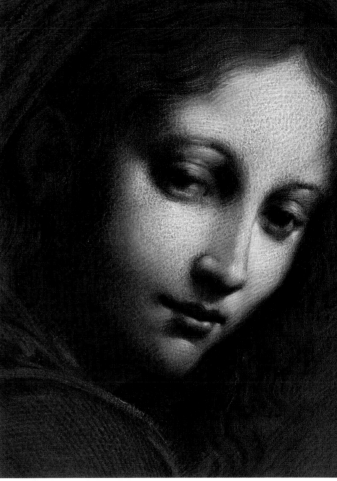

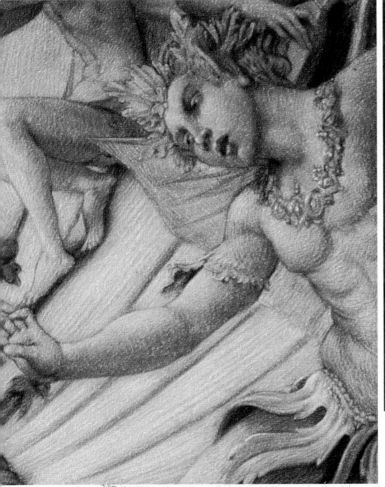

▲ Wenner. *Madonna Study.* Bettona, Italy. Wenner created many works in a traditional Italian style. Because of the refined technique and knowledge of classical form, most of the public could not distinguish his original work from copies of masterpieces.

 ▲ Wenner. Detail of *Titania Encantado.* Burgos, Spain. As street painting covered the globe, the imagery was able to change with its environment. What was once a conservative folk art became a global phenomenon.

2

THE MAKING OF A MADONNARO

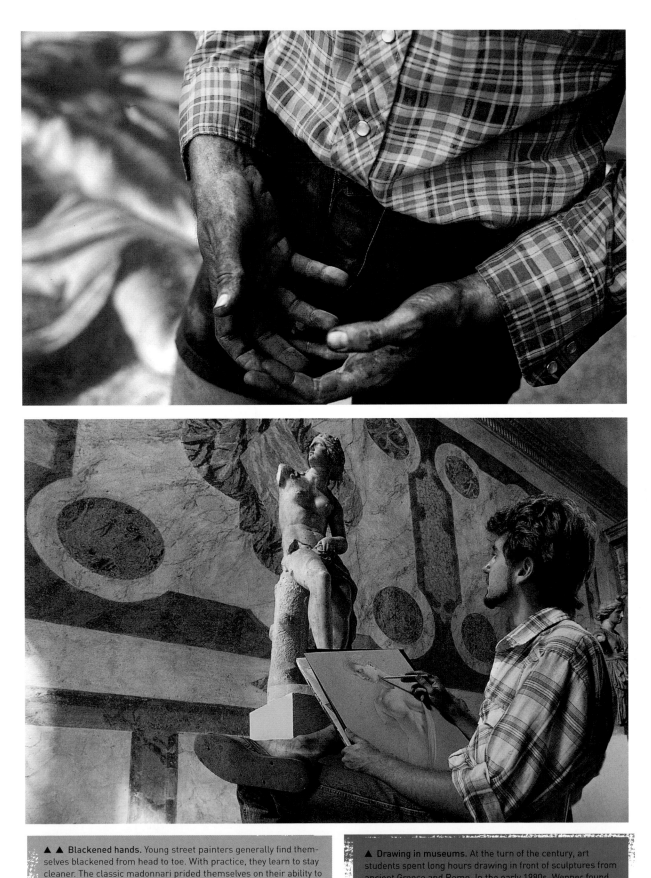

▲ ▲ Blackened hands. Young street painters generally find them-
selves blackened from head to toe. With practice, they learn to stay
cleaner. The classic madonnari prided themselves on their ability to
stay clean.

▲ Drawing in museums. At the turn of the century, art
students spent long hours drawing in front of sculptures from
ancient Greece and Rome. In the early 1980s, Wenner found
himself the only artist drawing in museums.

Kurt Wenner's path toward becoming a street painter began years ago at a well-known art school on the East Coast of the United States. An instructor declared that Wenner had no talent for drawing the human form, and advised him to choose an artistic path that did not include figures. Not long after, a guest lecturer recommended that Wenner burn his portfolio and start over. Wenner had entered the prestigious art college expecting to be initiated into the drawing secrets and techniques of the Old Masters, naively assuming that there would be wise teachers schooled in the disciplines of formal art training. The teachers quickly disabused him of such antiquated notions, asserting, "Drawing is a matter of talent—you have it or you don't," and adding, "Drawing cannot be taught!"

AT THE TIME, I was quite young, and it was difficult to understand how to cope with such comments. Eventually, I was forced to come to terms with the problem. Before the twentieth century, generations of art students studied perspective, light and shadow, anatomy, and other foundations of art in European classical academies. While my attempts at figure drawing were not at the top of the class, none of the other student drawings were at the level of the academies a hundred years earlier. And certainly nothing on the order of a Renaissance drawing was produced by any of the students or instructors. BASED ON WHAT MY TEACHERS SAID, WE HAD PRODUCED AN ENTIRE CULTURE THAT LACKED TALENT! I knew this was not the case, and realized we had developed a culture that could no longer teach the foundations of classicism.

Over the past centuries, students laboriously copied the masterpieces of Michelangelo, Rembrandt, Leonardo, and ancient Roman sculptors, minutely observing each brushstroke or chisel mark that added up to greatness. Wenner had long dreamed of such an education, but the sweep of modernism across the twentieth-century art world did away with all rigorous formal training. Wenner found the distinguished school he was attending capable of offering him only an education that narrowly focused on breaking away from past conventions.

▶ Wenner. *Head of Seneca.* This drawing from a famous antique bust is one of hundreds of drawings Wenner executed in European museums to study classical drawing.

▶▶ Wenner. *The Farnese Hercules.* Naples, Italy. This study was done in the National Archaeological Museum in Naples.

Out of a sense of self-preservation, Wenner left the school on the East Coast and enrolled in Art Center College of Design in Pasadena, California. Art Center had a strong drawing program, and Wenner's heart soared as he watched an instructor draw with so much grace and ease that the works seemed to create themselves. As instructor Harry Carmean worked from life models, he explained the drawing process to the students. To finally see an artist draw brilliantly was exhilarating and disturbing for Wenner. For the first time, he comprehended that art was a process, an act of expression, as much as a final product. As with playing a musical instrument, the act of drawing existed only in time. Wenner could not imagine having that skill.

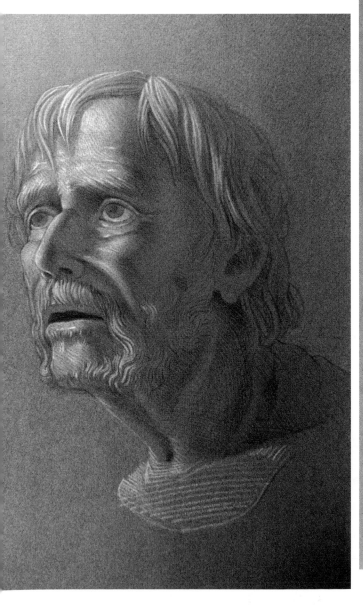

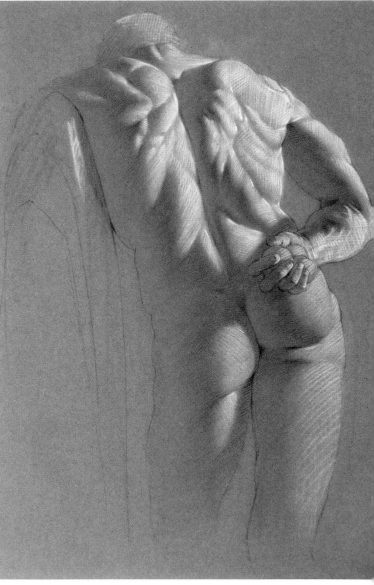

In order to pay Art Center's expensive tuition, Wenner worked as a scientific illustrator for NASA at the Jet Propulsion Laboratory. He spent his time drawing extraterrestrial landscapes according to scientific information provided by the *Voyager* spacecraft, and creating conceptual paintings of spacecraft for proposed future missions. His job was one that many graduates dreamed of, but for him it was simply a means of supporting his studies. Eventually, he realized that he couldn't learn any more from his art professors and that he would have to go to Rome to continue his education. While saving up for his studies abroad, he lived a monk-like existence, spending eighty hours a week hunched over a drawing board. Finally, in order to save on rent, he camped out in a sleeping bag inside a defunct wind tunnel. Once a month, the NASA staff would send a supersonic airflow through the tunnel in order to maintain it in working condition. One day, they fired it up on a different day than usual. Wenner searched for his sleeping bag, and while he never did find it, he did notice a fine layer of fluffy feathers coating the walls of the lab. With no place to sleep and a fistful of savings, it seemed like the right time to move on. He left Art Center, NASA, friends, and family, and headed for Rome to continue his study of classical art.

I HAD FALLEN IN LOVE WITH A STUDY THAT SEEMED TO HAVE NO FUTURE. THE FEW STUDENTS I KNEW WHO HAD SPENT THE YEARS NECESSARY TO MASTER THE ART OF DRAWING WOULD OFTEN JOKE ABOUT FINDING EVENTUAL EMPLOYMENT AS BODY OUTLINERS FOR THE LOCAL POLICE DEPARTMENT. IRONICALLY, IN MY CASE I WOULD COME EXTRAORDINARILY CLOSE TO THIS REALITY BY EVENTUALLY CHALKING FIGURES ON THE STREET FOR A LIVING. ALTHOUGH THE INSTRUCTION I RECEIVED AT ART CENTER WAS BRILLIANT, I FELT A NEED TO GO TO THE SOURCE OF THE CLASSICAL TRADITION IN ORDER TO FULLY UNDERSTAND THAT TRADITION. BEGINNING AROUND 1660, THE GRAND TOUR HAD SERVED AS AN EDUCATIONAL RITE OF PASSAGE. IT WAS A TRIP THROUGH EUROPE WITH AN EMPHASIS ON ARTIFACTS OF ANTIQUITY AND THE RENAISSANCE. I WAS DETERMINED TO MAKE MY OWN GRAND TOUR TO STUDY DRAWING. I BOUGHT A PLANE TICKET, AN ITALIAN DICTIONARY, AND A MAP OF EUROPE, BECAUSE I HAD NO IDEA EXACTLY WHERE ROME WAS!

▲ **Wenner.** *Sunscape.* Before leaving for Italy, Wenner painted conceptual views of future NASA projects at the Pasadena Jet Propulsion Laboratory. He was the last artist to be trained in traditional perspective technique before the introduction of CGI.

▶ **Wenner. Drawing for** *St. George and the Dragon.* This picture was Wenner's first classical composition. It turned out to be a favorite with children, and was used in the educational film *Chalk Magic.*

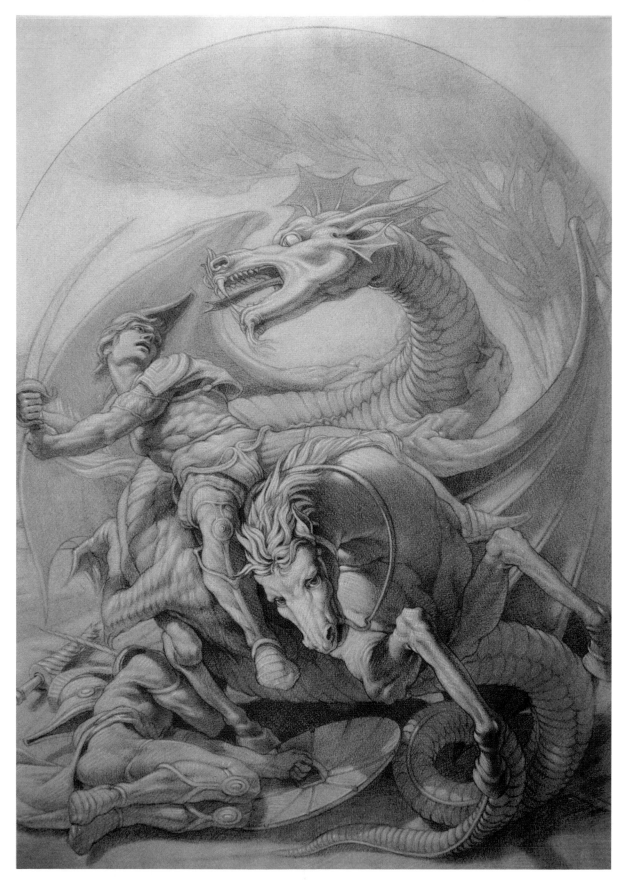

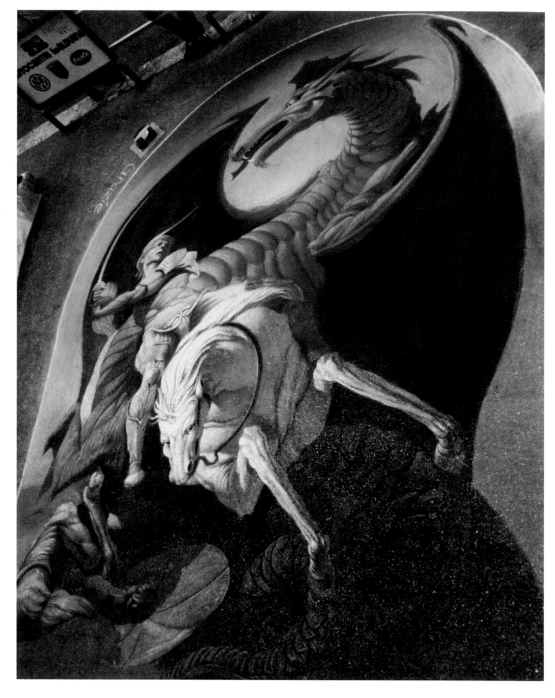

Wenner boarded the plane with just a handful of rock-bottom necessities that would fit into a backpack. While in transit at London's Heathrow Airport, he was informed by an apologetic airline official that his backpack had been sent to Singapore. With no bag in tow, he made his triumphant entry into Rome bearing a passport, a notebook, and a map.

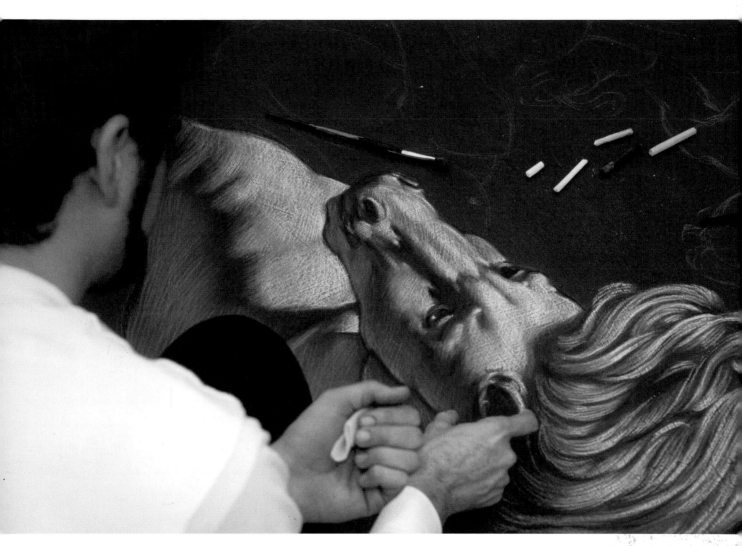

It was 1982, and Italy retained much of its Old World charm, customs, and beliefs. The Italians still held strong regional identities, as globalization had not yet begun to homogenize the different cultures. The ancient traditions and art of the Catholic Church were seen everywhere. Life moved at a leisurely pace, with plenty of time to enjoy a good meal and good company. As Wenner settled into his new surroundings, he got started on his to-do list, which he had designed to keep his educational project on track. The first thing was to get an overview of his new living classroom by seeing all the major monuments and museums in Rome.

▲ **Wenner working on** *St. George*. This working shot shows Wenner's careful and precise drawing style based on hours of study in the museums.

◄ **Wenner.** *St. George and the Dragon*. **Rome, Italy.** Confusion was created with this work by an "unknown" author. The work never reached completion in Rome due to many rainstorms.

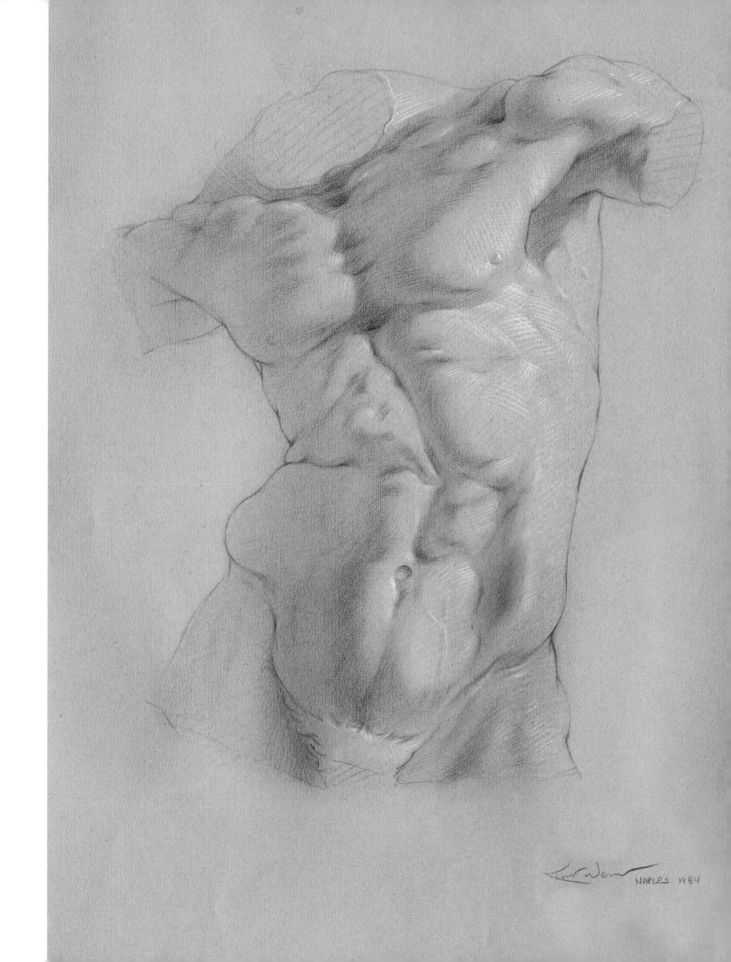

NAPLES 1984

I NEVER KNEW THERE WAS SUCH A WEALTH OF ART ANYWHERE IN THE WORLD, LET ALONE PACKED INTO ONE CITY. I WAS USED TO SPENDING TIME AT DIFFERENT MUSEUMS IN THE UNITED STATES, BUT ROME WAS COMPLETELY DIFFERENT. MUSEUMS IN THE STATES WERE HEATED AND WELL LIT, WITH SMALL PAINTINGS SPACED CAREFULLY ON NEUTRAL BACKGROUNDS. IN ROME, MUCH OF THE PAINTING WAS IN THE FORM OF VAST FRESCOES, SURROUNDED BY SCULPTED MOLDINGS AND PAINTED AND GILDED DECORATION, AND ACCOMPANIED WITH INLAID MARBLE. I WAS COMPLETELY OVERWHELMED BY THE DIZZYING SCALE AND RICHNESS OF THE WORK. WHILE WATCHING THE RAIN FALL THROUGH THE OPEN OCULUS OF THE PANTHEON ON THE FOURTH DAY, I KNEW I HAD TAKEN IN TOO MUCH.

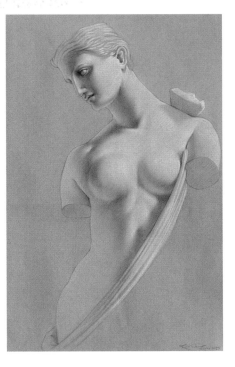

After less than a week, Wenner had come down with a bad case of Stendhal syndrome, a well-documented illness with flu-like symptoms that strikes tourists whose vision has become over-stimulated as a result of viewing too much grandeur. He spent the next several days in bed, looking up at the fuchsia-colored ceiling in his little room. When the visions of frescoes stopped spinning in his head, Wenner decided to take a more organized approach and went in search of art schools. Unlike the sterile but clean halls of Art Center, these buildings were decrepit, filled with graffiti, and looked like the party headquarters in a third-world country that had suffered a revolt. Classicism was no more alive in Rome's educational system than it was back in the States, and it did not appear that they would be offering the fabulous art instruction Wenner had dreamed of.

Left with no other option, he continued with a self-designed course of study. With much trepidation, he entered the Villa Borghese with a small drawing board, a pencil box, and a tiny three-legged folding stool. He didn't know how to ask for permission to draw in the museum, so he just began. A hundred years ago, the museum would have been buzzing with students copying the works of art and discussing one another's drawings. In the early 1980s, Wenner was alone in the large, echoing rooms. He nervously set up his stool in front of a sculpture and began drawing using a sanguine-colored pencil. The early masters often used these blood-red-colored pencils for drawing and sketching. It wasn't long before he became completely lost in what he was doing.

▶ Wenner. *Torso of Psyche*. Naples, Italy.

◀ Wenner. *Torso Study*. Naples, Italy.

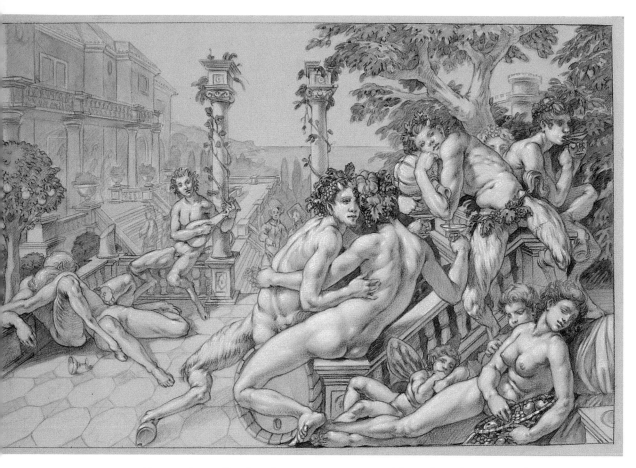

He spent months drawing in museums, arriving when they opened and leaving only when he heard the doors beginning to close. He spent day after day communing with the masterpieces, and grew to feel an intimate connection with the artists whose works he copied. Dressed in a pair of jeans and a shirt with the sleeves rolled up, Wenner sat for long hours on his stool, balancing a drawing board on his knees as he worked. By looking at him, few would have guessed the level of skill he possessed. Occasionally, a visitor took the time to watch him work and observe his developing mastery.

Guards were soon greeting him by name, and each day tourists would crowd around him to watch him draw. Sightseers often asked to purchase a drawing, but it was the museum guards, insulted by the minuscule amounts the tourists offered, who became his patrons for drawings of the masterpieces they so loved and protected. It wasn't long before he had a list of twenty Vatican guards waiting for drawings.

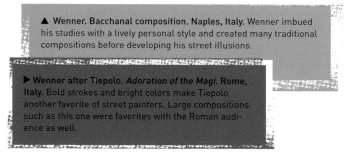

▲ **Wenner. Bacchanal composition. Naples, Italy.** Wenner imbued his studies with a lively personal style and created many traditional compositions before developing his street illusions.

▶ **Wenner after Tiepolo. *Adoration of the Magi*. Rome, Italy.** Bold strokes and bright colors make Tiepolo another favorite of street painters. Large compositions such as this one were favorites with the Roman audience as well.

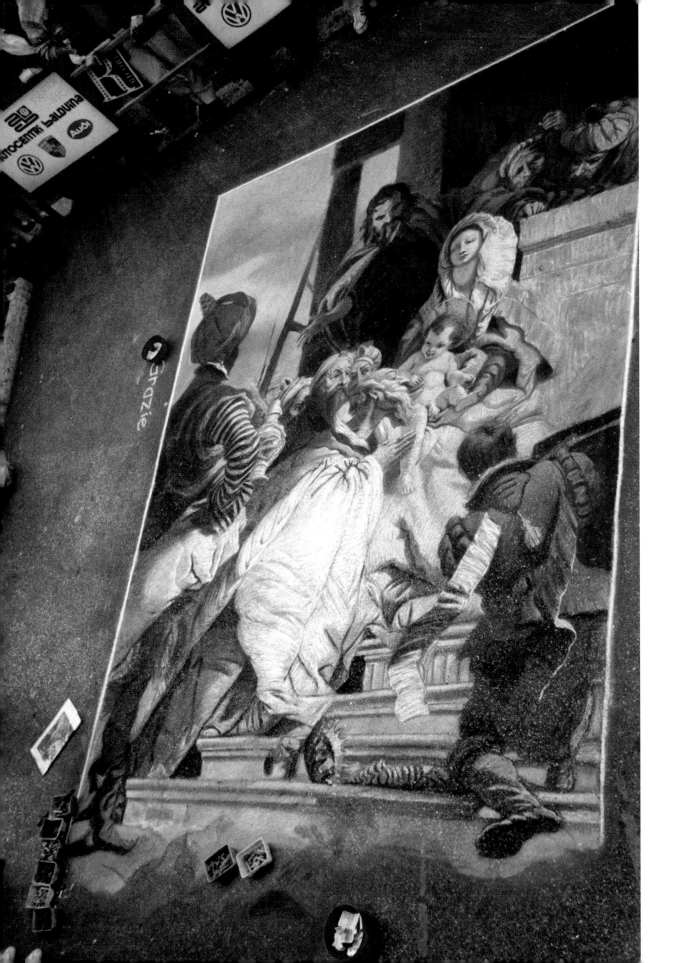

Wenner spent vast amounts of time in the various museums throughout Rome, blending into the silence, which was interrupted by loud tour groups, shouting guides, and shrieking schoolchildren. In the many months spent studying, he never once encountered an art student or an art class drawing in the museums. The exercises he undertook were invaluable and built on what he had studied in school. Unlike life models, the sculptures told stories about the artists and cultures that created them. Merely looking at sculptures does not reveal this information, any more than looking at the cover of a book tells the story inside. Only by drawing them is the formal language revealed. He slowly began to obtain the skills needed to compose drawings in the classical tradition.

THE DRAWING SALES HELPED SHORE UP MY SHRINKING SAVINGS. HOWEVER, I COULDN'T PRODUCE DRAWINGS FAST ENOUGH TO PAY FOR FOOD, RENT, AND ART SUPPLIES. THE THOUGHT OF BEING DESTITUTE IN A FOREIGN COUNTRY WAS A FRIGHTENING ONE, YET MAKING ART WAS THE ONLY THING THAT HELD ANY IMPORTANCE FOR ME. I KNEW I NEEDED TO FIND ANOTHER SOURCE OF INCOME IF I WAS GOING TO BE ABLE TO CARRY ON STUDYING IN THE ETERNAL CITY.

One afternoon while walking home past the Trevi Fountain, Wenner saw two young men on their hands and knees working on the pavement of the Via del Corso. They were absorbed in drawing a traditional Madonna and Child, using a mixture of thick sidewalk chalks and finer commercial pastels. The image was quite rough, as dirt and the pavement's texture combined to prohibit fine details or rich color.

Wenner was surprised to see a work of religious art emblazoned on the busy sidewalk. People stood around and observed the painters quietly. It was as if the painting brought the sanctity of a shrine out onto the dusty pavement, creating an island of calm on an otherwise frenetic corner. He had just come across the work of two madonnari and observed his first street painting. He didn't know it yet, but his life would be forever changed.

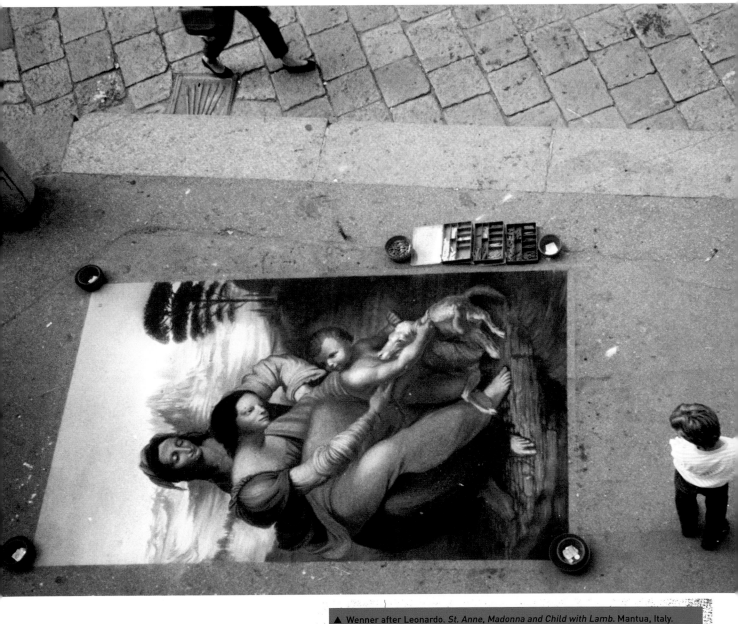

▲ **Wenner after Leonardo.** *St. Anne, Madonna and Child with Lamb.* **Mantua, Italy.** Wenner painted this simple image to pay for his expenses while traveling through the city of Mantua.

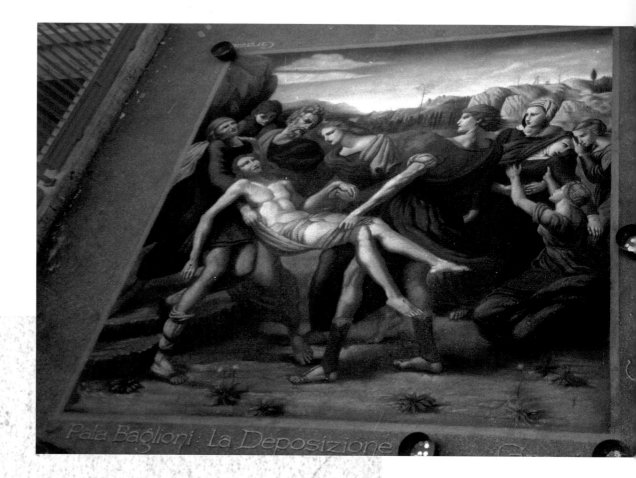

THE FOLLOWING MORNING, I APPROACHED THE SAME SPOT. GATHERING ALL MY COURAGE, I ASKED THE PAINTERS A FEW QUESTIONS IN HALTING ITALIAN. THEIR REPLY WAS EQUALLY RUDIMENTARY, BUT WITH A GERMAN ACCENT. I WAS OVERJOYED, AS I SPOKE SOME GERMAN, AND AS IT TURNED OUT THEY SPOKE SOME ENGLISH. I WAS ASTOUNDED TO LEARN THAT THEY ACTUALLY MADE THEIR LIVING FROM STREET PAINTING. FROM THEN ON, EVERY EVENING I MADE IT A POINT TO PASS BY THEIR SITE, CHAT WITH THEM, AND WATCH THEM PAINT.

▲ Wenner after Raphael. *The Deposition.*

▶ Wenner after Raphael. *The Deposition* detail.

True to tradition, the artists never revealed to Wenner how much they earned on the street, and like most people, he assumed it was very little. They had plenty to talk about, and Wenner was amazed to learn that they had come to Rome specifically to street paint rather than to visit the museums. Wenner didn't know it at the time, but one of the two painters, Manfred Stader, would become a lifelong friend. After a week, the artists asked Wenner to paint the head of an angel that had been giving them trouble while they went to dinner. He hesitatingly consented.

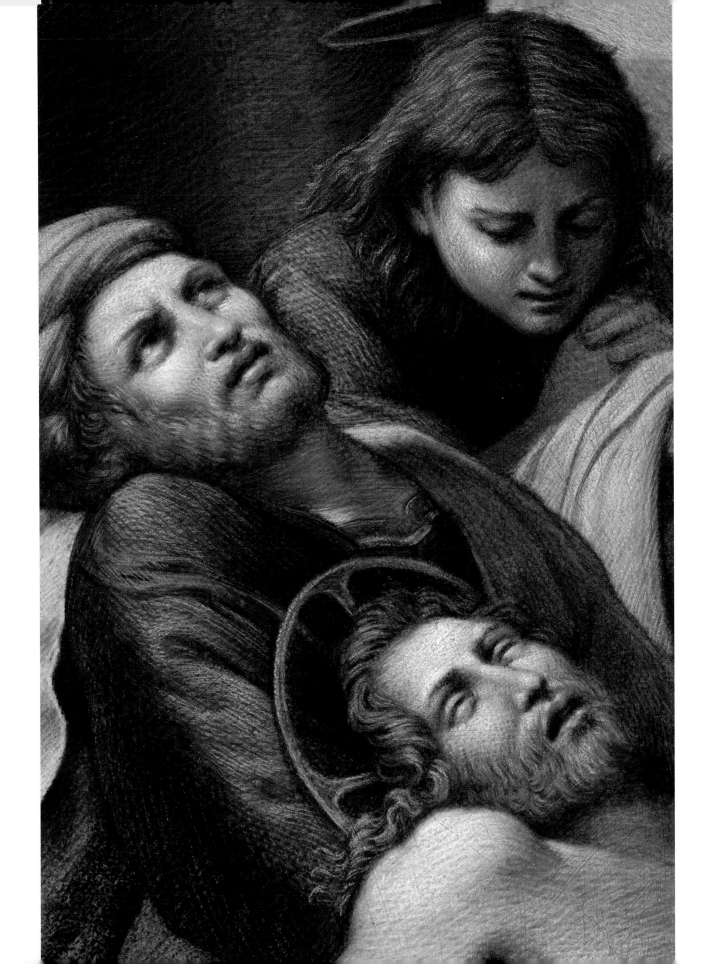

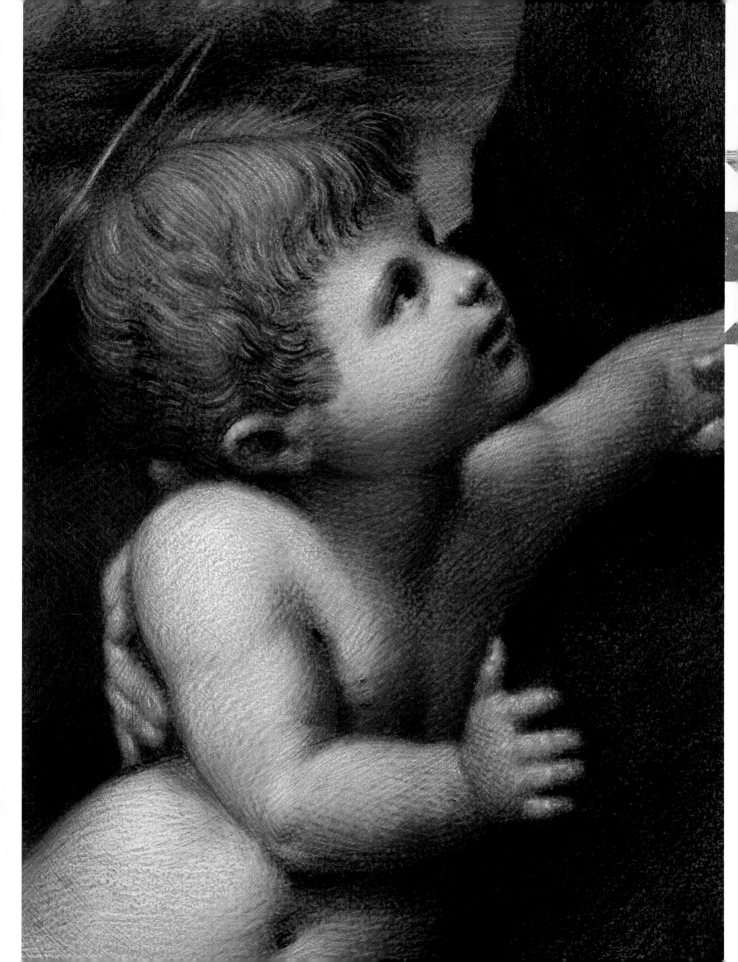

I WAS NERVOUS AND SELF-CONSCIOUS AS I SAT DOWN ON THE PAVEMENT. I SURVEYED THE VIA DEL CORSO, GAZING UP AT THE BUILDINGS FROM THIS NEW ANGLE. I THEN TOOK A DEEP BREATH AND SET TO WORK. TO MY SURPRISE, IT WAS IMMENSELY ENJOYABLE. I HAD AN IMMEDIATE, VISCERAL RESPONSE TO THE SOFT, FRESCO-LIKE PALETTE OF COLORS. THE POPULATED STREET WAS MORE FRENETIC THAN ANY MUSEUM, BUT I SOON BECAME SO INVOLVED IN THE WORK THAT I DIDN'T NOTICE THE SOUND OF THE PASSING CARS, THE WHINING MOTORS OF THE EVER-PRESENT VESPAS, AND THE CLATTER OF HURRYING FEET AROUND ME. IT SEEMED LIKE ONLY MINUTES HAD PASSED BEFORE MY NEW FRIENDS RETURNED FROM DINNER. THEY PERUSED THE ANGEL AND COMPLIMENTED MY WORK. THEN THEY EMPTIED THE BASKETS OF THE DONATIONS MADE WHILE I HAD BEEN PAINTING AND HANDED THEM TO ME IN A PLASTIC SACK. I HAD BEEN SO ABSORBED IN THE WORK THAT I HADN'T NOTICED ANYONE TOSSING COINS INTO THE BASKETS. I ACCEPTED THE SACK AND REALIZED IN THAT ONE HOUR I HAD EARNED ENOUGH MONEY TO COVER MY DAILY EXPENSES!

Elated and streaked with grime from the street, Wenner practically floated home, dreaming about how street painting could be his much-needed source of income. He also thought about how it could be a way for him to create the full-scale copies of masterpieces that he had longed to execute as a formal exercise for his self-study program. He had not been able to accomplish this, due to a lack of studio space, however, street painting opened up the vast expanses of sidewalks and piazzas in Rome to use as his studio.

◀ **Wenner after Raphael.** *St. John* detail. Rome, Italy. Raphael's pictures remain a favorite for street painters. The simple contours and subtle tones contrast nicely with the texture of the pavement.

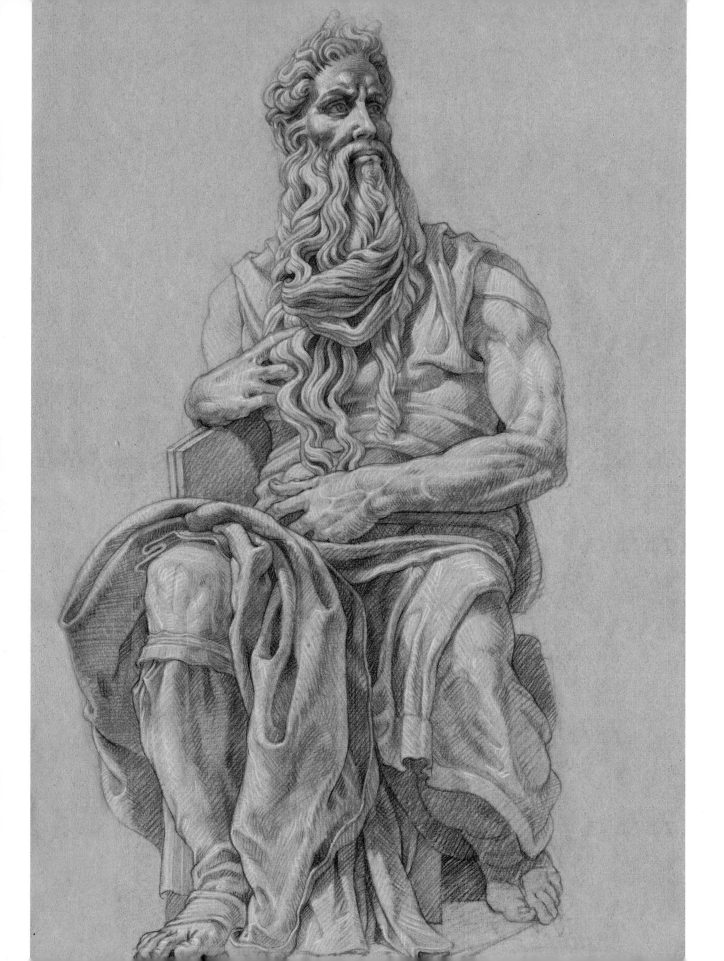

THE FIRST DAYS AS A STREET PAINTER

As soon as I had my first experience street painting I thought about making my own, and where and what I would paint. With the constant repairs and renovation in the ancient city, finding a spot with a smooth surface and lots of foot traffic would be a challenge.

The next day, I scouted around, looking down at the pavement instead of up at the magnificent facades. I had to find a location where I would not block anything or anybody, and as I searched I discovered remnants of other street paintings. Had I walked over these faded images in the past and never noticed? I finally decided on the piazza in front of Termini, Rome's central train station.

Early the next morning, I headed for the piazza determined to start a street painting on my own. I knew there were risks involved, such as having my fingers stepped on, or being moved on by the police. The idea of being able to apply all that I'd learned in the past months to a full-scale painting kept me from backing down. At the time, the train station was anything but gracious or comfortable. It had been under construction for many years, and was covered in rusty siding that funneled commuters into a narrow corridor. Black-market sellers, drug pushers, and Gypsies all sought their victims here.

By the time I arrived at the station, my heart was pounding. I wove my way through the commuters, looking for an appropriate spot to set out my materials. As a visual reference, I was using my drawing of Michelangelo's statue of Moses. An endless distracting dance of feet fell all around me, but soon a small group of spectators formed, and in their stillness I was protected from the surrounding chaos. I experienced for the first time a phenomenon that would come to repeat itself over and over again: the power of the image transformed not only the space but also everything and everyone around it. As the image grew, so did the audience, and the synergy created

◀ Wenner. Drawing from Michelangelo's *Moses*. Rome, Italy. This drawing from the famous Michelangelo statue was used by Wenner to create his first street painting.

BETWEEN THE TWO WAS A TANGIBLE, POSITIVE FORCE. BEING IN THE CENTER OF THIS RADIANT FIELD GAVE ME THE CONFIDENCE I NEEDED TO SET OUT A FEW BASKETS TO COLLECT OFFERINGS. PEOPLE TOSSED IN COINS IMMEDIATELY AND ENTHUSIASTICALLY. GIVEN THE SHADIER DENIZENS OF THE AREA, I THOUGHT IT WOULD BE DIFFICULT TO HOLD ON TO THE MONEY. HOWEVER, NO ONE TRIED TO TAKE THE COINS FROM THE BASKETS. AT ONE POINT, A LARGE GROUP OF GARISHLY DRESSED GYPSIES SURROUNDED ME. I TRIED TO IGNORE THEIR PRESENCE AND CONCENTRATED ON MY WORK AS THEY SCRUTINIZED THE PICTURE. THEY POINTED AND TALKED AMONG THEMSELVES, IN THEIR OWN LANGUAGE, UNTIL THEY SEEMED TO ARRIVE AT A COLLECTIVE DECISION. I BRACED MYSELF. SUDDENLY THEY ALL DROPPED SOME COINS INTO THE BASKETS, NODDED AT ME, AND THEN SILENTLY DEPARTED.

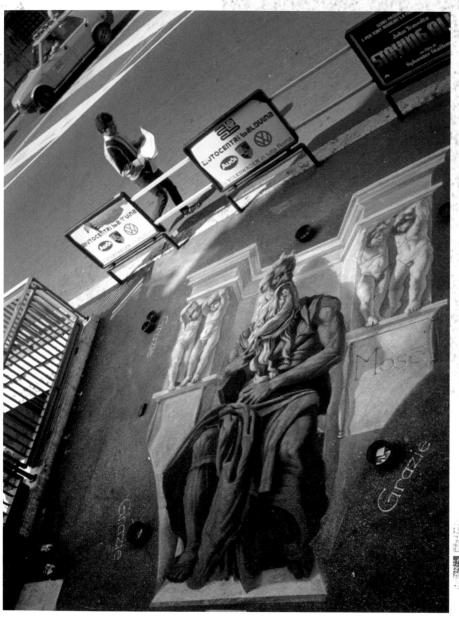

◀ **Wenner. Street painting from Michelangelo's** *Moses.* **Rome, Italy.** Wenner first created the image at the Rome train station, then repeated it at a more leisurely pace on the more lucrative and less dangerous Via del Corso.

▶ Wenner. Detail of *Moses.*

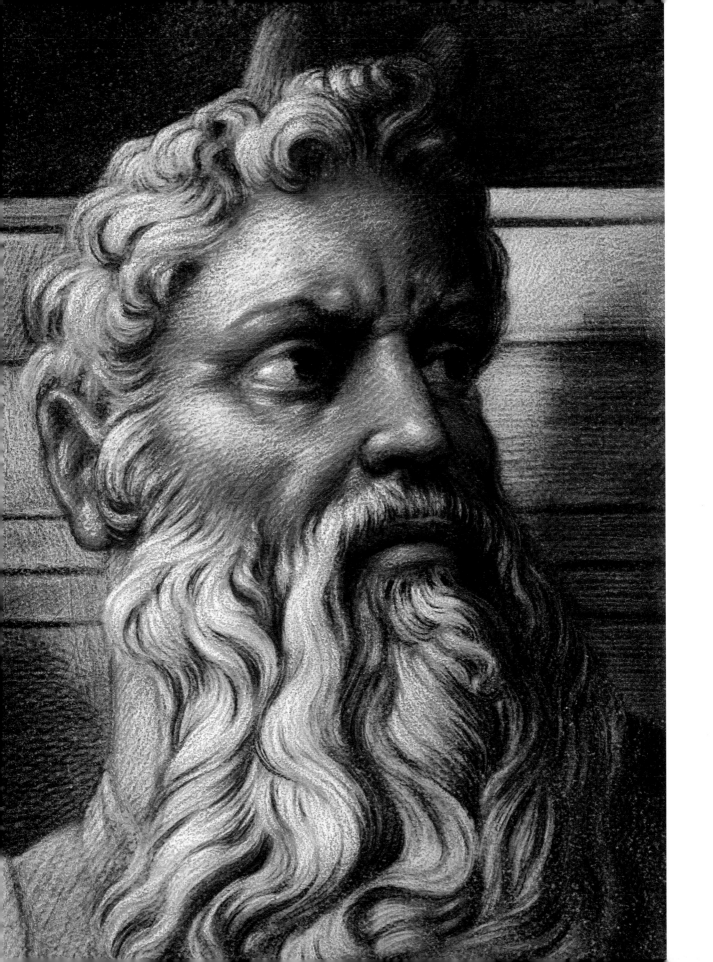

RELIEVED THAT THE MORNING HAD GONE WELL, I CROSSED THE STREET TO A LOCAL BAR FOR A MUCH-NEEDED ESPRESSO. I WAS SERVED INSTANTLY AND GIVEN THE CORRECT CHANGE IN A MANNER THAT IS USUALLY BESTOWED ONLY ON A BAR'S REGULAR CLIENTELE. I THOUGHT I MUST FINALLY LOOK LIKE I BELONGED, AND THEN I CAUGHT MY REFLECTION IN A MIRROR AND SAW I WAS COVERED FROM HEAD TO TOE WITH A PUNGENT COATING OF SWEAT MIXED WITH PASTEL DUST AND SIDEWALK GRIME. I REALIZED THE BARTENDER JUST WANTED TO GET ME OUT OF HIS SHOP AS QUICKLY AS POSSIBLE! THAT EVENING, WHEN IT GREW TOO DARK TO SEE THE PAINTING, I PACKED UP AND BEGAN TO HEAD HOME. LOOKING AT MY WATCH, I DISCOVERED THAT I HAD SPENT TWELVE HOURS SQUATTING, KNEELING, AND CRAWLING ABOUT ON THE SIDEWALK. MY BAG WAS PAINFULLY HEAVY WITH COINS, SO I TRIED TO TAKE A CITY BUS, BUT THE DRIVER TOOK ONE LOOK AT MY APPEARANCE AND REFUSED TO LET ME RIDE. I HAD NO CHOICE BUT TO DRAG MY BAG AND MY ACHING BODY FIVE MILES ACROSS TOWN TO MY ROOM. AFTER SCRUBBING OFF THE GRIMY COATING, I SAT IN MY ROOM, EVERY MUSCLE PAINFULLY SORE FROM THE CONTORTIONS I HAD BEEN PERFORMING ALL DAY. I EMPTIED THE COINS ONTO THE TABLE AND COUNTED THEM. I WAS STUNNED TO DISCOVER THAT THEY ADDED UP TO MY DAILY SALARY BACK AT NASA. EARLY THE NEXT MORNING, I RETURNED TO THE TRAIN STATION, AND MUCH TO MY SURPRISE I FOUND THE PICTURE NOT ONLY IN GOOD CONDITION, BUT COVERED WITH COINS!

I FOUND THE WORK MUCH LESS STRESSFUL ON THE SECOND DAY. NOW THAT I WAS FAMILIAR WITH MY SURROUNDINGS, IT WAS EASIER TO ENJOY THE AUDIENCE'S APPRECIATION, WHICH INCREASED AS THE PAINTING PROGRESSED. I WORKED STEADILY THROUGHOUT THE DAY, NEARLY FINISHING THE IMAGE. I DID MY BEST TO KEEP CLEAN, BUT I WAS STILL BLACK BY THE TIME EVENING CAME AROUND, AND MY BAG WAS UNBEARABLY HEAVY WITH COINS. FORTUNATELY, A MORE COMPASSIONATE DRIVER ALLOWED ME TO BOARD THE BUS HOME. THAT EVENING, AS SOON AS I HAD WASHED AND PUT ON FRESH CLOTHES, I SET ABOUT COUNTING THE COINS AND DISCOVERED MY EARNINGS HAD TRIPLED! I RETURNED TO THE PAINTING SITE THE NEXT MORNING AND QUICKLY TOUCHED UP THE PICTURE, AND THEN CONCENTRATED ON FINISHING. AFTER ADDING THE FINAL DETAILS, I STEPPED BACK AND SURVEYED MY FIRST COMPLETED STREET PAINTING. I WAS FILLED WITH JOY; NEVER HAD I IMAGINED WORKING ON SUCH A LARGE SCALE WITH SO MUCH SPEED. I WAS CERTAINLY RELIEVED ABOUT FINDING A WAY TO SOLVE MY FINANCIAL DIFFICULTIES, BUT MORE IMPORTANT I WAS EXCITED ABOUT STREET PAINTING PROPELLING ME FORWARD IN MY STUDIES.

That evening, Wenner fell into bed, overjoyed, relieved, and utterly spent. Sometime after midnight, he awoke to the damp scent and soft sound of falling rain. With his very first street painting sacrificed to the elements, Wenner had been initiated into the full cycle of the medium. He had also been lured by the siren's song into the life of a madonnaro.

▶ Kurt drawing in 1983. Wenner was only twenty-two years old when he began street painting in Rome.

3
ON
THE
STREET

▶ Wenner and Stader after Raphael. *Sistina Madonna.*
Vienna, Austria. Still learning to scale their works,
Wenner and Stader created a huge image in Vienna.

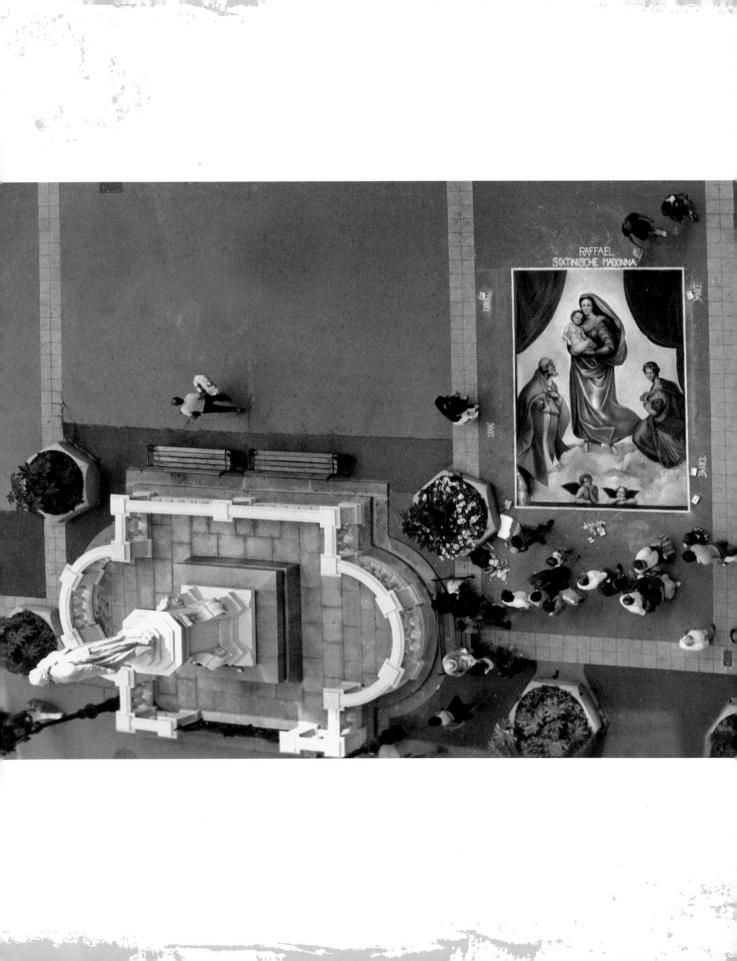

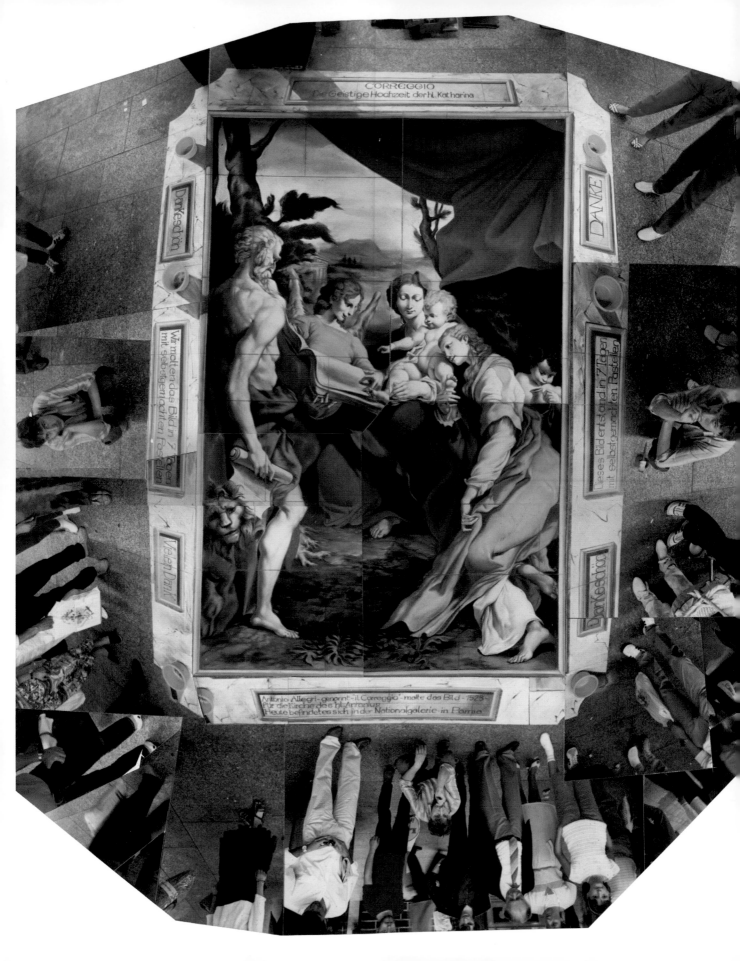

That summer, Kurt Wenner and Manfred Stader, one of the artists in Rome who had initiated him into street painting, decided to do some painting together. They boarded a crowded, all-night train to Vienna, and arrived in the city exhausted but eager to get to work. Immediately they began looking for a good site.

Wenner was still new to street painting and drawing copies of paintings to scale, so he and Stader ended up painting a twenty-foot Madonna! The Viennese responded enthusiastically to the theatricality of the gargantuan painting and gave generously. The two later moved on to Salzburg, Mozart's birthplace, where the annual Salzburg Music Festival was taking place. However, as Wenner and Stader wandered around looking for a likely site, they discovered that all the streets were paved with quaint but impossibly bumpy cobblestones. Europe is filled with a variety of paving materials, which pose endless challenges to madonnari.

After their disappointment in Salzburg, they decided to stick to cities that Stader knew, such as Nuremberg and Saarbrücken. Knowing Wenner's weakness for painting bizarrely large and complicated pieces, Stader selected cities with huge underpasses that protected them from the elements. Unbeknownst to them at the time, many northern street painters work on paper. This is due in part to the weather, and in part because the northern cultures relate better to highly crafted images that take a long time to create. Painting in Germany was decidedly different than in Italy, but the earnings were good and Wenner was saving money to fulfill his dream of buying a camper.

One evening while they were in Saarbrücken, a drunken man began yelling at Wenner and Stader, saying, "This is the worst work I have ever seen and I should know, because I am a *Meister Tapezierer*!" Wenner's knowledge of German was far from complete, but even Stader was perplexed at the man's statement, because *Meister Tapezierer* means "master paperhanger." The next thing they knew, the man was reaching down and smearing the edge of the picture with his fingertips.

◄ **Wenner and Stader after Correggio.** *Madonna di San Gerolamo.* **Saarbrücken, Germany.** Sometimes the public had a hard time believing the works were actually painted directly on the pavement. In this case, a drunken paperhanger smeared the picture several times trying to lift it up.

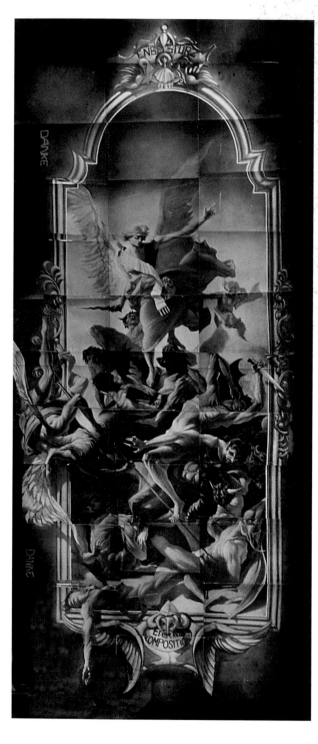

WE WERE PAINTING ON A FLOOR MADE OF SMOOTH MARBLE BLOCKS WITH DEEP GROUT LINES IN BETWEEN. IT SLOWLY BECAME APPARENT THAT THE MEISTER TAPEZIERER THOUGHT THAT THE WORK HAD BEEN GLUED DOWN IN SHEETS, AND WAS UPSET BECAUSE THERE WAS A VISIBLE SPACE BETWEEN THE SEGMENTS. THE MAN BECAME MORE AGITATED AND LUNGED AT THE PAINTING. SEVERAL BYSTANDERS PULLED HIM OFF THE PICTURE, BUT HE LUNGED FORWARD AGAIN. THIS TIME THE COMBINED FORCE OF THE PEOPLE WAS SO GREAT THAT HE WAS INADVERTENTLY SENT FLYING THROUGH THE AIR AND LANDED WITH A SLAP ON THE MARBLE FLOOR SEVERAL FEET BACK. THERE WAS A MOMENT OF SILENCE BEFORE THE MAN PICKED HIMSELF UP AND WENT AWAY, MUTTERING ABOUT OUR SHODDY CRAFTSMANSHIP.

While in Nuremburg, the two friends encountered a German trait that didn't lend itself to street painting: cleanliness. Each morning at 5 AM, a street cleaner would pass by and wash off any paintings he found. The artists had to stand by their painting each morning and physically guard it.

As the colder months approached, Wenner decided it was time to buy a camper. With Stader's help, he found an ancient but sound vehicle that met his budget. It was an old Mercedes that had been used as an armored car for emptying parking meters. This seemed to suit Wenner's new profession quite well. Stader stayed on in Germany, while Wenner drove south to warmer weather in Sicily.

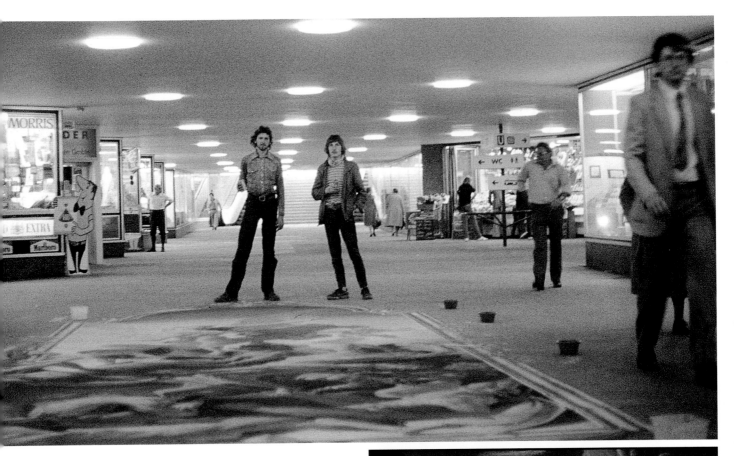

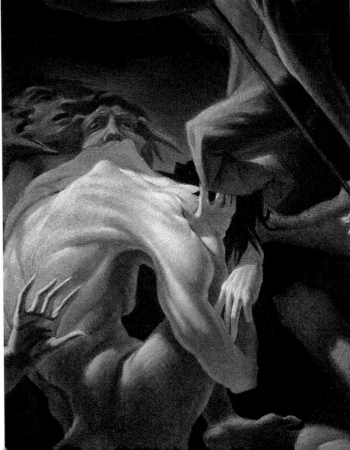

▲ **Wenner and Stader in Nuremberg.** Plenty of coffee was necessary to survive the long days while creating the large composition.

▶ **Wenner and Stader partially after Tiepolo.** Detail of *Fall of the Rebel Angels*. **Nuremberg, Germany.** Wenner and Stader started with a work by Tiepolo, but improvised on the bottom part, creating their own fallen angels.

◀ **Wenner and Stader partially after Tiepolo.** *Fall of the Rebel Angels*. **Nuremberg, Germany.** This large composition (fifteen by forty feet) could only be documented by tiling many photos taken from the ceiling of the underpass. An overzealous street cleaner destroyed the work the day after it was finished.

The first place in Sicily he created a street painting was Messina. He made a copy of Bronzino's *Holy Family*. The chalk painting looked beautiful on the smooth piazza, and there were plenty of people, but nobody spoke to him and few made an offering.

Wenner drove from Messina to the city of Catania, arriving very late at night. He was uncertain if the people of Catania would be receptive to his work, but he knew he wanted to try a simpler painting than the one he did in Messina. He decided to paint a copy of Raphael's *Madonna della Seggiola*, a small Renaissance painting with a devotional character that made it icon-like. It was the kind of traditional image madonnari had copied for generations.

▲ **Wenner in camper.** Traveling through Europe in a camper made it much easier to be an itinerant street painter. Some supplies and books could be brought along, and it was possible to transport the massively heavy Italian currency.

▶ **Wenner after Bronzino.** *Sacra Famiglia con Sant'Anna e San Giovannino.* **Messina, Sicily.** This small composition received a cold reception in Messina. Wenner fared better with simpler Madonnas in other Sicilian towns.

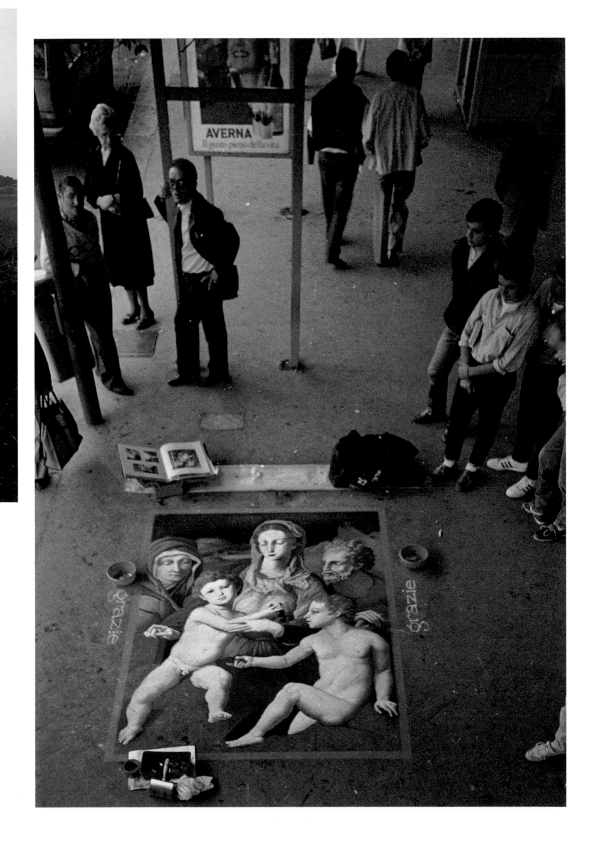

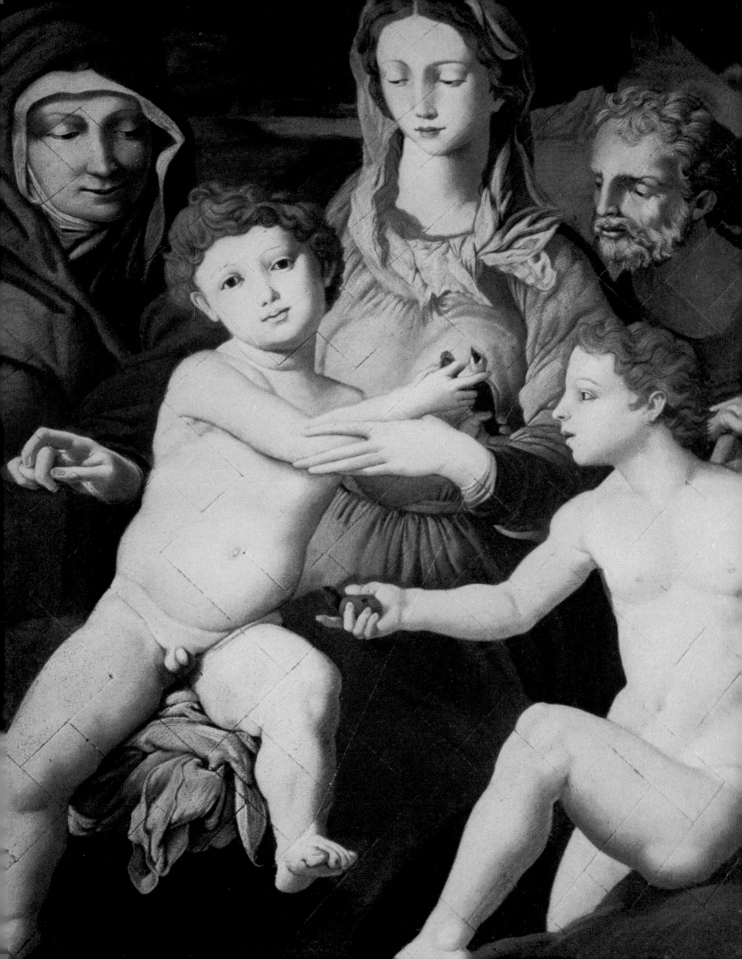

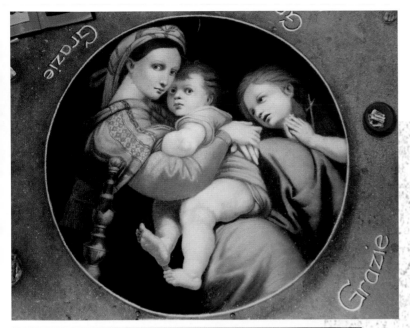

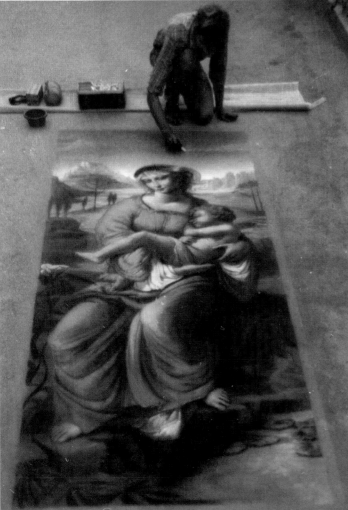

I SET OUT MY BASKETS AS USUAL, BUT THEY WERE COMPLETELY IGNORED. INSTEAD, THE LOCALS PLACED MONEY DIRECTLY ONTO THE IMAGE ITSELF, SLIDING BILLS UNDER THE MOUNTING STACKS OF COINS TO KEEP THEM FROM BLOWING AWAY. IT WAS A DISTRACTING WAY TO WORK, BUT I WAS VERY ENCHANTED BY THEIR PRACTICE OF GIVING AN OFFERING DIRECTLY TO THE MADONNA. IT DIDN'T TAKE LONG UNTIL THIS CHARMING TRADITION COMPLETELY OBSCURED THE PAINTING.

▲ Wenner after Raphael. *Madonna della Seggiola*. Catania Sicily. This famous work was a bread-and-butter image for the madonnaro in southern Italy.

◀ Wenner. *Piccola Madonna*. Rimini, Italy. This image was typical of the kind of small picture Wenner created in southern Italy. Not wanting to overdo the copying, he created original images like this one. Some people would not believe they were original, even if they could not see him working from a reproduction.

◀◀ Wenner. *Sacred Family* detail.

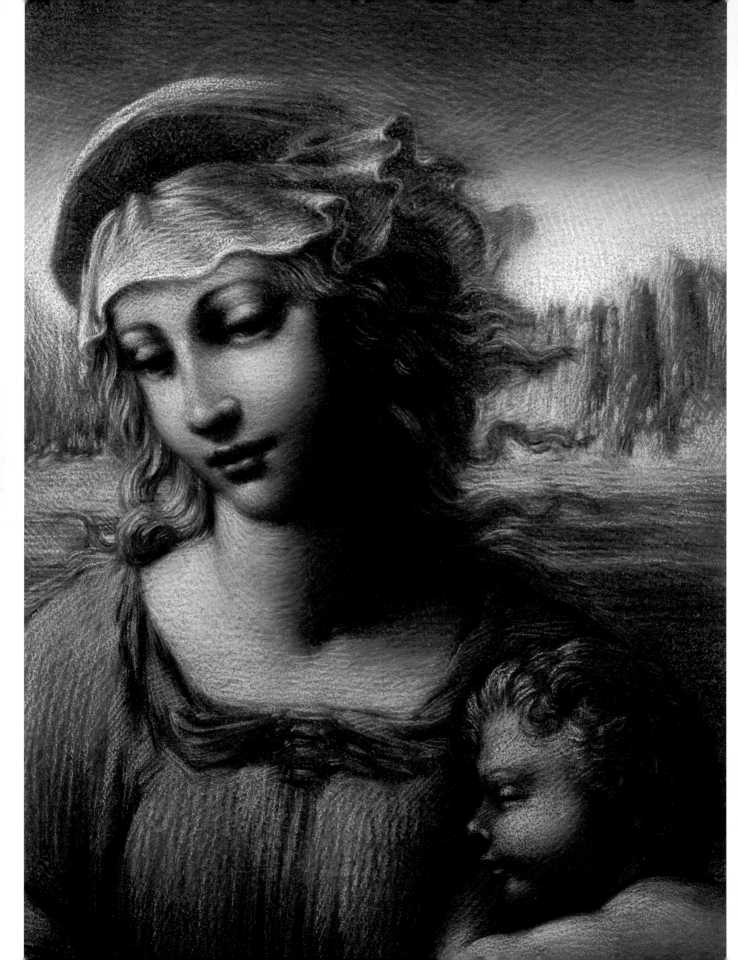

Wenner's success in Catania gave him the courage to paint in the towns of Piazza Armerina and Caltagirone. He continued with the theme of devotional Madonnas, as they seemed to go over well with the traditional Sicilians. Wenner found Sicily to be beautiful and fascinating, but it was an austere environment for street painting. Although the initial distrust of the people transformed into warmth and generosity in each town, the cycle repeated itself wherever he went.

After traveling through Sicily, Wenner headed back to Rome, where he met up with Stader, who was preparing to return to Germany. The two of them agreed that Wenner would take over Stader's spot on the fashionable Via del Corso, where the passersby were a mix of government officials, high-end shoppers, journalists, tourists, and an assortment of young Italians. The location was just across the street from Piazza Colonna and the Italian Parliament, in the heart of Rome. Such

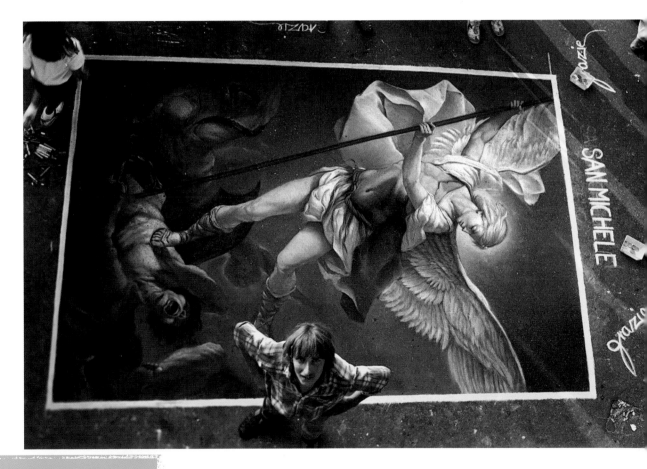

◄ Wenner. *Piccola Madonna* detail.

▲ Wenner and Stader after Giordano. *San Michele*. Ostia Lido, Italy. The artists created this work in preparation for the festival in Grazie. Eventually they selected Pontormo's *Deposition* as the subject.

a setting meant that Wenner never knew what the day would bring, as there could be demonstrations with shouting protesters or a general strike that left the streets empty and deserted. But being at the center of Italian politics also meant that the national newspaper's offices were just a stone's throw from the painting site, and Wenner soon became the subject of many articles.

Unlike sites in most cities where the monetary offerings would start to dwindle after several days, it seemed that the Via del Corso could be worked indefinitely. Wenner was content to stay on the same spot for months, washing his finished pictures off and starting new ones. Observing his pictures became a part of people's daily lives. Romans were especially accustomed to seeing street paintings, and they were munificent in their appreciation of his efforts. Besides tossing coins into his baskets, they showered him with boisterous, effusive compliments. As they left an offering or passed by, they would exclaim, *"Molto bello! Magnifico! Squisito!"* Supportive shopkeepers who had taught him only months earlier to carefully scrutinize his change so he didn't get cheated came and lobbed a coin or two his way. Wenner enjoyed the Romans immensely.

As Wenner's images grew more expansive, they also became more interesting and lucrative. He would now spend three to five days on a picture, which meant he had to protect the image at night. In the evening, he would stretch a sheet of plastic as tight as glass to shield the work from dirt, wind, dogs, and homeless people who might draw on it during the night to get tips from the odd passerby. It rains frequently in Rome, so seeing a picture through to the end was often an arduous task. Wenner soon learned to heed the ranting of several vagrants who were able to predict storms with uncanny accuracy. Every time they would mutter their warnings, he would instantly cover his work and head for shelter. The plastic didn't keep the painting dry for long, as the water would seep under, but it did prevent the work from being stepped on and the colors tracked all over the sidewalk.

ONCE A STORM PASSED, I WOULD TAKE OFF THE PLASTIC AND WAIT FOR THE GROUND TO DRY. THEN, WORKING SWIFTLY WITH LARGE, BOLD STROKES, I'D REDO WHAT HAD BEEN LOST TO THE RAIN AND CONTINUE AT A FRENETIC PACE TO FINISH THE PICTURE. THE PRESSURE OF HAVING TO DRAW QUICKLY INCREASED MY ARTISTIC ABILITY, AS DID THE EXERCISE OF COPYING SO MANY GREAT MASTERPIECES. BECAUSE MY STREET PAINTINGS WERE COPIES AND NOT ORIGINAL WORKS, I WAS CONTENT TO PRODUCE A VAST NUMBER OF THEM AND THEN WATCH THEM DISAPPEAR. EACH ONE GAVE ME INVALUABLE INFORMATION ABOUT COLOR, FORM, AND PERSPECTIVE ON A LARGE SCALE. ONCE A COPY WAS FINISHED, I HAD LEARNED ALL I COULD FROM IT, AND WAS HAPPY TO HAVE A RAINSTORM WASH IT AWAY!

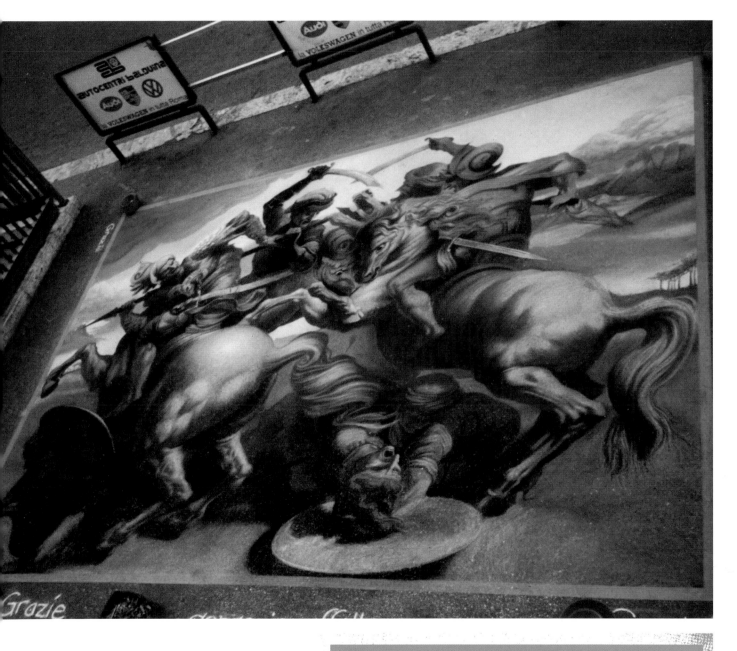

▲ **Wenner after Leonardo and Rubens.** *Battle of Anghiari.* **Rome, Italy.** In the case of this composition, the original painting has been lost, and it can only be re-created by referring to copies of it.

▲ Wenner. *Battle of Anghiari* detail.

▶ Wenner. *Three Archangels.* **Rome, Italy.** Another improvised composition meant to be seen from different viewpoints.

As Wenner worked on the streets of Rome, people would constantly offer him commissions for permanent paintings and drawings. This became a cultural conundrum, because Wenner couldn't sort out who was serious and who was angling for cheap, or even free, artwork.

Some kindhearted locals began to advise Wenner about who was trustworthy and who was out for a free painting. They told him not to work for priests with churches in the rural countryside (*campagna* in Italian), as such priests had no resources and would have him painting in return for hospitality. Unfortunately, the language still caused him to often misunderstand people.

One day while street painting, a priest with a magenta-colored cap approached Wenner saying that he had a church in Campania, and needed someone to paint the ceiling. Immediately Wenner assumed that this was the sort of priest he had been warned about and quickly told the priest that he was too busy to accept commissions. Later he learned that he had turned down the archbishop of Montecassino, who had come personally to ask Wenner to paint the ceiling of a major cathedral. In this case, the word *Campania* referred to a region of Italy outside Rome, and not the countryside, but the sound of the two words is so similar that he couldn't distinguish one from the other at the time. Focusing so much on the idea of a church in the *campagna*, he completely forgot that you can identify priests, bishops, and archbishops by the color of their caps.

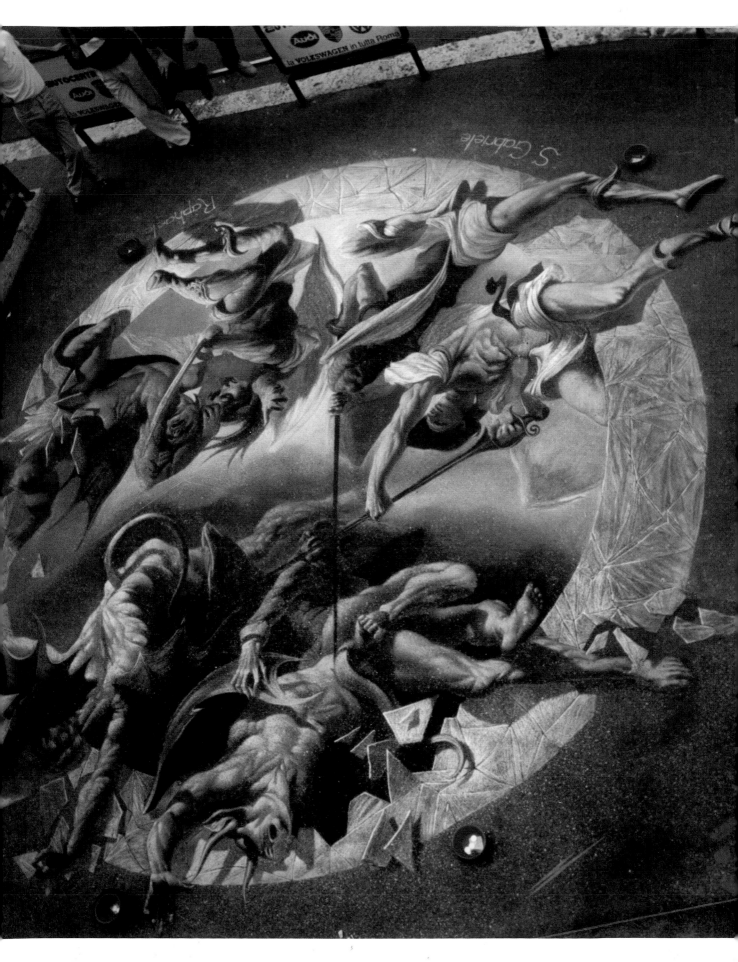

Two years later, an art restorer told Wenner about an important commission for the ceiling of a famous cathedral. As they walked into the archbishop's office to offer their services, Wenner recognized the archbishop as the one who had approached him in Rome. He remembered Wenner as well and was very cordial. Unfortunately, he explained that while he had possessed the funds to pay for the ceiling two years before, they were no longer available.

On another occasion, a man in an elegant suit handed Wenner his business card, explaining he was a set designer for the great filmmaker Federico Fellini. He asked if Wenner would come work for Fellini. Wenner did not understand at the time that in Italy when someone hands you a card, it is an important invitation. Two years later, Wenner followed up and Fellini's secretary wrote a lovely letter saying there were no films in progress at the time. Fellini died in 1993.

Not having full command of the language was difficult, but Wenner did not miss every opportunity that came along. Ironically, he was invited on several outings by his East Coast alma mater, which besides telling him as a student that he had no talent to draw had also denied his application to its Rome program. He felt privileged to be experiencing Rome on his own terms. Other people he met invited him to assist with archaeological digs, view hidden masterpieces, see long-closed churches, and climb through secret passages to vaults and cupolas in certain churches to view frescoes up close.

ONE DAY AS I WAS WORKING ON THE STREET, A BEARDED MAN INTRODUCED HIMSELF AS AN ART RESTORER AND ASKED IF I WAS INTERESTED IN SEEING THE RESTORATION WORK OF THE SISTINE CHAPEL CEILING UP CLOSE. I TOLD HIM I WAS, AND UNBELIEVABLY, HE RETURNED THE FOLLOWING DAY WITH AN APPOINTMENT. WHEN WE ARRIVED, THE RESTORER WAS SURPRISED THAT THE VATICAN GUARDS KNEW ME BY NAME. AS I CLIMBED THE SCAFFOLDING, I SAW THE METICULOUSLY RENDERED SIGNORELLI AND BOTTICELLI FRESCOES. THEN, STRAIGHT ABOVE ME, THROUGH AN OPENING IN THE PLATFORM, AN ENORMOUS FOOT APPEARED. ALTHOUGH I HAD VIEWED THE PAINTINGS ON THE CEILING FOR COUNTLESS HOURS FROM THE FLOOR BELOW, AND COPIED SEVERAL OF THEM, I WAS UNPREPARED FOR THE SHEER SIZE OF MICHELANGELO'S FIGURES. AFTER MONTHS OF CHALKING ON THE STREET, I FOUND MYSELF IMAGINING THE ARM MOVEMENTS HE MUST HAVE HAD TO MAKE TO CREATE THE ENORMOUS FORMS. UP CLOSE, I COULD SEE DETAILS THAT ARE OTHERWISE NOT VISIBLE FROM BELOW. STANDING AT ARM'S LENGTH FROM THE WORK, I HAD A SENSE OF THE STRUGGLE AND FATIGUE MICHELANGELO MUST HAVE SUFFERED. BECAUSE OF THAT EXPERIENCE, THE CEILING IS EVEN MORE REMARKABLE TO ME.

◄ Wenner after Michelangelo. *Jonas*. Rome, Italy. Wenner especially enjoyed copying the Sistine Ceiling frescoes. It was pleasurable to work on figures that had been conceived on a large scale.

PEOPLE OF THE STREETS

Eventually, Wenner did accept several large commissions from people he met on the street. Creating copies of masterworks in a permanent medium was not to his liking, and it was another year before he felt ready to create original permanent works of art.

ONCE I BEGAN MAKING ORIGINAL COMPOSITIONS ON THE STREET, IT BECAME MORE IMPORTANT TO ME TO PROTECT THE PAINTING FROM DAMAGE OR DESTRUCTION BY THE ELEMENTS. I WANTED TO SPEND MY TIME MOVING THE PICTURE FORWARD, NOT REPAIRING DAMAGE. SUN, WIND, AND RAIN ALL TOOK THEIR TOLL, BUT ROME'S LARGE POPULATION OF VAGRANTS WAS A PROBLEM AS WELL. IN ORDER TO MAKE A LITTLE MONEY AT NIGHT AFTER I HAD GONE HOME, THEY WOULD STRIP AWAY THE PROTECTIVE PLASTIC AND PRETEND TO WORK ON THE PAINTING, DRAWING INVISIBLE STROKES WITH A CIGARETTE BUTT IN PLACE OF A PIECE OF CHALK.

The homeless meant no harm and merely hoped to profit a little from the people strolling through the city after hours. Since Wenner was familiar with the challenges of earning a living on the street, he empathized with them and thought about how he and they could both benefit.

► **Conversation with nuns.** Rome was filled with clergy and pilgrims who were especially appreciative of the street painters.

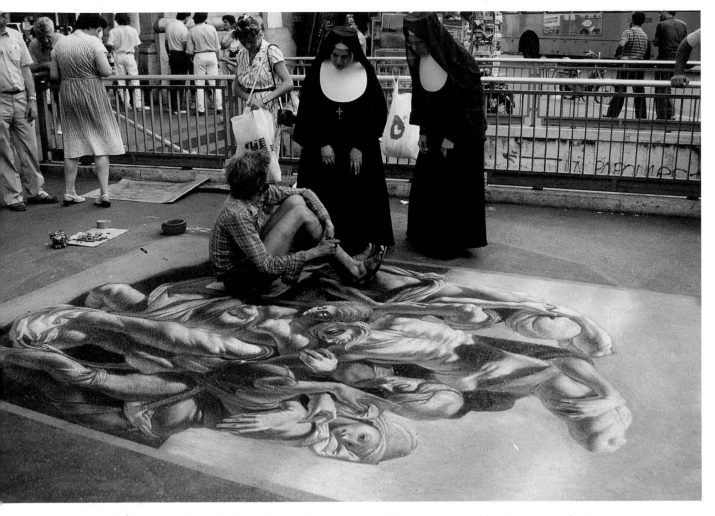

To protect the paintings, he enlisted and paid the more capable street people to guard his work when he wasn't there. They had a pecking order among themselves, so they worked out their various shifts of protecting the picture. During each turn, a man would pass himself off as the creator of the artwork, collecting all the gratuities and compliments. Late one evening as Wenner passed by on his way home, he saw one of the "assistants" giving an elaborate art history discourse to a small, spellbound group of Romans. As he looked to be about seventy years old, with blackened teeth, he seemed to fit the stereotype of a street painter. He had listened to Wenner respond to frequently asked questions and had memorized many facts and concepts and could now deliver his own lecture with great conviction and gusto. When a person attempted to commission a painting from him, he cited the purity of his work, asserting with disdain that his work was "true art" and could not be sold.

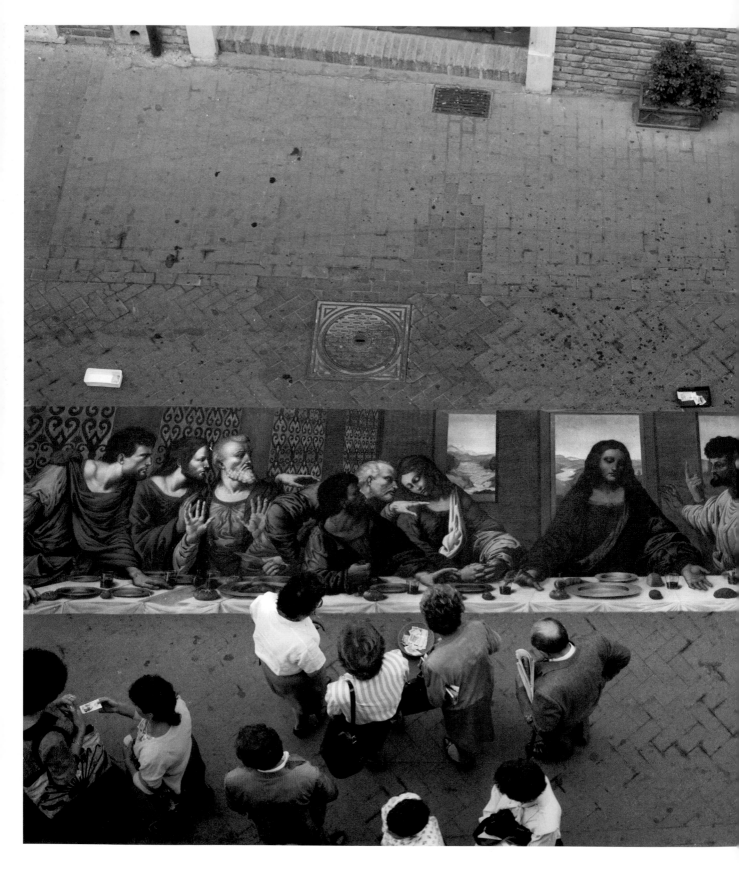

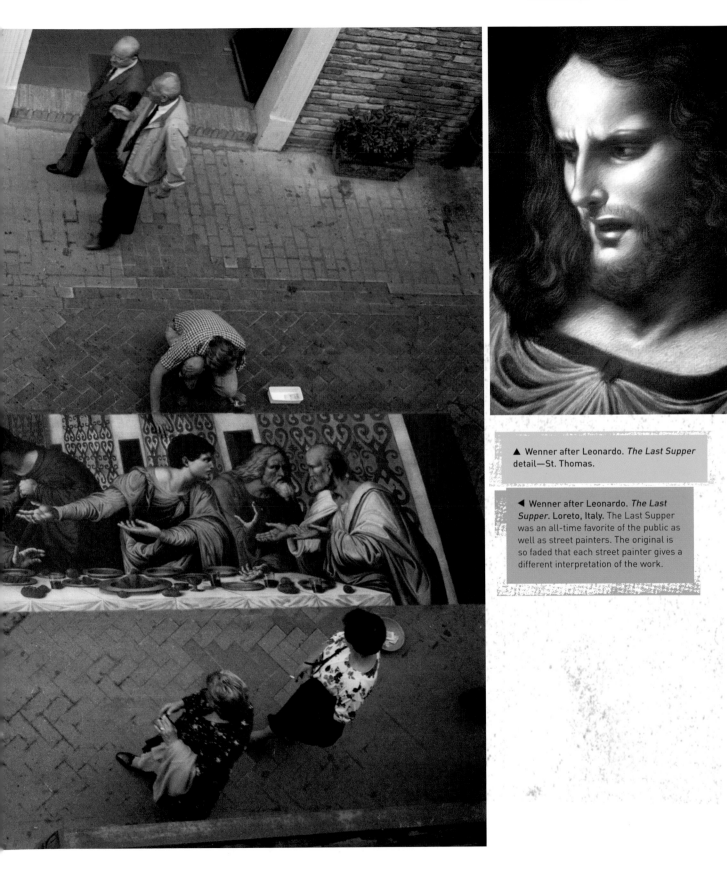

▲ Wenner after Leonardo. *The Last Supper* detail—St. Thomas.

◄ Wenner after Leonardo. *The Last Supper*. Loreto, Italy. The Last Supper was an all-time favorite of the public as well as street painters. The original is so faded that each street painter gives a different interpretation of the work.

When a picture was completed and there was no rain, Wenner would occasionally take a break for a few days to enjoy the city and its endless treasures. His "assistants" would take over the painting and collect the offerings. They proved to be invaluable, for not only did they look after the artwork, but also they enabled him to hold on to his prime location indefinitely. An unwritten law among street painters is that good sites are always available on a first-come, first-served basis. No other artist will take over an area as long as someone else is working on an image. However, there can be a race to grab a lucrative spot the minute it is empty, even if it is because rain has erased the image. Over time, Wenner's images grew so large and impressive that the space on Via del Corso was no longer sufficiently lucrative for other street painters with their smaller and simpler images, yet it was still important for his street assistants to guard the spot from drifters or addicts.

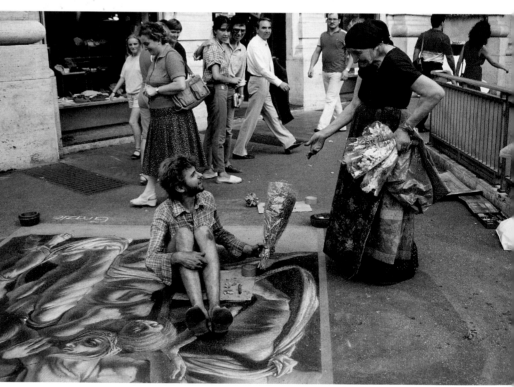

▲ **Advice to artists.** Rome's "Flower Lady" was a familiar sight in the 1980s. She called out advice to the street painters and reminded the public to make a drop.

◀ **Public art.** It is the people on the street who directly support the madonnari. Street artists learn quickly what the public tastes are.

I CAME TO KNOW MANY OF THE STREET PEOPLE, SUCH AS AN OLD CRONE SELLING ROSES. WHEN MY PAINTING SITE WAS ESPECIALLY CROWDED, THE FLOWER LADY WOULD APPEAR OUT OF NOWHERE AND PUSH HER WAY THROUGH THE SPECTATORS. PRETENDING TO BERATE ME, SHE WOULD WORK THE CROWD, WAVING HER HANDS IN THE AIR CRYING, "WHAT'S THIS? NOT AGAIN! I KEEP TELLING YOU NOT TO PAINT THESE LARGE, COMPLICATED WORKS. WHAT DO WE KNOW ABOUT ART? GIVE US SOME LITTLE MADONNA OR A SAINT AND WE'RE HAPPY. FORGET THESE LARGE MASTERPIECES! YOU WORK FOR DAYS, AND DOES ANYONE UNDERSTAND IT? NO, THEY DON'T. JUST LOOK AT THESE BASKETS—EMPTY! YOU MAKE NOTHING. JUST PAINT SOME SIMPLE LITTLE MADONNA, AND THEN PEOPLE WILL GIVE YOU SOMETHING!" NATURALLY, HER HARANGUE WOULD CAUSE THE CROWD TO DROP LOTS OF MONEY INTO THE BASKETS. AFTER THEY HAD DISPERSED, SHE WOULD QUIETLY CIRCLE THE PAINTING AND PLUCK A COUPLE OF BILLS FROM EACH OF THE BASKETS AS COMPENSATION. BEFORE DEPARTING, SHE WOULD LEAVE BEHIND AN OFFERING OF SOME PARTICULARLY POOR ROSES.

▶ **Weighing coins.** The Italian lira was a bulk currency. Pound for pound, its value was roughly the same as espresso coffee or parmesan cheese. Street painters brought home many kilos of coins each day. Alfredo, the kind manager of the famous bar Tazza d'Oro, weighs and bags Wenner's coins.

SMALL CHANGE

Early street painters survived on bread, wine, olive oil, and an occasional coin received as donations for their work. By the time Wenner began street painting, coins and small bills made up the bulk of the offerings. He depended on the tips he received, and the virtuosity of his work attracted such appreciation that it ended up causing a considerable problem: too many coins! Most Italian coins were worth very little, which meant there were a lot of them in circulation. As a result, the banks refused to change them into bills or accept them for deposit, and very few merchants would agree to be paid with them.

The baristas at La Tazza d'Oro, a café Wenner frequented, told him to bring his coins in and they'd exchange them. That evening, he hauled a large sack bulging with change back to La Tazza d'Oro. The baristas were shocked at the quantity of *soldini* (small change). After a rapid-fire discussion involving much gesticulation, they poured the coins into the bags used to sell coffee beans and placed them on the scale to determine their value.

It wasn't long before the Tazza d'Oro had all the coins it could possibly use. Wenner had to find other means to exchange or spend them. In order to possibly convince a merchant to accept the coins, Wenner needed to roll and carefully label them. Then, to be on the safe side, he would let a merchant know up front that he needed to pay with them. It took effort to convince others to accept the neat bundles as payment, but his efforts were rewarded with a good meal, an evening at the opera, or a train ticket for more extensive sightseeing. Eventually, his earnings enabled him to rent a room in a pensione across from the Pantheon. He also found a small room in a nearby piazza to use as a studio. He now had lodging and a studio in the heart of Rome, with his work site just around the corner.

He received roughly four thousand coins each week, which meant he could scarcely carry the heavy sacks away at the end of each day. In his studio, there were so many bags piled up that there was practically no room to move, and all the merchants he knew had already accepted buckets of change from him. On one particularly lucrative day, he had to call a taxi, as the coins weighed too much to carry. When the driver arrived, he tried to casually lift the bag so as not to call attention to how much money he had made. In front of everyone, the handles ripped off, leaving the heavy bag firmly planted on the ground. The crowd instantly understood what had happened and went wild with laughter, applauding his good fortune.

Luckily, Wenner heard about a pizzeria near the Trevi Fountain that was always short of change, because tourists would cast their coins into the fountain before deciding to buy a slice of pizza. Wenner approached the owner, who offered to take all the coins off his hands for a reduced price per pound. It took several trips to transport all the bags from the Pantheon piazza over to the Trevi Fountain. The owner instructed his workers to accept the coins in his absence, most likely thinking there would be just a few sacks full. When he returned, he discovered that his storeroom was full of coins.

◀ **Sorting coins.** Italian banks did not exchange coins for bills, but when carefully counted and rolled, street painters could hope to spend them.

DURING EASTER, ROME FILLS WITH PILGRIMS, MAKING IT THE ONE TIME OF THE YEAR WHEN LOTS OF ARTISTS ARRIVE TO WORK ON THE STREETS. RATHER THAN COMPETE FOR SPACE, I SUGGESTED TO SEVERAL STREET PAINTING FRIENDS THAT WE WORK IN GROUPS AND OCCUPY FOUR HEAVILY TRAF- FICKED SITES. BECAUSE WE WERE SPREAD OUT ALL OVER THE CITY, WE NEEDED SOMEPLACE TO STORE OUR EARNINGS. EACH EVENING, WE'D MIX ALL THE MONEY TOGETHER, DIVIDE OUT THE BILLS, AND PLACE THE COINS IN MY CAMPER, WHICH WAS PARKED ILLEGALLY IN FRONT OF THE BANK OF ITALY. THERE WERE NO LEGAL PARKING SPACES NEAR MY WORK SITE, AND I FIGURED THE CAMPER WAS TOO HEAVY TO BE TOWED, AS THE WHEELS HAD FLATTENED UNDER THE WEIGHT OF THE COINS. BY THE END OF THE WEEK, THE VEHICLE MUST HAVE HAD MORE COINS THAN THE BANK ITSELF.

After the Easter festivities came to a close, Wenner and his street painting friends decided to take a day in the countryside to sort, count, roll, and divide up the coins. They packed a picnic of bread, sausages, cheese, and wine, and headed out to the hills of Frascati. They set to work, but soon conversation and good food took over and no one felt much like going through the coins. As the light began to fade, they piled up the sacks and covered them with dry leaves, marking the spot for another day. The group never did go back for the coins.

LA POLIZIA

When Wenner made his first street painting in Rome, he had no knowledge what laws might govern the art form. As it turned out, street painting is considered a valid form of popular art and is not illegal. However, it is a bit like parking in that it is legal to park in many places—but not everywhere. The problem with street painting is that the legal spaces are not delineated, and asking for permission from the authorities is seldom effective. No official will deny permission, but they will rarely grant it, either.

The bottom line is that if you want to be a street painter, you have to accept the possibility of being moved on by the police.

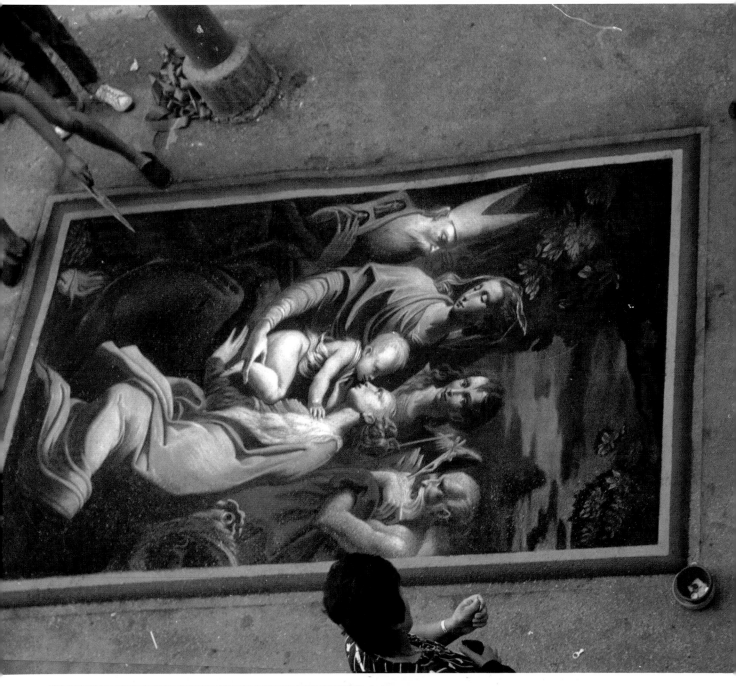

◄ The *vigili urbani.* The *vigili urbani* were the branch of police who confronted street painters. The public would typically get involved and side with the artist.

▲ Wenner after Parmagianino. *Madonna di Santa Margherita.* Rimini, Italy. In the summer, street painters follow the Italians in their migration from the cities to the coastlines and mountains.

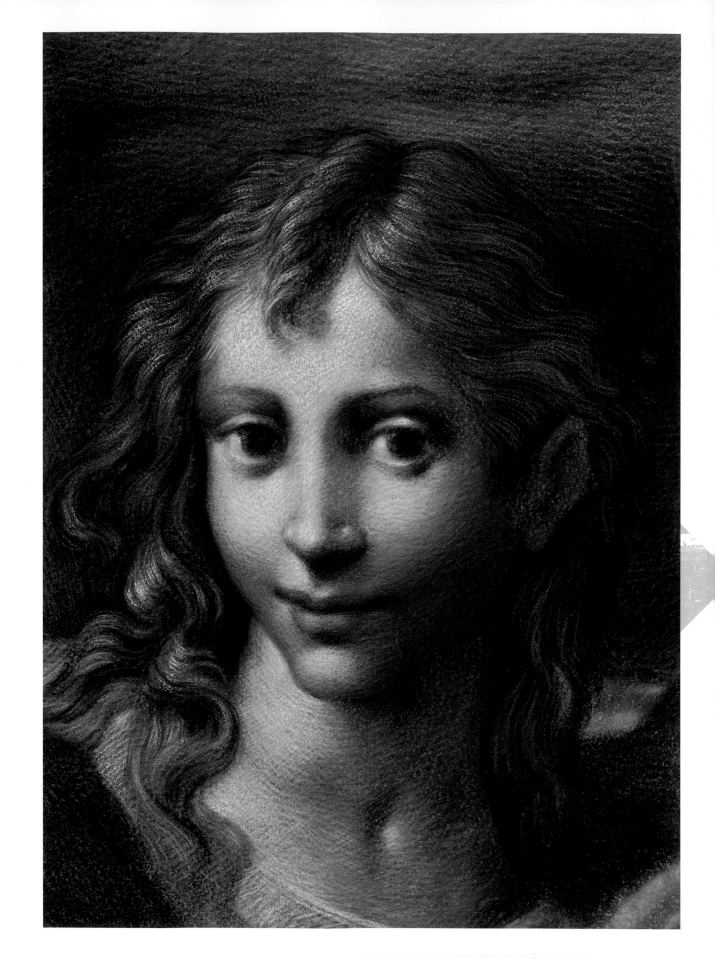

Frequently, on the first day in a new location the police would show up in the late morning. Shopkeepers would typically call them when a street painter starts to work. Madonnari were not known for causing any threat; therefore, it would generally take the police quite some time to appear. By the time they arrived, the image was usually well under way. The police tended to watch Wenner paint for a while before speaking with the shopkeeper, and they normally left without saying anything.

Wenner had only one serious encounter with a particularly aggressive officer. A *vigile urbano* (traffic officer) arrived at his painting, bellowing, "Get out of here!" while kicking over the baskets and sending coins rolling every which way. Wenner would have normally tried to reason with the officer, but in this particular case he was working with a friend, a German baron who loved to act the part when angered. The baron told the *vigile,* "I'm a real artist, so you should call a real policeman." While this was all well and good for his friend, Wenner had been in the country far past the official three-month entry limit. The last thing he wanted was a real policeman showing up.

THANKS TO MY FRIEND, A CARABINIERE WITH THE POWER OF ARREST WAS ON HIS WAY! THE OFFICER ARRIVED ON A GLEAMING MOTORCYCLE, WEARING AN IMPECCABLE UNIFORM. THE VIGILE WAS BY THIS TIME IN A HEATED DISCUSSION WITH A CROWD OF ANGRY SPECTATORS. THE CARABINIERE DIDN'T HIDE HIS IRRITATION WITH THE VIGILE, AND PROCEEDED TO HUMILIATE HIM BY LOUDLY INFORMING HIM THAT WE WERE PERMITTED TO STREET PAINT, AND THAT IT WAS UNFATHOMABLE THAT HE HAD BEEN DISTURBED FOR THIS. THE BARON REVELED IN THE SPECTATORS' PRAISE, WHILE I DISAPPEARED IN SEARCH OF A STIFF DRINK. THE ROMANS ALWAYS LOVE A GOOD SHOW, AND ON MY RETURN I FOUND OUR BASKETS OVERFLOWING.

The most dramatic confrontation with the police occurred in Naples. The neighborhood priest asked Wenner to create a street painting of San Gennaro for the saint's feast day. The saint's dried blood is kept in a reliquary in the church and publicly displayed while prayers are said for the miracle of San Gennaro to occur (the liquefaction of the blood). Wenner had just started painting when a police officer arrived and ordered him to move on. Wenner returned to the church and found the priest.

◀ Wenner. *St. John* detail.

The priest said Wenner had his protection and, more important, the protection of San Gennaro. He advised Wenner to return to the painting, adding that the officer would have already departed. Wenner continued working on the street painting for a few hours before the officer returned with a companion. By then, a large crowd had gathered around the painting. The officers politely attempted to pack up his supplies. However, the onlookers stopped them by unpacking everything and putting each item back in its place. The officers attempted to force the issue, but in a moment of inspiration Wenner faced the Neapolitans and asked, "Is it right to destroy the image of a saint on his feast day?" That was more than the people could take. They lifted up the officers and carried them away.

By midday, the streets were nearly empty and Wenner was still working, but not without a sense of dread. Off in the distance, he heard sirens approaching and decided he had better quickly pack up his belongings. Retreating into the church, he looked through the door to see police cars pulling up alongside his work. He ran upstairs and interrupted the priest, who was eating lunch. Wenner apologized and explained that the *polizia* had just arrived. Calmly, the priest said, "You have my protection, you have San Gennaro's protection, and you have the protection of the Madonna." He further assured Wenner that all was well and encouraged him to continue with the painting.

Wenner returned downstairs and peered out the door. He could see the *polizia* cars surrounding his drawing, which now looked like a crime scene. Sensing that the protection of the priest was similar to that of San Gennaro, more spiritual than physical, he opted to put his trust in St. Peter and immediately returned to Rome. He never found out what happened to the painting.

Eventually, Wenner would receive a letter from the superintendent of culture, history, and monuments for the region of Campania. The letter gave him sweeping privileges to enter any museum for free and to create a street painting wherever he liked. A similar letter from the Italian national government provided a further talisman. Notwithstanding such high acknowledgments, the possibility of a confrontation never completely disappeared.

▶ **Wenner and Stader after Barocci.** *The Deposition.* Milan, Italy. This piece was photographed by National Geographic as part of a documentary on street painting.

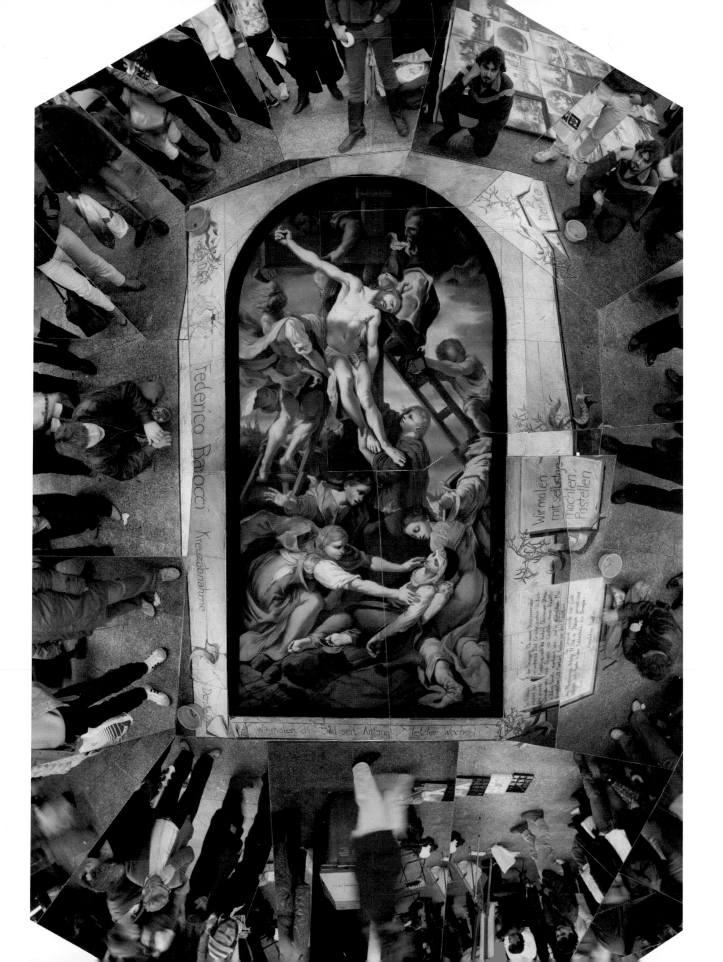

Federico Barocci · Kreuzabnahme

Denke

Wir malen mit selbstge-
machten Pastellen.

Wir malen das Bild seit Anfang letzter Woche.

SWITZERLAND

Wenner headed to Rome, looking forward to being back on its familiar streets. He had many pleasurable months creating large, elaborate paintings for the appreciative Roman audience. With the arrival of the summer heat, however, the Eternal City is transformed into a ghost town, and without the Romans to set an example of tossing a coin or two in a street painter's basket, the earnings evaporate. The year before, Wenner had booked a room at a pensione in Rimini, on the Adriatic coast, where he spent the summer working among the hordes of bathers that fill the coastline. Always in pursuit of new sites and experiences, he decided to try summer in Switzerland.

Street painting in Switzerland is not universally permitted. Some cities allow it if you've paid for a permit, while in others the police will allow you to stay on as long as they see the locals enjoying your work. Wenner knew about the regulations in just a few cities, which meant the easiest way to find out if it was permitted in the rest was to start a painting and see what happened. He was fined just once, in Montreux. Generally, if street painting wasn't permitted he was politely asked

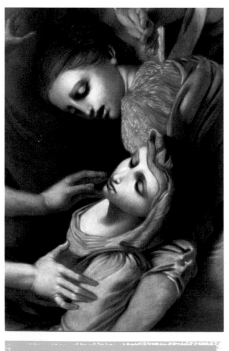

▲ Wenner. Barocci *Deposition* detail.

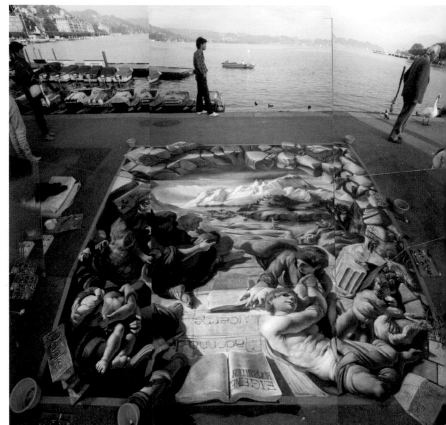

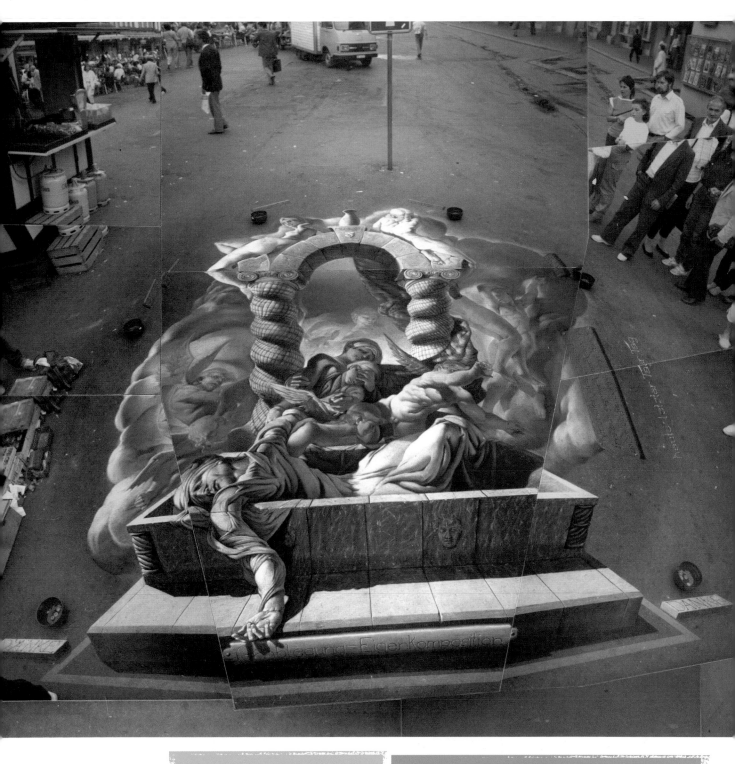

◀ Wenner. *Madonna of Lucerne*. Lucerne, Switzerland. Wenner improvised such pieces to study the perspective effects he would later formalize to create his illusionistic pieces.

▲ Wenner. *The Bern Entombment*. Bern, Switzerland. Wenner collaged together photographs of his early works until he found the proper lens to document his works.

to move on within a day or two. The Swiss keep a tight rein on their cities with the help of surveillance cameras, and whenever a policeman approached Wenner the officer knew exactly where Wenner had parked and how long he had been painting, and even had a good approximation of his earnings.

LIFE ON THE STREET IN SWITZERLAND IS MUCH EASIER THAN IN ITALY, AND THE PAVEMENT IS SO IMMACULATE THAT THERE IS NEVER ANY NEED TO WASH IT OFF BEFORE STARTING A PAINTING. THE SWISS ARE ALSO GENEROUS WITH THEIR DONATIONS, WHICH THEY CONSIDER TO BE A TIP RATHER THAN A RELIGIOUS OFFERING OR A HANDOUT. MY ONLY COMPLAINT ABOUT WORKING IN SWITZERLAND IS THE WEATHER. EVEN IN SUMMER, IT TURNS BITTERLY COLD WITH ICY ALPINE WINDS THE MINUTE A STORM COMES UP. THE STORMS NOT ONLY MOVE IN SWIFTLY, BUT THEY DROP A LOT OF RAIN AND HAIL AS WELL. MOST OF MY PAINTINGS HAD TO SURVIVE SEVERAL BOUTS OF RAINFALL BEFORE COMPLETION. WHEN THE WEATHER WAS GOOD, SWITZERLAND WAS SPECTACULAR; THERE WAS NO BETTER PLACE TO BE. IN LUCERNE AND LAUSANNE, I DID PAINT BESIDE CRYSTAL-CLEAR LAKES FILLED WITH ELEGANT SWANS.

The Swiss accepted street paintings with secular subjects, and this gave Wenner the opportunity to branch out from the traditional religious compositions expected by Italian audiences. The tranquil environment, combined with the flexibility the Swiss showed toward the subject matter, allowed him to progress toward developing his own style of street painting and experiment with allegorical and mythological themes. On the sidewalks alongside the lakes, Wenner first began to refine and formalize the geometry of his anamorphic illusions. Like a true madonnaro, he eventually developed a circuit of lucrative and friendly cities to paint in, and his reputation grew as he traveled among Italy, Switzerland, and Germany.

◀ Counting Swiss change. After the Italian lire, Swiss coins were a dream. No matter how hard the work was, Wenner always felt a bit illicit counting the change at the end of the day, like a small-time crook.

▶ Wenner. *Madonna di Rimini*. Rimini, Italy. When Wenner tired of copying existing masterpieces, he improvised his own compositions. Pictures such as this were done without preparatory drawings.

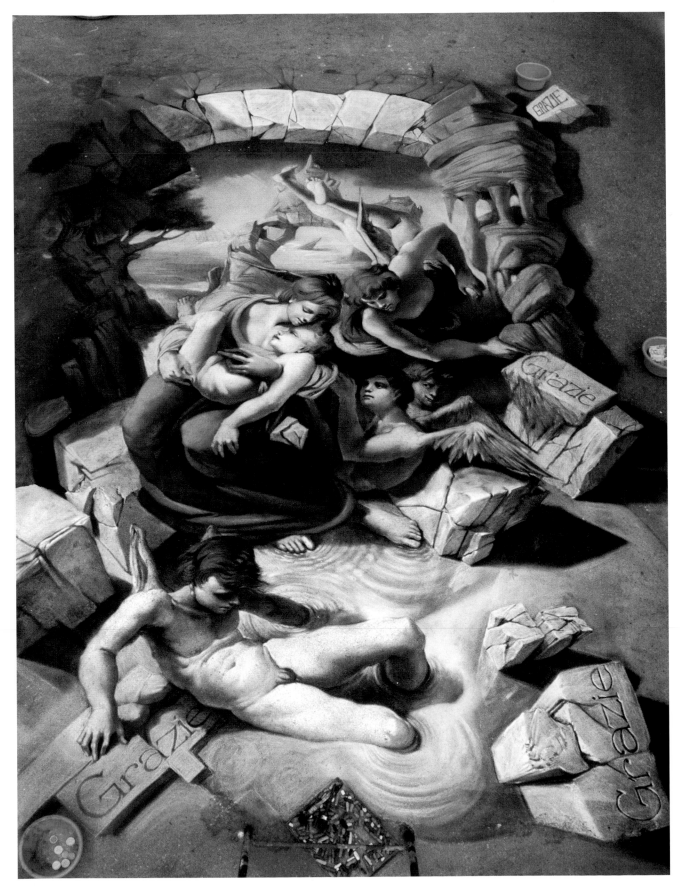

4
THE SPIRITUAL HOME OF THE MADONNARI

▶ **In front of the sanctuary.** As the sun sets on the piazza, artists await the judges and the award ceremony.

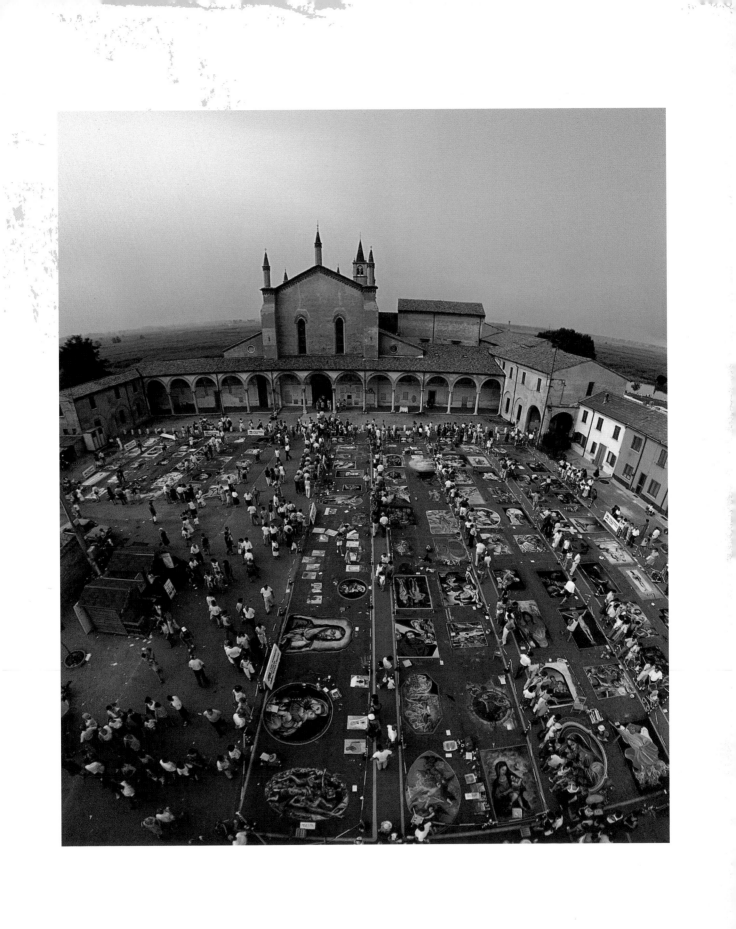

While searching for the right spot to begin their Vienna street painting, Wenner and Stader came across the work of another artist. The painter was not present, but all the tools of his trade were neatly arranged on the sidewalk. A small photo album lay open for passersby to leaf through, and lying next to it was a dog-eared brochure for a street painting competition in Italy. In the true territorial style of one accustomed to surviving on the streets, the madonnaro had cut out the event pictures from the brochure and replaced them with photos of his work. That altered pamphlet would not only change the lives of the two friends, but forever alter the course of street painting.

They learned that the street painting competition was an annual event that was to take place in three weeks' time in a town called Grazie di Curtatone, near Mantua. It wasn't long before the two artists left Austria's summer charms and returned to Italy to practice their composition for the competition. Much of the population of Rome had already left for their seaside holidays, so Wenner and Stader decided to head to Ostia Antica, an ancient Roman port town. There they found miles of sand dotted with rows of sun beds, umbrellas, changing cabins, and vacationing Italians en masse.

OUR SUBJECT WAS A PAINTING OF ST. MICHAEL I HAD SEEN IN BERLIN. WE SET UP TO WORK IN FRONT OF THE TRAIN STATION. EVERY FORTY-FIVE MINUTES, A TRAIN WOULD ARRIVE AND A NEW WAVE OF BEACHGOERS WOULD SURGE OUT OF THE CARS INTO THE STATION. AS SOON AS THE CARS WERE EMPTY, A SWIRL OF OUTBOUND TOURISTS WOULD BOARD AND DEPART. BETWEEN TRAINS, WE RETREATED TO AN OUTDOOR CAFÉ TABLE FOR AN ESPRESSO OR A COLD BEER. IT WAS A RELAXING AND COMFORTABLE VENUE.

▶ *Madonna delle Grazie.* This much-revered panel is a symbol to the community that hosts the festival of street painters, and therefore an icon for the art form as well.

By the end of the dry run, Stader was confident they were ready for the competition in Grazie di Curtatone. They decided to take a night train to avoid paying for a hotel room. The *signora* at their pensione offered them a sleeping pill to help them get some rest on the train, instructing them each to take half of the tablet. The pill turned out to be fiendishly powerful, however, and the two of them were rendered comatose almost instantly. They awoke in Mantua, four miles away from Grazie di Curtatone, so groggy and disoriented that neither of them could remember changing trains in Verona.

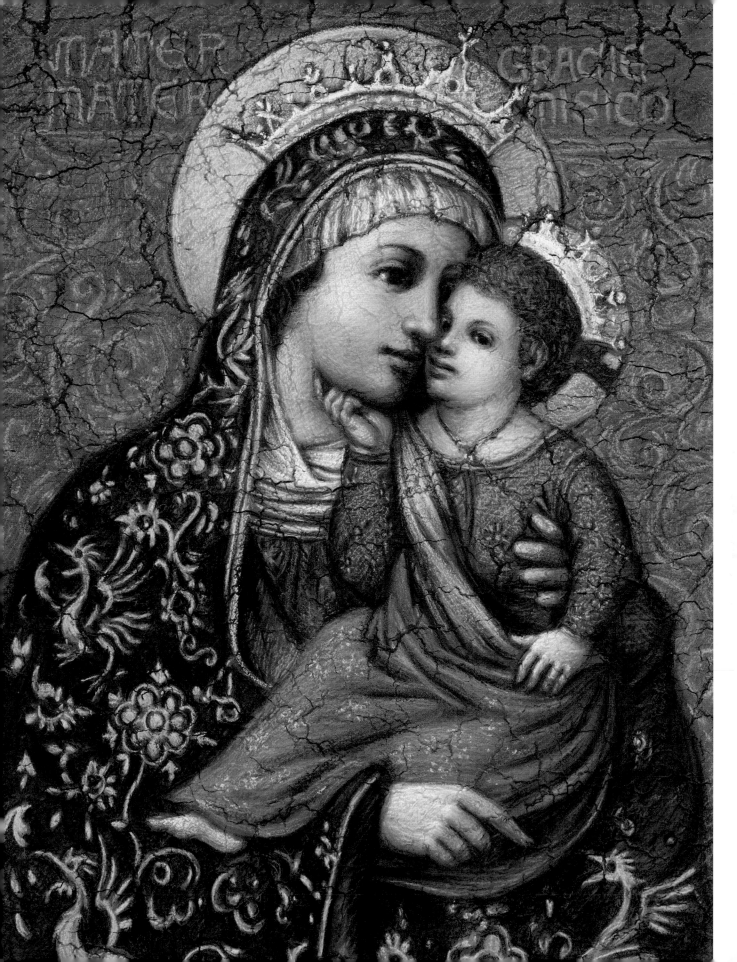

The two artists staggered into a ratty hotel across the street from the train station and checked in. They then went to the nearest bar and drank copious amounts of strong Italian espresso in an attempt to counteract the effects of the sleeping pill. In this inglorious manner, Wenner entered the town that would become his home for nearly two decades.

The two caught a bus and headed to Grazie di Curtatone. The route wound through fields of corn and sunflowers, which sizzled in the intense summer heat and humidity. The village sits on a tiny peninsula in a vast lake. The banks of the lake are lined with dense patches of reeds, and giant water lilies blanket the water as far as the eye can see. The village itself comprises a ring of medieval houses with red-tiled roofs and crumbling stucco walls that reveal centuries-old brickwork. These structures surround a paved piazza, with a graceful fifteenth-century Gothic-style sanctuary, complete with a delicate arched portico, as its focal point.

WE ARRIVED TWO DAYS BEFORE THE FESTIVAL, BUT THERE WAS LITTLE EVIDENCE OF THE UPCOMING EVENT. A FEW ORANGE TRAFFIC CONES BLOCKED OFF THE STREETS LEADING TO THE PIAZZA, AND SOME CRUDE HAND-LETTERED SIGNS DESIGNATED NEARBY FIELDS AS PARKING LOTS. A ROW OF PLANKS IN FRONT OF THE CHURCH DELINEATED THE COMPETITION AREA, AND HEAT SHIMMERED AS IT RADIATED OFF THE ASPHALT. WE HAD NEVER IMAGINED HAVING TO WORK ON SUCH A VIOLENTLY HOT SURFACE.

▲ **At the lake.** Grazie, Italy.

▶ **The sanctuary.** Layers of dust and decay once covered the decorations inside the recently restored sanctuary. Although the restoration was necessary, the site was especially suggestive in its unrestored state.

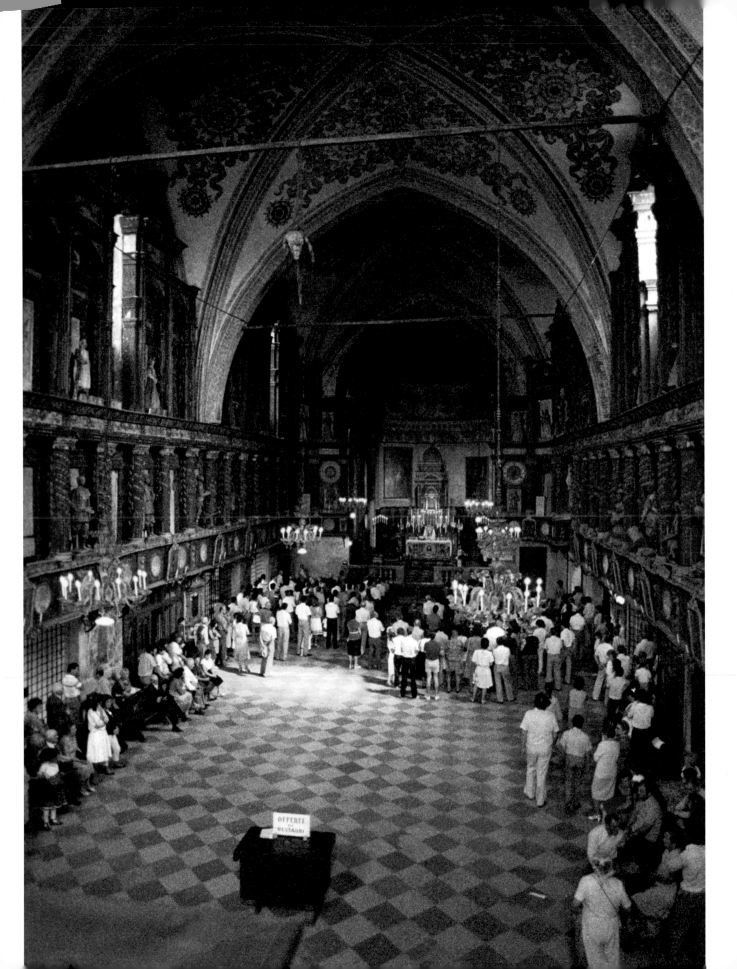

Thanks to the tattered pamphlet they had come across in Vienna, Wenner and Stader had just stepped into the most historic venue in the world of street painting. They needed to find a festival representative, and in a town of a few hundred inhabitants that wasn't hard to do. The organizer let them know that the competition was structured into two categories, and that every newcomer had to start in the Amateur category and work his way up the ranks by winning the title of each section (Amateur and Professional). Each division could have just one winner each year.

The next day Grazie transformed itself from a sleepy little village into an enormous fairground, with stands spilling down the main and side streets. The closed-up trailers and trucks that had lined the streets the day before unhinged their side panels and transformed into stands selling roast pork, cheese, fruits, nuts, polenta, underwear, fur coats, and a variety of useful gadgets. After the better part of the day, Wenner and Stader had reluctantly registered as Amateurs. This category had the much-despised title *Amanti del Gessetto,* or "Lovers of the Little Chalk." The two artists then claimed a painting space on the asphalt in the piazza.

The competition wasn't set to start until midnight, so they went to the peaceful lakeside sanctuary of Santa Maria delle Grazie to escape the heat. The sanctuary's elegant and restrained exterior does nothing to prepare a visitor for its interior. The upper walls of the nave are lined with strange wooden structures, and an elaborately painted floral ceiling runs overhead, neither of which conforms to any preconceived notions of a Late Gothic church. A dead crocodile, suspended by a chain from the ceiling, dramatically underscores this point.

▲ The crocodile. Swimming in a sea of floral decoration, the beast is a protagonist of local lore.

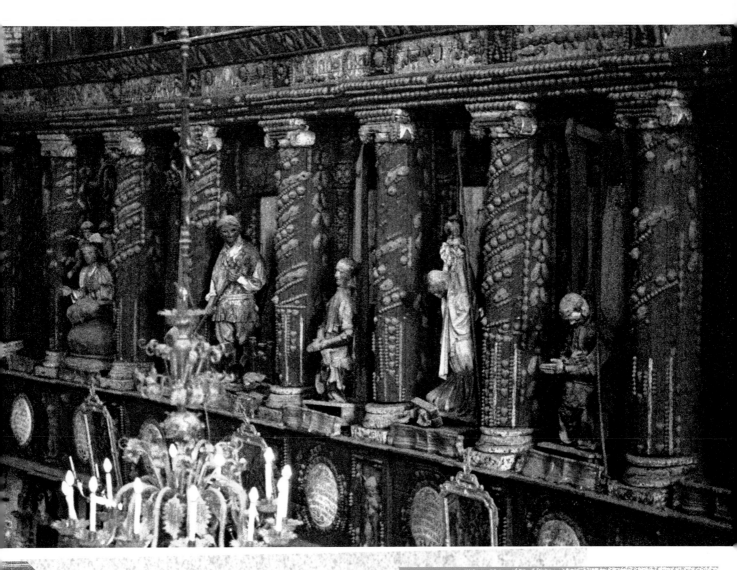

ON ENTERING THE SANCTUARY, I WAS IMMEDIATELY GREETED BY A LARGE REPTILE, HANGING ABOVE ME ON A LONG CHAIN. THE CREATURE'S FEET HAD LONG SINCE FALLEN OFF OR BEEN EATEN AWAY BY INSECTS, AND BITS OF STRAW HUNG FROM OPENINGS IN ITS BODY, EXPOSING THE TAXIDERMY. THE LOCALS CLAIMED THE CROCODILE HAD ONCE TERRORIZED THE COMMUNITY, WHICH BATHED AND LAUNDERED IN THE LAKE, UNTIL A BRAVE KNIGHT PRAYED TO THE MADONNA AND MIRACULOUSLY SLEW IT.

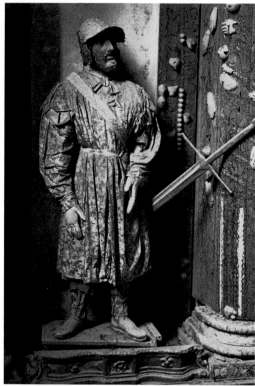

▲ **Soldier.** Before restoration, many of the papier-mâché statues in the sanctuary were in advanced states of decay, giving them a haunted-house appearance. During one cleaning, some were found to have fabulously valuable suits of Renaissance armor.

▶ **Wax body parts.** On close inspection, one notices that the decoration of the niches is done with wax replicas of body parts. These are meant to represent ex-votos, but add another morbid touch to the overall drama.

The stuffed carcass had been presented to the sanctuary by the locals in gratitude to the Madonna for rescuing them from its threatening jaws. But the crocodile, while an unusual religious ornament, is only the overture to the rest of the decor. A multitude of ornaments made from wax and plaster were arranged as garlands. Decorative geometric designs were created with replicas of hands, eyes, breasts, hearts, and bubonic plague sores. Just above arm's reach, the walls were lined with wooden columns and niches filled with decaying life-sized statues made from wax, plaster, and papier-mâché.

These eerie effigies portray the people who attributed their dramatic rescues from untimely deaths to the Madonna's divine intervention. The commissioned statues had been left at the sanctuary as ex-voto offerings to the Madonna delle Grazie. Some of the figures were clad in the Renaissance armor of the donor, while others were draped in rare antique fabric. Those whose clothing had disintegrated over the centuries were now dressed in papier-mâché gowns.

Kurt was particularly drawn to the *travolette*, small painted panels depicting miraculous rescues attributed to the Madonna. These paintings showed men being pulled from a stormy sea, being saved from a firing squad, and being lifted out from under the hooves of a horse drawing a carriage. In all the tavolette, a simply painted figure of Grazie's Madonna blesses the devotee from the upper right-hand corner. Some panels have only the initials *PGR*, which stand for *per grazie ricevuta* (for grace received) stamped in metal or embroidered on cloth. Only the Madonna still knows the nature of the miracle, though many stories about the statues are woven into the local folklore. The tavolette are works by folk artists and were often created by early madonnari.

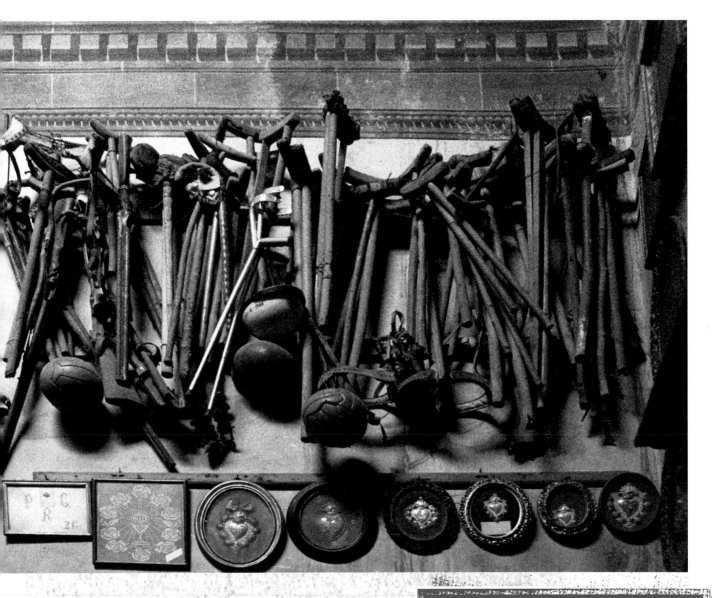

▲ **Crutches and soccer balls.** The crutches are testimony to miraculous healings. The soccer balls possibly attest to equally miraculous victories.

I PICKED UP A SMALL LEAFLET FROM A PILE PLACED NEAR THE ALTAR, WHICH EXPLAINED THAT THE SANCTUARY WAS BUILT BETWEEN 1399 AND 1406 AS AN EX-VOTO, IN GRATITUDE FOR DELIVERANCE FROM THE PLAGUE. THE GILDED ICON OF THE MADONNA DELLE GRAZIE EMBRACING THE CHRIST CHILD IS STILL CONSIDERED BY THE FAITHFUL TO BE A MIRACLE-WORKING IMAGE. WHETHER THE MADONNA IS KEEPING PLAGUE OUTBREAKS AWAY FROM THE VILLAGE, OR EXTENDING HER GRACE TO THE LOCAL SOCCER TEAM DURING AN IMPORTANT MATCH, THE RECIPIENTS OF HER GRACE HAVE ALWAYS LEFT A VISIBLE TOKEN OF GRATITUDE. TO ME, THIS SANCTUARY FILLED WITH THOUSANDS OF EX-VOTOS IS CERTAINLY THE SPIRITUAL HOME OF THE MADONNARI AND THEIR ART.

To pass the hours, Wenner and Stader spent time exploring the many stalls, enjoying the vast array of goods and specialties available. While strolling about, the two artists were summoned inside the local elementary school by some of the festival organizers. The assembly for the Congress of the Italian Street Painting Association was in session. The two men discovered that they had automatically become members of the association when they signed up for the competition. At the assembly, they witnessed the bitter rivalries that existed among the older generation of street painters as they exchanged angry words and colorful insults. The streets had not always been kind to many of the older madonnari, who were used to vigilantly defending their scraps of turf. Misery does not always love company, especially when the company might compete for one's meager livelihood.

The mayor repeatedly warned the madonnari that anyone who sabotaged or attempted to destroy another artist's work would be expelled. A street painter sporting a magnificent mustache and a northern accent whispered to Kurt that a previous competition had grown ugly when the older madonnari began trading insults. The confrontation culminated with the men heaving buckets of water over one another's paintings, until all that remained on the asphalt were a few patches of color. Until then, Kurt had thought of street painting as a fun, unfettered means of traveling around Europe and making a living with his art, but he could see that it was serious business to these artists.

The sun had set by the time the meeting adjourned, and the piazza was illuminated with stadium lights and lanterns hung from poles around the merchants' stands. The heavy evening air sat motionless while the asphalt, which had reached oven-like temperatures in the afternoon, radiated the day's heat. Wenner and Stader followed the street painters as they joined the townspeople and tourists to form a procession. The two eldest street painters carried a reed basket with colored chalks for the ritual blessing by the local priest.

After the late setting of the summer sun and fortifying themselves with food and wine for the long night ahead, the two friends took their assigned places on the piazza and set up their materials. There was a rising sense of anticipation with the great number of painters standing on their spaces waiting to begin. Some knew one another and were conversing, while others glared at the competition, sizing them up. Finally, at midnight, a whistle blew and the event was officially under way. The artists would have twelve hours to complete their

▶ **Wenner after Pontormo.** *Hands.* **Mantua, Italy.** The surface of the street dictates the speed of the work and the amount of detail an artist can obtain. The piazza of Grazie has always had terrible asphalt, making the competition especially difficult for less experienced artists.

work. Although they had made their practice run in Ostia Antica with a painting of St. Michael, Wenner and Stader had since decided to make a copy of Jacopo da Pontormo's *The Deposition from the Cross*. They felt a skillful copy in chalk of this complex masterpiece would have a stunning presence.

Painting at night saved the artists from the scalding sun, but the stadium lights on the edge of the piazza were spotty and illuminated some work spaces better than others. As observers milled about, they cast shadows onto the surface, making it impossible for the artists to see their work. The rough and porous asphalt was particularly challenging, making detail exceedingly difficult to produce. Wenner and Stader were not used to working on such a poor surface. Finding an artistic solution while painting in near-darkness was a formidable challenge.

AROUND THREE IN THE MORNING, THE SHADOWS OF TWO PEOPLE OBLITER-ATED OUR PAINTING. THIS TIME, HOWEVER, THE SHADOWS DIDN'T MOVE ON. WE LOOKED UP TO FIND TWO THUGS HOVERING OVER US, DRESSED IN OLD GREASE-STAINED SHIRTS AND WORK PANTS AND REEKING OF SWEAT, STALE TOBACCO, AND LIQUOR. THEY WERE OBVIOUSLY NOT AMONG THE COMPETING STREET PAINTERS BUT HAD A MESSAGE TO RELATE. ITALIAN THREATS ARE INDIRECT AND SUBTLE, AND WE DIDN'T SPEAK ENOUGH ITALIAN TO UNDERSTAND THE MEN'S ELLIPTICAL UTTERANCES, SO WE KEPT SHRUGGING. THE THUGS GOT INCREASINGLY EXASPERATED AS THEY WERE FORCED TO BECOME MORE EXPLICIT. THEY FINALLY PERFORMED A DRAMATIC PANTOMIME OF BEATING US UP IF WE WERE TO WIN THE COMPETITION. ALTHOUGH RATTLED BY THE ENCOUNTER, WE REASONED THAT WE WERE SAFE AS LONG AS WE STAYED IN THE CROWDED PIAZZA.

At daybreak, hundreds of exhausted chalk-covered artists descended on the first open bar. Sanitation facilities were at a minimum throughout the village, and the bar's tiny bathroom was one place where the madonnari could clean up. Wenner looked admiringly at one of the old-guard artists, who wore a white suit that was seemingly impervious to chalk dust, black asphalt, and perspiration. The number of participants surprised Wenner and Stader—although by morning it was clear that not all of them were artists competing for prizes and recognition. Various local residents, including entire families, came to paint simply for the joy of participating in the festival. They greeted friends, ate, drank, sang songs, and went home when they were tired. They slept, showered, and returned, refreshed and ready for more fun. Most of the older traditional street painters started their pictures in the morning after a good night's sleep, as they seldom ever worked on a picture for more

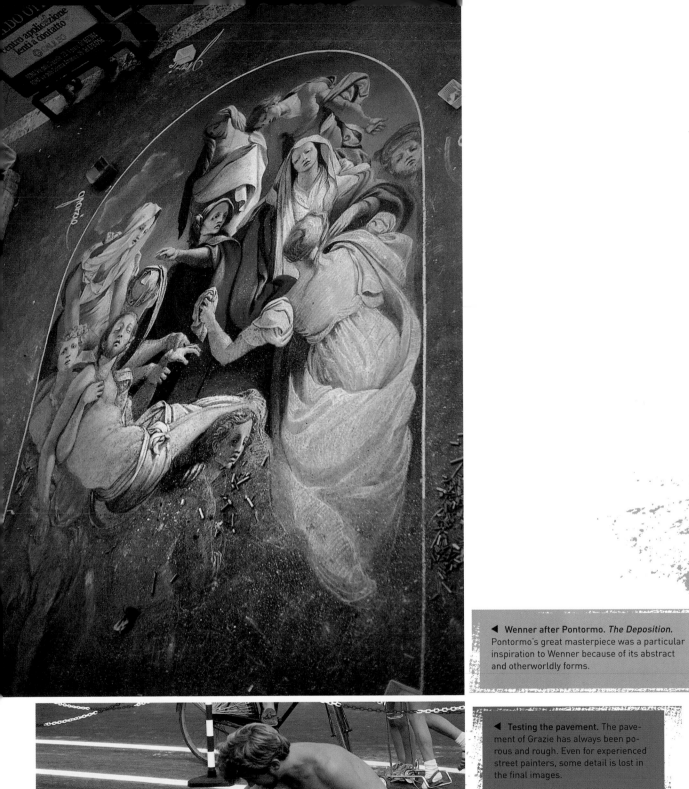

◀ **Wenner after Pontormo.** *The Deposition.* Pontormo's great masterpiece was a particular inspiration to Wenner because of its abstract and otherworldly forms.

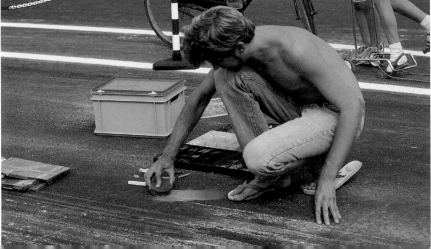

◀ **Testing the pavement.** The pavement of Grazie has always been porous and rough. Even for experienced street painters, some detail is lost in the final images.

than a few hours. Although it is not obligatory to paint through the night, those who hope to win use every available hour.

Manfred and Wenner worked furiously throughout the morning, hoping to finish their painting in time for the judges' final walk-through at midday. The late-morning sun was melting the asphalt, which caused it to emit fumes. The heat burned their hands and knees as they painted frantically through the final hour. A group of judges walked by each painting, stopping occasionally to write their observations on small notepads. Onlookers, artists, and local participants all went by, taking in the finished works and sizing up the competition.

While the judges convened, the artists speculated among themselves. Finally, amid much fanfare and reverie, the judges mounted the stage. They made never-ending speeches that Wenner and Stader could only partially understand. Eventually, the judges ran out of things to say and announced the winners. Wenner and Stader were jointly awarded the title *Madonnaro Qualificato,* ceremoniously presented with a gold-colored medal, and invited to participate the following year in the Professional category. The artists' dreams of cash evaporated. Their only prize was the promise of receiving a payment the following year in the next category.

Just about broke, yet too tired and disappointed to wait by the painting for any tip money that might be thrown onto it, they boarded a bus to Mantua. The pair searched for hours for a cheap pensione

▲ **The award.** Every festival ends in an award ceremony. Awards are also given to works outside the competition.

willing to take them in, but no one would accept them in their filthy post-competition state. They wandered around exhausted and dejected until Stader spotted some rusty chaise lounges outside a gas station. They carried them down beside the lake and collapsed.

Little did the artists know that their experience was only the beginning of a long relationship with Grazie di Curtatone. They would eventually see the once sleepy local festival explode in size and become a worldwide phenomenon.

li 16 agosto 1985

Comune di Curtatone
SEDE MUNICIPALE IN MONTANARA
PROVINCIA DI MANTOVA

N. _____ di Prot.
Risposta al foglio N. _____
del _____
OGGETTO: _____

Il Comune di Curtatone, fra gli Enti organizzatori della manifestazione annuale ove si incontrano i Madonnari a Grazie, riconosce il Signor KURT WENNER, nato a An Arbor - Michigan -U.S.A.——, il 31 agosto 1958, quale dipintore dell'asfalto come attesta anche la tessera a lui rilasciatagli dall'Associazione Madonnari d'Italia che gli è stata conferita per i meriti conseguiti negli incontri del 1982, '83 e '84.
In occasione del XIII Incontro dei Madonnari ha ideato e realizzato il manifesto.
Si riconoscono nel Signor Kurt Wenner il lodevole impegno e dedizione al lavoro di dipintore dell'asfalto nonchè approfondite conoscenze nel campo delle tecniche artistiche.

IL SINDACO
Attilio Flisi

COMUNE DI CURTATONE
ASSESSORATO ALLA CULTURA · BIBLIOTECA COMUNALE · PROLOCO
E.P.T. AMMINISTRAZIONE PROVINCIALE MN · REGIONE LOMBARDIA
15 AGOSTO 1985
dalle piazze d'Italia a
GRAZIE DI CURTATONE (Mantova)
PER IL TREDICESIMO INCONTRO

I MADONNARI

▲ Wenner. Grazie poster. Grazie di Curtatone, Italy. After winning the title of Master, Wenner returned the favor by designing the poster for the following year. It was the first poster designed by a madonnaro, beginning a tradition that continues to this day.

▲ The permit. Although the city hall of Grazie had no authority to permit street painting, it issued a letter quoting a national law and certified the artist as a bona fide exponent of the art form. Otherwise unprotected, street painters often relied on this talisman when confronted by the police.

5

INNOVATION

► Wenner. *Office Stress.*

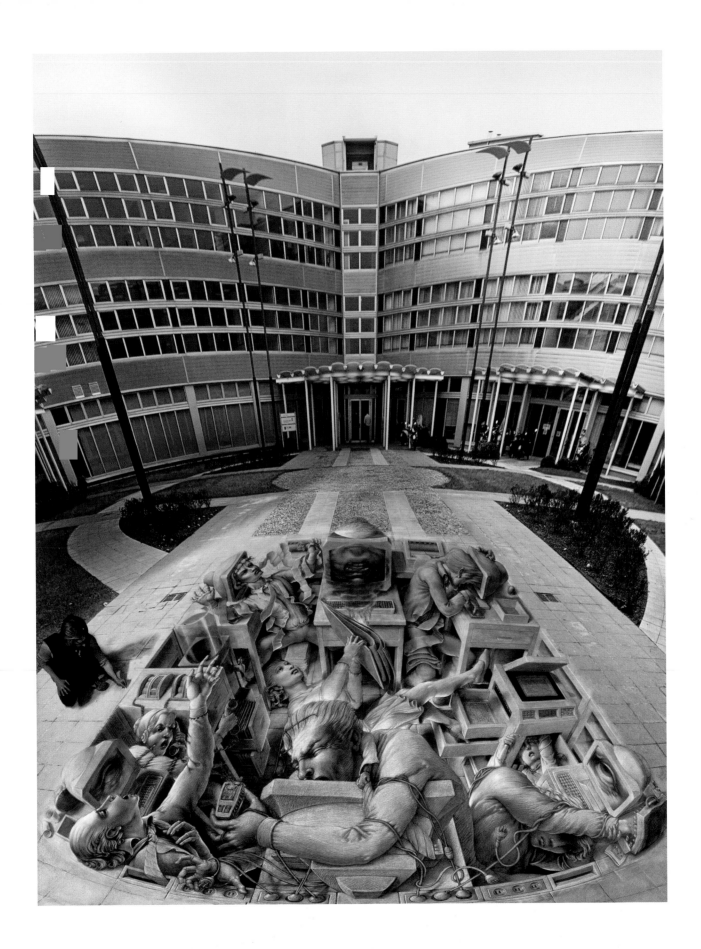

CREATING PASTELS

As winter in Rome approached, Wenner retreated into his small studio in Piazza Chiara behind the drum of the Pantheon. Having never been fond of commercial chalks because of the dust and limited color palette, he always created his street paintings with pastels. Chalks are made from calcium carbonate, a common white rock composed mostly from the remains of minute sea organisms. This natural substance is ground into a fine powder and mixed with a binder to form white chalks. Tinting chalk powder with a minimum of pigment or dye makes colored chalks. Pastels are created from a clay-like paste traditionally composed of pure pigment and binder. Most commercially available pastels also contain a percentage of chalk to make them smooth. Wenner used the cold months to study and experiment with making pastels by hand. Just one of his large paintings could consume nearly a hundred pastels, and purchasing expensive high-quality ones took a large bite out of his profits.

Generations of madonnari worked with only black and white, and perhaps a bit of red derived from a scrap of brick or roof tile. Over time, though, they used more and more colors. They began by making stone-shaped chalks and pastels from powdered pigments. This tradition started to disappear once bright but flat-toned colored chalks appeared on the market. In Orwell's account in *Down and Out in Paris and London,* the pavement artist Bozo says, "I'm what they call a serious screever. I don't draw in blackboard chalks like these others, I use proper colors the same as what painters use; bloody expensive they are, especially the reds."

I UNCOVERED SEVERAL ANTIQUE RECIPES FOR PASTELS. THEIR AUTHORS HAD USES IN MIND OTHER THAN STREET PAINTING, BUT THE RECIPES SERVED AS A STARTING POINT. THESE WERE PERSONAL FORMULAS BASED ON THE EXPERIENCES AND INTUITIONS OF THE ARTISTS. THEY CALLED FOR MIXING NATURAL PIGMENTS WITH A RANGE OF COMESTIBLE BINDERS, SUCH AS SUGAR, MILK, FIG'S MILK, BEER, ALE, AND HONEY. ORWELL REPORTS THAT PAVEMENT ARTISTS BOUGHT THEIR COLORS IN THE FORM OF POWDER AND WORKED THEM INTO CAKES USING CONDENSED MILK AS THE BINDER. THE OLD RECIPES SIMPLY CONSISTED OF INGREDIENT LISTS, WITHOUT PROPORTIONS. OCCASIONALLY A "SPOONFUL" OR A "CUPFUL" OF AN INGREDIENT WAS MENTIONED, BUT WITHOUT ANY REFERENCE AS TO THE ACTUAL SIZE OF THE SPOON OR CUP.

▲ **Handmade pastels.** The amount of color variation possible becomes limitless when the artist fabricates the pastels, changing the medium entirely.

▲ **1. Emulsion.** A rather dangerous process that suspends beeswax in water.

2. Sifting. Pigments are sifted together to obtain the desired tints.

3. Adding emulsion. A mixture of binder and emulsion is added slowly to the dry pigment, then worked into it.

4. Working the dough. Dry pigment is added to the mixture and worked by hand until a clay-like consistency is achieved.

5. Dividing the mass. The ball of pastel clay is divided into small pieces.

6. Forming pastels. Pastels are formed by hand and rolled gently.

Wenner frequently purchased pastels at the neighborhood art supply shop, G. Poggi. Each time he entered, an entire wall lined floor-to-ceiling with powdered pigments in glass containers like apothecary jars from an old pharmacy intrigued him. To make his own pastels, he knew he needed to learn about the physical properties of each pigment in order to determine which ones were best suited to his particular needs. Every pigment has its own specific binding strength and absorbency, which affects its ability to become a pastel. At the time, highly toxic pigments were sold, such as lead white, Naples yellow, and minium (lead oxide), which Wenner had to learn to avoid.

It took months of experimenting to get the right mixtures, as some pastels would turn out too hard and brittle, while others were too soft and powdery. Once Wenner perfected his recipe with the proportions for each pigment, he was able to make pastels that were exactly the color he wanted. He developed his own classical palette, which seeks to balance the hue, value, and saturation of the colors.

▲ ▲ **Twenty-one thousand pastels.** Seven street painters from six countries created thousands of pastels in one week in Naples. The pastels eventually circled the globe.

▲ **Ingredients for pastels.** In addition to pigments, binders are used.

▶ **Creating pastels.** A group of artists pose behind their production of thousands of pastels in Naples, Italy. Some pigments needed to be bought in bulk, and the artists later divided the production to obtain full palettes.

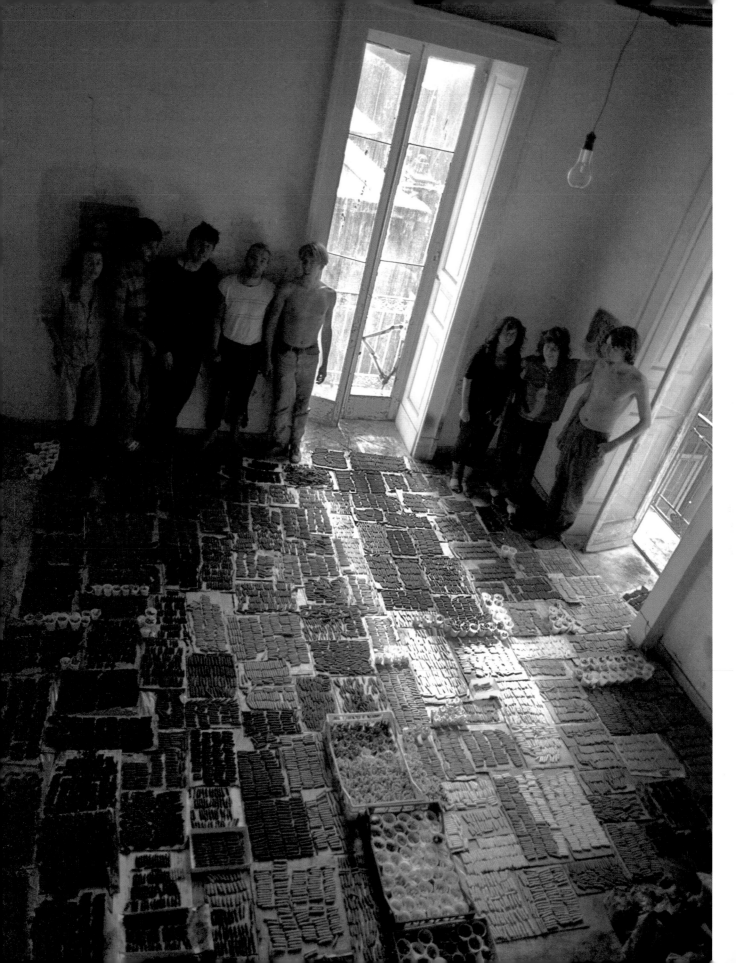

DRAWING

From the start, Wenner developed a drawing technique that was radically different from that of other street painters. Most sketch their subjects in simple white outlines and build up layers of color using the side of the chalk to rub the color into the pavement. This technique results in large areas of smoothly blended color. As a final touch, details are added on top of the amalgamated chalks. This technique limits the amount of refinement and subtlety of detail that can be obtained, and the final images often resemble airbrushed or spray-painted works of art. The idea of obliterating the initial drawing held little appeal to Wenner.

I'VE NEVER BEEN DRAWN TO IMPASTO TECHNIQUES THAT OBSCURE THE UNDERLYING DRAWING. FOR MY WORK, IT IS ESSENTIAL TO HAVE A SMOOTH TRANSITION BETWEEN THE DRAWING PROCESS AND THE FINAL WORK OF ART. WHEN I FIRST STARTED STREET PAINTING, I HAD A SENSE OF PANIC WHEN THE INITIAL STROKES OF THE PASTEL HIT THE PAVEMENT. I WAS TEMPTED TO PRESS HEAVILY ON THE PASTEL, BUT IT ACTUALLY TAKES AN EXTREMELY LIGHT HAND TO PREVENT A PASTEL FROM BREAKING. AT FIRST, IT SEEMED IMPOSSIBLE TO CREATE A DELICATE OR DETAILED DRAWING ON A ROUGH SURFACE.

Wenner discovered that if he used the same drawing techniques he employed in his classical studies, he could achieve the results he desired. He applied color in separate strokes that would overlap and change direction, a technique known as crosshatching. Wenner was the first to apply this method to street painting. He uses it for the entire surface of the picture, including vast areas such as sky. Although it might seem that creating a picture from thousands of separate strokes would take much longer than rubbing in large areas of color, for Wenner this is not the case.

▲ Wenner. *The Hand* (drawing). The hand holds a street painting pastel in the position Wenner prefers.

◄ Wenner. *Venus* (drawing). Wenner created many drawings from sculptures in order to learn the language of classical form.

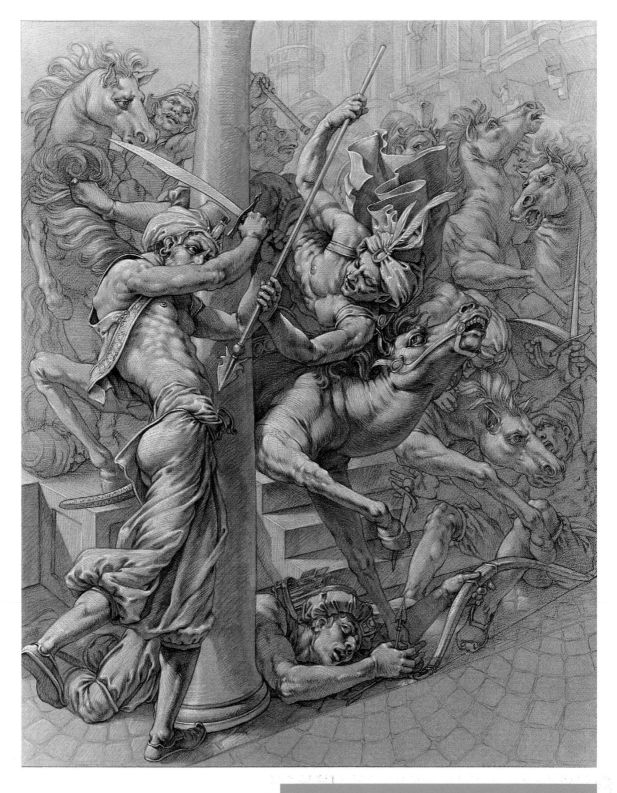

▲ Wenner. *Battle Scene* (drawing). Wenner uses the same drawing skills in permanent and ephemeral works.

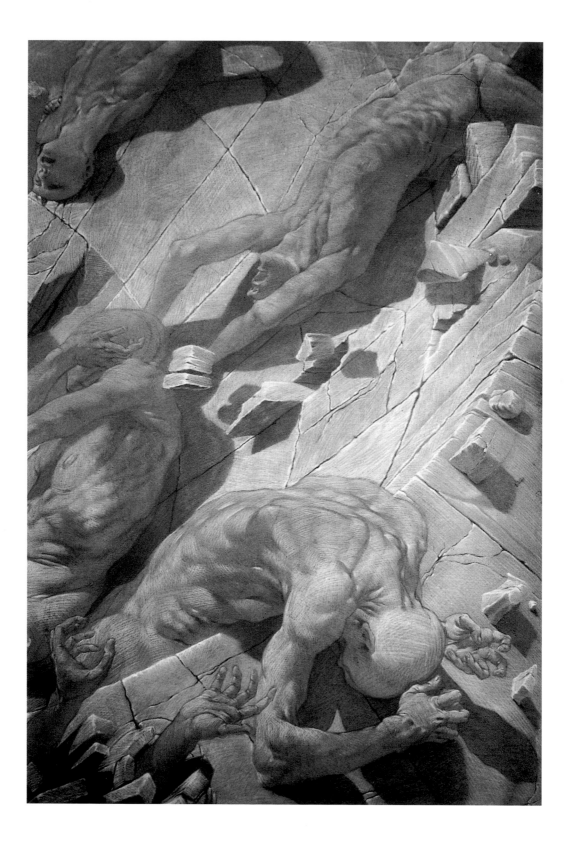

Many street painters eventually adopted this practice, and this helped the art form take off in new directions. As the technique spread, individual styles became more apparent, as the drawing was no longer obscured.

COMPOSING

Wenner ventured even further afield from traditional street painting by executing large, original compositions. During the long months of training and study in Europe's great museums, he gave a lot of thought to the significance of classical art, and was anxious to compose original works of art within that language. His first compositions were not easy to distinguish from Renaissance and Baroque works, and most people mistook them for copies.

Sculpture and architecture from the ancient world were a major inspiration for Italian Renaissance art. In order to describe three-dimensional forms in a drawing

or painting, Renaissance artists developed the technique known as chiaroscuro (light and shadow), which is based on the observation of light and shadow in the natural world. As the technique evolved, painters were no longer dependent on merely reproducing the effects of light and shadow in the observable world; chiaroscuro had become an artistic language capable of describing imaginary worlds all on its own.

Renaissance artists also formalized various perspective techniques in order to create specific geometric relationships that a painter could tailor to suit distinct compositions. In addition to classical drawing, Wenner did much research into perspective

► Wenner. *Dies Irae* (detail of drawing).

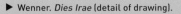

◄ Wenner. *Dies Irae* (detail of drawing).

and geometry, reading ancient texts in order to understand the evolution of this form of mathematical theory. Far from being a set process, Wenner discovered that perspective was also a language. If classicism was the language of form, then perspective was the language of space. Before perspective theory was frozen into the conventional geometry of the camera lens and film plane, it was an exciting and flexible study that stimulated and challenged artists. Wenner's art is based on the essential elements of classicism: perspective, formal drawing, and chiaroscuro.

I ENJOY DESIGNING paintings in a traditional manner, using figures and elements from my imagination. When I began creating original works on the street, the public's reaction was immediate and puzzling. For a while, it was fun listening to the spectators as they guessed at the authorship of my work. ALL THE GREAT MASTERS' NAMES WERE INVOKED, AND I FELT FLATTERED. Quite unexpectedly, I experienced great difficulty in convincing the public that my works of art were indeed my own compositions and not copies of paintings by Renaissance masters. I was incredibly discouraged and frustrated when some spectators insisted my images were pastiches. A PASTICHE WORK OF ART IS ONE WHERE THE ARTIST COMBINES BITS AND PIECES FROM OTHER PAINTERS' WORK, and is the artistic equivalent of plagiarism.

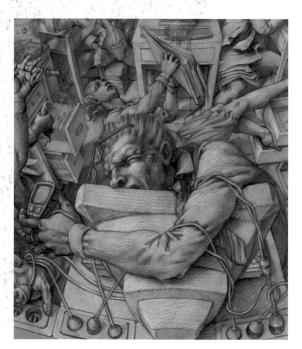

Wenner soon realized that the majority of people assumed a classical composition could no longer be created, and therefore did not recognize his compositions as belonging exclusively to him. His extraordinary paintings did cause a new set of people to ask questions and engage him in conversation and debate. Some questioned his artistic direction, ascertaining that figurative art had reached its pinnacle centuries ago and that there was no point in revisiting the past. Many thought contemporary figurative paintings could only be

▲ Wenner. *Office Stress* (drawing). Wenner often creates elaborate tonal drawings for his works. The perspective in the drawing reflects the curvature of the final image. The actual art does not have curves in the architecture.

▶ Wenner. *The Magic Flute* (tonal drawing). Wenner created an entire set of studies for this early composition based on Mozart's famous opera.

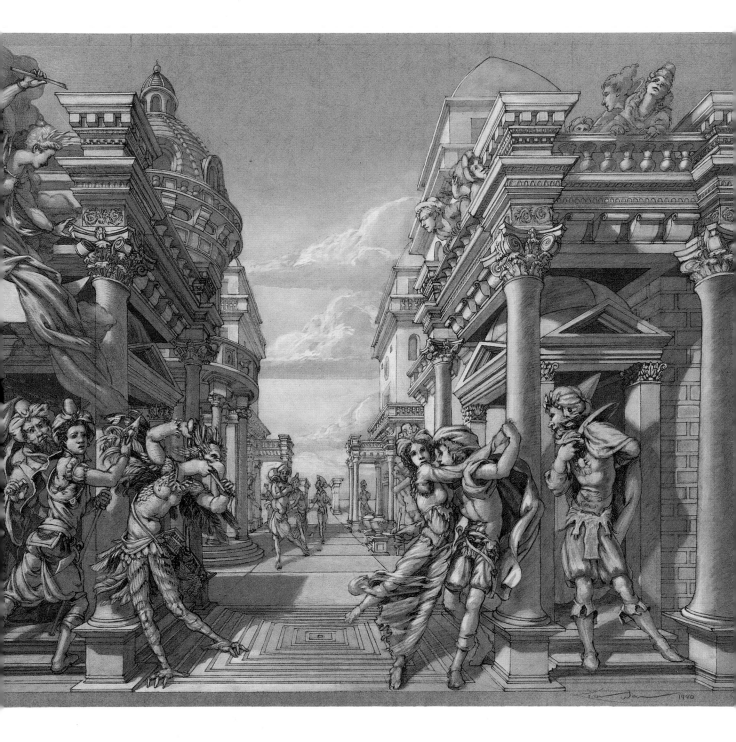

weak interpretations, copies, or amalgamations of what has already been done. Wenner realized he needed to resolve the difficult problem of getting the public to understand that his work is original, and that not everything within the field of classicism has yet been expressed.

When Wenner started the street painting festival in Fresno, California, he created an original composition based on Mozart's *The Magic Flute*. It was such a success that a couple of the city council members decided to commission the piece as an oil painting for the new city hall. Although they raised private funds for the work, some community members protested the acquisition because it was not considered a work of art that followed the conventions of modernism. Once the mural was presented, the protesting stopped and the art was widely accepted. In the years that followed,

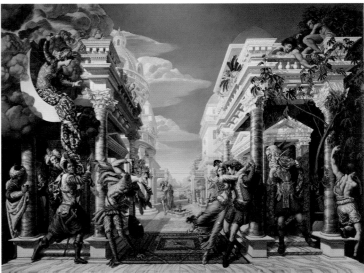

▲ Wenner. *The Magic Flute* (oil on canvas). The final work became a popular backdrop for wedding photos.

◀ Wenner. *The Magic Flute*. Fresno, California. The work was a great success, and Wenner was asked to re-create it as an oil painting for the new city hall.

Wenner worked on numerous large-scale commissions of permanent works almost exclusively for private patrons. Without street painting, the general public would have had little chance to see his work.

In the early 1980s, there was no room in the modernist mind-set to consider figurative art as a living language that had evolved over the past four hundred years. Wenner did not agree with this, believing figurative art to be a continuing and valid form of expression. However, in modernist theory, an artist was expected to create original works in an original form. Wenner thought about whether it was possible to create a unique form of art within the language of classicism. He also considered whether an audience could recognize and accept a new form if he could create it.

Classical art differs fundamentally from other types of realistic art, because classicism does not begin with an attempt to draw or paint exactly what one sees. Rather, it is based on the ancient Greek philosophy that human perception can be codified into a series of harmonious relationships by reducing the complex forms in nature into ideal geometric relationships of form and proportion. Therefore classical art can be seen essentially as abstract art. A classical masterpiece often gives the illusion that it is a copy of nature, although in reality most or all of the elements may come from the artist's imagination. Ultimately, artists themselves become fooled by the illusion and begin to try to copy from nature. Attempting to copy from nature causes the downfall of classicizing styles, because it removes the art from the image. When artists forget that they are dealing with pure form, the works fall apart. In a masterly classical work, every brushstroke has purpose. It communicates form and space to the viewer and carries an emotional or spiritual message.

Contemporary art has inherited the modernist tendency to alienate the public. Often, audience members are confronted with images they cannot understand or simply do not like. Artists may demand a great deal from viewers by requiring them to be informed about the artist's background and motivation, as well as the context in which the art was created. As a result, contemporary art is often accompanied with a verbal description, and frequently an elucidatory or enigmatic title. All of this serves to distract the viewer from what may be no more avant-garde than a blank white wall. While Wenner contemplated the idea of creating a new form for the expression of classical art, he couldn't help but wonder if the public would embrace it.

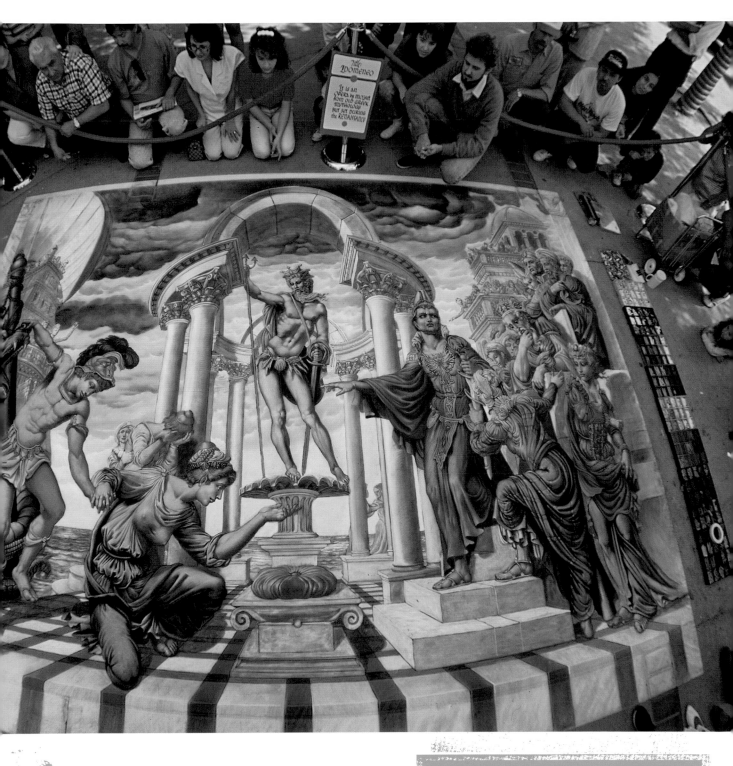

▲ **Wenner.** *Idomeneo.* **Mantua, Italy.** Wenner used his first street painting commissions to compose large works in a classical style, training himself for later mural commissions.

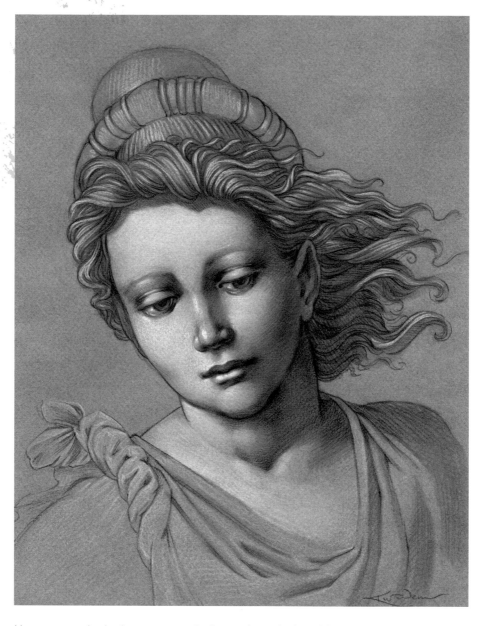

He was particularly concerned about the relationship between drawing and photography. While it is a commonly held belief that photography caused classical art to decline because there was no longer a need for artists to create representational images, Wenner suspected that viewing photographic images caused a structural change in human perception.

WHILE STUDYING, I SPENT UNTOLD HOURS IN THE COMPANY OF CLASSICAL PAINTINGS. ONE DAY, IT OCCURRED TO ME THAT MY PERCEPTION OF THE WORLD WAS BECOMING ALTERED, BECAUSE I WAS STARTING TO SEE LIFE IN TERMS OF A PAINTING. I REALIZED THAT THE ARTISTS OF THE PAST HAD NEVER SEEN ANY IMAGE THAT HAD NOT BEEN CREATED BY THE HAND OF ANOTHER ARTIST. THEY HAD NO CHOICE BUT TO SEE THE WORLD IN TERMS OF A CLASSICAL PAINTING. ALTHOUGH SOCIETY NOW BELIEVES THAT WE SEE "LIKE A PHOTOGRAPH," ART HISTORY SHOWS US THAT THIS WAS NOT TRUE BEFORE THE INVENTION OF PHOTOGRAPHY. PEOPLE ACTUALLY SAW "LIKE A PAINTING." THIS EXPERIENCE IS WHAT CAUSED ME TO SUSPECT THAT PHOTOGRAPHY HAS PROFOUNDLY ALTERED HUMAN PERCEPTION. FROM THE TIME WE ARE BORN, WE ARE BOMBARDED WITH PHOTOGRAPHIC IMAGES, WHICH GIVE US THE PERCEPTION THAT WE SEE "LIKE A CAMERA." IS THIS JUST AN ILLUSION, OR HAS OUR PERCEPTION OF THE WORLD BEEN TRULY ALTERED BY CONSTANTLY VIEWING PHOTOGRAPHIC IMAGES?

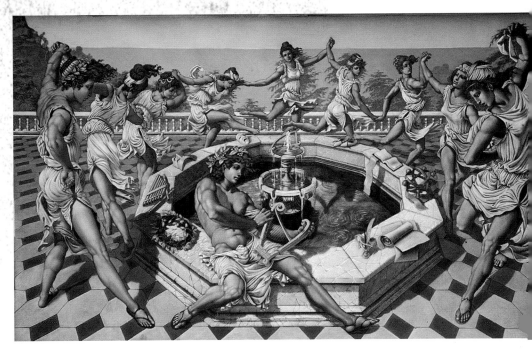

▶ Wenner. *Parnassus*. The Kennedy Center, Washington, DC. This work was commissioned for the Kennedy Center's "Imagination Celebration."

◀ Wenner. *Head of a Muse*. Mantua, Italy. This drawing was a preparatory study for Parnassus. It was part of a solo exhibition at the Kennedy Center in Washington, DC.

Wenner came to understand that classical training is more than a skill; it is a profound alteration of perception. The subject of a painting needs to be deconstructed in the artist's mind until it is reduced to its most elementary forms. Then the artist must reconstruct the image using the perceptual language of classicism. Perhaps most important, classicism is a powerful mnemonic device that allows an artist to mentally store and organize complex visual relationships. Artists of the past conjured up images of figures, animals, plants, and flowers from their imaginations as easily as if they had drawn them from life. The characters in a Renaissance painting may have been drawn from life, from statuary, or purely from the imagination. For a classical artist, there were no differences among observation, memory, and imagination.

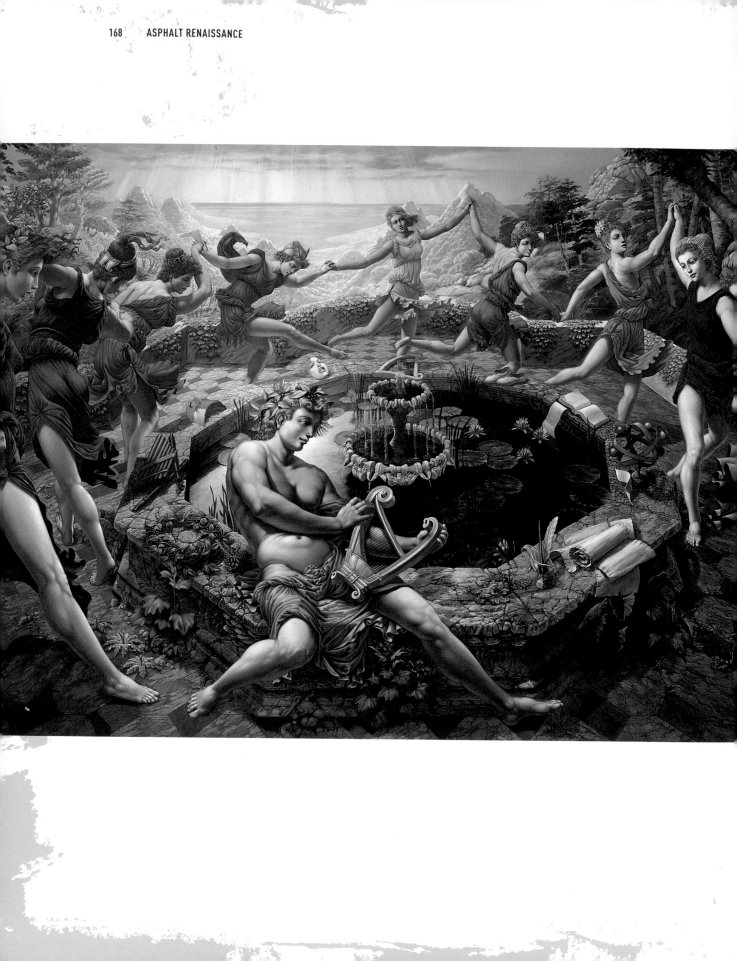

A NEW FORM OF EXPRESSION

The invention of an entirely new form of perspective was born out of Wenner's need to make an irrefutably original artistic statement within the context of classicism. He was determined to find a way to make people understand that he was making original compositions. As he worked, he constantly considered different ways to reintroduce the language of classical art to the public. He knew he had to create something so astonishing that it would catch people completely off guard and shake them free of any assumptions they held about classical art.

Linear perspective, as we know it today, was invented in the early Italian Renaissance. When geometry was applied to art, it ended up revolutionizing painting and drawing. By making mathematical calculations taken from the point of view of a theoretical spectator looking directly at the finished painting hanging on a wall, artists designed images that made the flat surface of the canvas appear to be three-dimensional. Painters were able to make some figures and objects appear nearer to the viewer, while others retreated into the background. The technique didn't work in every application, however.

Almost a century before the High Renaissance, artists began to study perspective geometry. They painstakingly projected complex dimensional forms point by point onto the flat surface of the paper. Certain projections confused them, as the geometry didn't seem to work. These aberrations are called "paradoxes" of perspective. One early author wrote a book about them and was himself nicknamed "Il Paradosso." The worst problems are seen in the projections of circles and spheres. The bases of columns appear to tilt when they are drawn at the edge of the picture plane, and spheres became elongated, appearing egg-like. These effects are not due to calculation mistakes, but are the result of the continuation of perspective geometry into the anamorphic plane. Today we can see this effect in photos taken with wide-angle rectilinear lenses.

▲ **Wenner.** *Parnassus* **(oil on canvas).** A number of Wenner's early compositions were finished as oil paintings. In later years, he composed anamorphic works for the pavement and traditional works as permanent murals. Only recently has digital technology made it possible to create permanent works on pavement surfaces.

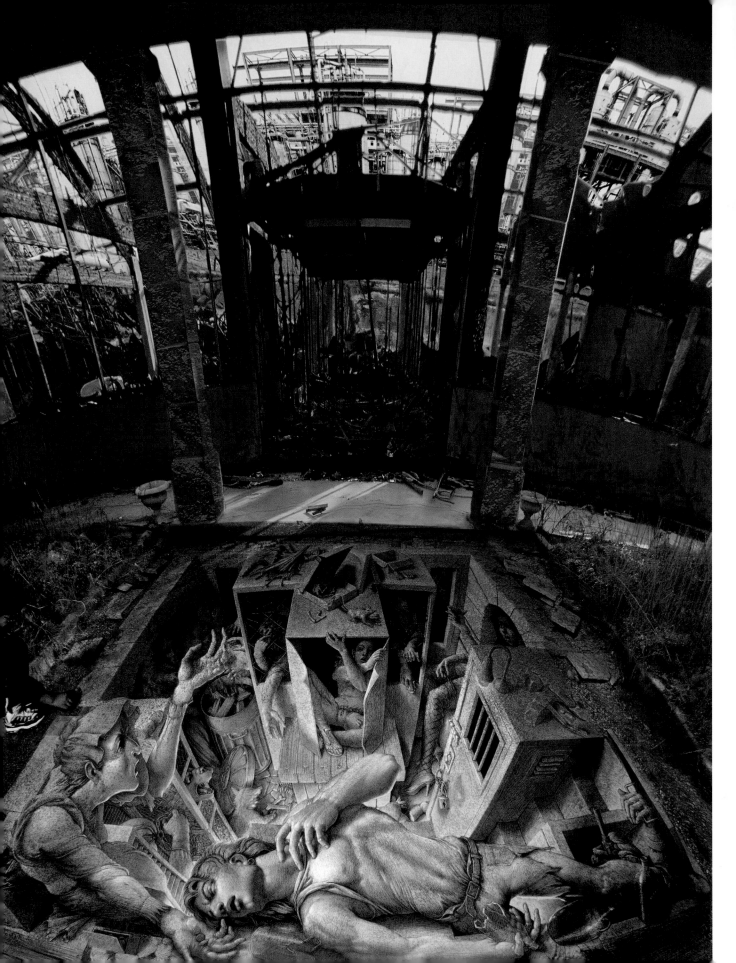

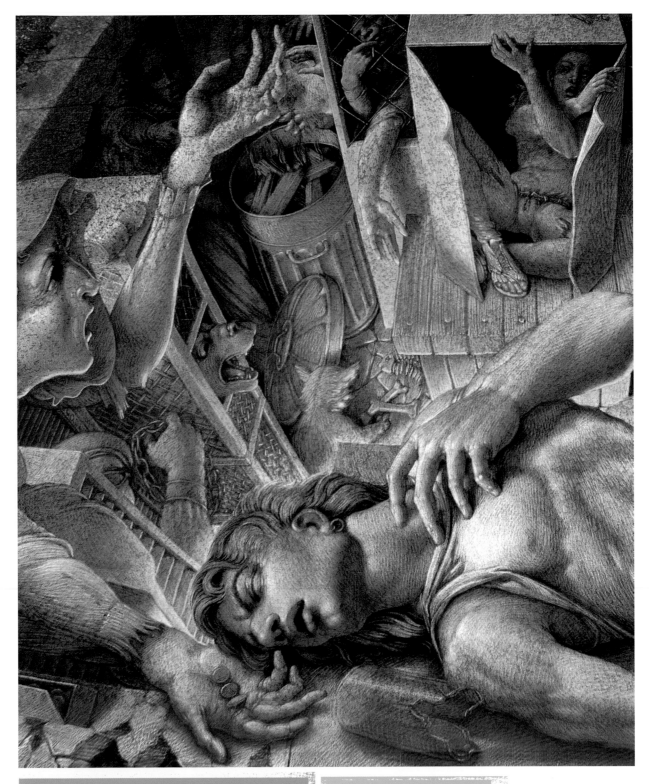

◀ Wenner. *The Ghetto*. Lake Garda, Italy. A nursery destroyed by fire provided a perfect backdrop for this composition, one of a series devoted to contemporary "hells."

▲ Wenner. *The Ghetto* detail.

Wenner is particularly drawn to a little-known form of perspective known as ana-morphism, or anamorphic perspective. This form of perspective was discovered in the Renaissance, but was not developed as an artistic technique until the seven-teenth century. It was usually employed in murals painted very high up on walls, such as those found in cathedrals and palaces. Instead of creating perspective by utilizing the conventional geometric calculations made from the point of view of someone looking directly at a painting hanging at eye level, the geometry for anamorphism was applied from the point of view of a spectator standing many feet below the painting and looking up at it at an oblique angle.

Sometimes illusionistic ceilings combine anamorphic perspective with trompe l'oeil. Actual architectural elements present on or near a ceiling, such as capitals, windows, skylights, and structural beams, can appear to continue into the painted decorations. When viewed from a particular point on the floor, the architecture blends with the painting to form a combined image. This results in a highly dra-matic perspective that gives a feeling of exaggerated height. In Rome, there are a number of ceilings that combine these effects, and it can be quite difficult to see were the frescoes stop and the architectural relief begins.

Wenner was attracted to the dramatic quality of anamorphic imagery. He liked the way anamorphic paintings incorporated architectural details into the works themselves, and thought that integrating paving stones and other facets of the streets into his paintings would be fun. Wenner's audience did not look above their heads at his paintings, but viewed them below eye level on the sidewalk. Onlook-ers saw the work at an oblique angle, and in the case of very large street paintings a viewer could not recognize the details at the top of the painting while standing at the bottom. Because the viewpoint of the audience always dictates the geo-metric calculations used in any type of perspective, Wenner would have to invent an entirely new type of pictorial geometry in order to create the correct anamorphic perspective needed to rec-tify the distortion caused by viewing his large images on the pavement.

▲ **Perspective demonstration.** This drawing is shown as an ana-morphic and curvilinear perspective. Spheres and circles become elongated when projected on a plane away from the center. The eye is curved, and therefore does not ever distort round objects. Like a fisheye lens, the eye projects straight lines as curves, but the brain ignores this fact.

◀ **Curvilinear perspective.** Wenner's use of perspective is different from historical anamorphic perspective because it takes into account the wide viewing angle of human vision. His works appear three-dimensional not because they are distorted, but because they are mathematically correct.

I VISITED CHURCHES AND PALACES WHERE EXAMPLES OF ANAMORPHIC PERSPECTIVE EXISTED AND WAS ABLE TO SOLVE THE PARADOXES THAT HAD CONFUSED THE ARTISTS OF THE RENAISSANCE. I DISCOVERED THAT THE DISTORTIONS FOLLOWED HYPERBOLIC CURVES, WHICH WERE THE GEOMETRIC INVERSE OF CURVILINEAR PERSPECTIVE. STUDYING THE PHYSIOLOGY OF THE EYE CONFIRMED THAT THE PROBLEMS WITH LINEAR PERSPECTIVE STEMMED FROM THE FACT THAT THE BACK OF THE EYE IS CURVED, AND THEREFORE HAS A MUCH WIDER FIELD OF VISION THAN LINEAR PERSPECTIVE CAN ACCOMMODATE. ANAMORPHIC DISTORTIONS DO NOT OCCUR WITHIN THE EYE ITSELF, AND THEREFORE ARTISTS WERE UNABLE TO ACCEPT INCORPORATING SUCH DISTORTIONS IN THEIR WORKS. CONVERSELY, IF A COMPOSITION IS TO DEPICT WHAT THE EYE SEES, IT MUST MOVE INTO THE ANAMORPHIC PLANE. I SPENT ENDLESS HOURS IN MY STUDIO STUDYING AND COMPOSING, USING A FISHEYE LENS TO BETTER UNDERSTAND HOW SIGHT AND PERCEPTION WORK. EVENTUALLY, I WAS ABLE TO INVENT THE GEOMETRY THAT ALLOWED ME TO UTILIZE ANAMORPHIC PERSPECTIVE FOR STREET PAINTING.

▶ Wenner. *Cocito*. Pasadena, California. Cocito is the name of the lowest level of hell in Dante's *Inferno*. This composition was premiered at the Pasadena Chalk It Up Festival.

Wenner soon began creating large compositions with astonishing depth that interacted with the environment. After years of learning how to draw the human form in proportion, he was now training himself to distort it. This time it wasn't in error, but rather a carefully calculated distortion. Interestingly, the forms and proportions of classical design are not affected by these distortions. This proved again to Wenner that classical design is abstract and exists independently of what it represents.

His new form of perspective is unique in that the forms are normal at the bottom of the painting and grow gradually longer and more attenuated as they recede from the spectator. The resulting images are very dramatic. For instance, a painted figure's arms or legs can reach vividly out to the viewer while, at the same time, the head and torso sink deeply into the background. Wenner was eager to see how the public would react to these distorted images as well as whether they could "read" them. He was anxious to know if the distortions would turn people away, or provoke them to take a closer look.

He was fascinated to learn that the public saw his images in many different ways. Some people barely noticed the more extreme distortions, while minor alterations

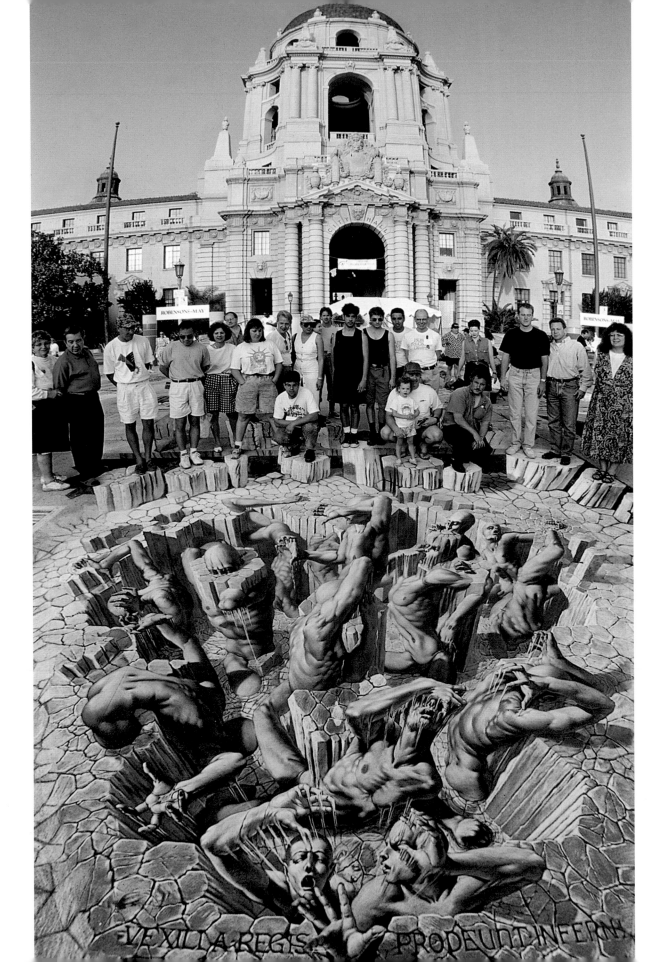

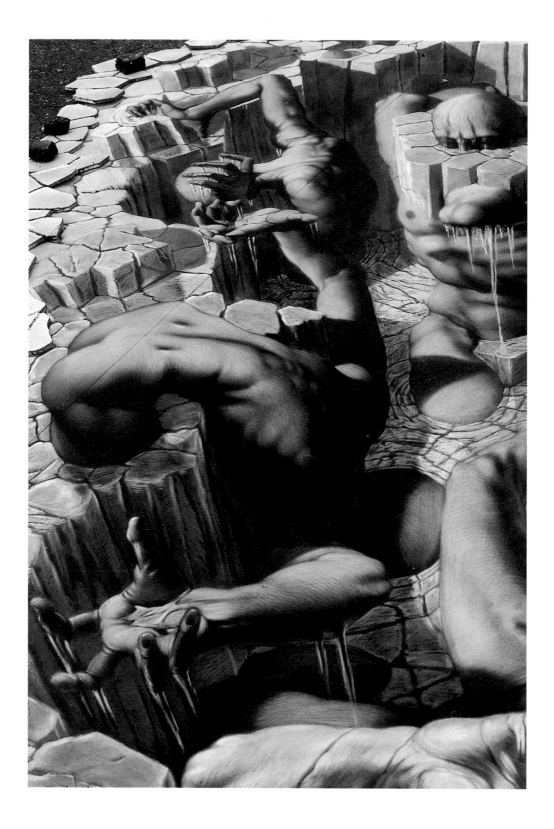

often proved very disturbing to them. The compositions were initially highly experimental, and the public's input enabled him to rework the ideas with a more complete understanding.

All painted images using perspective assume a precise location of the viewer. In most works, the viewer can stand at the point from which the artist has calculated the perspective. Composing a street painting to be viewed from the bottom respects the philosophy of perspective geometry. A conventional mural perspective on the street places the viewing position as floating above the picture so the image appears equally distorted from all angles.

Wenner's invention enabled him to make undeniably contemporary art while remaining true to his beloved classicism. He began by creating elaborate three-dimensional paintings, with figures desperately attempting to crawl out of a glowing inferno or break free from an icy underworld. A single hand or foot might be seen to emerge through an actual crack in the pavement and extend the illusion beyond the painting's borders.

I LOVE INSERTING dramatic images into everyday contexts. An apocalyptic scene or view of DANTE'S HELL creates a powerful juxtaposition between the artwork and the viewers who stand around it wearing shorts and t-shirts, looking complacently at a horrific scene of doom and destruction. OTHER COMPOSITIONS MAY DEPICT IDYLLIC SCENES IN SHARP CONTRAST WITH GLUM SURROUNDINGS. Such images do not exist within the safe borders of decorative picture frames; they bend the limits of perception.

People love to be fooled into thinking that unlikely images such as a fiery pit, a pool filled with Greek goddesses, or cracks in the pavement are real. It evokes a sense of wonder, similar to the response of an audience to magic acts performed by a skilled magician. While stylistic references may link Wenner's work to another period in time, the photographic images are bound in the present, incorporating the contemporary environment that surrounds the painting. Wenner enchants us by bringing literature, history, and imagination to ordinary locations and transforming them. His images incorporate the viewer into the art, making us wonder if the physical world is truly more substantial than the perceptual one.

◀ Wenner. *Cocito* detail. Pasadena, California.

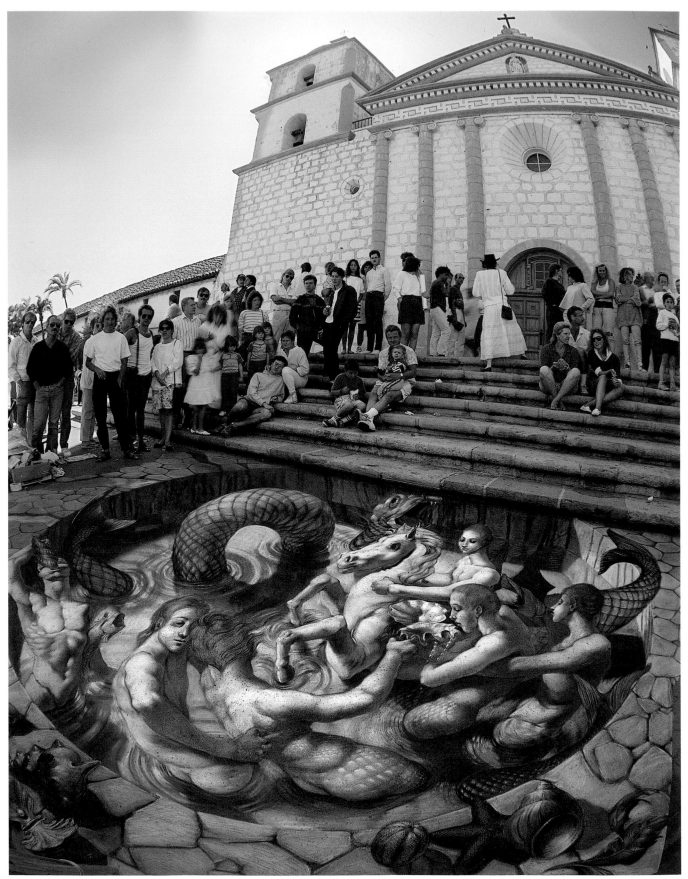

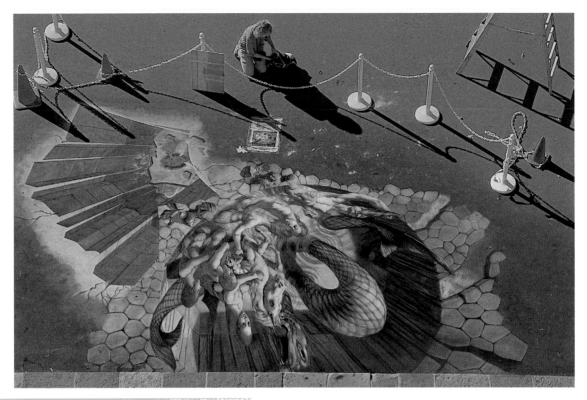

▲ *Mermaids* **from above.** From the top of the Santa Barbara Mission, the works can be seen in their elongated anamorphic forms.

◀ **Wenner.** *Mermaids.* **Santa Barbara, California.** This work was created during the second I Madonnari Festival.

Images created with conventional perspective look realistic only when the observer stands in the spot from which the perspective was mathematically calculated. Yet even when an observer walks around a conventional picture, the image will sometimes still be perceived as being three-dimensional. This happens because conventional perspective is a language of seeing rather than an illusion. The human eye is a vastly complicated mechanism, and the way in which the brain interprets what the eye sees has much to do with individual physiognomy and cultural conditioning. The images in Wenner's street paintings truly appear realistic only when viewed from the specific point he has selected. If such paintings were hung on a wall, the viewer would see all the anamorphic devices, and the images would look oddly elongated and distorted.

Wenner has undoubtedly achieved his goal of creating unique, original images within the genre of classicism, and for his efforts he has received global recognition.

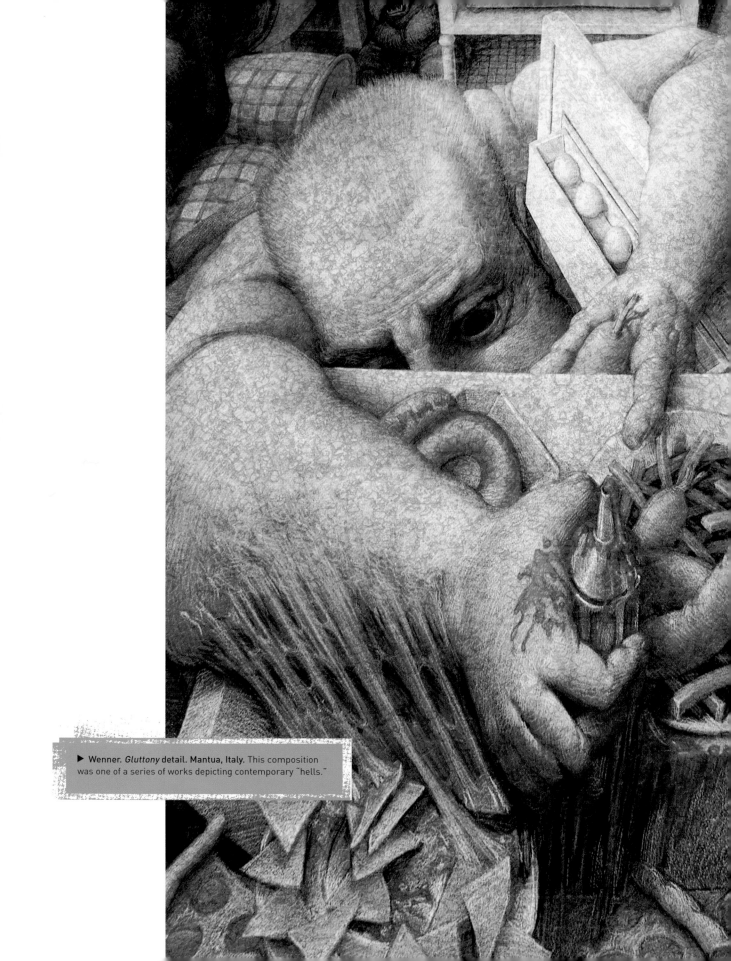

► Wenner. *Gluttony* detail. Mantua, Italy. This composition was one of a series of works depicting contemporary "hells."

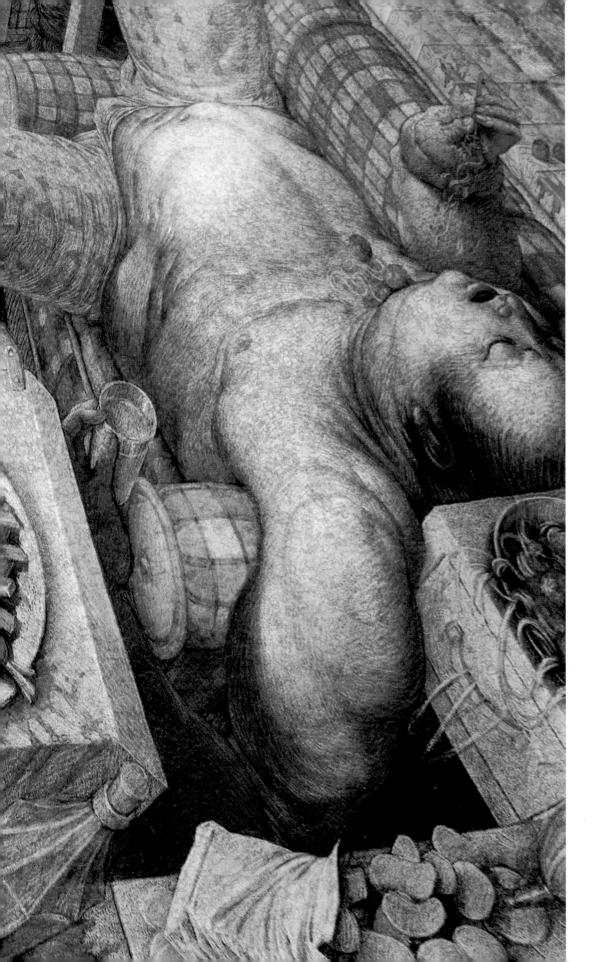

SURFACES

In a perfect world, all street paintings would be done directly on the pavement without any preparation. In reality, this is often unfeasible. Out of all the pavement surfaces, sealed asphalt is the very best for street painting. Bitumen holds chalks or pastels brilliantly, and the dark surface complements the light color palette. Asphalt that has not been properly sealed becomes rough, dry, and porous. This significantly limits the level of detail and increases the amount of time needed to complete a painting. Slurry seal is the top choice for sealing asphalt for street painting. Painting on concrete is more difficult, because the smooth surface usually has a sealer that makes it a bit slick for chalks to grip, resulting in paintings that look washed out.

IT HAS NEVER BEEN EASY TO FIND A GOOD SPOT FOR STREET PAINTING. LOCATING THE RIGHT COMBINATION OF PEDESTRIAN TRAFFIC, ROOM TO EXECUTE A LARGE WORK, AND A GOOD WORK SURFACE CAN TAKE HOURS IN A BIG CITY. AS EUROPE'S ECONOMY HAS GROWN OVER THE PAST COUPLE OF DECADES, STREET PAINTING LOCATIONS HAVE BEEN DISAPPEARING. ASPHALT PIAZZAS AND PUBLIC SQUARES ARE BEING REPLACED WITH COBBLESTONES AND DECORATIVE PAVERS. THE DECLINE IN SUITABLE PAINTING SURFACES HAS CAUSED MANY PAINTERS TO WORK ON VARIOUS SUPPORTS IN ORDER TO CONTINUE THEIR WORK IN PUBLIC SPACES.

▶ Wenner. *Romans in Utrecht* detail. Utrecht, Holland. It is not always possible to find an appropriate surface for street painting. In Utrecht, the organizers laid out cement pavers for the event. After the competition, the pavers were brought inside to be displayed until the next festival.

▶ Wenner and Bottoli. *The Dream of Ozymandias.* Monza, Italy. For some unknown reason, the Italians insisted on using pressboard for events held in locations where the paving was unsuitable. The panels of this work were later hung up precariously as a stage backdrop, risking crushing the famous cellist performing there.

In the northern countries, street painters have worked on supports such as paper for as long as anyone can remember. This is due in part to the weather, as well as to local public property regulations. Northern European artists have a penchant for producing time-consuming fine details, and painting on a support enables them to continue working on the same painting for weeks or months. Artists in Italy must sometimes use portable supports in order to work in areas without appropriately paved surfaces. For some inexplicable reason they mostly choose pressboard, a

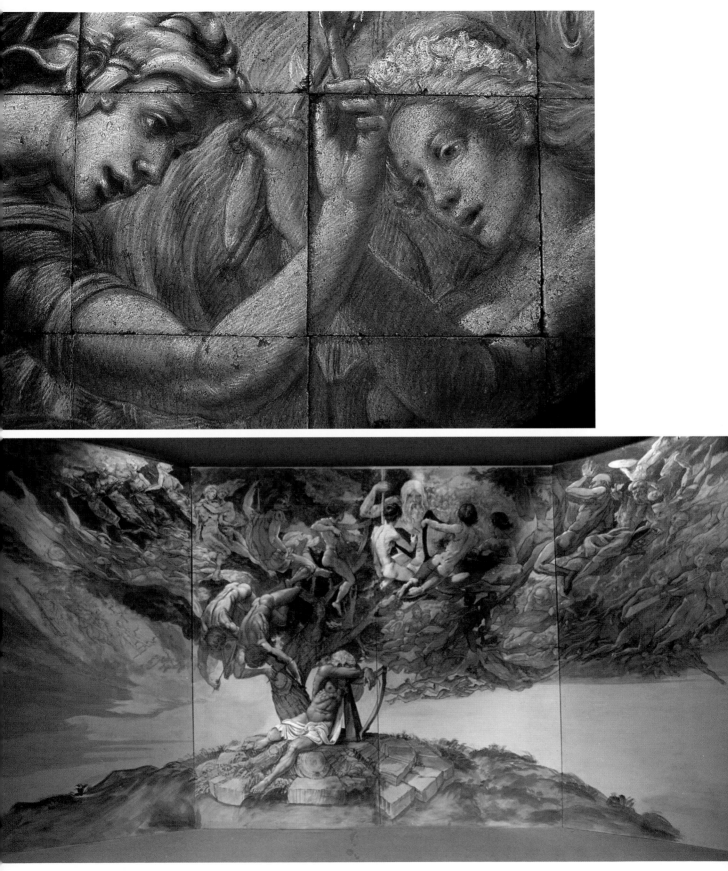

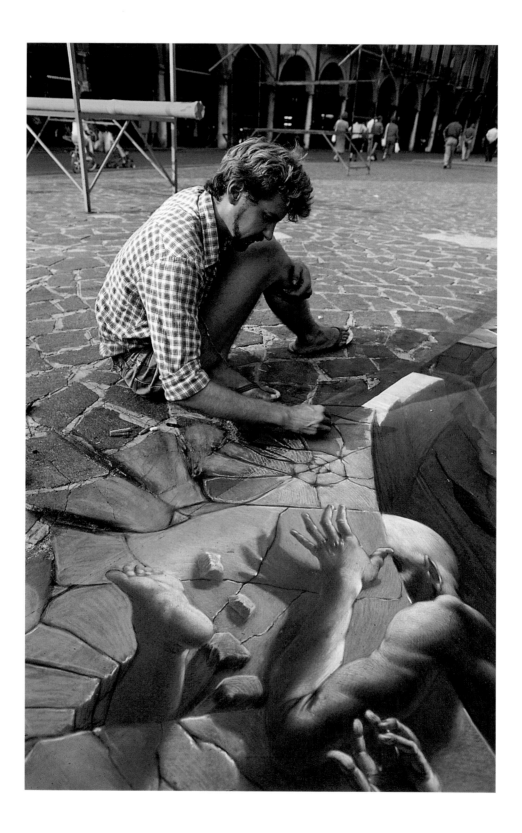

clumsy and difficult surface to transport, as opposed to paper or canvas, which is light and easily rolled.

Wenner eventually developed a technique for working on canvas. Pastel on canvas is an extremely long-lived technique when the art is placed under glass, but the very nature of Wenner's anamorphic art prevents it from being hung on a wall and protected in such a way.

▲ **The lens in Times Square.** Wenner created a traveling lens by combining a Plexiglas hemisphere with a glass plane. When the space between the two surfaces is filled with water, the shape of the water makes a lens. The lens increases the depth of field of the human eye and thereby intensifies the illusion.

◀ **Installation technique.** When the drawing surface is thin enough, a composition can be continued onto the pavement, obscuring the transition. This allows the artist to make good use of otherwise impossible surfaces.

▲ **Yokohama lens.** In Yokohama, Japan, a more permanent lens was created to view a large stereo-scopic work by Wenner.

6
CAPTURING THE EPHEMERAL

▶ Wenner. *The Muses.* Lucerne, Switzerland. This work was created for the National Geographic documentary *Masterpieces in Chalk*.

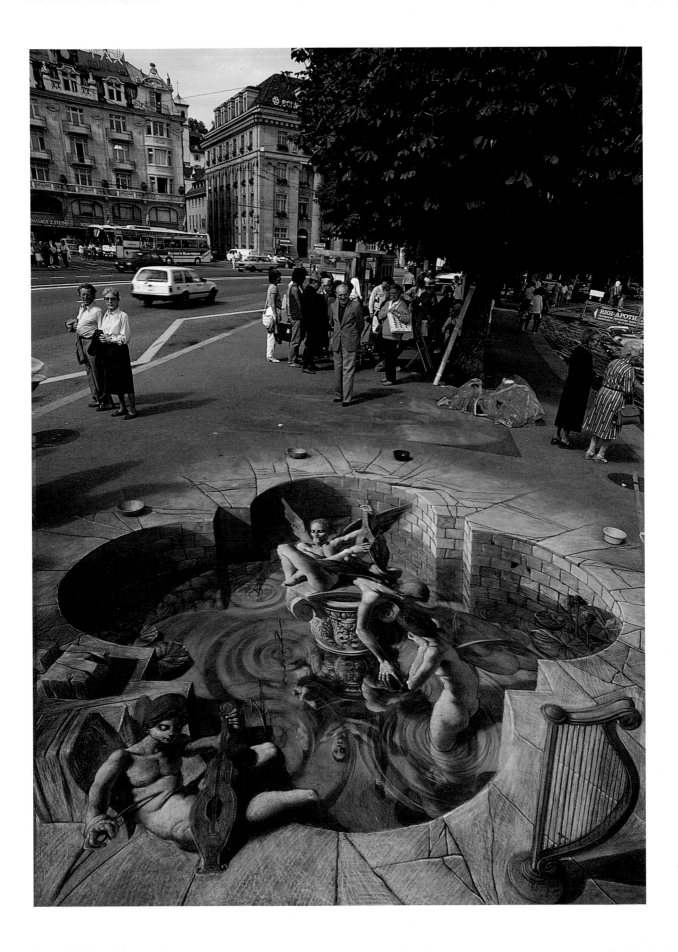

Street painting's long and fascinating tradition offers a unique opportunity to artists, especially young ones, but the town of Grazie di Curtatone is too small a venue to propagate the art form. The festival is often covered by Italian national television, but it was not known outside the country until the Associated Press International duly noted that an American had won a gold medal. The API story was picked up by newspapers across the country, including Wenner's hometown of Santa Barbara, California.

A family friend, Jessie Alexander, was quite taken with Wenner's street painting and was present at the festival in 1983 when Wenner won first place in the Professional category. He was lucky to get the shots he was after, as the festival organizers initially were not going to let Wenner compete for the title. Years earlier, Maria Grazia Fringuellini, the founder of the festival, had established a generous stipend only for the Professional participants. When Wenner and Stader arrived at the competition for their second year, the organizers announced that they could not move up to the Professional category after all, as they had created the previous year's painting as a team, when the rule was that each painting had to be made by one individual. Curious as to why he and Stader had not been informed about the rule at the time, Wenner was told that the organizers had made it retroactively. As it turned out, they simply did not have the money to pay two new artists in the Professional division. Wenner and Stader consented to split the stipend in order to both compete, with the organizers agreeing on the condition that they do separate works.

▶ Wenner. *The Deposition*. Rome, Italy. Wenner practiced his original composition in Rome before creating it for the Grazie competition. With this work, he won the trophy for the first time.

◀ *Madonnari*. Rome, Italy. An early book on street painting was created exclusively with photographs and interviews done during three weeks in Rome.

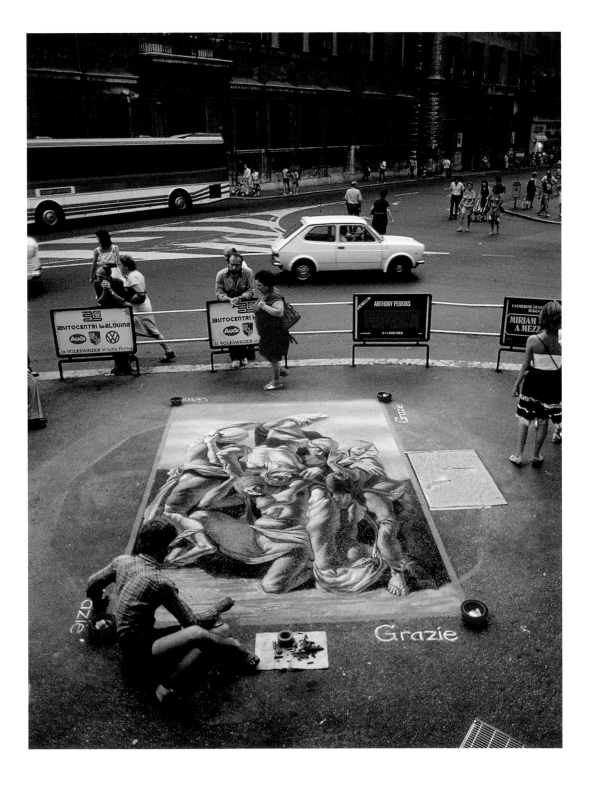

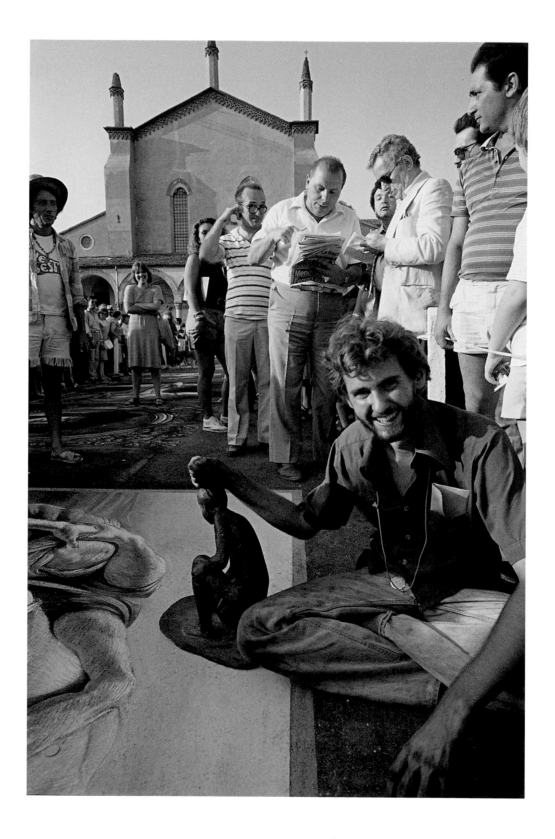

I DECIDED TO MAKE A LARGER STATEMENT THAT YEAR BY PAINTING A DEPOSITION OF MY OWN DESIGN. IT WAS NOT AN ILLUSIONISTIC COMPOSITION, BUT THE FACT THAT IT WAS ORIGINAL MADE A LARGE IMPACT ON BOTH THE ORGANIZERS AND THE OTHER STREET PAINTERS. STADER AND I HAD ALREADY RAISED THE BAR ON THE ART FORM THE YEAR BEFORE, AND IT WAS IMPORTANT TO SHOW THAT IT COULD BE PUSHED FURTHER.

I WON THE COMPETITION AND RECEIVED A SIMPLE, BUT EXTREMELY HEAVY, BRONZE TROPHY THAT I WOULD HAVE TO CONSIGN BACK TO THE ORGANIZERS THE NEXT YEAR SO THEY COULD HAND IT OUT TO THE NEW WINNER!

The town council purchased a run-down house in the piazza, intending to one day convert it into a small street painting museum. The house had been built in the 1400s, during the same era as the sanctuary, and had three levels, with one room on each floor. The top floor was suitable for a bedroom, the ground floor had a kitchen sink, and the middle floor was perfect for a studio. Steep ladder-like stairways connected the rooms. The nearest bathroom was across the piazza.

It would be a number of years before the council raised enough funds for a renovation, so they decided to offer it rent-free to Wenner on his return.

Because of his status as a foreigner, no one could legally rent him a place long-term. According to the law, he had to leave the country every three months. The mayor of Grazie, Attilio Flisi, helped him get the residency papers he needed to live legally year-round in Italy. In order to do so, he had to go out on a limb by informing the Italian immigration officials that the town had been allowing Wenner to live there illegally.

▲ **The museum.** City officials gave Wenner the use of a dilapidated house in the piazza of Grazie pending restoration. The house later became part of the museum of street painting.

◀ **Wenner with Grazie trophy.** Wenner poses for photographers with the most coveted prize in street painting. Although it appears small, the trophy is solid-cast in bronze, making it very difficult to carry. Wenner hauled it off for several years before the town fathers rightly decided to keep it at Grazie.

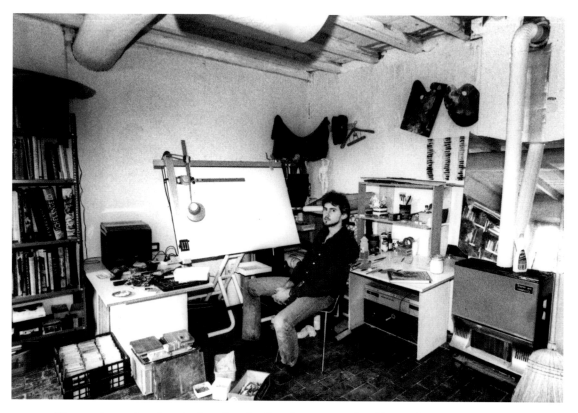

Wenner's professional standing in Grazie was rocky. If a political group aligned with him, then another formed to oppose any initiatives he might propose. It was a difficult time, with the festival organizers, locals, and a revolving group of street painters all struggling for their separate interests. Much of the difficulty centered on the fact that street painters were used to having the approval of the public, and they seldom ever needed any sort of local official sanction due to the Ministry of Culture's decree that street painting is a legal activity. The locals and festival organizers, however, needed to meet certain regulations in order for the annual event to occur within their community.

One problem that came up repeatedly was that some of the street painters did not want to compete against Wenner, so they pressured the organizers to find a way to prevent him from being in the competition. At the annual meeting, these artists tried to prohibit copies of masterpieces and disqualify original works. The traditional street painters, however, disparaged these ideas, as they considered their works to be original and not in the naive category.

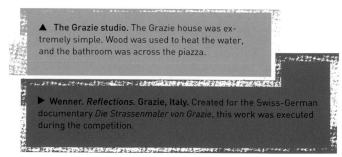

▲ **The Grazie studio.** The Grazie house was extremely simple. Wood was used to heat the water, and the bathroom was across the piazza.

▶ Wenner. *Reflections*. **Grazie, Italy.** Created for the Swiss-German documentary *Die Strassenmaler von Grazie*, this work was executed during the competition.

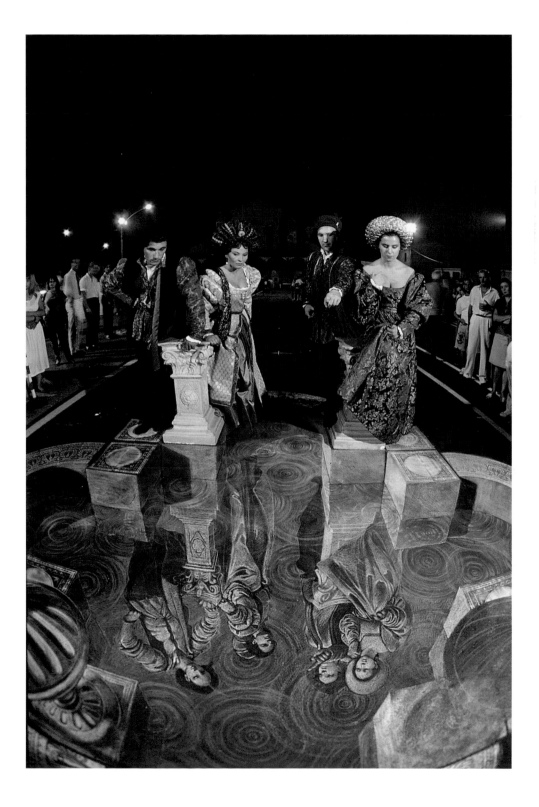

Once Wenner was awarded the title of Professional, a new and higher category was suddenly created. All the old traditional painters who had been automatically awarded the title of Professional were now placed in a new Master category. Wenner would have to win this next title by competing again. Ironically, this is what so many did not want to see happen.

MEANWHILE, STATESIDE MY AUNT HEARD A LECTURE AT AN ANTHROPOLOGY CONFERENCE BY A NATIONAL GEOGRAPHIC STAFF MEMBER WHO WAS LOOKING FOR IDEAS FOR THE EXPLORER DOCUMENTARY SERIES. SHE SUGGESTED THAT THE GEOGRAPHIC CREATE A DOCUMENTARY ABOUT ME, HER NEPHEW, WHO WAS MAKING PASTEL PAINTINGS ON THE STREETS OF EUROPE. THE LECTURER REQUESTED I SEND SOME MATERIALS IN, SO I HANDWROTE SOME NOTES ON THE BACK OF A FEW PHOTOGRAPHS OF MY WORK AND SUBMITTED THEM.

▶ **Wenner.** *Dies Irae.* **Mantua, Italy.** The *Dies Irae* depicts the "day of wrath" according to a famous thirteenth-century Latin hymn of the same name. The resulting photograph has become iconic on the Internet.

The small photographs made a big impact, and executives from the series asked director Kevin Peer to investigate further and verify that there was enough material for a documentary on Wenner. "In the first years of the show, we were still inventing the wheel and doing a lot of experimentation," explains Peer. "National Geographic had strict criteria for basing a program on one individual. He or she had to be world famous and a world-class artist. Some people at the office thought, 'Oh, this is just an American who is copying Italian art.' However, when I saw for myself the way Wenner took Italian mannerist influences and created compositions that were completely his own, I knew that his works were not copies of anything. This man was obviously a genius. The whole package was very attractive: Wenner's talent, his young age, and the colorful story of his life as a street painter. I knew that it would make a terrific film. Kurt Wenner is a great argument for reincarnation. He had to have lived in Italy during the Renaissance and been a major artist at that time."

After an additional submission of photos and press clippings, National Geographic decided to send the award-winning director Kevin Peer to Italy. He decided to film in Milan, at the festival in Grazie, and in Lucerne, Switzerland. By this time Wenner

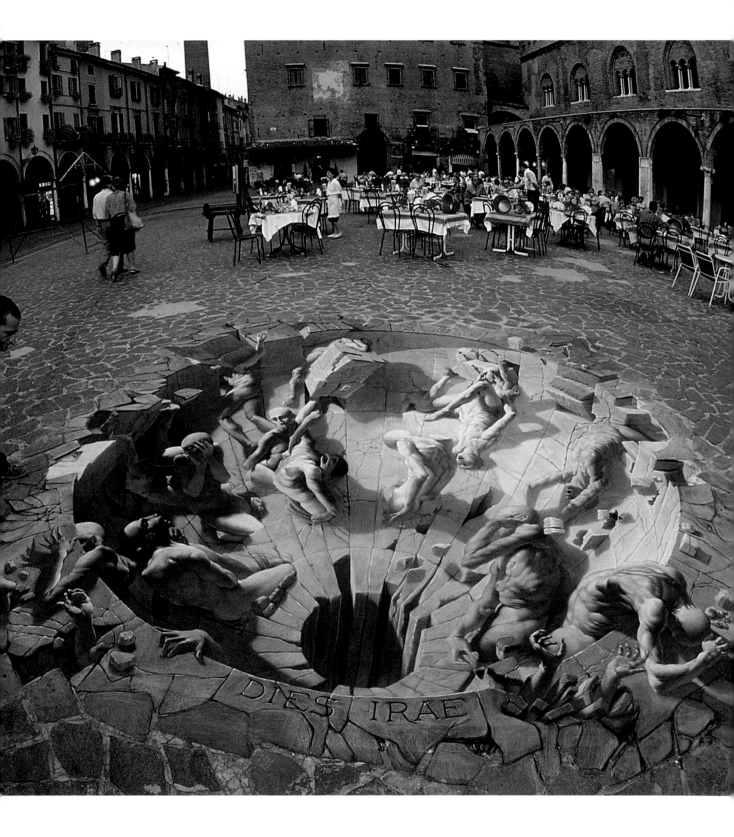

had enough experience to present the project to the town council in Grazie. They were unanimously delighted to have the recognition, but there were some painters who were not pleased with the idea.

Peer observes, "The people in Grazie deeply appreciated what Kurt was doing for them by putting their town on the map, and they had adopted him as one of their own. However, because he was so incredibly talented, Kurt had also upset the apple cart. He had revolutionized street painting, raising the bar to a much higher level of mastery and innovation. That caused resentment and jealousy among some of the street painters."

THE COMPETITION WENT smoothly, with many of the street painters happy to be interviewed. Nobody was anxious to have his or her hostility documented for eternity. Although I did win the title of Master that year, my victory was not included in the documentary. After all that had happened, I was looking forward to finding a way to participate at the festival in the future without competing.

"I had been filming around the world for National Geographic, and it was a joy to work in Grazie," Peer remembers. "I had experienced a lot of anti-American feeling in other places, but the Grazie townspeople were very friendly and welcoming." A group of town officials invited Peer to a luncheon to be given in his honor. The multi-course feast lasted for several hours. "The men wanted me to taste all the local specialties, and they kept refilling my glass to the rim with a delicious local red wine. After a while, I began to notice people winking at each other each time they topped off my glass. I realized that there was a conspiracy afoot to get Dottore Peer-e, as they called me, as drunk as possible. When someone noticed that I was on to them, he whispered that the townspeople thought I was way too serious, and they were trying to loosen me up!"

The locals and officials were hospitable and cooperative, wanting street painting and their festival to receive international recognition. However, the shoot was not without difficulties, and filming inside the sanctuary was one of them. Peer

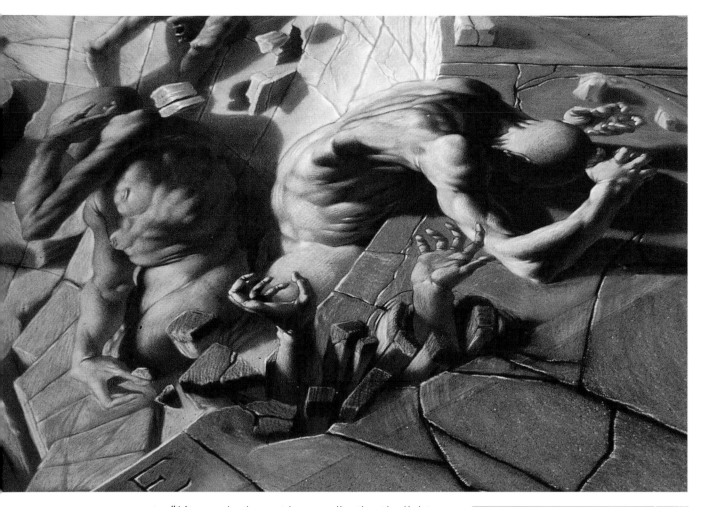

recounts, "After we had spent hours adjusting the lighting and were just beginning to film, the priest suddenly became intensely agitated and ordered us to leave the sanctuary immediately. Sensing our resistance, the cleric hobbled around the room as fast as he could manage, clutching his robes and fingering his cross while hurling curses at us in rapid-fire, high-pitched Italian. Then he started grabbing the lights and attempting to dash them on the ground! He really was quite mad. In a panic, we wrestled the lights away from him. In the end, we barely rescued all our equipment and fled before the priest could destroy it. I didn't get to film the sanctuary's interior at all, which was a loss to the documentation of street painting's history." Peer had better luck shooting in Mantua's Palazzo Te.

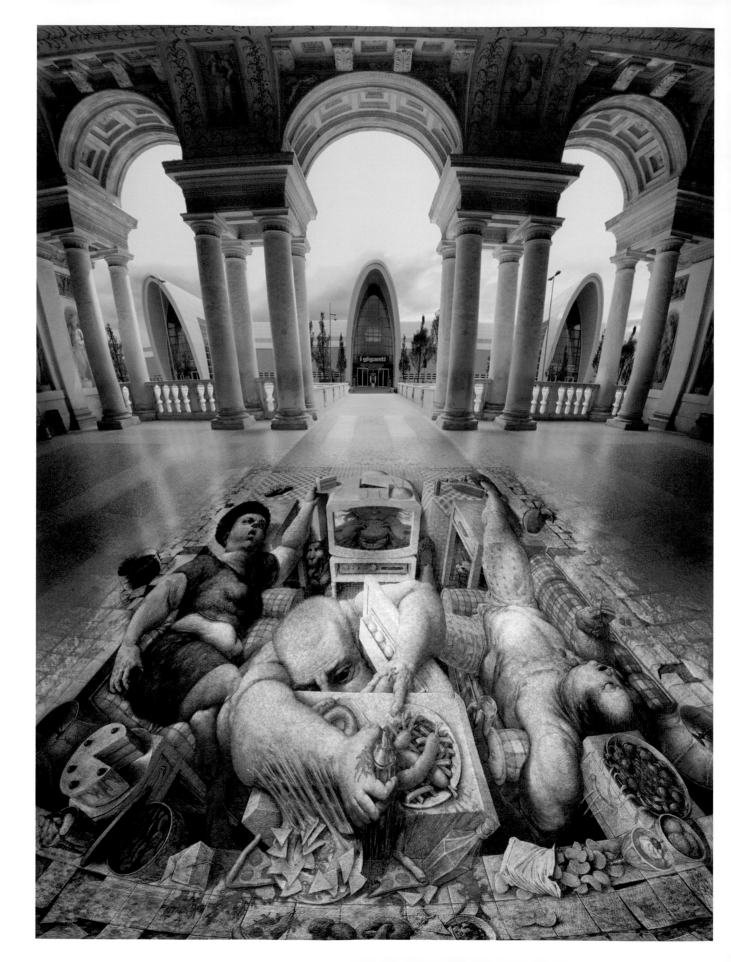

PALAZZO TE WAS wonderfully photogenic. At the time, it had not yet been restored, and few people knew about it or went to see it. The Room of the Giants is covered with dramatic paintings from floor to ceiling, showing the destruction of a mythological realm. AN ANCIENT ROMAN TEMPLE APPEARS TO BE COLLAPSING AROUND THE VIEWER, as pillars and walls tumble down, chunks of rock fall from the illusionistic ceiling, and terrified giants attempt to flee before being crushed by the rubble. Peer positioned me next to a painted wall to give the viewer a sense of the enormous scale. As I stood in place, the murals towered over me, and the gigantic temple collapsed all around me.

After Grazie and Mantua, the documentary crew headed for Milan. Special permission had been obtained to film Wenner creating a street painting directly in front of Milan's famous Duomo, one of the world's largest churches. Its facade was a magnificent backdrop for the art. Peer remembers that the weather caused a lot of trouble that day: "The opening scene was to be shot in front of the main cathedral, and there was a vicious storm that day—one of those weird ones they have in Europe, with intensely high winds. A lot of construction was taking place around the cathedral. The clouds darkened, and we had just barely completed the filming when the storm hit. Plywood was flying off the scaffolding, hitting cars and bouncing off the pavement. We could have been killed! It was a powerful experience for me."

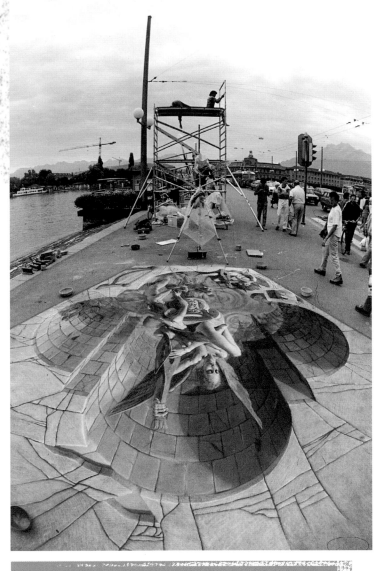

▲ **Reverse view.** Anamorphic pictures are made to be seen from one point in space, and look odd when viewed from the opposite side. The scaffolding was set up by the Swiss for the National Geographic documentary filming. The work was damaged by four rainstorms before it was finally completed.

◀ **Wenner.** *Gluttony.* Palazzo Te, Mantua, Italy. Palazzo Te was the backdrop for the filming of the drawing sequence in the National Geographic documentary. This work is a pun on *Room of the Giants*, a famous fresco cycle by the mannerist artist Giulio Romano. Ironically, a nearby commercial center also sports the name "The Giant." Here the depicted figures show the results of consumerism, becoming "giants" themselves.

Day by day as the filming continued, the challenge of documenting impermanent work became more evident. Peer understood that the process and challenges that go into making a documentary are quite similar to creating an ephemeral work of art on the street. "When making a documentary film, there is always the story you want to tell, and then there are the circumstances the universe throws your way during the filming. There is a dynamic tension between those two realities."

After Milan, Peer and Wenner selected a stunning site for shooting along the bank of the Vierwaldstättersee in Lucerne. The asphalt-covered promenade runs along

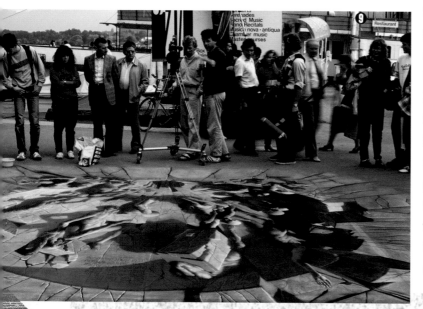

the lake's shoreline, with its gorgeous views and swans paddling on the shimmering water. In the late afternoon, the light bathed the landscape in pink and gold, and the snowcapped Alps reflected the colors off in the distance. Opposite the shore are some lovely grand old hotels and luxury Swiss shops. Wedged between these two worlds, Wenner was busy creating a magnificent fountain for the documentary.

WHILE WORKING ON THE STREET PAINTING FOR THE FILM, I HAD TO CONFRONT THE NATURE OF MY OWN CREATIVITY. I WANTED TO DEMONSTRATE THAT I WAS CAPABLE OF INVENTING ORIGINAL COMPOSITIONS ON THE SPOT, SO I DELIBERATELY DIDN'T MAKE ANY SKETCHES FOR THE PIECE I WAS TO CREATE. I HAD BEEN ACCUSED MANY TIMES BY ONLOOKERS OF COPYING RENAISSANCE PAINTINGS, AND THE PUBLIC OFTEN REFUSED TO BELIEVE THAT I CREATED MY OWN UNIQUE ORIGINAL COMPOSITIONS. CREATING AN ORIGINAL WORK OF ART WAS STILL NOVEL IN THE WORLD OF STREET PAINTING, AND IT WAS IMPORTANT TO ME THAT PEER CAPTURED THIS IN THE DOCUMENTARY.

▲ Filming the National Geographic documentary in Lucerne, Switzerland. Here a rare wrong-side view of the work is shown along with the director and cameraman.

▶ *The Muses* (detail). From the viewing point, a three-dimensional effect is achieved regardless of the lens used.

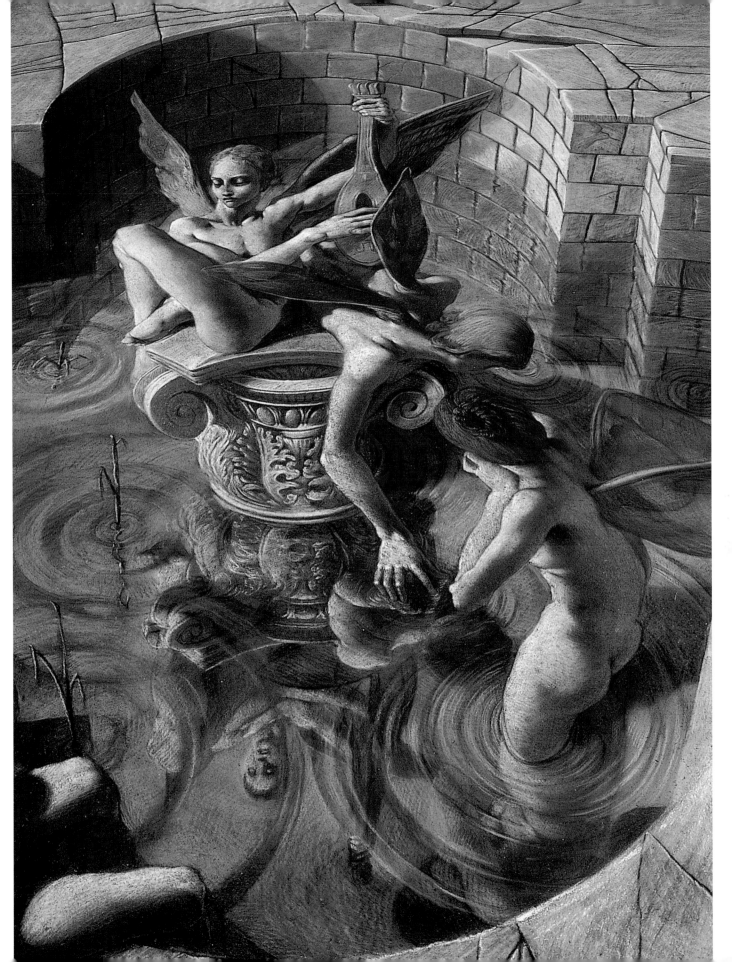

It was difficult for Peer to accept this spontaneous approach, as he would have no way to know if an unplanned creation would end up being good enough for the film. Kurt decided to paint the Muses, which as a theme lent itself to improvisation. The Muses also symbolize the idea that even though works of art are ephemeral, the inspiration behind them is immortal.

The film crew was set up and ready to go. As Wenner began laying out the painting's composition, he realized that he had always been able to work without time constraints. Wenner now had to reconcile his creative side with the realities of a budget and a deadline for completing the painting.

The weather was gorgeous for the first day and a half. Then, much to the director's delight, a huge rainstorm moved in. Peer was happy because he wanted to document a rainstorm, but it rained the next day, and the day after, and the day after that. All the while, Wenner was scrambling to keep the sheet plastic on the work and repaint the destroyed parts in between downpours. The rain was causing the film crew's bills to go up with each successive cloudburst. Peer finally asked, "What will happen if the weather doesn't clear?" and all Wenner could tell him was, "We won't be able to finish."

Peer was distraught. "I thought the weather would sink the film, so we appealed to the Swiss tourist office for help." They set up scaffolding around the painting and draped plastic over it, which enabled Wenner to finish. As the rain seeped in around the edges of the plastic, the crew members would mop it up to keep the painting from being damaged.

"In the evenings I did a lot of tape recording with Kurt," says Peer. "We'd get into these in-depth, heartfelt discussions about what he was doing on the street. The next day, I would find visuals outside that would express those longings." Peer looked for unique ways of presenting how difficult it is to street paint. "I set up the cameras on the balcony of the restaurant across the street to show the crowds forever milling around the artists. I used a telephoto lens and shot Wenner from across the street through the traffic, to show how Kurt was working right next to heavy traffic. There's a timeless quality to Wenner's work, which I tried to convey by showing the passage of time, yet giving a timeless quality to the film itself. Kurt has worked really hard and stayed true to his vision."

Masterpieces in Chalk proved to be a breakthrough. It introduced millions of Americans to Italian street painting, and it promoted a positive image of street painting

as a fine-art technique. The film won a blue ribbon at the American Film and Video Festival, a Chris Award from the Columbus International Film Festival, a Gold Award from the International Film and Television Festival of New York, and a Silver Award at the CINDY Competition. Peer's intent to make the film both timely and timeless paid off, as *Masterpieces in Chalk* continues to be broadcast year after year.

TEACHING THE ART

The political wind at Grazie had begun to change, and a particularly low point in Wenner's experience came when he decided to make a street painting with a group of local school children. He designed the project as a means of withdrawing from the competition while still showing event spectators and the community that street painting has many applications, such as education.

Some of the street painters were so spiteful that they accused Wenner of exploiting the schoolchildren to gain free help with his street painting. These madonnari were vocal enough that the festival organizers ordered the children to leave the event. Wenner finished his part of the painting and then left. The disappointed children were allowed to return and complete their work only after the festival was over. Eventually, town officials took over the children's street painting program and conducted it themselves.

▶ **Demonstration.** During one competition, Wenner designed a piece in collaboration with local children. Jealous competitors accused Wenner of cheating, and the work could only be completed after the festival was over.

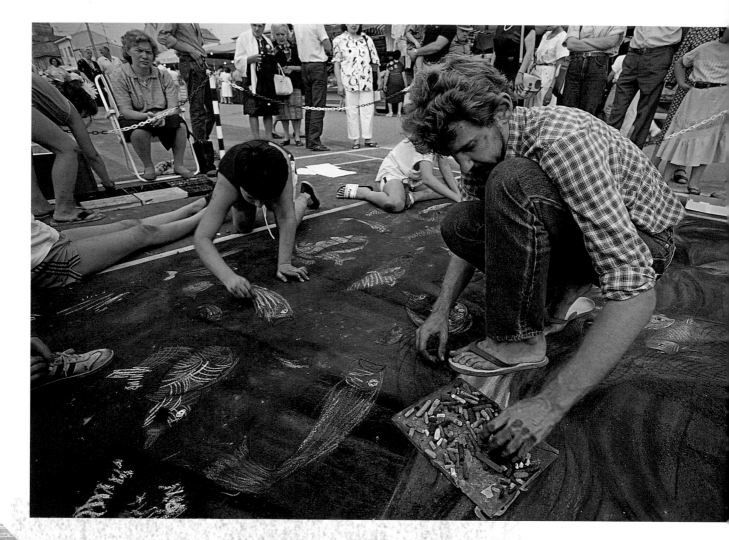

AFTER THE FIRST FIVE YEARS, I WAS READY TO STOP PARTICIPATING AT THE FESTIVAL. IT WAS CLEAR TO ME THAT I COULD NOT CONTINUE WITHOUT COMPETING, AND I COULD NOT COMPETE WITHOUT BEING EMBROILED IN POLITICS. I THOUGHT IT WAS IMPORTANT FOR THE FESTIVAL TO BE A SHOWCASE FOR THE ART FORM, AS WELL AS A COMPETITION. THE CONTEST SHOULD BE FOR GAINING RECOGNITION, AND THE ARTISTS WHO HAD ALREADY DISTINGUISHED THEMSELVES OUGHT TO BE ALLOWED TO CREATE INNOVATIVE AND INSPIRING WORKS WITHOUT BEING BOUND BY THE SAME RESTRICTIONS. UNFORTUNATELY, THE FESTIVAL IS NOT WILLING TO ALLOW THE ART FORM TO HAVE ANY EXPRESSION BEYOND THE NARROWLY DEFINED RULES OF THE COMPETITION.

▲ **Working with children.** Although his project with schoolchildren at Grazie was ill-fated, the city was inspired to create its own educational programs for children, which continue to this day.

▶ Wenner. *The Last Judgment—Hell* (detail of drawing).

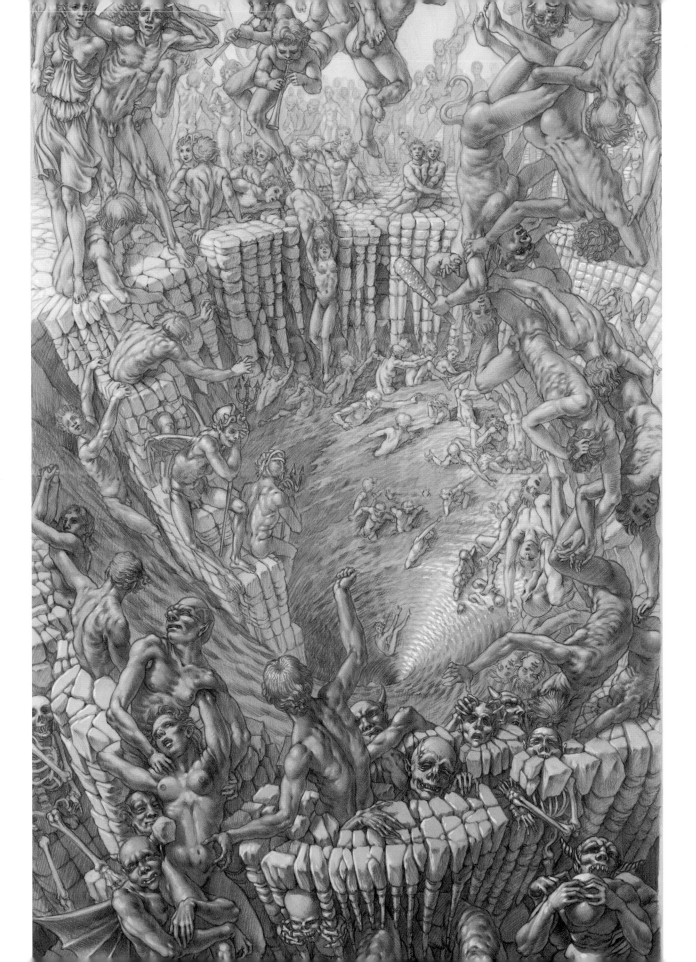

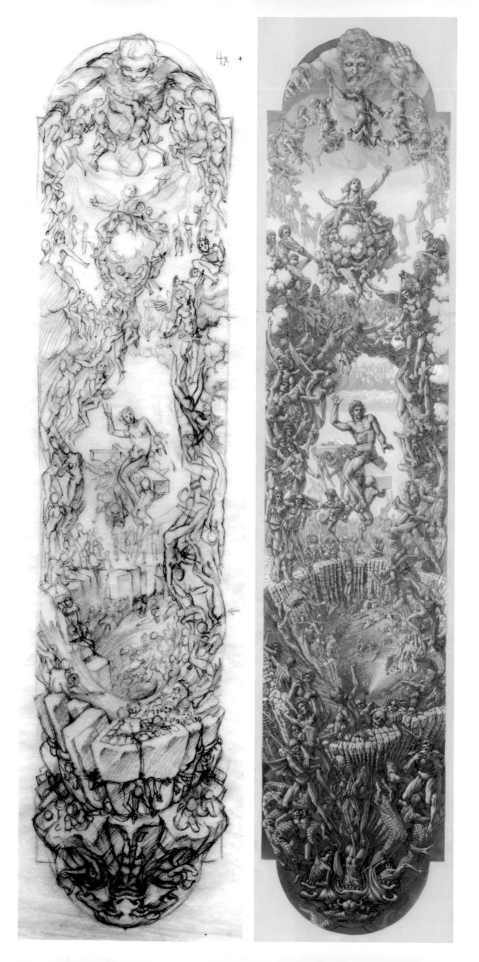

Wenner was lured back to Grazie's piazza for a momentous occasion. In 1991, it was announced that Pope John Paul II would visit Mantua and the sanctuary at Grazie. It had been more than five centuries since a pope had last set foot on Mantuan soil. In the mid-1400s, Pius II had arrived to ask the duke of Mantua to supply him with troops for a crusade. The residents of Mantua had waited an astonishingly long time for a pope to return, and a visit from the beloved John Paul II was a particularly blessed event. It was decided that a grand work in Grazie's piazza was to be commissioned in honor of the papal visit. This was a bold decision, since the church had an ambivalent attitude toward the art form. Some of the clergy perceived it as competing with the church by using sacred images for private gain. The town therefore hoped to finally obtain the pope's blessing for the art form. A special congress of madonnari was convened, and Wenner was unanimously elected to design and direct the execution of a monumental street painting.

He designed a composition using the theme of *The Last Judgment*, which measured fifteen feet by seventy-five feet. The painting contained 170 figures, most of which were life-sized. Thirty-two madonnari from various countries

▶ **Wenner with Vittorio Sgarbi.** Wenner pauses during a visit from the famous Italian art historian and critic Sgarbi.

◀ **Wenner. The Last Judgment (sketch and tonal drawing).** The city fathers at Grazie were concerned that Wenner had lost his mind when he proposed the complicated design, but the street painters enthusiastically accepted the challenge.

were selected for the project, and they began by making pastels in order to work with a unified color palette. Throughout the event, there was great enthusiasm and camaraderie. The artists were selected for their skill level, and with high spirits and a dozen languages floating in the air, the group got through difficult setbacks as the picture went through three thunderstorms. The artists worked in the piazza for ten days straight, breaking briefly for lunch and working until the last light was gone. In the end, they finished the painting just two hours before the pope arrived.

Wenner and the other artists hurried out of the piazza to wash and change into clean clothes. As Wenner entered the piazza, the pope was just arriving. The artist quickened his pace, and as he made a beeline across the piazza toward the pontiff, a small army of security agents grabbed Wenner, immobilizing him as they frisked him for weapons. The mayor ran over and explained that they had hold of the artist who had been commissioned to design the artwork. The agents released Wenner and thrust him forward to meet Pope John Paul II.

A LIMITED NUMBER OF PEOPLE WERE ALLOWED IN THE PIAZZA WHILE THE POPE WAS PRESENT. AS I STOOD WAITING FOR HIM TO ARRIVE AT THE PAINTING, I SAW THE POPEMOBILE STOP AT THE BOTTOM OF THE PICTURE. I HAD NOT REALLY CONSIDERED THAT THE FIRST POPE TO VISIT GRAZIE IN OVER FIVE CENTURIES, AND PROBABLY THE FIRST TO EVER SEE A STREET PAINTING UP CLOSE, WOULD BE GREETED BY THE SCENE OF SUFFERING IN HELL. SUPPORTED BY A CARDINAL IN A ROBE ADORNED WITH HANDMADE LACE AND FOLLOWED BY BODYGUARDS, THE TOWN PRIEST, THE MAYOR, AND VARIOUS TOWN DIGNITARIES, JOHN PAUL II WALKED SLOWLY UP THE SIDE OF THE PAINTING, INSPECTING IT CAREFULLY. HE ADVANCED PAST THE JUDGMENT AND TOWARD THE SAINTS AND THE MADONNA WHO RESIDED IN HEAVEN. THE POPE LOOKED MORE AT EASE ONCE HE REACHED THE CELESTIAL REALMS.

▶ Wenner with thirty street painters. *The Last Judgment.* Grazie, Italy. The street painters worked ten days through three rainstorms to create this monumental work.

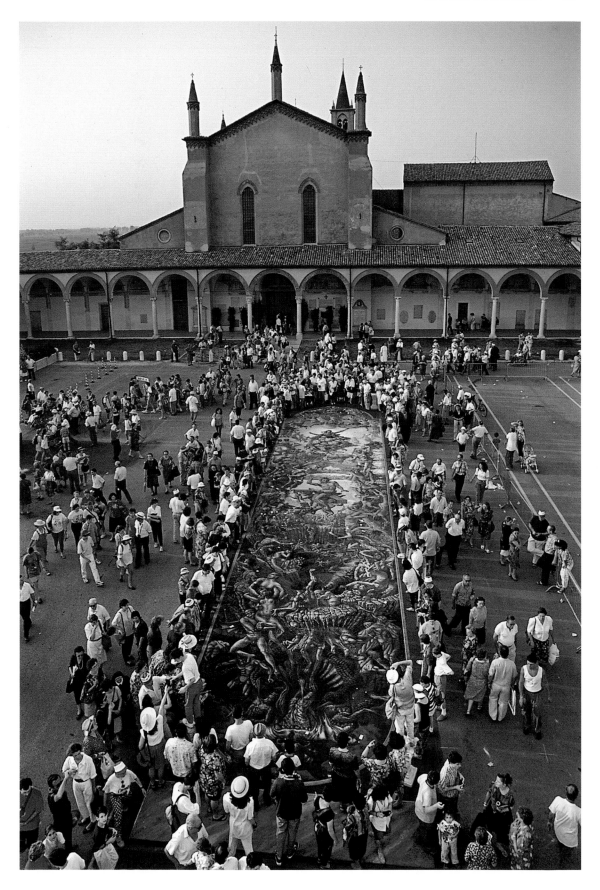

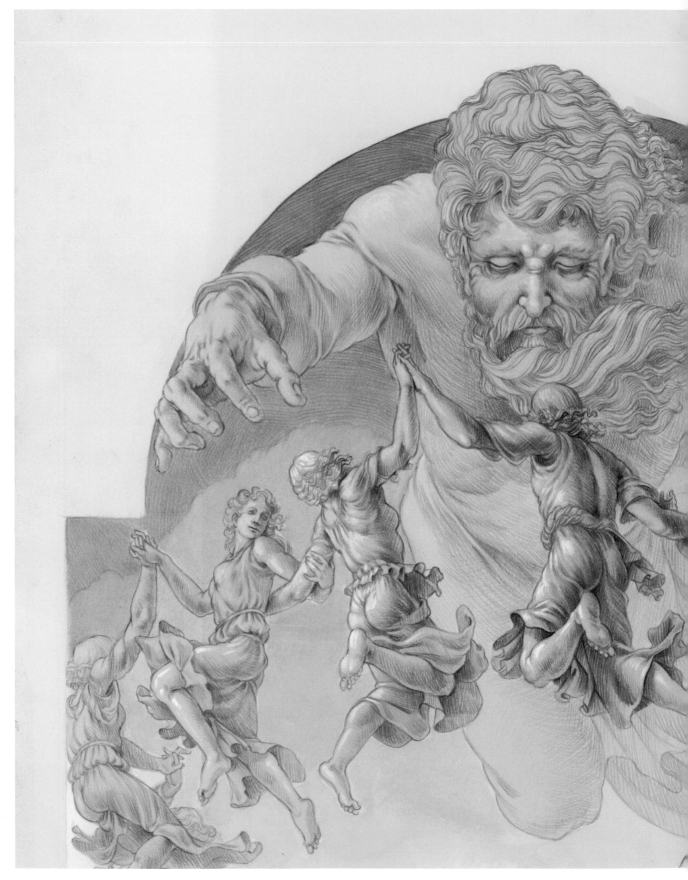

◄ Wenner. *The Last Judgment—God* (detail of drawing).

Pope John Paul II shook hands with each of the artists who worked on the mural-sized street painting, and was then introduced to Wenner.

THE POPE LOOKED INTO MY EYES, AND I COULD FEEL THE AURA OF SANCTITY IN HIS PRESENCE. HE GRASPED MY FOREARM AND HELD IT FOR A LONG TIME, AND I SENSED AN INTENSE SPIRITUAL POWER COMING THROUGH HIS HAND. IT WAS A VERY POWERFUL AND SIGNIFICANT EXPERIENCE FOR ME.

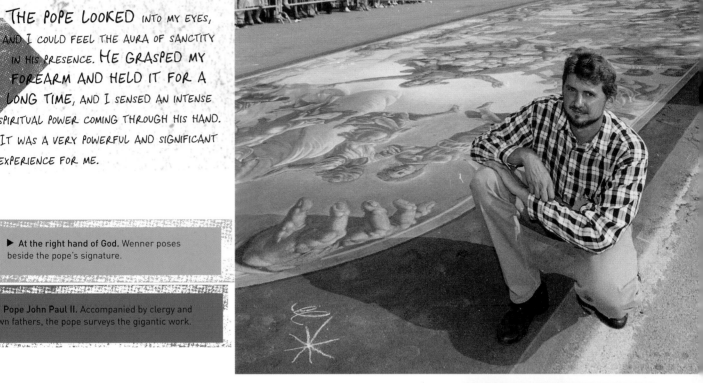

▶ **At the right hand of God.** Wenner poses beside the pope's signature.

◀ **Pope John Paul II.** Accompanied by clergy and town fathers, the pope surveys the gigantic work.

After the introduction, the former mayor, Attilio Flisi, quietly pressed a piece of white chalk into the pope's hand. The Pope bent down and signed the street painting with his papal symbol next to the right hand of God. The chalk broke several times, but the pope persisted until he was finished. For the first time, the highest member of the church had consecrated a street painting. The act was taken to be the Catholic Church's long-awaited acceptance of street painting as a sacred art.

The morning after the event, Kurt returned to photograph the pope's signature alongside the painting, but he was too late. The pavement containing the signature was being jackhammered out of the piazza! No one knows better than the folks in Grazie how fleeting pastels can be, and they were determined to preserve the signature in the street painting museum. The hole was quickly filled with a bronze replica to commemorate the spot. Unlike the pope's signature, the monumental painting was sacrificed to the elements.

7

DIFFUSION

▶ **Young street painters.** Children work on a collaborative piece as part of Wenner's school residency program.

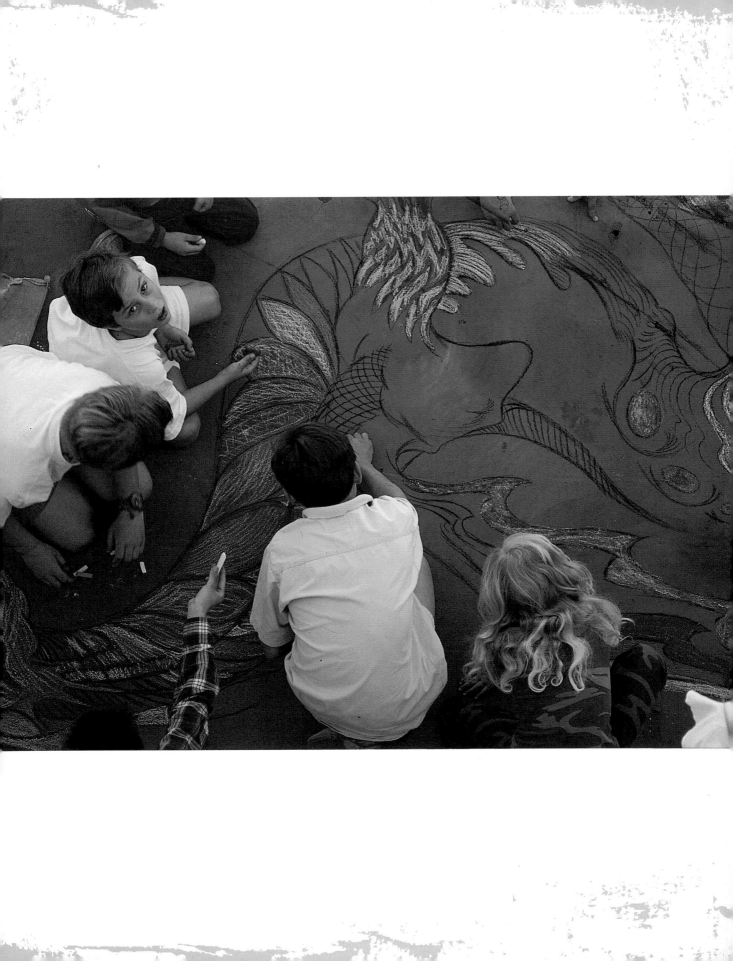

In 1984, Wenner gave a lecture and slide show accompanied by the creation of a street painting at the Santa Barbara Museum of Art. The audience was captivated by the art form, and Wenner was soon contacted by John Kline to create the documentary *Chalk Magic*. The film focused on Wenner creating a street painting at a local school. Wenner enjoyed working with the children and found the experience very rewarding.

WE DIDN'T HAVE A LOT OF TIME TO FILM, SO I WAS UNABLE TO TEACH THE CHILDREN MANY TECHNIQUES FOR USING THE CHALKS. AS I WORKED, THEY OBSERVED THE PROCESS AND WERE SOON DRAWING ENTHUSIASTICALLY ALONGSIDE ME. WHILE TALKING WITH THE TEACHERS, I REALIZED ART HAD NOT BEEN TAUGHT IN THE SCHOOL SINCE THE STATE OF CALIFORNIA PASSED A BALLOT INITIATIVE KNOWN AS PROPOSITION 13. THE PROPOSITION CAPPED THE AMOUNT OF REVENUE A SCHOOL DISTRICT RECEIVED (IN ORDER TO LOWER PROPERTY TAXES), LEAVING THE PUBLIC SCHOOL SYSTEM IN AN ONGOING CRISIS FOR FUNDING. ARTS EDUCATION PROGRAMS WERE AMONG THE FIRST CUT FROM THE CURRICULUM. IT WAS THROUGH THIS EXPERIENCE THAT I REALIZED HOW PERFECTLY SUITED THE MEDIUM OF STREET PAINTING WAS FOR ART'S EDUCATION. SCHOOLS NEARLY ALWAYS HAD ASPHALT, AND LOW-COST CHALKS FIT WITHIN THE BUDGET OF CALIFORNIA'S STRICKEN SCHOOL SYSTEM. THE ART FORM ALSO EMBRACED ART HISTORICAL AND TECHNICAL PRINCIPLES, MAKING IT A DIDACTIC DREAM.

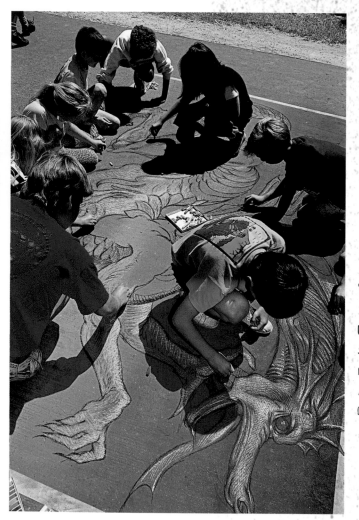

◀ **Children at work.** A group of children work on a collaborative piece as part of Wenner's school residency program.

▶ *The Dragon.* A group of children stand proudly behind their finished work.

Wenner developed a comprehensive two-day residency program in connection with the Music Center of Los Angeles County's education division to teach street painting in the K–12 school system. Music Center officials are known for bringing performing artists into the public schools, and they immediately caught on to the benefits of offering street painting. It is a natural tool for teaching art to children, and a large, colorful outdoor event provides them with a memorable experience. With the emphasis on process and not product, even the most apprehensive children enjoy participating. Prior to Wenner arriving on the campus, the teachers discussed drawing technique, painting, and color theory, as well as perspective and geometry. Many teachers integrated the street painting event into the students' curriculum so that the compositions were based on their current studies in science, history, and literature.

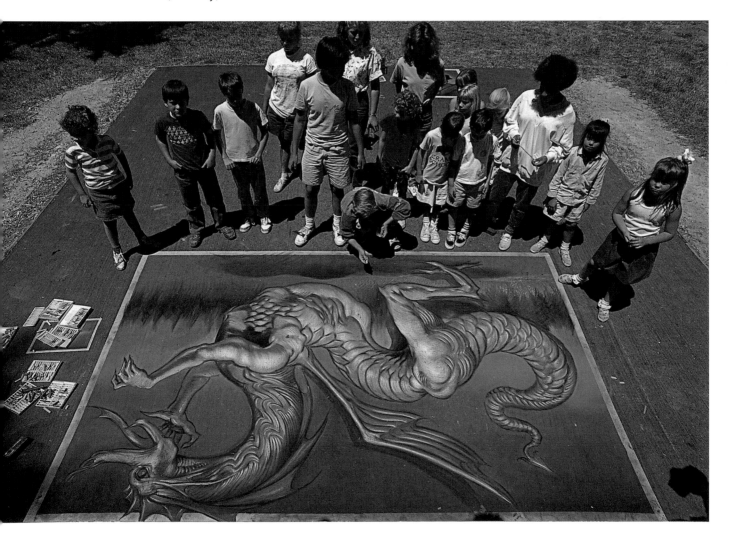

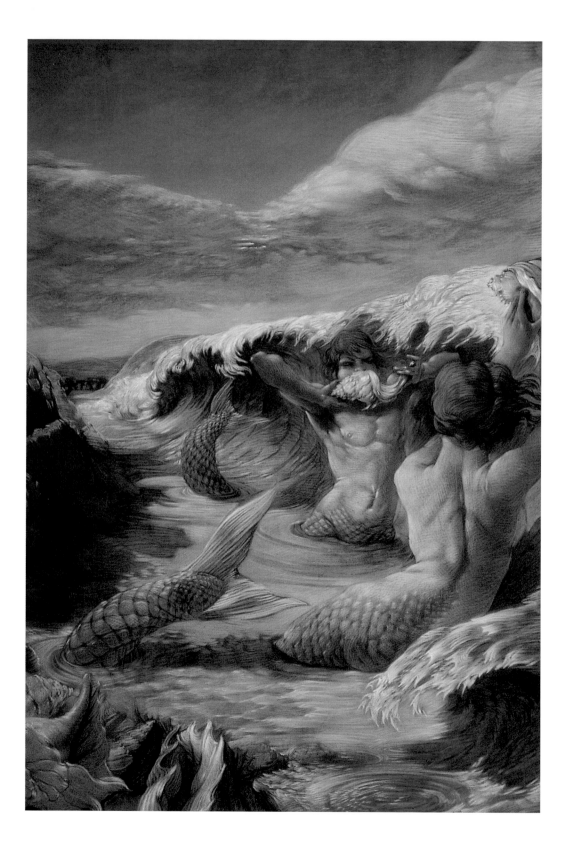

The program was a great success, and street paintings suddenly began gracing playgrounds across the United States. Working in the schools was very demanding, as some of the larger elementary schools had up to one thousand students. During the residency, Wenner would give a slide lecture and demonstration to every class. It didn't take long before the playgrounds were busier and louder than any of the streets in Europe.

▲ **Dirty hands and feet.** Chalk painting has tactile as well as visual appeal to children.

◀ Wenner. *Mermaid and Merman* (demonstration piece for children). In addition to directing the dragon piece and demonstrating pastel technique, Wenner created small demonstration pieces for the schools.

For a decade, Wenner devoted one month a year to his school residency program and taught more than a hundred thousand children in a variety of environments. He found it was fascinating that many of the schools with the strongest arts programs were in the poorest areas. The children in those areas related wholeheartedly to the art form of street painting. He was truly honored when he received the Kennedy Center Medallion in recognition for his outstanding contribution to arts education in the United States.

CREATING FESTIVALS

In 1986, with the release of National Geographic's *Masterpieces in Chalk*, the idea of street painting was starting to take hold in the United States. Wenner was invited back to the Santa Barbara Museum of Art to officially launch the art of street painting in the United States. The community loved the work and was eager to pursue street painting on a larger scale. Many local artists were inspired by the slides of the festival in Grazie and proposed a similar street painting event in Santa Barbara. The event further developed into a fund-raiser. Many local artists were happy to donate their time, and the Franciscans offered the plaza around the Santa Barbara Mission as a venue. Local businesses became involved by sponsoring squares, and the Italian Club was happy to set up booths and provide hospitality. With Wenner's guidance and expertise, the first street painting festival in North America was launched at Santa Barbara's Queen of the Missions in 1987.

THE FESTIVAL WAS A GREAT OPPORTUNITY TO SHARE WITH ARTISTS AND THE PUBLIC MY EXPERIENCES AND VISION OF THE ART FORM. I GAVE SEVERAL PUBLIC LECTURES ON THE HISTORY OF STREET PAINTING, ACCOMPANIED BY A SLIDE SHOW OF TRADITIONAL ICON-LIKE IMAGES, PAINTINGS THAT WERE COPIES, AND MY INNOVATIVE THREE-DIMENSIONAL PICTURES. MY PERSONAL ILLUSIONISTIC WORKS OF ART HAD THE UNINTENDED RESULT OF CAUSING SOME ARTISTS TO EMBRACE MY PERSONAL TECHNIQUES, BECAUSE THEY HAD MISUNDERSTOOD IT TO BE PART OF THE ART FORM'S HISTORY. I DIDN'T KNOW AT THE TIME THAT MY INNOVATION OF THREE-DIMENSIONAL STREET PAINTING WOULD BECOME A WORLDWIDE PHENOMENON.

◄ **Kennedy Center medallion.** Wenner received this medallion after taking his program to dozens of schools. Other artists and teachers carry on the program.

► **Wenner.** *Nativity.* **Santa Barbara Museum of Art, Santa Barbara, California.** This original composition, along with a slide lecture, introduced the tradition of Italian street painting to the Santa Barbara audience for the first time.

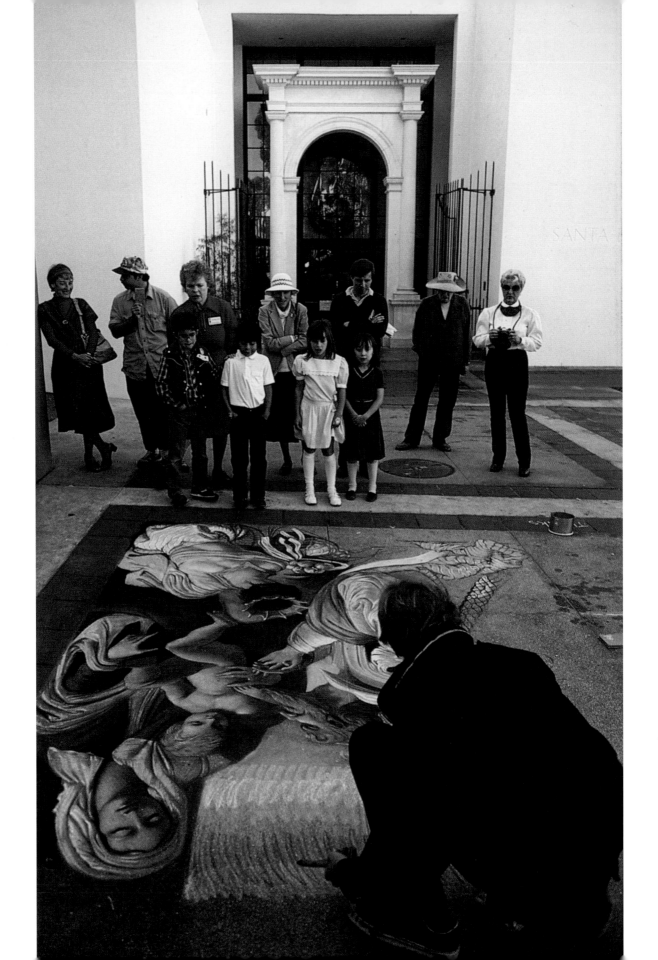

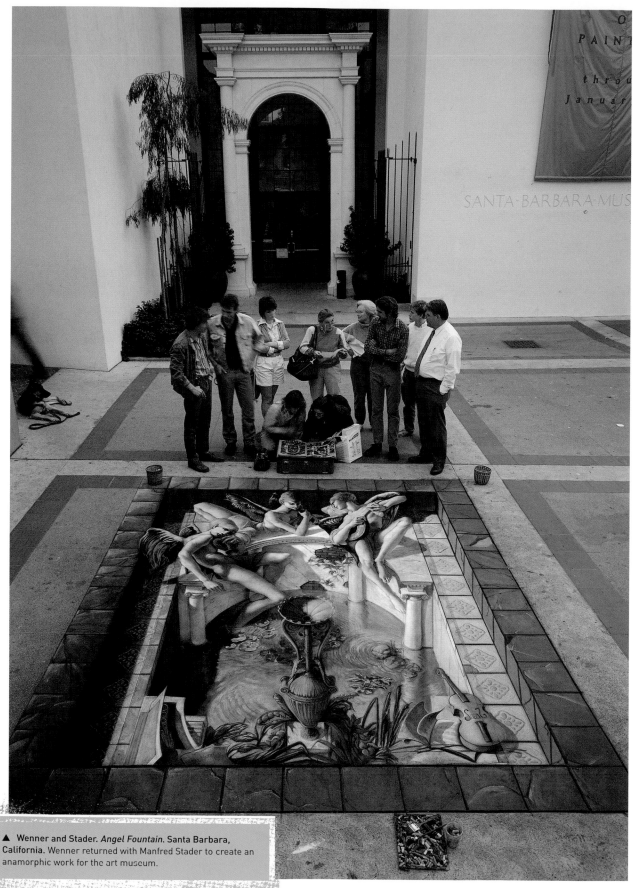

▲ Wenner and Stader. *Angel Fountain*. Santa Barbara, California. Wenner returned with Manfred Stader to create an anamorphic work for the art museum.

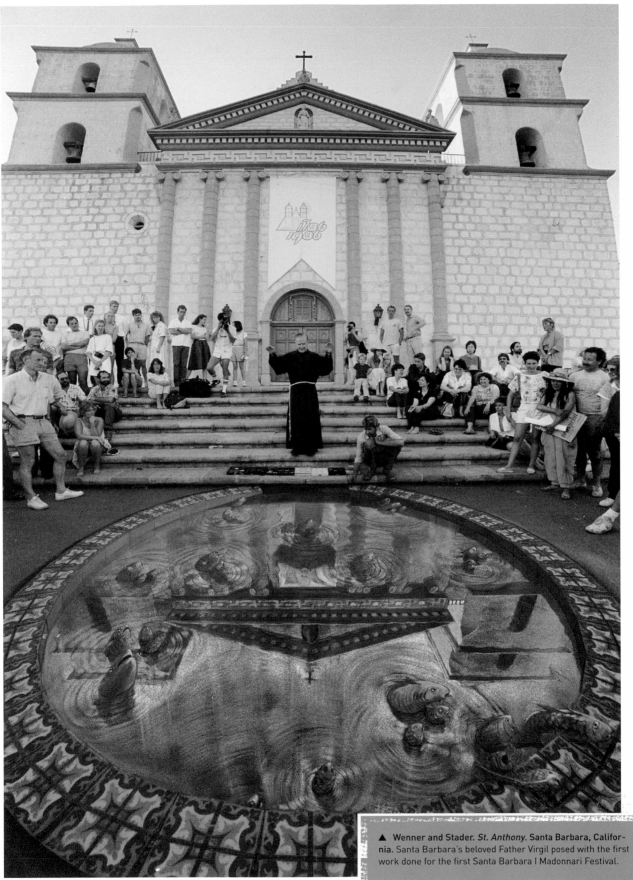

▲ Wenner and Stader. *St. Anthony.* Santa Barbara, California. Santa Barbara's beloved Father Virgil posed with the first work done for the first Santa Barbara I Madonnari Festival.

Wenner asked Stader to join him at the festival and assist with training the artists who volunteered for the event. Since everyone was unfamiliar with the art form, Wenner and Stader had to teach them how to make pastels, crosshatch, blend colors, add details, and so on. The two also dispensed lots of good advice for staying clean. Throughout the event they were on hand to answer questions and assist with the many technical problems that arose. At the base of the steps that lead up to the mission's church, Wenner and Stader created a showpiece anamorphic painting to inspire others and draw in news media to cover the festival.

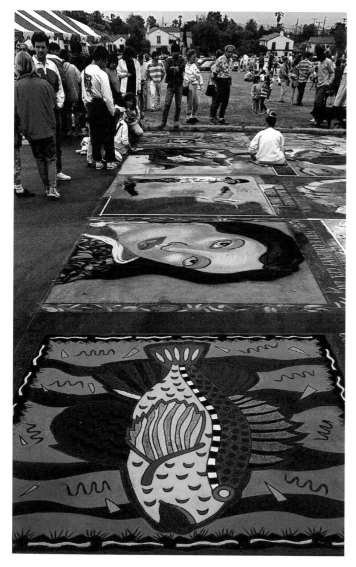

A relaxed atmosphere and a vibrant graphic sense combined with strong colors distinguished the Santa Barbara festival from its Italian counterpart. The event was like a big art class, with people strolling around looking at one another's work and talking about their experiences with street painting. Some artists copied classical and religious imagery, while others created original works or tried their hand at trompe l'oeil. The artists were friendly and helped one another out by keeping their work spaces clean. The art form was undergoing a metamorphosis, adapting itself to the new environment.

Other communities and event organizers soon contacted Wenner to bring the art of street painting to their area. Like Santa Barbara's annual festival at the mission, most events are an adaptation of the original one in Grazie—minus the competition. Wenner started another fes-

◀ **Detail of piazza, Festival at Santa Barbara.** The Santa Barbara I Madonnari Festival is not a competition. Among the works are copies of masterpieces, along with highly original compositions.

▶ **Wenner. *Dies Irae* poster. Santa Barbara, California.** This poster design was created for the second I Madonnari Festival. Shown is a later printing of the poster with the original Latin text.

Kurt Wenner, Madonnaro, presents «Dies Irae»
Una scenografia nella strada / A Street Scenography / Ein Bühnenbild der Straße

Dies irae, dies illa, solvet saeclum in favilla: teste David cum Sibylla.
Quantus tremor est futurus, quando judex est venturus cuncta stricte discussurus.
Tuba mirum spargens sonum per sepulcra regionum, coget omnes ante thronum.
Mors stupebit et natura, cum resurget creatura iuicanti responsura.
Liber scriptus proferetur in quo totum continetur unde mundus iudicetur.
Iudex ergo cum sedebit, quidquid latet apparebit: nil inultum remanebit.
Quid sum miser tunc dicturus? quem patronum rogaturus, cum vix justus sit securus.
Rex tremendae maiestatis, qui salvandos salvas gratis, salva me, fons pietatis.
Recordare, Jesu pie, quod sum causa tuae viae; ne me perdas illa die.
Quaerens me sedisti lassus: redemisti crucem passus: tantus labor non sit cassus.
Qui Mariam absolvisti, et latronem exaudisti, mihi quoque spem dedisti.
Preces meae non sunt dignae: sed tu bonus fac benigne, ne perenni cremer igne.

tival in Fresno, California, and trained many local artists for the event. Community members were so taken by the composition that they commissioned him to re-create it as an oil painting to hang in the new city hall. Wenner also helped start a large street painting event in Pasadena, California, which is currently known as Absolut Chalk. The artwork at this event is particularly accomplished due to the participation of artists from the nearby film studios of Disney, Warner Bros., and Universal. In the years prior to initiating the festival, Wenner conducted numerous workshops and classes for Disney's top artists, many of who became enthusiastic street painters. It was rewarding for Wenner to see so many accomplished artists try their hand at the art form.

Street painting festivals across the United States have had a positive effect on the public perception of art and artists. All too often, the public is alienated from the

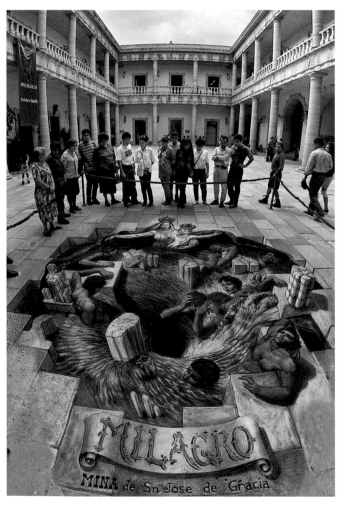

fine-arts community; street painting festivals help bridge this gap, enabling people to watch and interact with an artist at work. For a young artist or art student with courage and initiative, street painting can still be an important opportunity to grow artistically while earning an income. Wenner's desire to share his knowledge and experience proved to be a catalyst for bringing street painting out of Italy and onto the pavements of the world.

By 1986, after four years of study in Italy, Wenner had become an accomplished artist and could have stopped street painting to create lucrative perma-nent works. He, however, felt a special affinity for the medium and continued to pursue it in addition to permanent commissioned work. Wenner took this languishing folk art and re-created it as a contemporary medium so others could enjoy the experience of street painting. He knew the art form needed

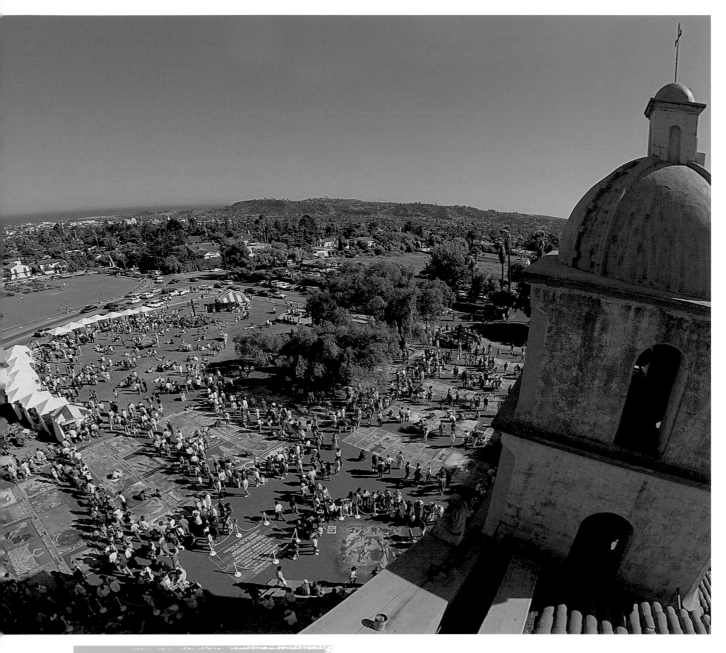

▲ Santa Barbara I Madonnari Festival, second year. The Santa Barbara festival was an instant success, and continues to this day. It inspired festivals around the country and the world.

◄ Wenner. *Milagro.* Guanajuato, Mexico. This composition depicts the miraculous survival of a group of silver miners who were trapped in a flooded mine for ten days. It was commissioned for the twenty-first Festival Internacional Cervantino.

new, young artists to keep it alive and growing, and festivals brilliantly utilized the natural appeal of a colorful medium to draw newcomers to it. The street painting festivals introduced the art form to those who otherwise would never have set out a basket for tips on a busy city street, and many artists quickly became enthralled with it. Naturally, the growth of an art form depends on its ability to inspire artists around the world. After having established a number of street painting festivals, Wenner moved on to larger national and international arts festivals where he could introduce the art form to countless spectators around the world.

▲ **Three-dimensional trick art poster.** Asian audiences like to refer to visual illusions as "trick art." This poster announces Kurt Wenner's demonstration at Huis Ten Bosch in Nagasaki, Japan.

▶ Wenner. *Echo and Narcissus.* Salt Lake City, Utah. Wenner was invited to compose another work based on Ovid's *Metamorphoses* for the Utah Arts Festival.

I WAS ABLE TO DISSEMINATE STREET PAINTING EFFECTIVELY BY PARTICIPATING IN A NUMBER OF HIGH-PROFILE EVENTS. THESE VENUES OFFERED ME AN EXCELLENT OPPORTUNITY TO HIGHLIGHT THE ART FORM AS WELL AS INTRODUCE IT AS A PERFORMING ART.

Robyn Nelson, former executive director of the Utah Arts Festival, recalls Wenner's participation. "A friend of mine saw Kurt's work and sent me a brochure about him. I went to see him for myself when he was working at another festival. We talked, and he showed me some slides in his hotel room that evening. My jaw just dropped. The way he approached his art was so totally non-American. It's not an indigenous art form, and here was a nice California guy doing it. I invited Wenner to participate in the next Utah Arts Festival. We put up a tent and a picket fence for his work area. We displayed

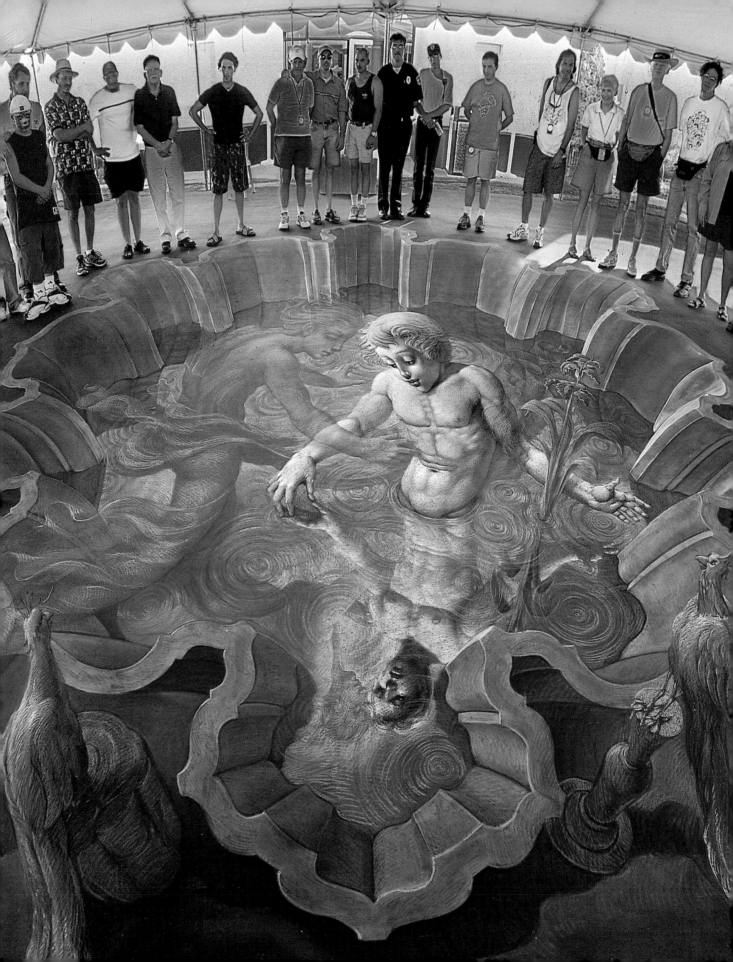

Kurt's answers to the ten questions people ask him most frequently, and showed the National Geographic *Explorer* film in a continuous loop. I never thought that people could be contemplative in the midst of a busy festival, but they stayed there for hours watching him work. His mythological subject matter is particularly appreciated in Utah, which has its own religious traditions."

For decades, Wenner traveled around the United States spreading the art form by creating large three-dimensional paintings at festivals and art events. In addition to the multitude of spectators who encountered the work firsthand, television and newsprint media exposed millions more to the art of street painting. It was a wonderfully fun and effective way to share his enthusiasm for the art with millions of people.

Robyn Nelson adds, "Kurt Wenner breaks down the precious distance between artists and audience. Contemporary art and artists can make people uncomfortable. They are charmed and drawn in, but they don't know what to do. It's not as intimidating to watch someone doing a piece that's on the street and will not be hung in a precious gallery. It's fresh, it's unpretentious, it's not studied—you see young kids from rough backgrounds, little old ladies—it makes people really look at the art. It's interactive. You don't have to be quiet and reverent. Also, to be able to talk to an artist who is that incredible is a great opportunity. His accessibility, how he can become part of and interact with an environment, the subject matter, the drawing, the techniques, and then answer practical questions from the viewers—it is a generous sharing."

▶ Wenner. *Vertumnus and Pomona.* Salt Lake City, Utah. Wenner composed this work based on Ovid's *Metamorphoses* for the Utah Arts Festival.

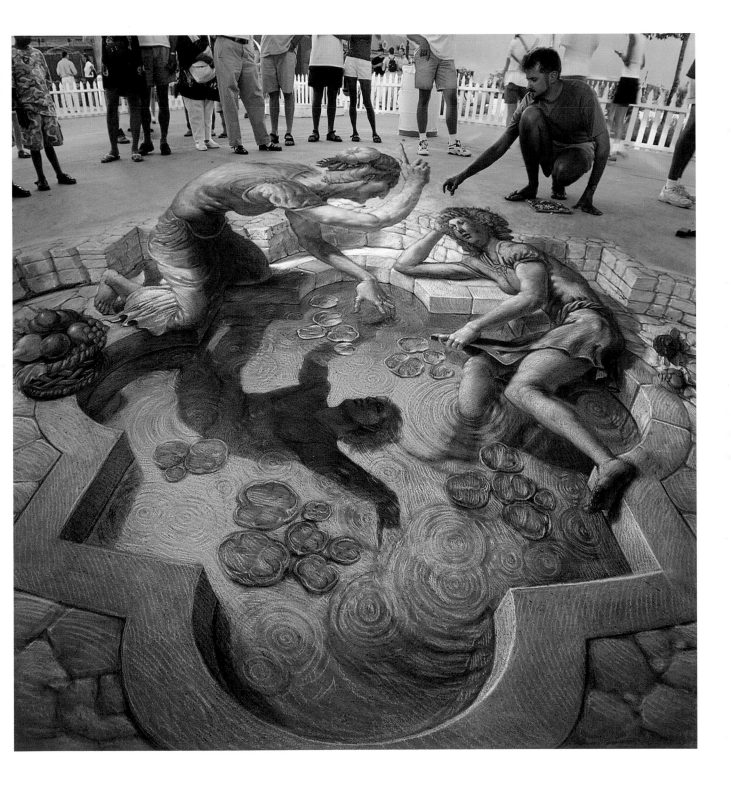

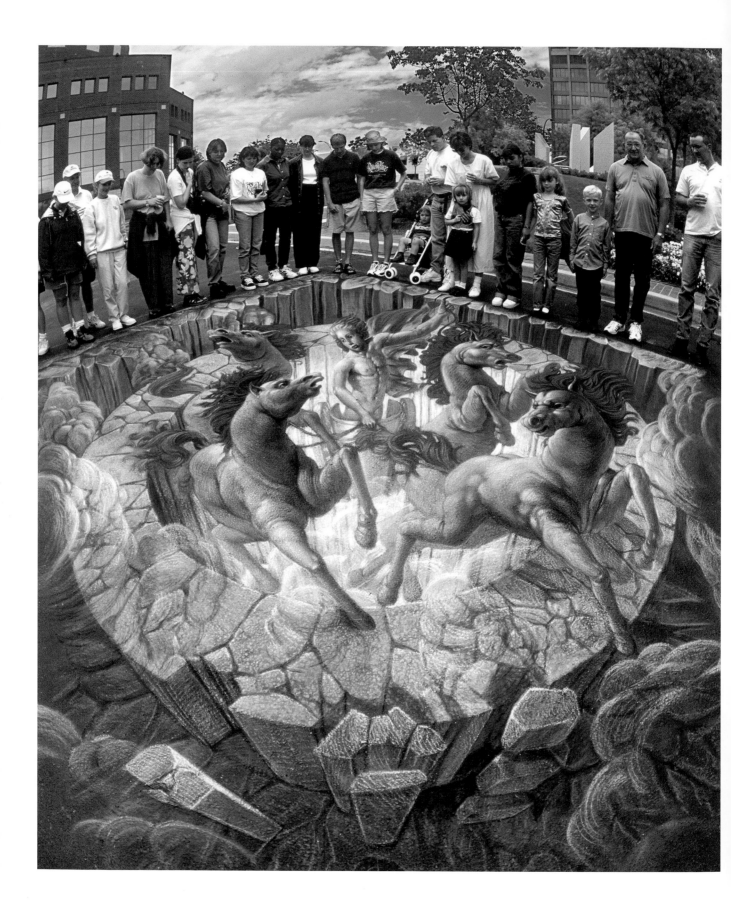

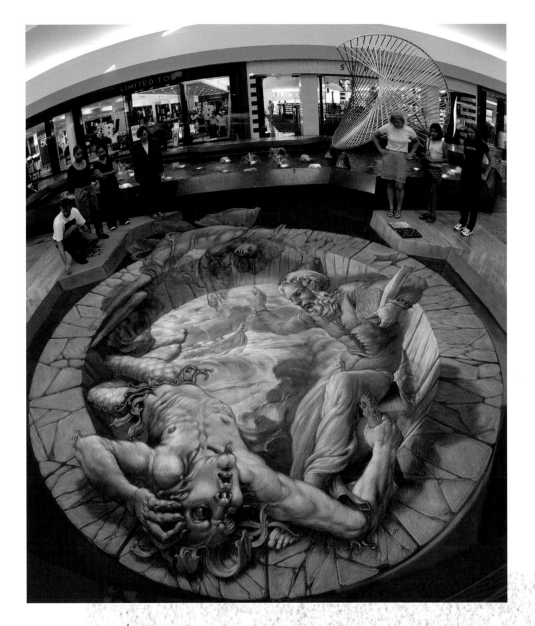

▲ Wenner. *The Tempest*. Reno, Nevada. Created inside a shopping center, Wenner's *Tempest*—which depicts characters from Shakespeare's famous play—was safe from any real tempests.

◄ Wenner. *Apollo's Chariot*. Greenville, North Carolina. Prior to the event, this work survived numerous rainstorms—a common problem in the South.

WORKING AT AN EVENT IS HARDER THAN PAINTING FOR TIPS. I GENERALLY PROVIDE A DRAWING BEFOREHAND TO LET THE PRESENTER PREVIEW THE COMPOSITION AND HAVE SOMETHING TO SHOW THE MEDIA. MY IMAGES AND THE STORY BEHIND THEM USUALLY AROUSE CURIOSITY AND ATTRACT A LOT OF MEDIA ATTENTION. IN THE UNITED STATES, THE MOST IMPORTANT TELEVISION COVERAGE OCCURS WITH THE MORNING WEATHER SPOT, AS IT ALWAYS HAS THE HIGHEST NUMBER OF VIEWERS. IN ORDER TO BE READY FOR AN INTERVIEW, I NEED TO START SETTING UP SHORTLY BEFORE DAWN. REGARDLESS OF WHEN OR WHERE, THE MOST DIFFICULT ASPECT OF TELEVISED COVERAGE IS TO GET THE FILM CREW TO SHOOT THE WORK FROM THE RIGHT ANGLE.

Subject matter can be an issue at many events. Ironically, the same religious themes that are obligatory in Italy are often unacceptable in the United States. Many of Wenner's themes for events are taken from classical mythology, opera, and literature, as the imagery fits his classical style.

Thanks to an abundance of publicity and press, most spectators arrive at an event prepared to see one of Wenner's famed anamorphic works. Sometimes he misses the surprise factor so common when people came across his work on the streets of Europe. At first they would just see a chalk painting; then slowly they would come to appreciate the quality of the execution, invariably comparing it to the many frescoes still fresh in their memory. To Wenner, the startled and confused look on the faces of many passersby was a much greater compliment than anything that could have been put into words.

Wenner's images have global appeal, and their diffusion through all media generates offers to create his magnificent works around the world. Most Western countries share European art traditions, so Wenner particularly enjoys bringing his art to people in Asian countries, who have a very different visual culture. In recent years, Wenner has done numerous works in China, Japan, Singapore, Jakarta, and Taiwan. In Taiwan, he depicted the palace of a sea dragon, which according to legend lies below the water in a city of 2,500,000 people. One thousand visitors per hour walked around the image, often waiting in long lines that measured up to half a kilometer. The site attracted 250,000 visitors, and more than 3,000,000 people followed the progress of the drawing on the Internet and in the Taiwanese press.

IT IS INTERESTING for me to see the way in which the different cultures perceive my work. In Europe and the United States, the impermanence of street painting is foremost in the public's mind. "WHAT HAPPENS WHEN IT RAINS?" WAS ONE OF THE FIRST ITALIAN PHRASES I EVER LEARNED. To Eastern minds, the impermanence of street painting is completely natural, even unremarkable. They are most fascinated by the drawing style itself, which is very exotic and intriguing to them. Many people in Asia admire Western art and music. SEEING AN ARTIST DRAW IN A WESTERN CLASSICAL STYLE IS FASCINATING TO THEM. Some are surprised to see how fluid the process is. Brush painting, which places a great value on spontaneity of expression, is an integral part of both Japanese and Chinese culture. Asians are surprised to see such a level of spontaneity in a Western drawing.

▶ Wenner. *The Giant*. Scottsdale Arts Festival, Arizona. This allegorical painting uses a myth about the formation of the Grand Canyon.

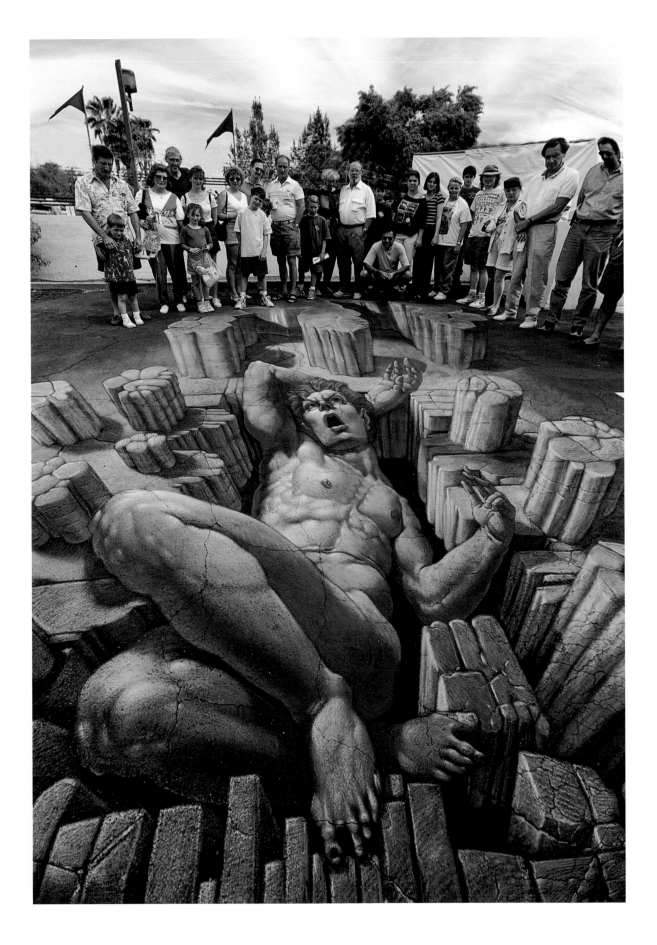

▲ Waiting to see the painting. Kaosiung,Taiwan. The public waited patiently in lines that measured up to five hundred meters for a fifteen minute view of the work.

▶ Wenner, *The Sea Dragon*. Kaosiung, Taiwan. In this interactive piece, a boy saves his brother from the vengeful dragon.

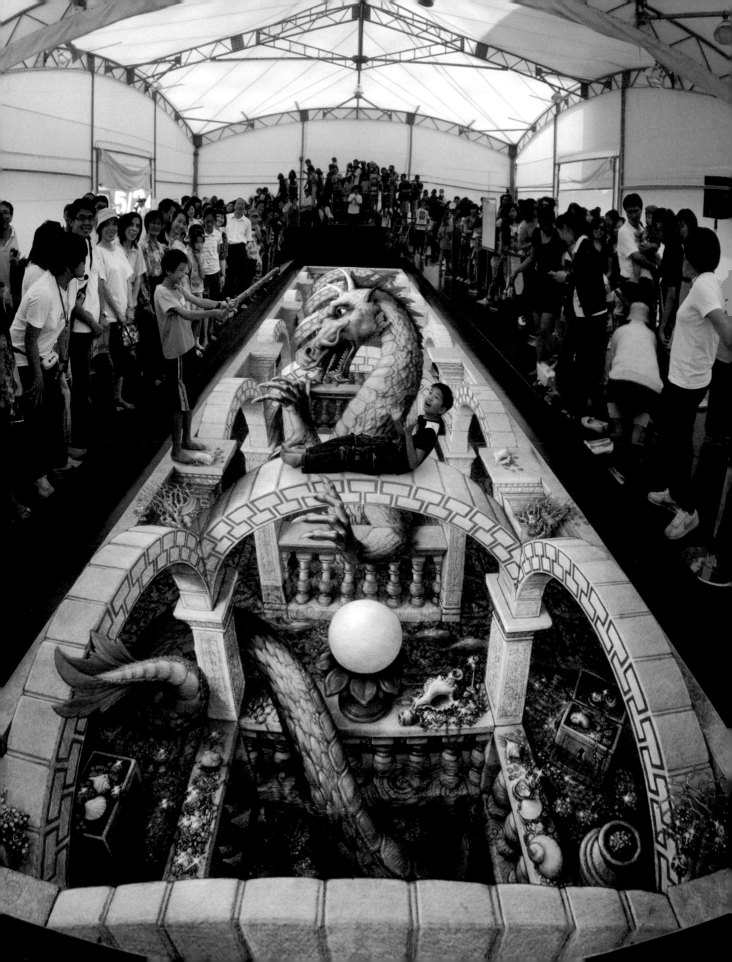

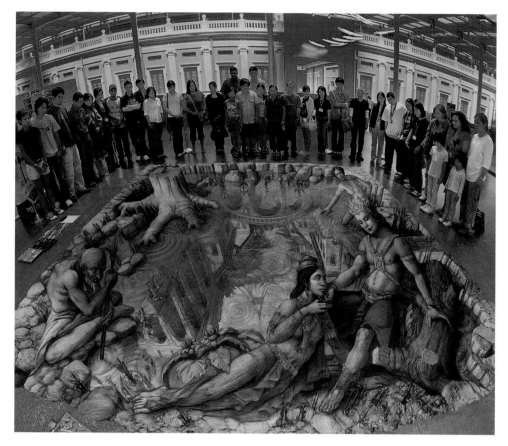

The art of street painting has indeed become global. There are now so many street painting events throughout the world that it is impossible to track them. While the United States tends to use these events to raise funds for charity, it has yet to embrace the idea of street painting as a profession. The European festivals are built on the perception that street painting is a profession and that a number of artists derive a significant portion, if not all, of their annual income from it. Throughout Asia, it is looked on as a novelty of Western culture. The perspective illusions have proven themselves to be particularly popular, and it is assumed that the artists are professionals.

Because both Grazie di Curtatone and the prestigious festival in Geldern, Germany award titles, the events attract street painters from around the globe. Many artists who have had success with the art form in their home country attend these events for the experience of working alongside those who are able to support themselves

▲ Wenner. *Iskandar*. National Museum of Singapore. The subject of this composition is the last king of Singapore and his ill-fated love affair. A view of nineteenth-century Singapore is reflected in the water.

▶ Wenner. *Neptune*. Scottsdale Arts Festival, Arizona. Neptune was always a popular subject for street paintings. Thanks to Disney, children have a fantastic ability to recognize the Olympian deities.

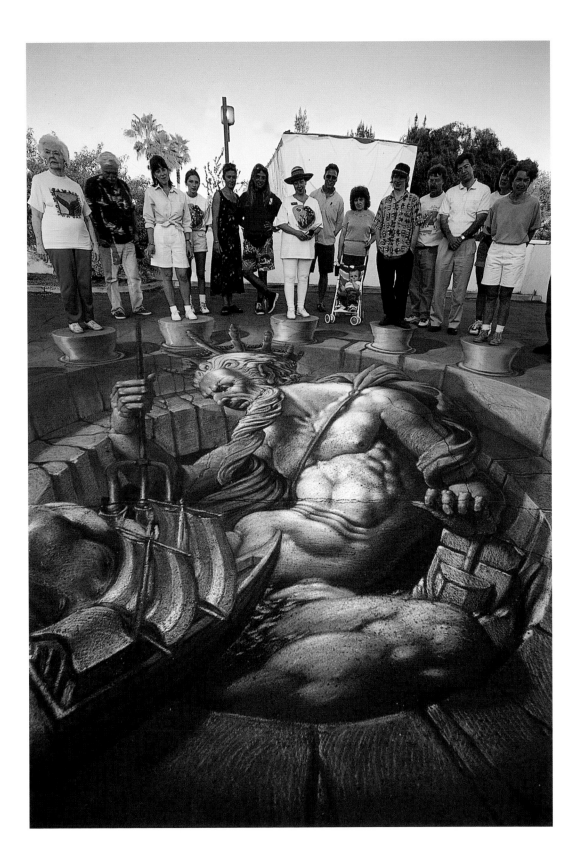

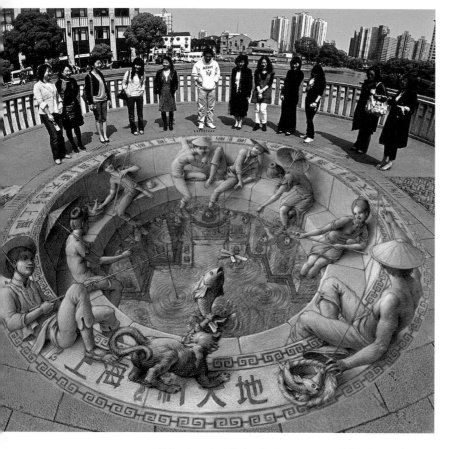

◀ Wenner. *Fishing in Old Shanghai*. Shanghai, China. This bucolic composition was done on a pier in a tree-lined lake in the middle of modern Shanghai.

▶ Wenner. *The Interrupted Tea Party*. Shanghai, China. Xintiandi is a high-end modern section of Shanghai with many beautifully restored buildings and European-style cafés. An international arts festival is organized here. The picture depicts the interruption of a 1920s tea party by a cat that overturns a birdcage. It is a bit of an allegory of the city.

by street painting. Winning a title is likewise helpful to artists who wish to offer their services professionally. The arrival of foreign artists in Grazie keeps the energy and enthusiasm for the festival and art form going, perhaps even saving it from obliteration by its own politics.

Cesare Spezia, the key organizer of the festival in Grazie di Curtatone, has survived a multitude of political changes and is the only continuous link between the competition today and its inception. Each year, just a handful of artists from the early days return to the event, as many of the traditional street painters have died or grown too old for the grueling conditions of the competition. Spezia's commitment to the event has kept it viable through the most difficult times. He is a welcoming presence in a sea of chaos during the competition, and he's always curious to learn where foreigners are from and what they will paint at the event. Global diffusion of the art form brings an annual influx of new street painters to Grazie each year, which helps to preserve the tradition started so many centuries ago.

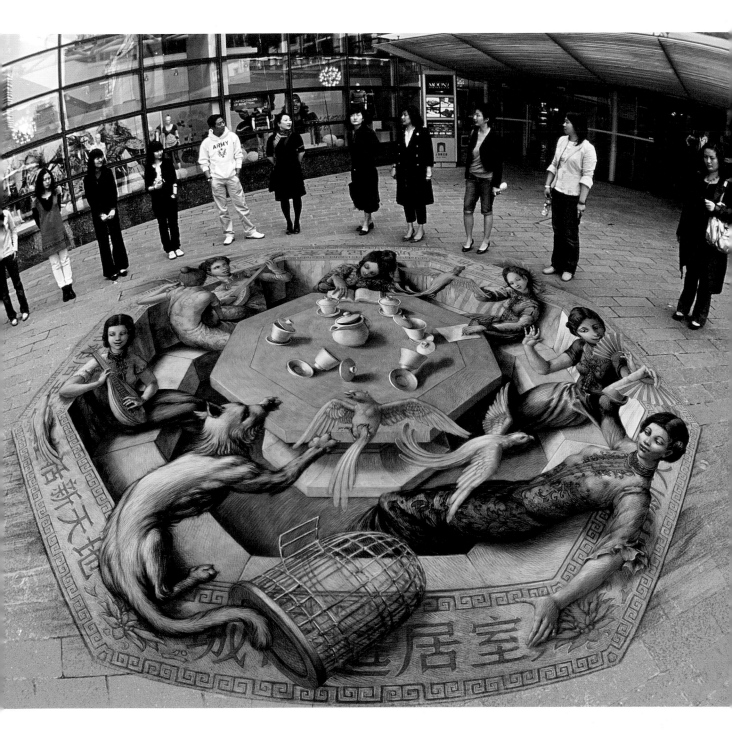

THE GLOBALIZATION OF STREET PAINTING

Once KurtWenner.com was launched, the global diffusion of Wenner's street painting images and the art form was complete. Icon painting that emerged from Crete and Venice and found its way to pavements throughout Italy as an ephemeral art centuries ago is now accessible to people in the most remote parts of the world.

For more than a decade, Wenner was the only artist creating such dramatic images on the street. In 2005, images were taken from Wenner's website and combined with works by Julian Beever. Neither artist was credited in a mass e-mail that circled the images around the globe. As with looking at a painting on the street, it was up to the viewer to discern the inherent quality and complexity demonstrated in the images. Wenner's large, narrative compositions and drawing style are visibly different from those of artists who have been inspired by his original use of anamorphic perspective.

◀ **Wenner. *Willibrord*. Utrecht, Holland.** Wenner participated in many European festivals and competitions while bringing street painting to new countries. This was a competition winner in Utrecht, Holland. The piece was done on cement pavers and reassembled in the city museum after the event.

▶ **Wenner. Celebration of the Arts poster.** This poster was done for the second street painting festival in Fresno, one of the first such events in the United States.

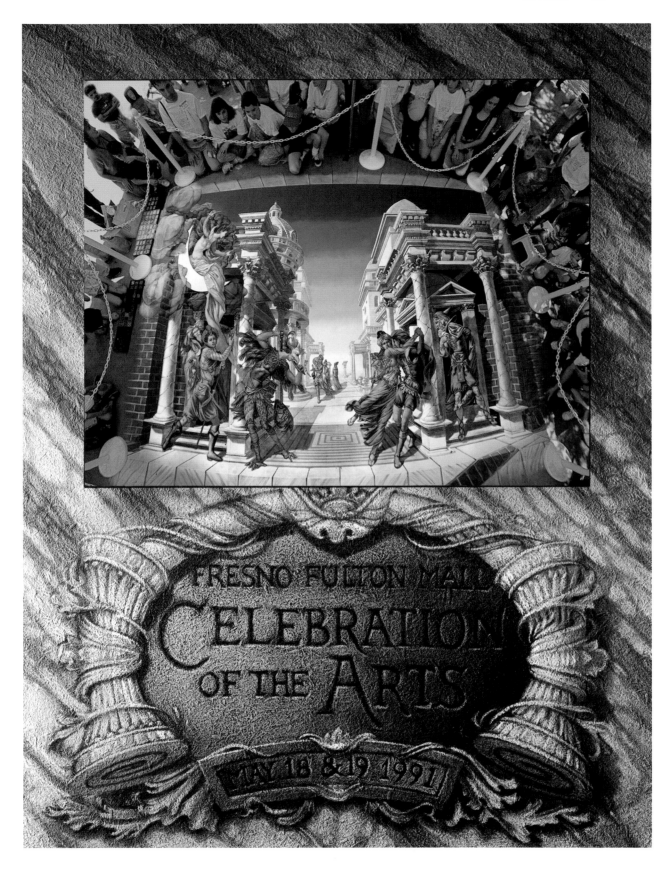

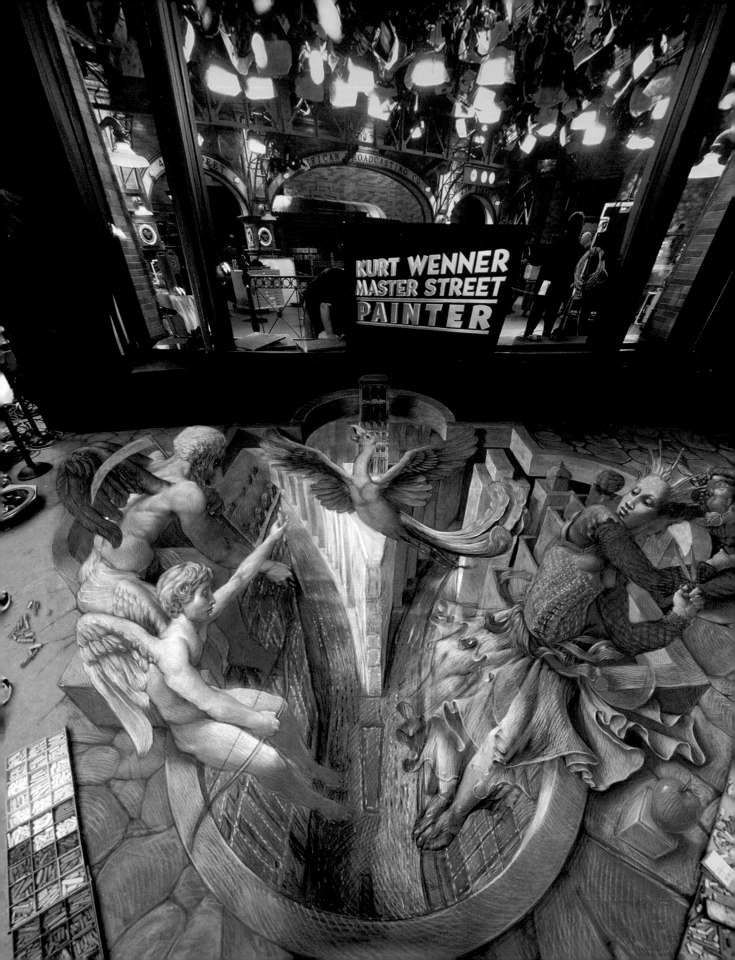

The vast numbers of e-mails circulating the globe caused the Snopes.com "urban legends" Web site to ask Wenner to verify that his images were authentic, and that he had actually created them.

Thanks to the efforts of Snopes.com and others, there is no doubt about the authenticity of Wenner's work. It is now well documented that he invented the geometry that enables him to create his unique three-dimensional works. Those inspired by his approach tend to cut corners and use one of two simple methods instead of fully mastering the geometry. Some artists create their art by looking frequently through a camera lens to check their progress and plan their next strokes. Other artists use Photoshop or other digital imaging programs to distort a picture and create a simplified traditional anamorphosis. The distorted image is then copied onto the street, and a second photo is taken of the chalk painting from the right angle to make the image appear correct again. The painted image then appears to be three-dimensional in the context of the photograph. The Internet controversy brought to light the fact that the popularity of Wenner's images had become so widespread that other artists were now attempting to mimic his invention.

▲ **Times Square, New York.** Wenner was sponsored to create a work for the hundredth anniversary of Times Square. It had daily coverage for a week during the event.

◀ Wenner. *Times Square Allegory*. Times Square, New York.

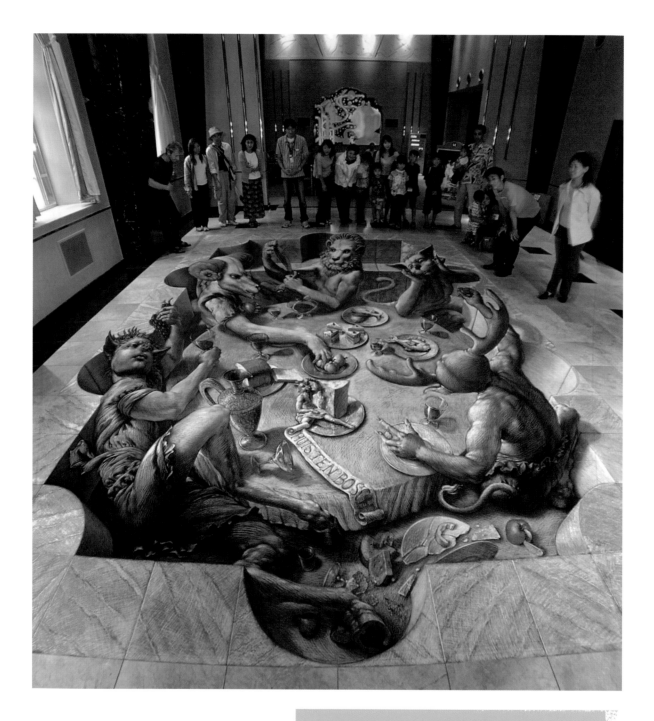

► Wenner. *Circe's Banquet*. Huis Ten Bosch, Nagasaki, Japan. The composition recounts the tale of the sorceress who turned her male guests into swine and sometimes other beasts.

► Wenner. *Water Brings Life to the Desert*. Palm Desert, California. This allegory depicts the importance of water to the desert communities.

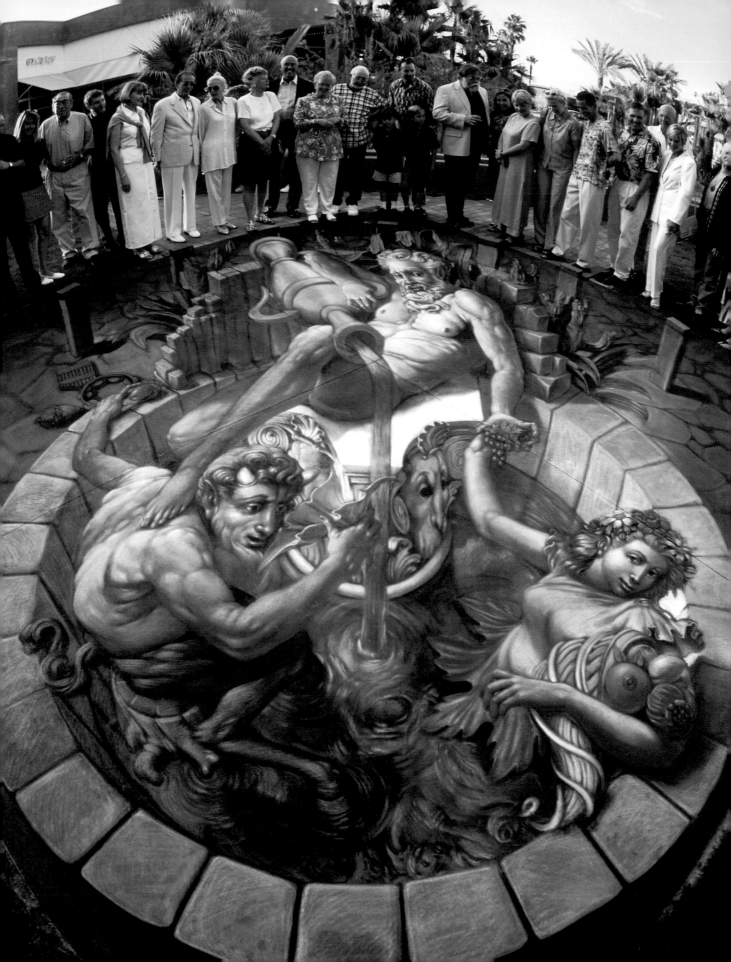

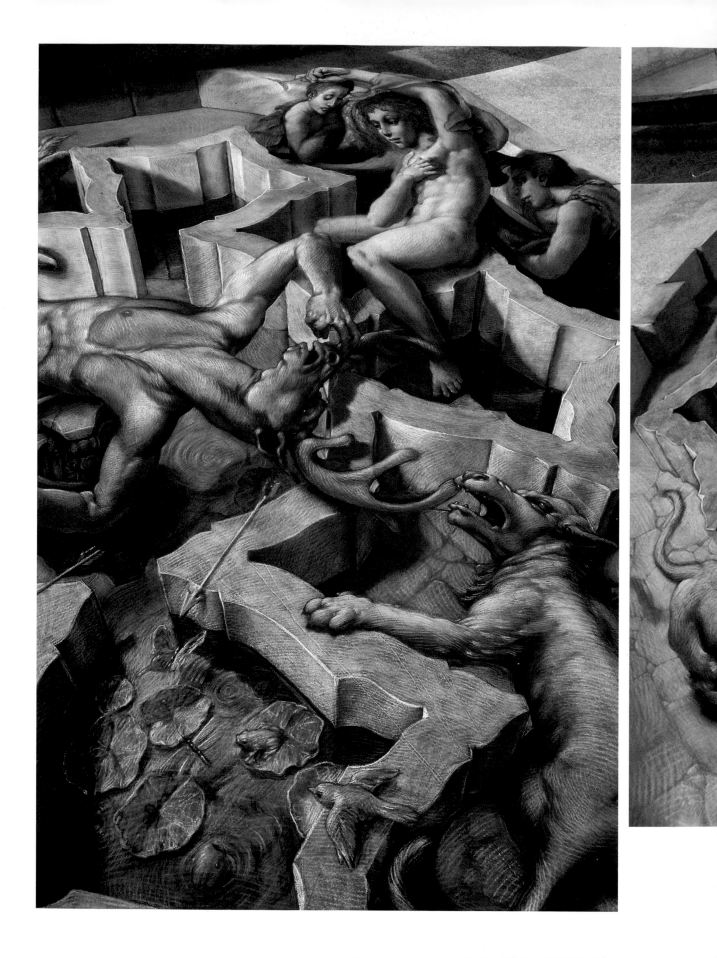

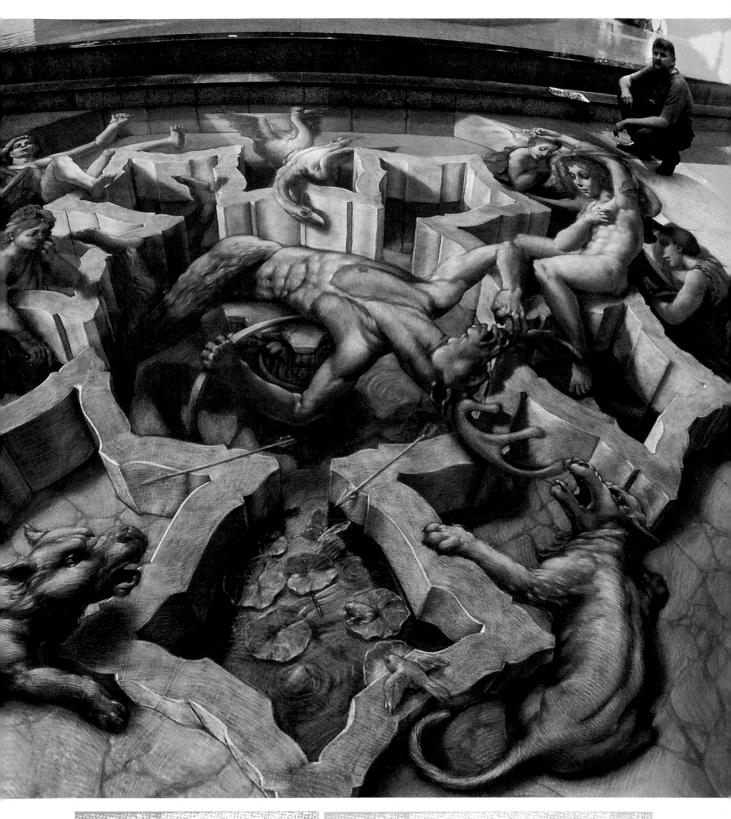

◀ **Wenner.** *Acteon* detail. Acteon was transformed into a stag and pursued by his own hounds after he caught the goddess Diana bathing in the nude.

▲ **Wenner.** *Acteon.* **Torino, Italy.** Commissioned by a large commercial center in Torino, the composition recounts the famous myth of Diana and Acteon. This theme was a favorite for noble hunting lodges. The king of Savoy built a palatial lodge in Stupinigi near Torino.

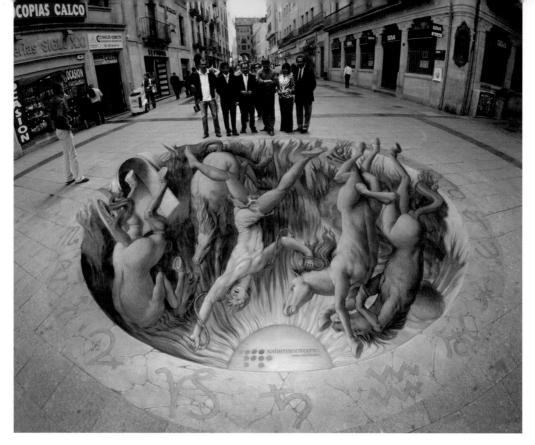

From its initial discovery in the Renaissance, anamorphic art evolved in two directions. Sometimes, it was used purely as an optical illusion: a normal two-dimensional image would be distorted in order to appear normal from a determined point. A more subtle and refined use of anamorphism recognizes it as the logical continuation of perspective geometry beyond narrow, conventionally established limits. Wenner creates his pictorial geometry by selecting the actual viewpoint of the observer of the painting. He creates perspective geometry around that point that is mathematically correct. Because the point of view is at a normal position and the perspective geometry is correct, his unique form of anamorphism is not technically an "optical illusion" any more than normal perspective is. Instead, he composes the work to envelop the peripheral vision of the viewer.

For nearly fifteen years, artists' attempts at imitating Wenner's dramatic images had little success. It wasn't until the use of computer graphics programs became widespread that artists began consistently attempting similar images using the simpler form of anamorphic projection, reminiscent of the optical illusions developed in the seventeenth century. Distorting a photo with a computer program such as Photoshop creates this kind of illusion. The distorted image is then copied onto the street, and a second photo is taken of the chalk painting from the right angle to make the image appear correct again. The painted image then appears to be three-dimensional in the context of the photograph, but not necessarily to the viewer on site.

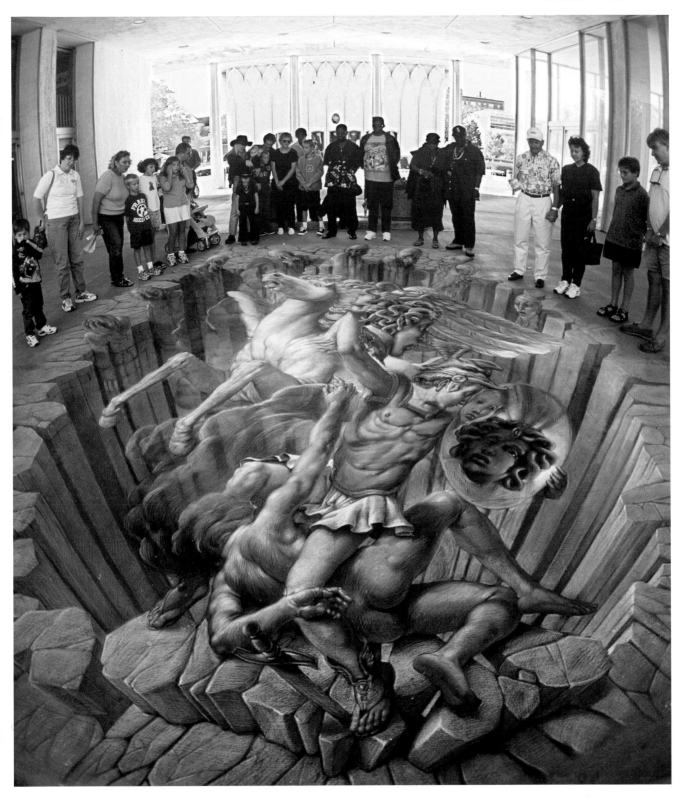

◀ Wenner. *Phaeton.* Salamanca, Spain. The unfortunate Phaeton attempts in vain to control the chariot of his father, the god Helios. The composition was created in homage to the city's famous golden-colored stone.

▲ Wenner. *Perseus with the Head of Medusa.* Detroit Festival of the Arts, Michigan. Perseus avoids looking directly at Medusa by using his shield as a mirror, and beheads the monster. She was so hideous that onlookers would turn to stone merely by gazing at her.

MANY PEOPLE ASK ME IF I COMPOSE MY WORK IN COMPUTER SPACE, AND THE ANSWER IS NO. I DEVELOPED MY FIRST ANAMORPHIC IMAGES BY APPLYING PURE GEOMETRY AND MY KNOWLEDGE OF PERSPECTIVE TO CALCULATE FORMS THE WAY ARTISTS DID FIVE HUNDRED YEARS AGO. MY ONLY TOOLS WERE STRING AND A BIT OF PACKING TAPE. I CAN'T IMAGINE ANYTHING MORE BORING THAN SPENDING HOURS COPYING A DISTORTED PHOTOGRAPH ONTO THE PAVEMENT. RUNNING BACK AND FORTH TO THE CAMERA LENS TO CHECK THE ILLUSION WOULD LIKEWISE BE AN UNINSPIRING EXPERIENCE. TO ME, THE VALUE OF CREATING A THREE-DIMENSIONAL STREET PAINTING IS THE ABILITY TO INSERT MY IMAGINATION INTO THE ENVIRONMENT AND MAKE A TIMELESS STORY TIMELY.

▶ Wenner. *Titania Encantado*. Burgos, Spain. In a composition inspired by Shakespeare's *Midsummer Night's Dream*, the fairy king Oberon orders his elf Puck to apply a sleeping potion to Titania's eyes. The potion is made from a flower called love in idleness, which also frames the composition and Burgos logo.

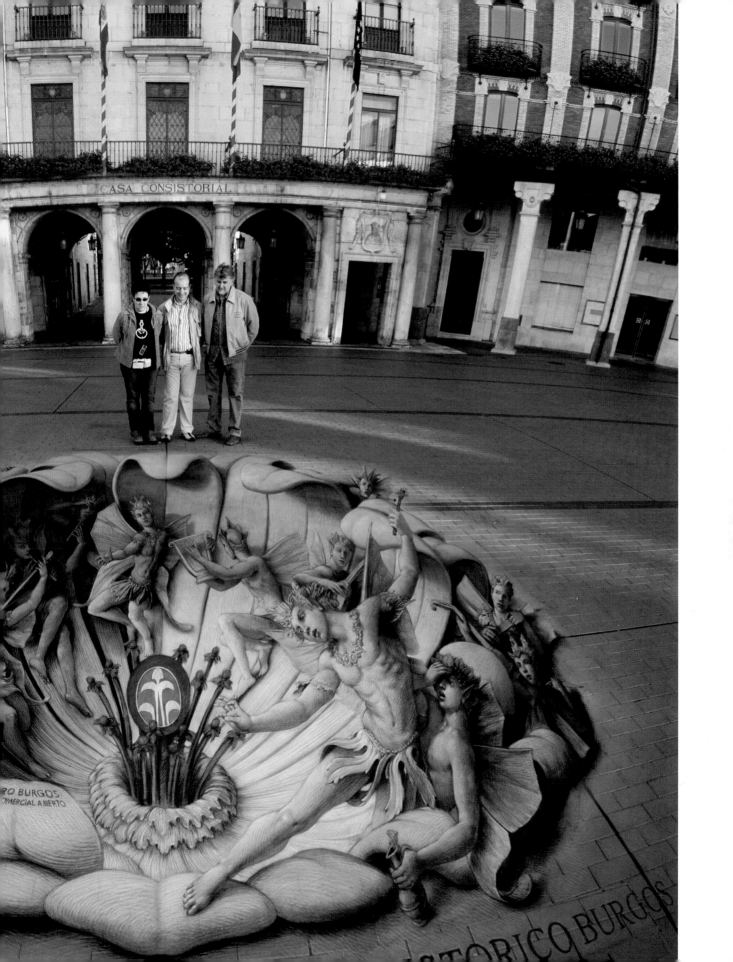

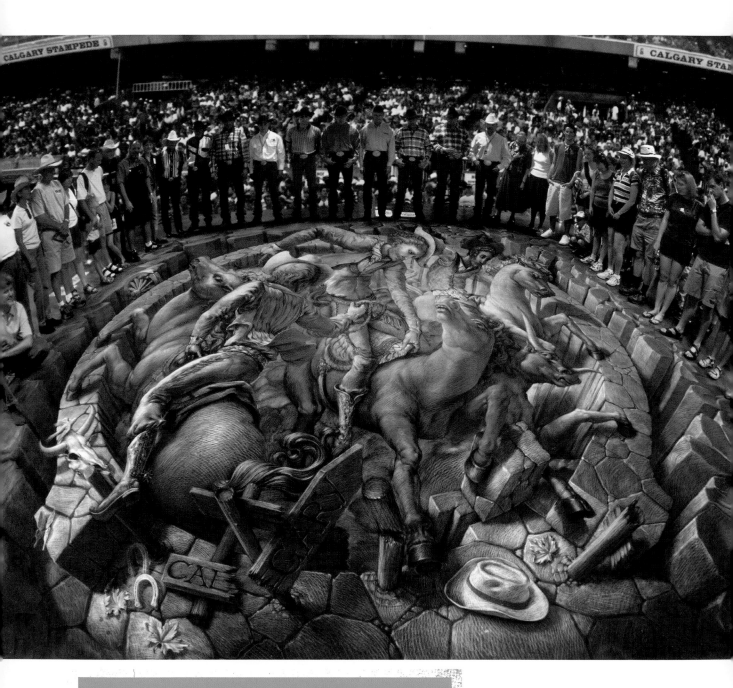

▲ Wenner. *Wild Rodeo.* Calgary, Canada. Real cowboys from the famous Calgary Stampede stand around this composition.

When the drawing itself is a copy of a photograph, the resulting image has the look of a photo composite, even if it technically is not. This was part of the reason for the Internet controversy, as the millions who saw Wenner's images in person knew they were genuine. People who saw only published works on the Internet by artists who created them using a distorted photo or computer graphics program concluded (wrongly) that all such images were simply a computer graphics hoax. For Wenner, the illusion has always been a vehicle to communicate broader ideas, rather than an end in itself.

Wenner was among the last artists who trained themselves in classical perspective theory. When he worked for NASA, he saw the first computer generated line drawings and realized he would be one of the last artists to create perspectives of spacecraft by hand. By the time Photoshop emerged, he was using a geometric method that was subtler than what the graphics program offered. His designs still begin with a perspective space constructed with a compass and straightedge. For him, the computer is now a time-saving device that comes into play late in the creative process. He may use it to check the effect of the final work or allow a presenter to preview the effect, although this can also be done with photography.

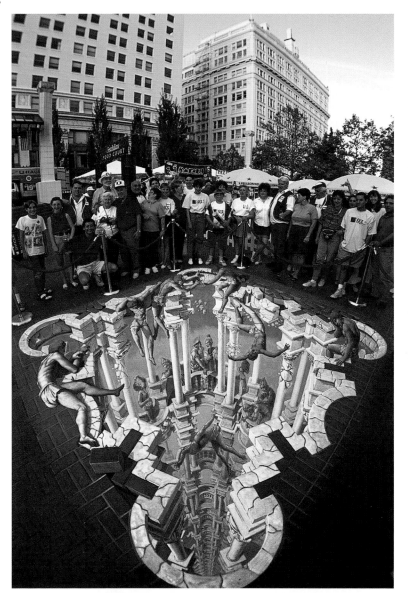

▲ Wenner. *Tower of Babel*. Festa Italiana, Portland, Oregon. Wenner participated for two years in this lively event.

Street painting as an illusion has seen wide dissemination on the Internet in the form of photographs of the images. For Wenner, the photograph will always be a secondary product. The most important part of the art form is the act of creation itself. If the Internet becomes the arbiter of street painting, then the photograph of the image may become more important than the image itself. This would indeed separate the art form from its roots. Wenner appreciates the value of the photograph, but within a larger context.

Like a live recording of a symphonic production, or a live taping in a film studio, a photograph of a street painting is what captures the moment for eternity. When a painting is viewed on the street, the audience concentrates on the work itself because it is an isolated phenomenon, and they evaluate it on its own merit. In a photograph of the work, there is a synchrony between the art and onlookers that is not always apparent to those physically present. The photograph merges the painting with the surrounding environment. Artistry is necessary for the documentation to stand on its own, and when it is successful a street painting becomes a "street scenography" that transforms mundane settings into works of the imagination. For this reason, a photograph does not merely document the street painting, but becomes a work of art in itself. Ironically, the photograph becomes the fine-art product that so many desire.

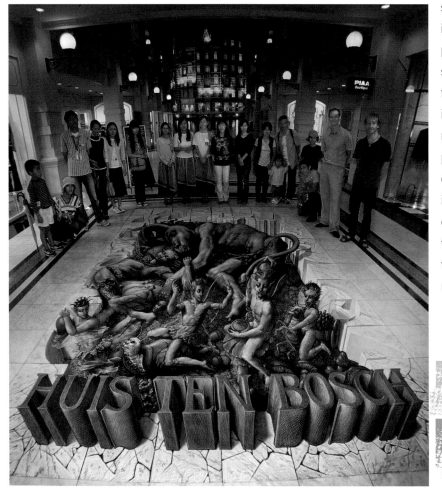

◀ Wenner. *The Triumph of Puck*. Huis Ten Bosch, Nagasaki, Japan.

▶ Wenner. *Crawfish Festival*. Woodbine, Georgia. Here a good use is made of the god Neptune, who cheerfully serves up the delicious crustaceans.

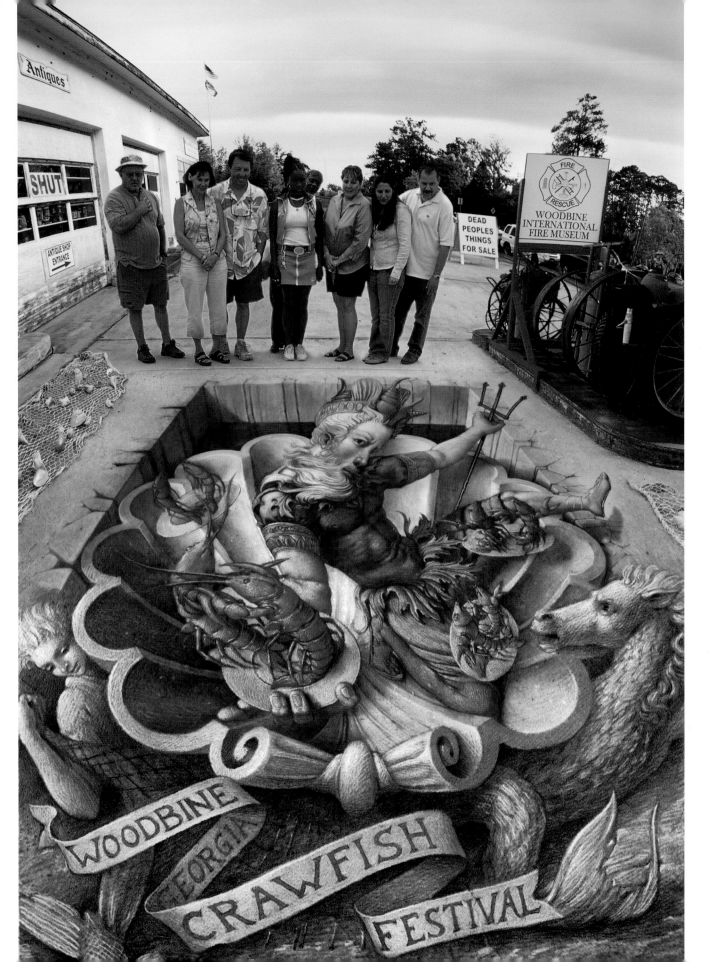

The popularity of Wenner's images on the Internet has caused many advertising agencies to take notice. These agencies are interested not in the history of street painting, but in the illusionistic quality and eye-catching mass appeal of his work. Until the *Absolut Wenner* print ad, all of his work had been strictly fine art. Wenner was curious to see if he could blur the line in advertising by inserting fine art into an otherwise applied-art arena.

THE ADVERTISING AND PUBLICITY AGENCIES THAT WANT MY WORK ARE SPECIFICALLY INTERESTED IN ANAMORPHIC ILLUSIONS.

I ENJOY THE PROJECTS, AS THEY PROVIDE A MEANS OF PROPELLING STREET PAINTING FORWARD. ADVERTISING AND PUBLICITY EVENTS BRING THE ART FORM TO AN EVEN BROADER AUDIENCE. THESE VENUES HAVE CLEARLY ESTABLISHED STREET PAINTING AS A CONTEMPORARY ARTISTIC PROFESSION. THIS IS A VERY IMPORTANT STEP IN ITS EVOLUTION AND SOMETHING I'VE WANTED TO PARTICIPATE IN.

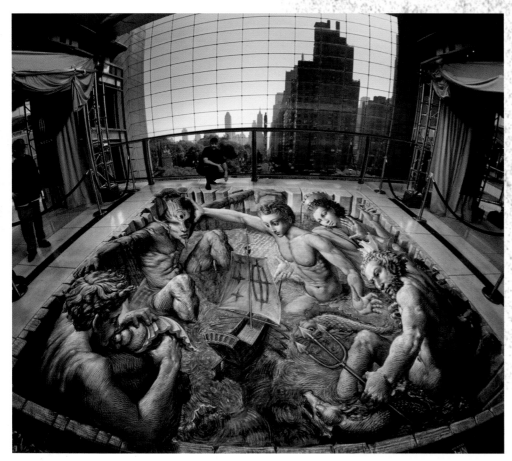

▲ Wenner. *The Odyssey*. Time Warner Center, Central Park, New York. Commissioned by Lincoln Motors, the composition shows the ship of Odysseus navigating treacherous god-infested waters.

▶ Wenner. *Absolut Wenner*. Absolut Chalk Festival, West Hollywood, California. This print ad image formed part of Absolut Vodka's famous-artist ad series. It was done years before the commercial use of street painting images became widespread.

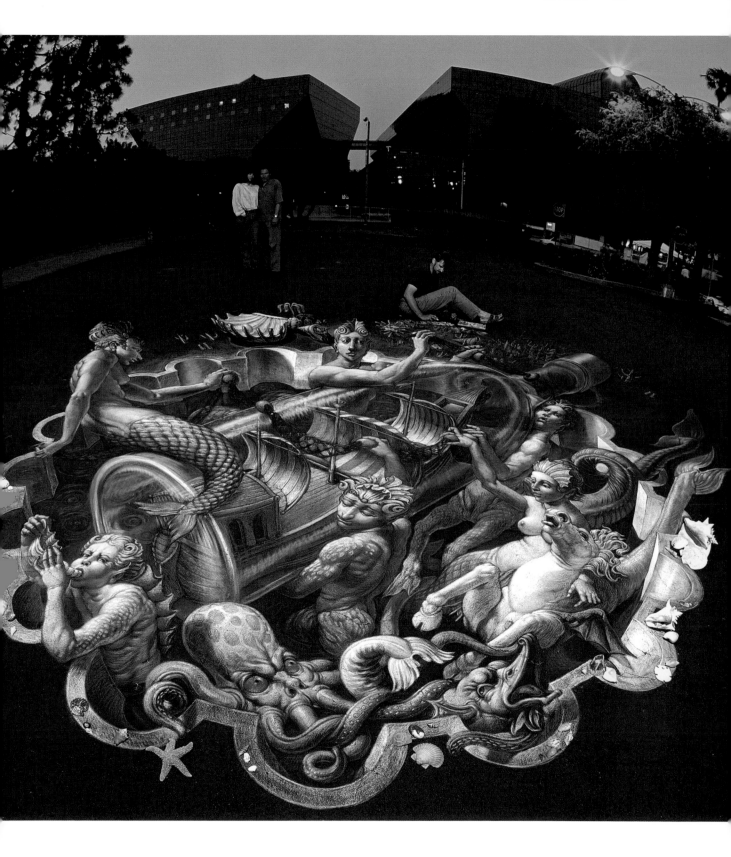

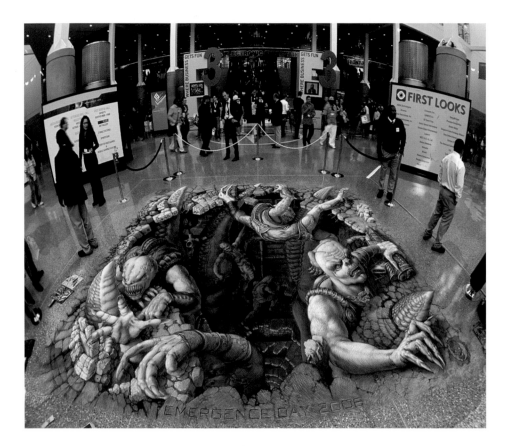

Advertising brought Wenner full circle, back to the concept of fine art and street painting. The term *fine art* strictly means art that is produced for beauty rather than utility. Nothing fits this idea better than ephemeral paintings. For most people, though, the idea of fine art implies a physical object that can be bought and sold. The permanence of the work makes it collectible and establishes its value as an investment. Ironically, advertising and publicity venues are the first to invest in street painting because they are more concerned with public appeal than permanent product.

▲ Wenner. *Gears of War.* E3 Expo, Los Angeles Convention Center, Los Angeles California. Monsters from the Xbox Gears of War game lent themselves well to a composition similar to Wenner's *Dies Irae*, done twenty-four years earlier.

▶ Wenner. *Absolut Wenner* (detail of drawing). The actual product was quite hidden in this composition.

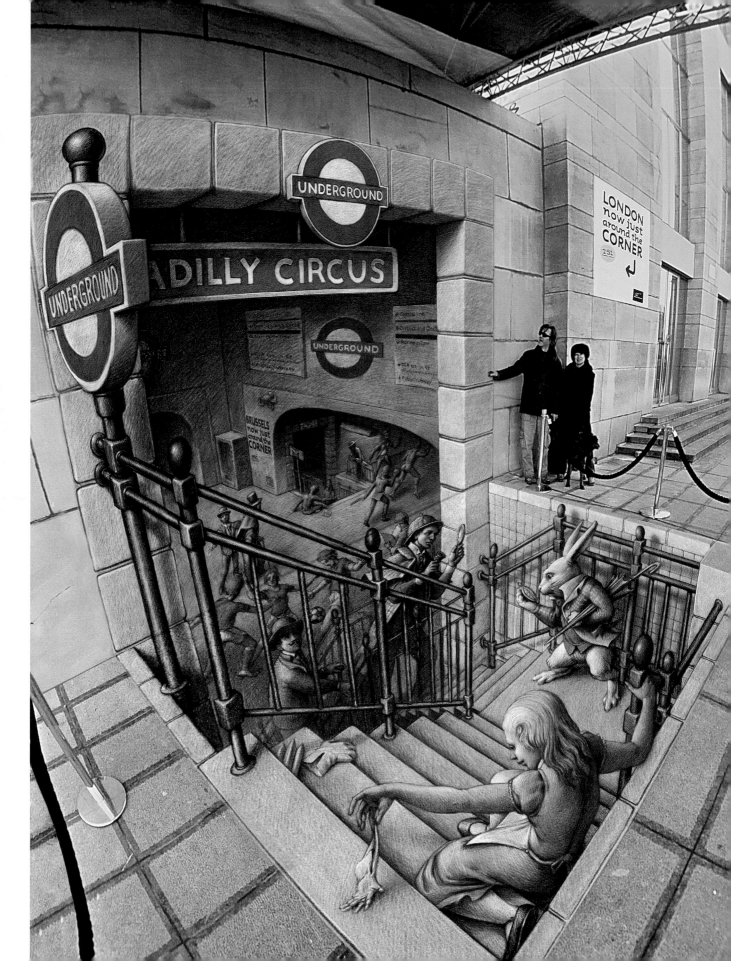

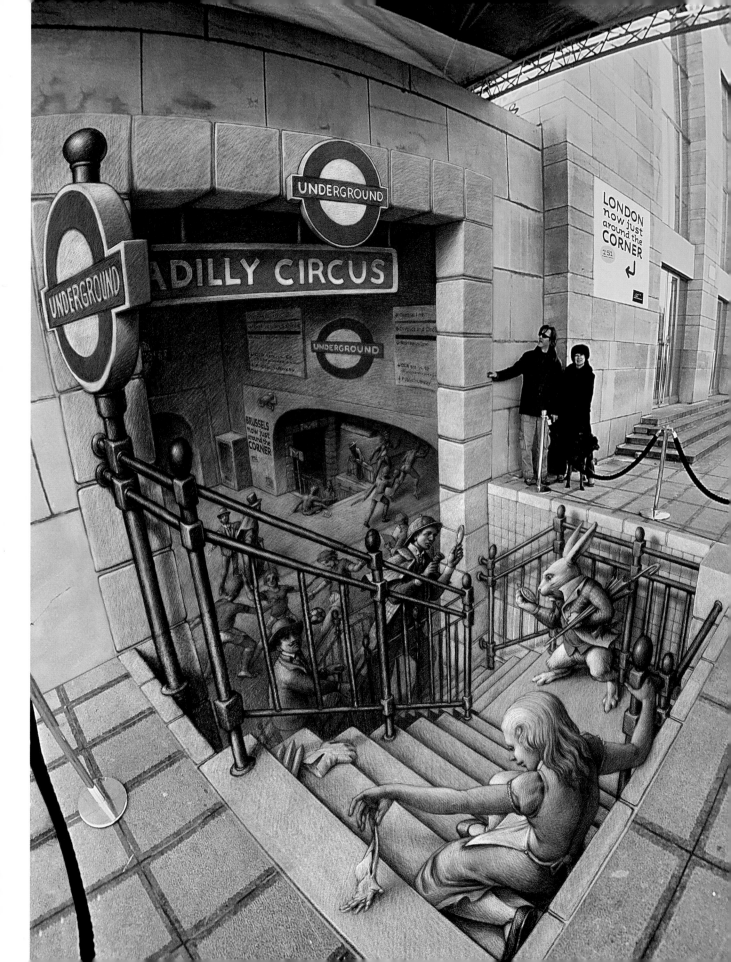

Twenty-five years ago, it would have been beyond the imagination that Fortune 500 companies would be hiring a street painter to represent their products. Today Wenner receives requests from all over the world for events and graphic images. The venue does not appear to be exhausting itself, but rather to be growing in popularity. Part of this demand is for live events, but a large part is for digital images. The rather recent invention of printing digital reproductions onto adhesive or vinyl surfaces has created a new venue for street painting images. Currently, the demand and acceptance of digital art and giclée prints has enabled the medium to enter the world of permanent fine art. Emerging technologies are providing new opportunities to insert street painting images into unique environments and markets.

WHEN I BEGAN street painting, products were limited to photographs or posters. Now there are many ways to create limited editions, murals, public art, and more from street painting images. I think the emergence of new ways to create collectible pieces will result in a further expansion for the art form. Advances in digital technology mean there are more ways to produce digital art, which is the ultimate way to create permanent pieces from street paintings. THE PRODUCT CAN BE REPRODUCED ON A DURABLE SURFACE, AND CAN BE REPLACED IF NECESSARY RATHER THAN RETOUCHED OR RESTORED. Many famous paintings that we see today have undergone numerous restorations, some of which have changed the original work dramatically. A digital file imbues a work with a permanence that no physical painting can ever have.

◀ Wenner. *The Belgian Underground*. Brussels, Belgium. This work re-creates a London subway station in the heart of Belgium. Detective Poirot is joined by Sherlock Holmes while Alice finds the rabbit's missing glove.

Street painting and the Internet both belong to the same pervasive, nonphysical world of images and ideas that define our time more than the world of objects that defined the last century. White rooms filled with splashes of paint on canvas, conglomerations of metal, and ponderous explanations have all been left behind. Nowadays images and ideas scatter into pixels like a Tibetan Buddhist mandala in the wind and are re-created digitally half a world away. Maybe we have come to accept the ephemeral after all.

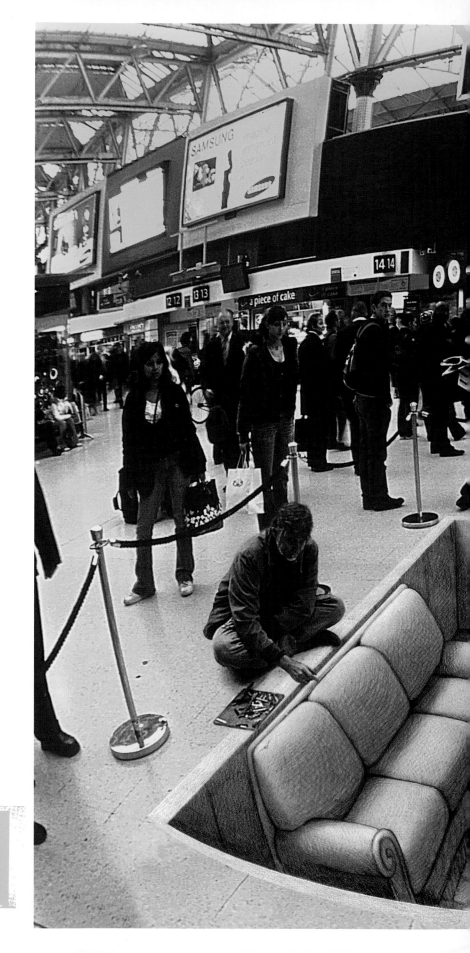

▶ Wenner. *Incident at Waterloo.* This composition is the first to incorporate a vertical panel. It was an instant success and led to a number of commissions. The format is more challenging than Wenner's much-imitated pavement illusions.

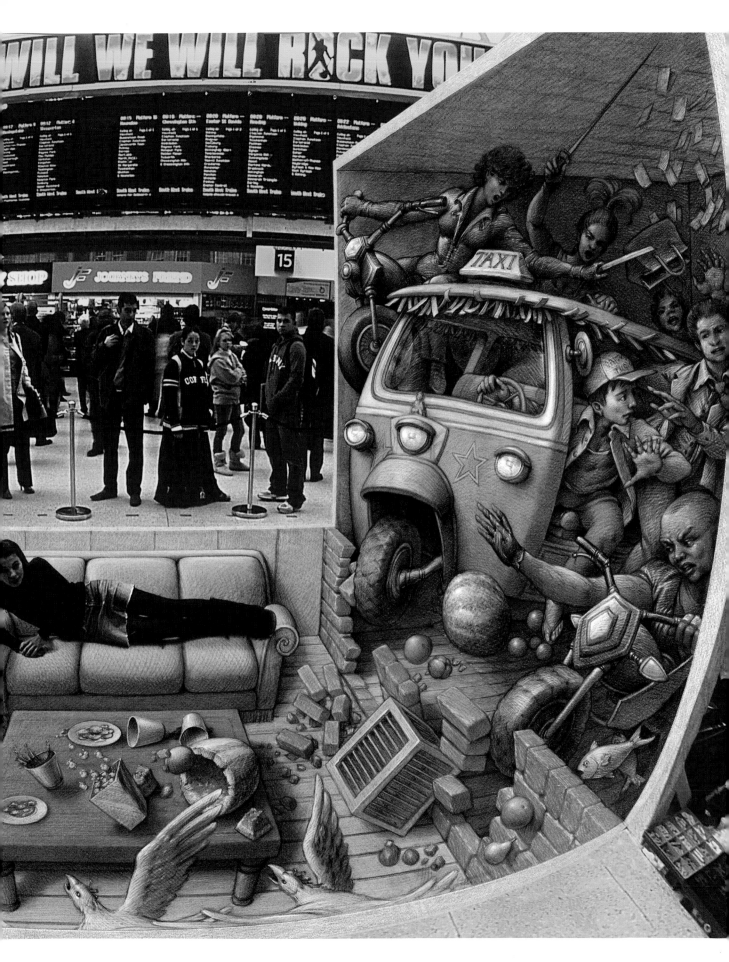

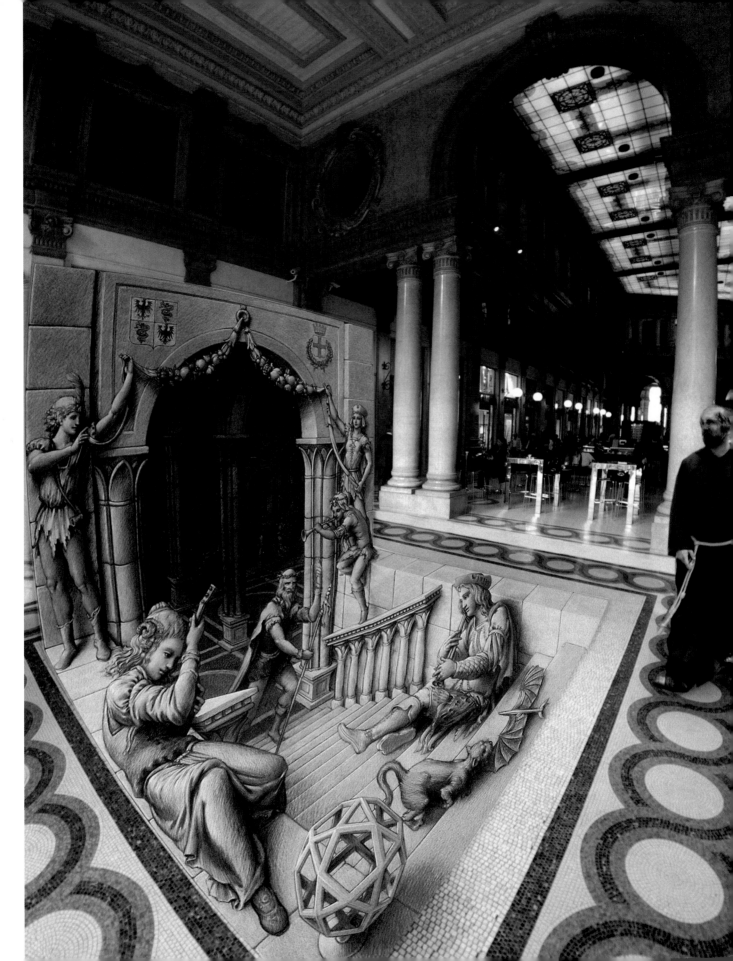

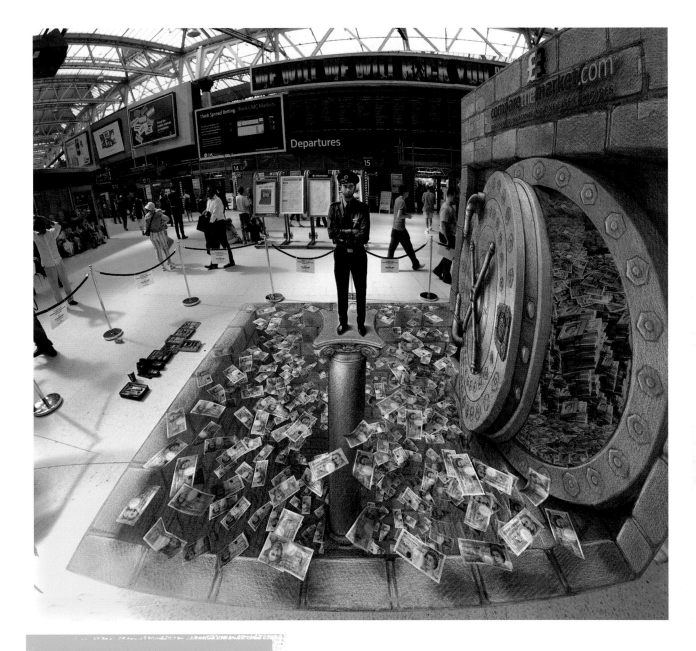

▲ Wenner, *The Moneypit*. Waterloo Station, London. This stereoscopic piece shows the money saved by comparing insurance prices online. The guard was a hired model.

◄ Wenner. *Leonardo in Milan*. Milan, Italy. While the composition was created for the Galleria Vittorio Emanuele II in Milan, Wenner did not supervise the installation. The work is shown here in the Galleria Alberto Sordi in Rome, a similar environment.

8

WHERE TO DRAW THE LINE?

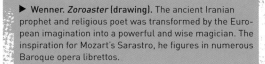

▶ Wenner. *Zoroaster* (drawing). The ancient Iranian prophet and religious poet was transformed by the European imagination into a powerful and wise magician. The inspiration for Mozart's Sarastro, he figures in numerous Baroque opera librettos.

When Kurt Wenner first came across a street painting in 1982, it was a simple and slowly changing form of artistic expression that was just beginning to be officially recognized. From his first encounter, he understood the potential of the medium and the art form. The quality of his traditional street paintings would have been enough to gain him distinction, but he took the art form further by composing original images and creating a new form of street scenography. The results were dramatic, and renown was immediate. Within a span of five years, Wenner created a new direction for street painting, and over the course of the next two decades he spread it globally. His interpretation of the art form as a performance art capable of expressing originality and virtuosity distinguished him from other street painters. He influenced the development of the art form in Italy at the very roots of its tradition. His firsthand connection to its history and the itinerant lifestyle of a madonnaro made his images authentic as well as original. This combination succeeded in capturing the imagination of all who encountered his work.

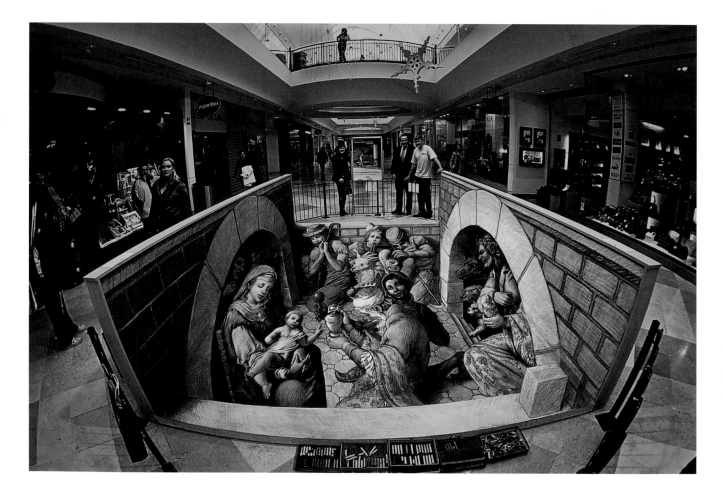

▲ *Nativity* installation. Seen from above, the anamorphic "distortion" is apparent. To use the term distortion is misleading, however, because all perspective is calculated from one point in space. Anamorphic perspective is in this case a geometrically accurate calculation done from a rationally selected point. If the calculation was not correct, no illusion would be achieved.

◄ Wenner. *Nativity*. Xanadu Commercial Center, Madrid, Spain. This traditional theme is carried across three surfaces.

I ARRIVED IN ITALY WITH A PRECISE GOAL OF GAINING AN UNDERSTANDING AND WORKING KNOWLEDGE OF EUROPEAN CLASSICAL ART. I WANTED TO BE ABLE TO CREATE ORIGINAL WORKS WITHIN THE CLASSICAL LANGUAGE OF FORM AND USE CLASSICISM TO COMMUNICATE MY IDEAS WITH THE PUBLIC. STREET PAINTING PROVED TO BE AN IDEAL VEHICLE FOR THIS, AS THE PROCESS OF SHARING MY IDEAS DIRECTLY WITH A CONTEMPORARY AUDIENCE WAS IMMEDIATE. WHEN I LOOK AT PHOTOGRAPHS OF MY STREET PAINTINGS OVER THE YEARS, I SEE MANY DETAILS I WOULD ALTER AND CORRECT. HOWEVER, PERFECTING A WORK AT THE EXPENSE OF COMPROMISING THAT PROCESS WOULD HAVE BEEN MISGUIDED. IF THE IMAGES HAD BEEN PERFECT, I WOULDN'T HAVE BEEN CHALLENGING MYSELF, AND I WOULDN'T HAVE GIVEN THE PROPER MESSAGE TO MY AUDIENCE. A STREET PAINTER NEEDS TO LEARN TO ACCEPT FLAWS IN AN IMAGE, BECAUSE EVERY PIECE SHOULD BE A LEARNING EXPERIENCE FOR HIMSELF AS WELL AS FOR THE AUDIENCE.

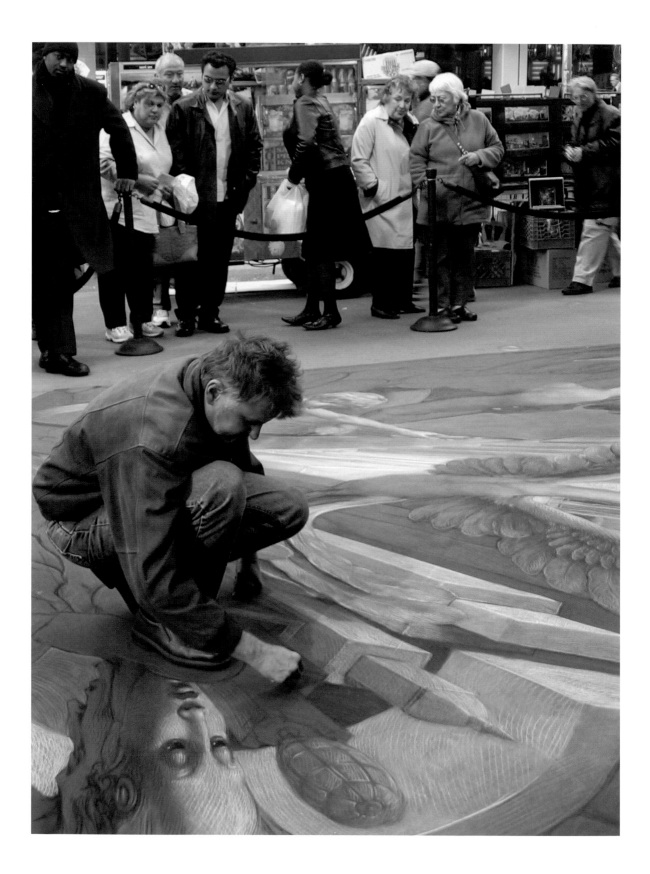

Wenner soon put forth the concept of defining street painting as a performing art. Because he was continually asked about the destruction of the work after it was finished, he needed to find a way to relate it to other media the public was already familiar with. He felt there was a parallel between how a street painter uses drawing and painting and the way an actor uses his body and voice, or a musician plays an instrument. This concept helped the audience understand and accept that the act of drawing and painting is what is essential. Whether or not the finished art is destroyed is inconsequential to the performance of the work.

The spread of street painting has been exceptional and has caused a renaissance of the art. Once created by a few isolated and often impoverished individuals, street painting has grown into a colorful and spectacular expression of artistry. Today thousands of artists and millions of spectators around the world enjoy it.

▶ Wenner. *The School of Architecture*. The Venetian Hotel, Las Vegas, Nevada. In addition to painting and pavement art, Wenner designs architecture and architectural details. He is working on programs for inserting classical architectural proportions into CAD technologies.

◀ Working in Times Square. Street painting has a fabulously wide demographic that can well be appreciated in culturally diverse environments such as Times Square. Old and young, street thugs and police stop to admire the work.

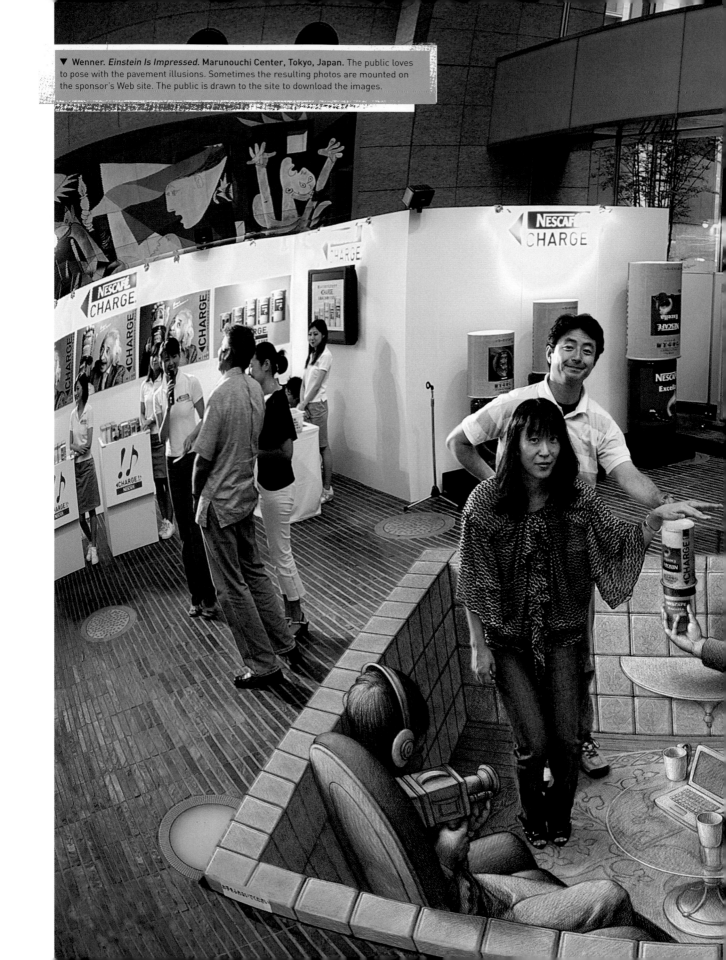

▼ Wenner. *Einstein Is Impressed.* Marunouchi Center, Tokyo, Japan. The public loves to pose with the pavement illusions. Sometimes the resulting photos are mounted on the sponsor's Web site. The public is drawn to the site to download the images.

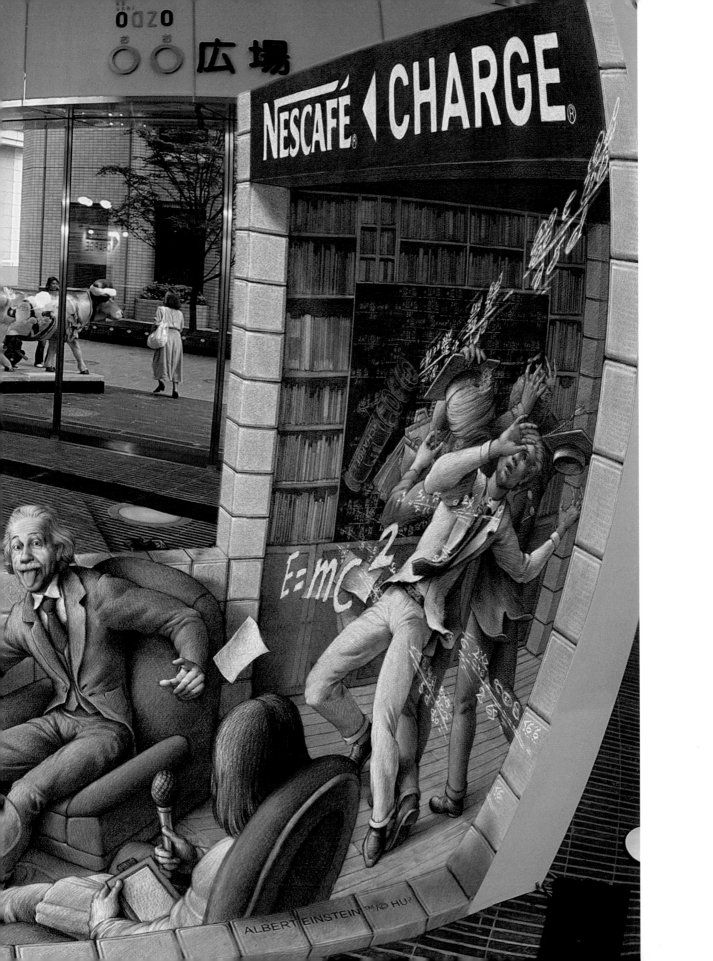

YEARS AGO, I NEVER WOULD HAVE GUESSED THAT THE ORIGI-
NAL FESTIVAL AT GRAZIE DI CURTATONE WOULD BE THE INSPIRATION FOR
DOZENS OF COUNTERPARTS IN THE UNITED STATES AND BE KNOWN AROUND
THE WORLD. MANY ARTISTS AND PRESENTERS HAVE NOW SPENT A DECADE
OR TWO PROMOTING AND PASSING ALONG THE ART OF STREET
PAINTING TO ENDLESS SCORES OF ARTISTS AND ONLOOK-
ERS. OVER THE YEARS,
I HAVE MET COUNTLESS
DEDICATED INDIVIDUALS WHO
HAVE HELPED PROMOTE
AND SUPPORT THE
ART FORM. MANY HAVE
MADE EXTRAORDINARY EF-
FORTS, AND I KNOW THEIR
COMMITMENT HAS HAD AN
ENORMOUS IMPACT.

Over the past quarter century, Wenner has created images in front of millions of
spectators. During this time, he has witnessed a metamorphosis in the art form
and a paradigm shift in the public's perception of it. Street painting has come full

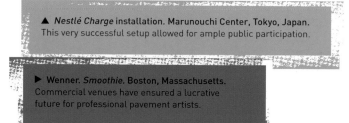

▲ *Nestlé Charge* installation. Marunouchi Center, Tokyo, Japan.
This very successful setup allowed for ample public participation.

▶ Wenner. *Smoothie*. Boston, Massachusetts.
Commercial venues have ensured a lucrative
future for professional pavement artists.

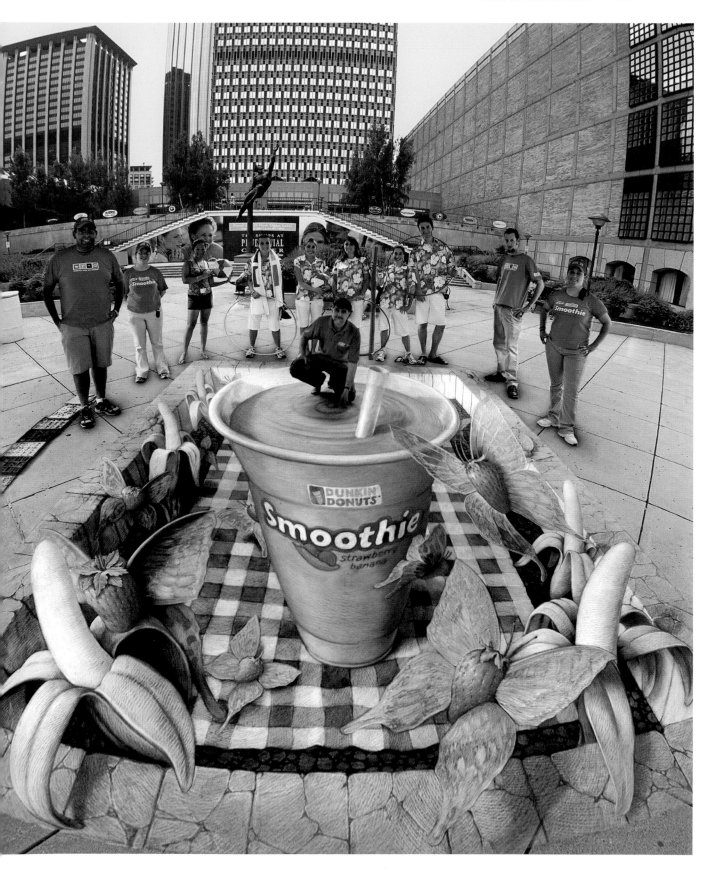

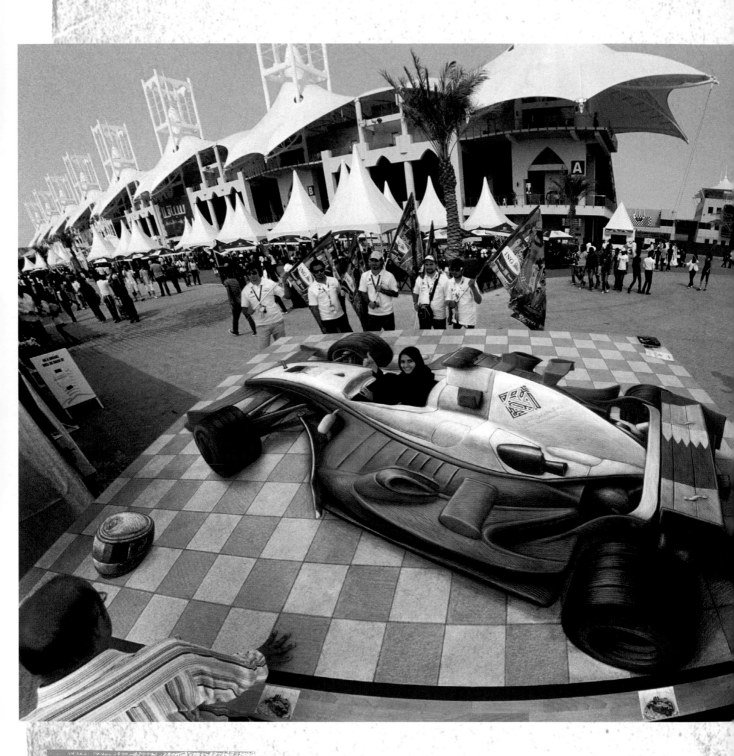

▲ Wenner. *Virtual Formula 1.* Bahrain International
Circuit, Bahrain. A hole in this drawing allowed for the
public to get into the vehicle's driver's seat.

circle: from its early roots in Italy, where street painters and their art were once considered a product of homelessness and poverty, to a fund-raising tool for charities. An art form once viewed as the product of untrained artists is now a vehicle for art instruction. Some of the same artists who were once "moved on" by the authorities are now commissioned by international corporations to create eye-catching images.

The boom in street painting's popularity is due in large part to its flexible nature. It's a medium that accommodates countless individual styles and skill levels. It adapts beautifully to multicultural form and content. It is impressive how vast and varied the audience for street painting is: Every age, religion, and level of education is drawn to it. It is an art form with no linguistic or cultural barriers. It is not a style of art or even a technique, but represents a unique interaction between a visual artist and the public. In recent years, the ephemeral aspect of the work has become less important than its ability to interact with the audience, and the performance aspect has also partially shifted from the artist to the audience—no longer content to pose behind the work, the public now desires to perform within its context.

The ancient art form has incorporated many new technologies as well. Cell phones that take photos, the Internet, and high-resolution digital imaging have all influenced the recent evolution of street painting. Thus the art form has been reborn as a new way for artists and the public to interact. The artist is presenting ideas, rather than commodities, directly to a public fascinated with imagination instead of auction-house prices.

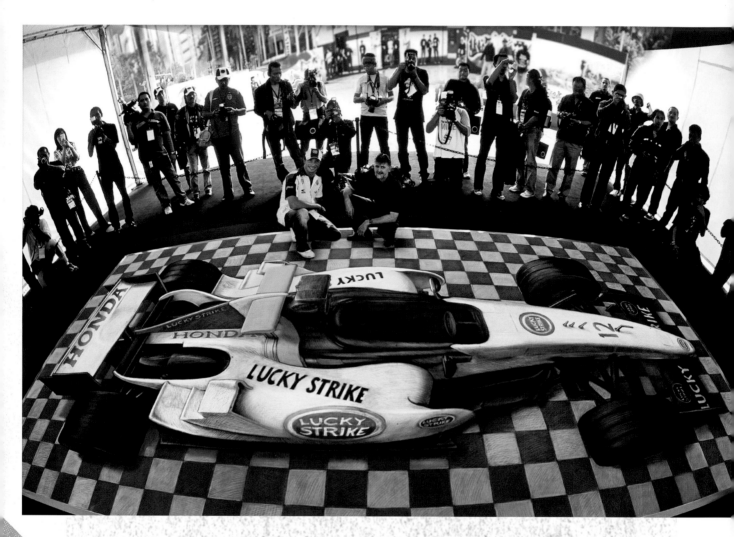

GRAZIE IS THE ITALIAN WORD FOR "THANK YOU," AS WELL AS THE NAME OF THE TOWN THAT HOSTS THE STREET PAINTERS WHO IN TURN WRITE THE WORD GRAZIE NEXT TO THEIR PAINTINGS. STREET PAINTERS PROBABLY HAVE MORE PEOPLE TO THANK THAN ANY OTHER SORT OF ARTIST. THE REMUNERATION THAT A STREET PAINTER RECEIVES IS IN EXCHANGE NOT FOR A PRODUCT, BUT FOR A VISION OR IDEA. THIS VISION IS NOT MERELY ONE OF A PAINTED IMAGE, BUT IT ENCOMPASSES THE ACT OF CREATION AND THE ARTIST HIMSELF. TO ALL THE ROMAN PASSERSBY WHO DROPPED A COIN OR BILL INTO MY BASKETS, TO THE MANY PRESENTERS, CORPORA-TIONS, AND CULTURAL ORGANIZATIONS THAT HAVE SPONSORED MY WORK, AND TO THOSE WHO STOPPED TO LOOK, OR TOOK A PHOTOGRAPH TO SHARE WITH A FRIEND, I WOULD LIKE TO SAY MILLE GRAZIE, A THOUSAND THANKS, FOR ALL YOUR SUPPORT.

▲ Wenner. *Honda Formula 1*. Jakarta, Indonesia. Formula 1 cars are known for being low to the ground, but none is actually flatter than Wenner's. The photo is taken with the famous F1 driver Jenson Button.

THE 15 MOST FREQUENTLY ASKED QUESTIONS

1.
DID YOU PAINT THIS?

Yes.

2.
WHAT HAPPENS WHEN IT RAINS?

RAIN IS A GREAT ENEMY OF STREET PAINTERS. DROPS OF RAIN WILL STAIN A PICTURE, AND THERE IS NO FOOLPROOF MEANS OF PROTECTION. TENTING THE PICTURE OR COVERING IT WITH PLASTIC HELPS, YET WATER WILL SEEP UNDER JUST ABOUT ANYTHING IF THE RAIN LASTS LONG ENOUGH. I FIX DAMAGED AREAS BY REAPPLYING THE COLOR.

▶ **Wenner.** *Lexus US Open.* **Flushing Meadows, New York.** This work makes a racetrack of the Lexus logo. It was created at the US Open tennis championship.

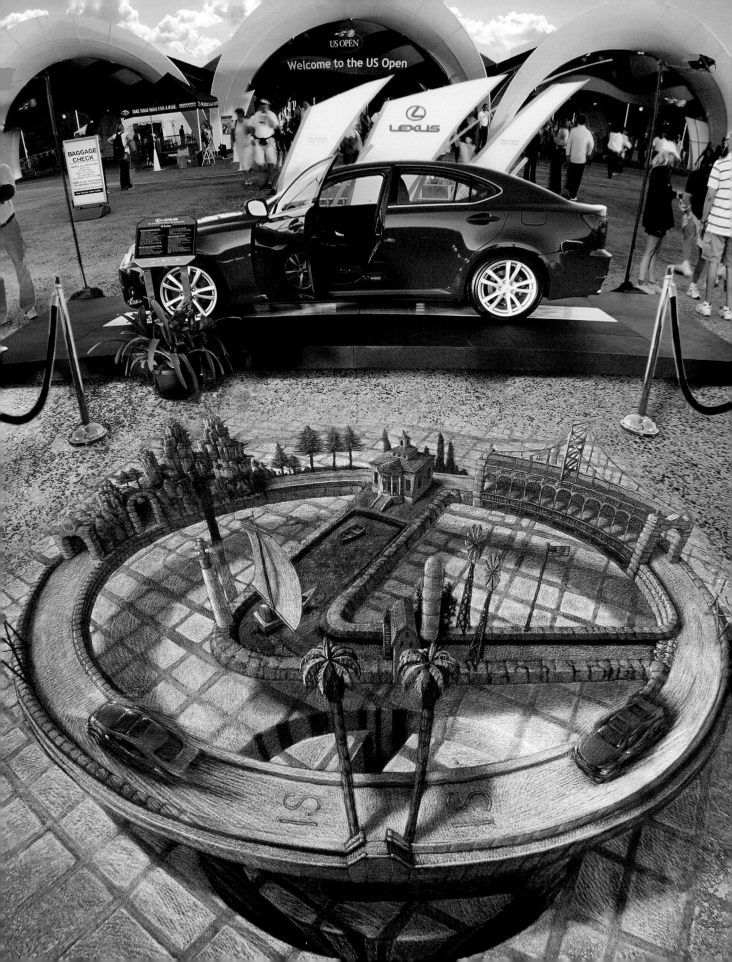

3.
HOW LONG DOES IT TAKE?

I PAINT SOMEWHERE BETWEEN TWO AND SIX SQUARE METERS [TWENTY-TWO TO SIXTY-FIVE SQUARE FEET] A DAY. THE COMPLEXITY OF THE DESIGN AND THE QUALITY OF THE PAINTING SURFACE DETERMINE HOW MUCH I AM ABLE TO ACCOMPLISH.

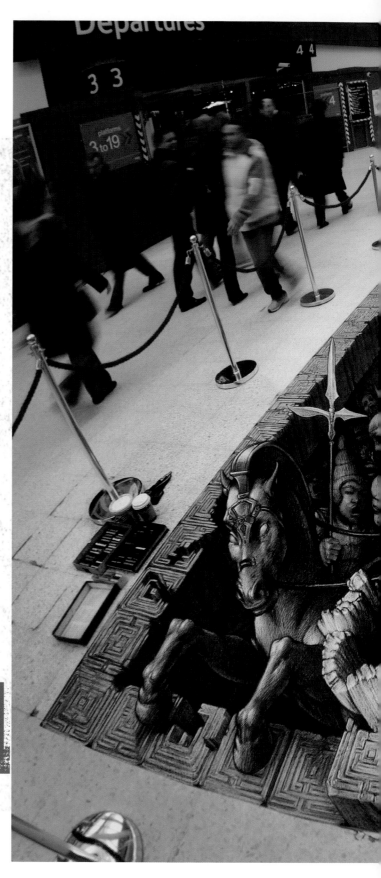

▶ Wenner. *The Mummy.* Waterloo Station, London. For publicity purposes, the interactive aspect of the art is extremely important. Stand-up elements add a new dimension to the designs.

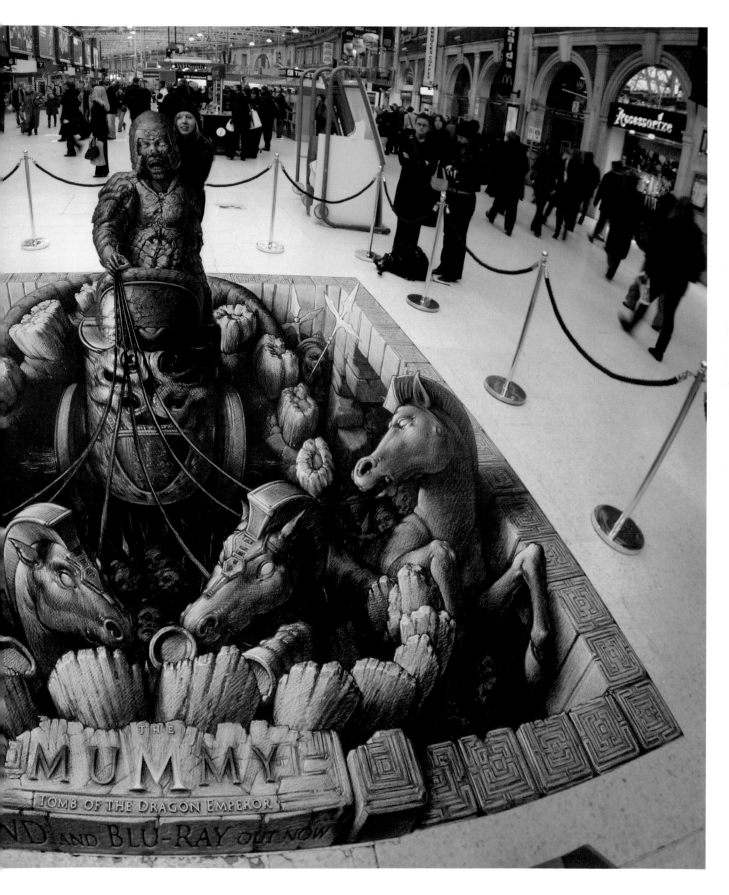

4.
ARE YOU DISAPPOINTED WHEN IT WASHES AWAY?

I AM ALWAYS AWARE OF THE IMPERMANENCE OF STREET PAINTING; WIND, SUN, DIRT, AND RAIN CONSTANTLY REMIND ME OF ITS FLEETING NATURE. EVEN AS I'M CREATING A NEW PART OF THE PICTURE, I CAN SEE THE FINISHED PARTS FADING. I'M NOT DISAPPOINTED WHEN IT WASHES AWAY BECAUSE STREET PAINTING IS PERFORMANCE ART; IT'S VERY MUCH LIKE ATTENDING A SYMPHONY. WHEN THE MUSIC ENDS, EVERYONE LEAVES WITH A MEMORY OF THE MUSIC. MY WORK IS THE SAME, EXCEPT THAT ONE IS LEFT WITH A VISUAL IMPRESSION. JUST AS MUSIC IS RECORDED TO HELP PRESERVE A MOMENT, MY PAINTINGS ARE PHOTOGRAPHED WHEN THEY'RE FINISHED.

▲ *Mummy* installation. Waterloo Station, London. Publicity events in train stations often have quiet moments. Here the backside of the mummy element is shown.

▶ Wenner. *The Eiffel Tower in Rome.* Piazza della Rotonda, Rome, Italy. Digital floor graphics are a new venue for the pavement artist. This stereoscopic design takes advantage of its location to create curiosity.

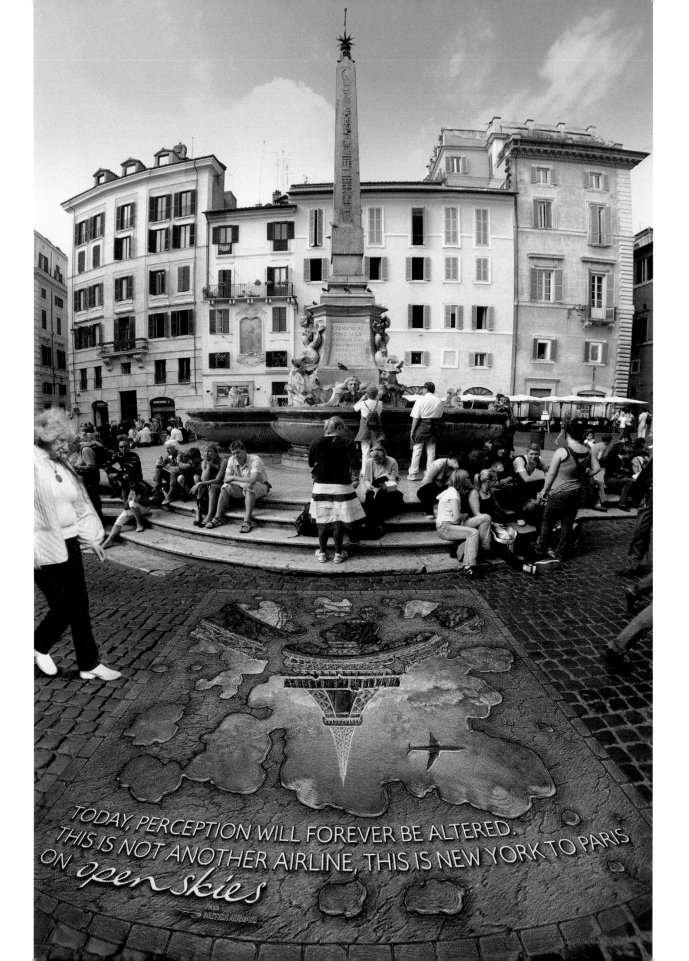

TODAY, PERCEPTION WILL FOREVER BE ALTERED.
THIS IS NOT ANOTHER AIRLINE, THIS IS NEW YORK TO PARIS
ON *open skies*
FROM BRITISH AIRWAYS

5.
HOW LONG DOES THE PAINTING LAST IF IT ISN'T DESTROYED?

IT IS DIFFICULT TO PINPOINT EXACTLY WHEN A PICTURE IS GONE. IN SWITZERLAND, WHERE THE CLIMATE IS VERY HARSH, I'VE RETURNED TO OLD STREET PAINTING SITES AFTER A YEAR AND STILL SEEN FAINT IMAGES OF THE PICTURES ON THE GROUND. CLIMATE, CARS, BICYCLES, AND PEDESTRIANS ARE ALL FACTORS THAT DETERMINE THE SURVIVAL TIME OF PAINTINGS. A STREET PAINTING IMAGE CAN LAST ANYWHERE FROM A COUPLE OF DAYS TO MORE THAN A YEAR.

6.
CAN YOU SPRAY SOMETHING ON THE PICTURE TO KEEP IT FROM WASHING OR FADING AWAY?

THE PERMANENCE OF ANY WORK OF ART DEPENDS MORE ON ITS ENVIRONMENT, ITS SUPPORT, AND THE QUALITY OF MATERIALS USED IN ITS CREATION THAN ON A PROTECTIVE VARNISH. ANYTHING SPRAYED ONTO CHALKS OR PASTELS WILL CAUSE THEM TO SINK INTO THE PAINTING SURFACE. THEREFORE, ANY SORT OF FIXATIVE APPLIED TO A WORK ON THE STREET WILL DO LITTLE TO PROLONG THE LIFE OF THE IMAGE.

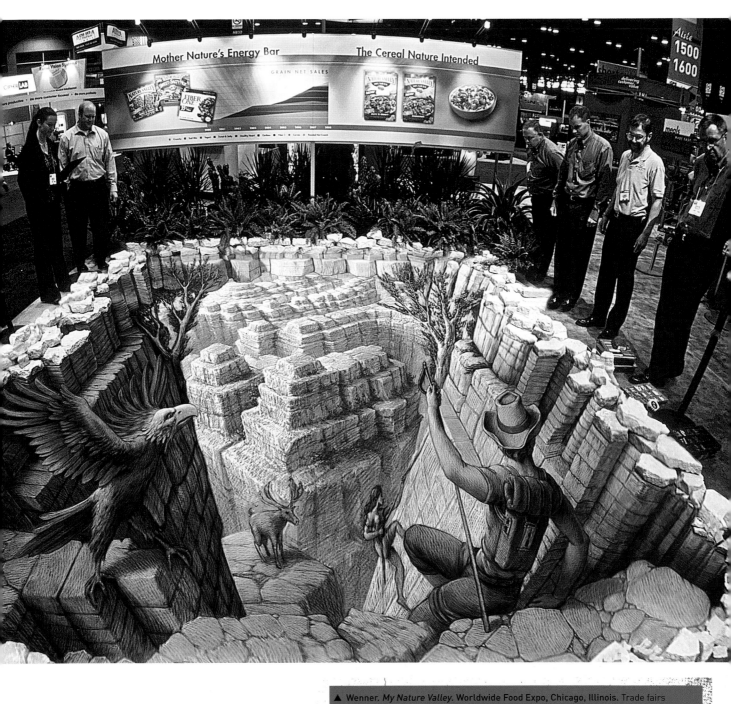

▲ Wenner. *My Nature Valley*. **Worldwide Food Expo, Chicago, Illinois.** Trade fairs present contemporary venues much like the traditional *fiere* of Italy.

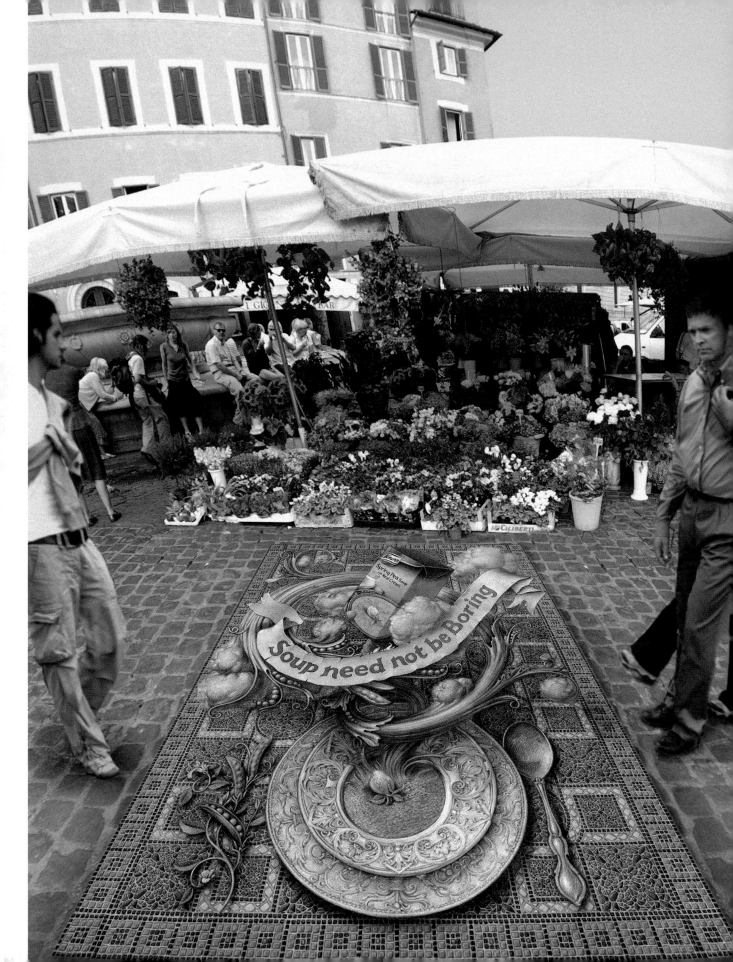

7.
IS IT PERMITTED TO STREET PAINT EVERYWHERE?

◀ Wenner. *Pea Soup.* Campo dei Fiori, Rome, Italy. This is another example of a floor graphic in a complementary location. Floor graphics can be produced in quantity for better coverage.

THE OCCUPATION OF PUBLIC SPACE WORLD-WIDE IS GENERALLY COVERED BY MUNICIPAL CODES, WHICH OF COURSE VARY FROM LOCATION TO LOCATION. I HAVEN'T HEARD OF MANY PLACES WHERE STREET PAINTING IS FORBIDDEN, EXCEPT FOR ZÜRICH, SWITZERLAND. THEREFORE, MOST STREET PAINTERS SELECT A SPOT THEY ARE HAPPY WITH AND BEGIN WORKING. IT USUALLY DOESN'T TAKE TOO LONG FOR A UNIFORMED PEACE OFFICER TO SHOW UP AND INFORM A PAINTER IF A PERMIT IS NEEDED, OR IF IT IS FORBIDDEN TO WORK IN THAT PARTICULAR LOCATION. STREET PAINTERS MUST ASSUME THEY ARE PERMITTED TO PAINT UNTIL THEY ARE TOLD OTHERWISE.

8.
CAN YOU MAKE A LIVING DOING THIS?

AS WITH MOST OCCUPATIONS, YOU GENERALLY ONLY FIND PEOPLE ENGAGED IN THE WORK BECAUSE IT SUPPORTS THEM. THERE ARE OF COURSE VARYING DEGREES OF SUCCESS. SOME PAINTERS LIVE HAND-TO-MOUTH, AND OTHERS ENJOY IT AS A LUCRATIVE PROFESSION. SUCCESS IS VERY DEPENDENT ON THE PUBLIC'S REACTION TO A PARTICULAR IMAGE AND THE ARTISTRY OF THE PAINTER.

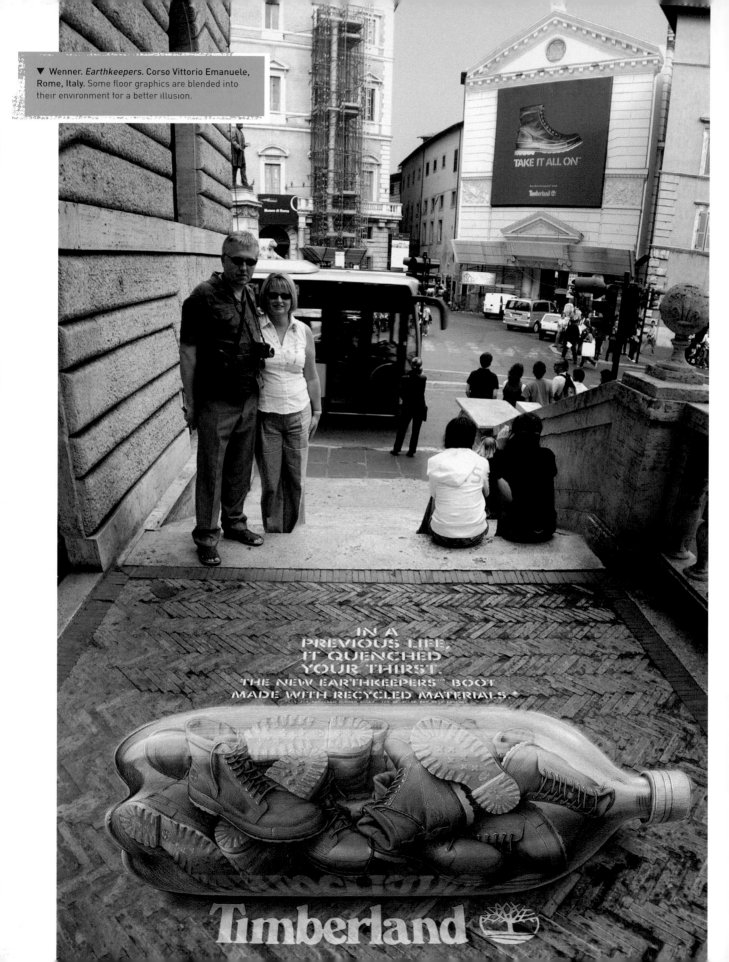

▼ Wenner. *Earthkeepers.* Corso Vittorio Emanuele, Rome, Italy. Some floor graphics are blended into their environment for a better illusion.

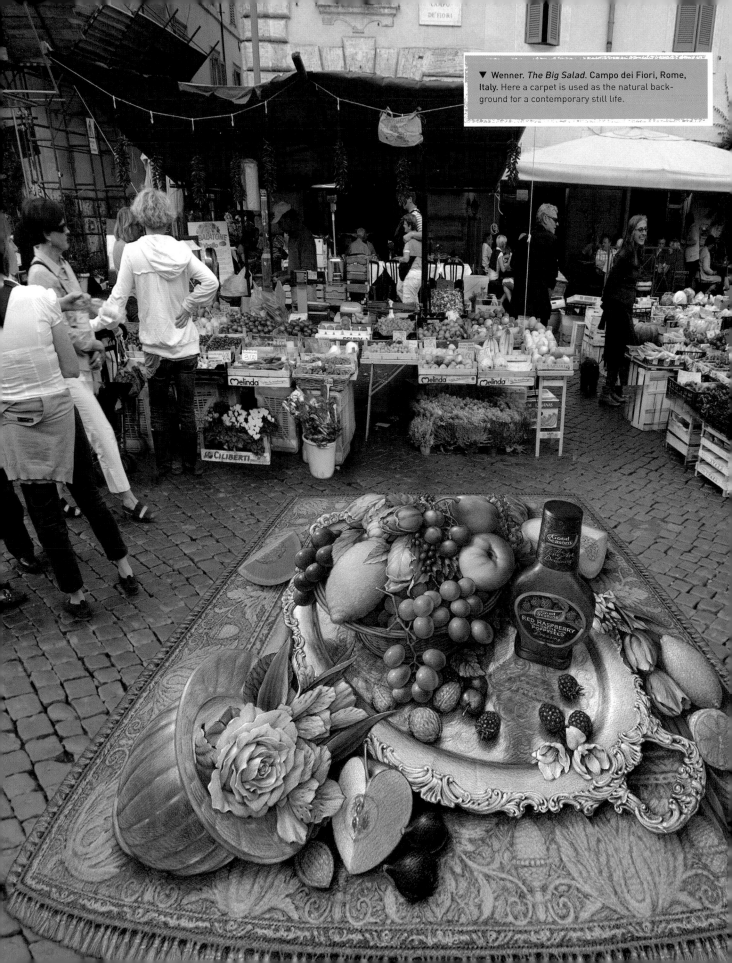

▼ Wenner. *The Big Salad.* Campo dei Fiori, Rome, Italy. Here a carpet is used as the natural background for a contemporary still life.

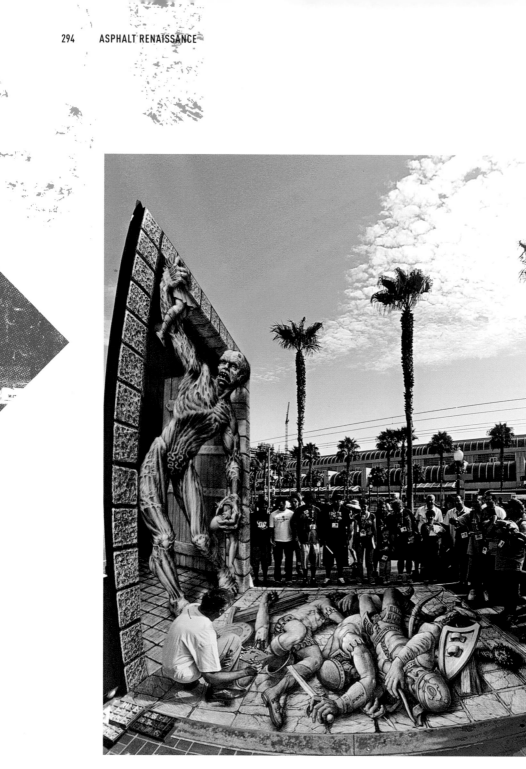

9.
HOW MANY PEOPLE MAKE THEIR LIVING AS STREET PAINTERS?

I IMAGINE THERE MUST BE BETWEEN TWO HUNDRED AND FIVE HUNDRED ARTISTS AROUND THE WORLD WHO DEPEND ON STREET PAINTING AS THEIR PRIMARY SOURCE OF INCOME. THERE ARE MANY MORE SEASONAL PAINTERS WHO WORK ONLY IN THE SUMMER MONTHS.

10.
HOW DID YOU LEARN TO DO THIS?

I BEGAN BY ATTENDING ART SCHOOL, WHERE I WORKED ON MY DRAWING SKILLS AND KNOWLEDGE OF PERSPECTIVE. AFTER THAT, I WORKED FOR NASA, UNTIL I LEFT MY POSITION IN ORDER TO GO TO ITALY AND STUDY DIRECTLY FROM THE MASTERWORKS. I SPENT COUNTLESS HOURS, FOR MONTHS ON END, DRAWING AND LEARNING FROM MASTER PAINTINGS AND SCULPTURES. ONE DAY, I SAW A STREET PAINTING AND ASKED THE ARTIST WHAT HE WAS DOING. HE EXPLAINED THE TRADITION OF STREET PAINTING IN EUROPE TO ME, AND AFTER VIEWING MY MUSEUM STUDIES HE ASKED ME IF I'D LIKE TO PAINT THE HEAD OF AN ANGEL WHILE HE WENT TO DINNER. WORKING WITH CHALK CAME VERY NATURALLY, AND FROM THAT POINT ON I'VE BEEN STREET PAINTING.

◀ Wenner. *Grendel's Revenge.* Comic-Con, San Diego, California. Vertical panels are especially effective outdoors, where they can be seen from a distance.

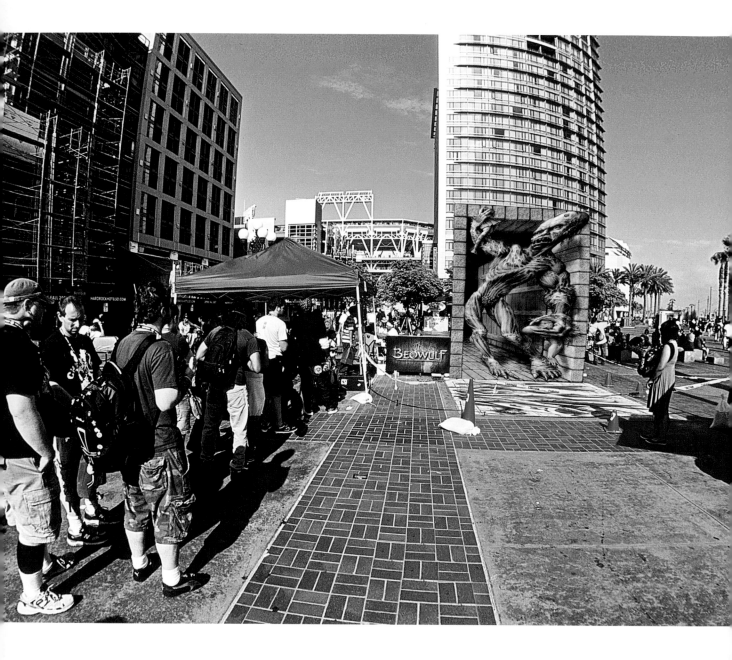

11.
WHAT KIND OF CHALKS ARE YOU USING?

WHEN I FIRST STARTED STREET PAINTING, I USED COMMERCIAL CHALKS AND PASTELS. I FOUND THE CHALKS TO BE VERY DUSTY, AND THEY BLEW AWAY EASILY. THE PASTELS WERE MORE PERMANENT, BUT VERY COSTLY, AS I'D USE A COUPLE HUNDRED STICKS PER PICTURE. OUT OF NECESSITY, I BEGAN EXPERIMENTING WITH PIGMENTS AND BINDER WITH THE HOPE OF MAKING MY OWN PASTELS. NOW I HAND CREATE MY OWN PASTELS, WHICH ARE STRONGER AND MORE PERMANENT THAN COMMERCIAL PRODUCTS.

◀ *Grendel's Revenge* installation. Comic-Con, San Diego, California. The public lines up to view and photograph the work through the lens. The anamorphic distortion can be seen on the vertical panel as well as on the floor art.

12.
HOW ARE YOU ABLE TO WALK ON YOUR PAINTING WITHOUT DAMAGING IT?

MOST OF THE PAINTING'S COLOR IS IN THE PORES OF THE PAINTING SURFACE. I TRY TO WALK ON THE PICTURE AS LITTLE AS POSSIBLE, BUT SOMETIMES I MUST IN ORDER TO RETOUCH A SPOT OR REMOVE DEBRIS THAT HAS BLOWN ONTO IT.

13.
DO YOU MAKE A DRAWING OF WHAT YOU ARE GOING TO PAINT?

WHEN I FIRST STARTED STREET PAINTING, I SELDOM MADE DRAWINGS OF WHAT I WOULD PAINT. NOW THAT I PAINT FOR SPECIAL EVENTS, I LIKE TO WORK OUT THE COMPOSITION AND GEOMETRY PRIOR TO ARRIVING ON SITE.

▶ Wenner. *The Moneypit.* Waterloo Station, London. This work is the premiere stereoscopic street painting designed by Wenner. When viewers don special ColorCode glasses, the ground gives way to a pit and the bills fly into the air. This is also a new technology that lends itself especially well to small-scale works. (See page 267 for a view of this piece from the right angle.)

14.
HOW CAN YOU SEE WHAT YOU ARE DOING?

UNLIKE OTHER PROJECTS WHERE IT IS POSSIBLE TO STAND BACK AND VIEW AN ENTIRE WORK, STREET PAINTING AND LARGE-SCALE MURAL PAINTING ARE UNIQUE IN THE SENSE THAT YOU MUST IMAGINE THE WHOLE PAINTING WHILE WORKING ON A DETAIL OF IT. IT TAKES SPECIAL TRAINING AND EXPERIENCE TO WORK IN SUCH A FORMAT.

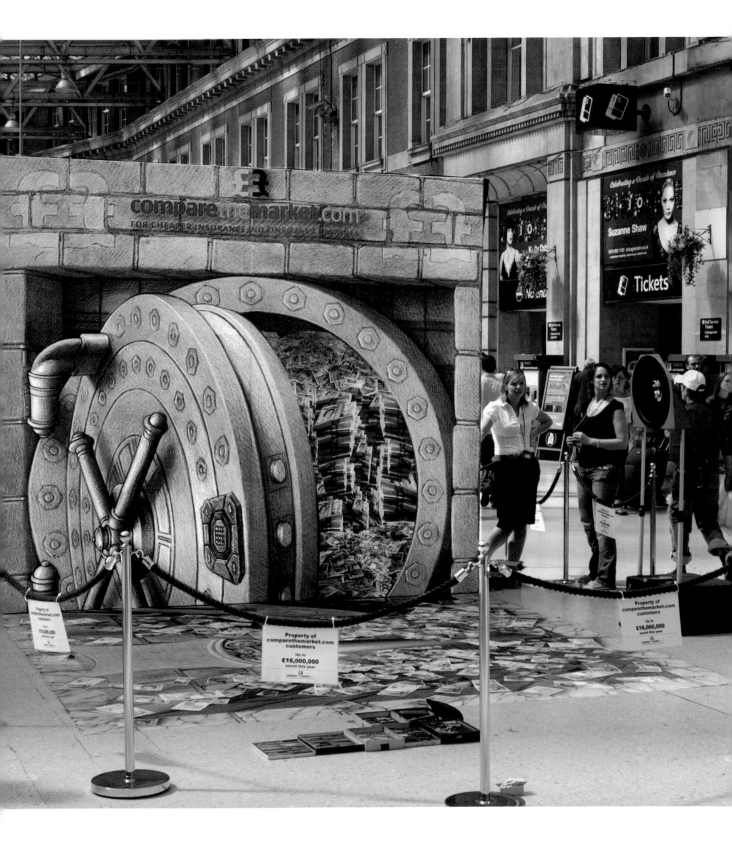

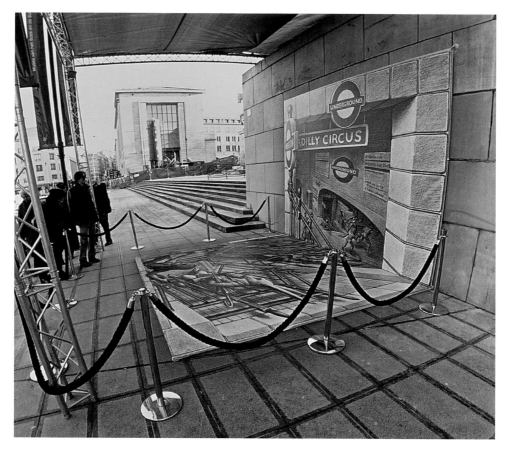

15.
DO STREET PAINTERS EVER CREATE PERMA- NENT WORK?

MANY STREET PAINTERS CREATE PERMANENT WORKS OF ART IN A VARIETY OF MEDIA. STREET PAINTING CAN BE AN IDEAL WAY TO TEST IDEAS AND PUBLIC REACTION BEFORE COMMITTING TO THE TIME AND COST OF CREATING A PERMANENT WORK.

▲ *Belgian Underground* installation. Brussels, Belgium. Some images appear especially strange from the wrong side. See page 262 for the correct view.

▶ Wenner. *Milagro* detail. Guanajuato, Mexico. Wenner usually creates preparatory drawings for his festival compositions. This work was composed on site due to the irregular pavers. See page 226 for the full work.

FURTHER READING

Castelli, Enrico. *Storia dell'Antichissima Fiera delle Grazie dal 1425 ad Oggi*. Mantova: Tipografia Grassi, 1979.

Fornasa, Paolo Longhini. *La Via Sacra Popolare*. Mantova: Universita Aperta Sermide, 1998.

Margonari, R. *Il Santuario Delle Grazie*. Mantova: Publi-Paolini, 1990.

Nalin, Felice. *I Madonnari*. Verona: Editrice MG, 1982.

Orwell, George. *Down and Out in Paris and London*. First published by Victor Gollancz, London, 9 January 1933.

Ottone, Giuseppe, and Roberto Ruggeri. *Madonnari*. Milano: Gammalibri, 1984.

Papagono, G., et al. *Santa Maria delle Grazie*. Mantova: Editoriale Sometti, 1999.

Turner, Jane. *The Dictionary of Art*. New York: Macmillan Publishers Limited, 1996.

Vantaggi, Rosella. *Mantua and Her Art Treasures*. Narni-Terni: Plurigraf, 1984.

PICTURE CREDITS

INDEX